ANTIGLOSSY

Cover / *Chloë Sevigny by Charlie Engman*
Modern Weekly China / Fall/Winter 2015

ANTIGLOSSY

FASHION PHOTOGRAPHY NOW

BY PATRICK REMY

MICHAEL BAILEY-GATES
JEFF BARK
JACK DAVISON
ANNEMARIEKE VAN DRIMMELEN
LENA C. EMERY
CHARLIE ENGMAN
JASON EVANS
ETHAN JAMES GREEN
JANNEKE VAN DER HAGEN
THOMAS HAUSER
JULIA HETTA
TODD HIDO
RUTH HOGBEN
SEBASTIAN KIM
KAREN KNORR
GLEN LUCHFORD
ANDREW MIKSYS
JOSH OLINS
MARK PECKMEZIAN
SARAH PIANTADOSI
JOANNA PIOTROWSKA
ROBI RODRIGUEZ
DANIEL SANNWALD
CASPER SEJERSEN
NOÉ SENDAS
HEJI SHIN
MAURITS SILLEM
JUERGEN TELLER
CHARLOTTE WALES
ERWIN WURM

Fashion Photography Now

There was a time, not so long ago, when fashion photography was an important step between design and distribution. Inspire! And, incidentally, encourage consumers to go to the store to buy that little dress spotted on glossy paper! Things today are more complex.

Over 40% of fashion consumers are now millennials, i.e. born in the 2000s, and they have their own information and consumption channels dictated by the digital. The gloss gradually wears out and large print-runs are increasingly confidential.

With the *see now, buy now* culture, the garment precedes magazines' series in the stores. No more time to dream! Fashion photography admittedly still exists but the stories have become segments of a strategy: the tale told in a series comprising a dozen images becomes a succession of small pebbles dropped on Instagram, Pinterest, Facebook or others, and we are not quite certain to find our own way in to the narrative, as in an endless conversation. The story becomes a multitude of stories... Never mind, our retina is quick to grasp it even if the eye does not really remember the subtleties in the images. On average, we spend over 608 hours each year on social webs, roughly equivalent to reading two hundred books. How many magazines?

Bloggers have become digital starlets whose measurements are calculated according to their number of followers. They are now the new trendsetters in fashion. Both fashion photographers and designers are after them, grabbing only but the crumbs of their fame. Often in vain! It takes a split second for the beholder to *Like*, or not! And what about the continuous flow of images? How can they be appreciated? Understood? Is fashion photography still attractive? Does it help to sell?

Fashion photography is still a marketing tool, one amongst many others. The format must be adapted, the garment well featured, the story well told. And the glamour varnish slowly wears away. The gloss no longer shines. So, does this mean that fashion photography should be buried after years of distinguished service?

With this digital tsunami, the pendulum always swings back. Back to books: *Loewe* offered literature books during one of their fashion shows, and for their (paper) magazine, they collaborate with artists who usually operate away from the fashion industry. *Gucci* has commissioned several such photographers for their books, just as *Bottega Veneta* did for their advertising campaigns.

Both the brands and the magazines are searching for meaning. Done with the shine and the glam: it may be the end of the glossy paper, but not the end of the image. The fashion business still needs artists to preserve and perpetuate the dream in the industry. An industry–a dirty word, which when associated with the word *dream*, becomes fashion... An industry that needs artists, fashion photographers, to justify itself, to deliver and further the dream. That slice of dream that brings garments to life before they are even worn by consumers.

The surprise now replaces references, and the antiglossy, the glamour. Misogyny is receding, the desire for the body leaves room to other values. And the struggle against standardization is permanent. Society as it is, and not as it is dreamt, has replaced the glam, the glitter and the gloss. Designers and consumers now aspire to and need a photography away from the usual references, singular in expression, as in the images in this book.

Let us wish for a world that would be less bland. Back to the real! Antiglossy!

Patrick Remy

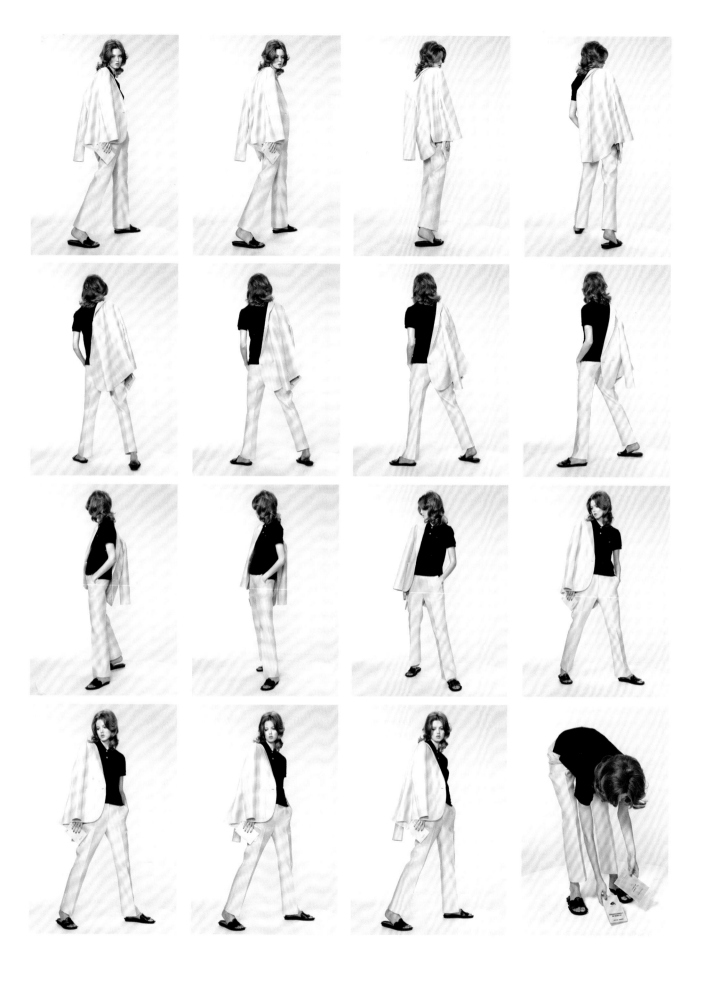

CHARLIE ENGMAN

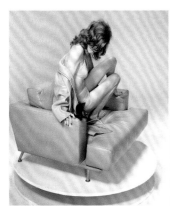 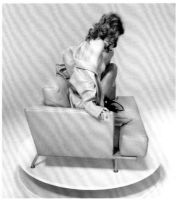 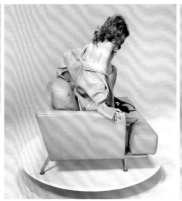 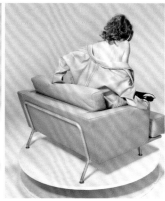

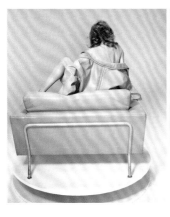 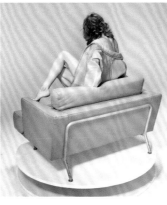 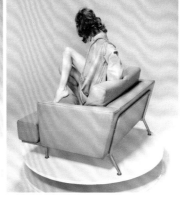 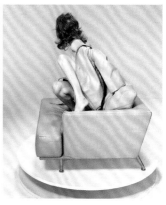

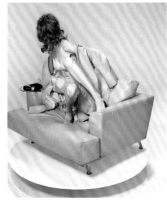 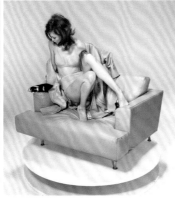 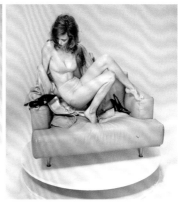 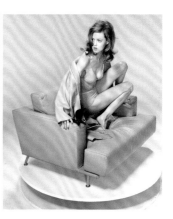

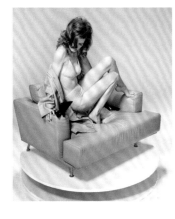 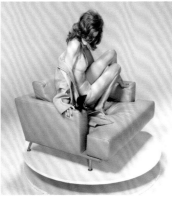 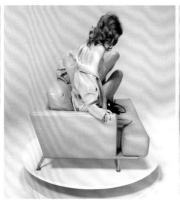 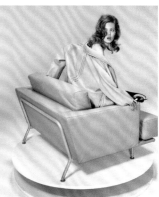

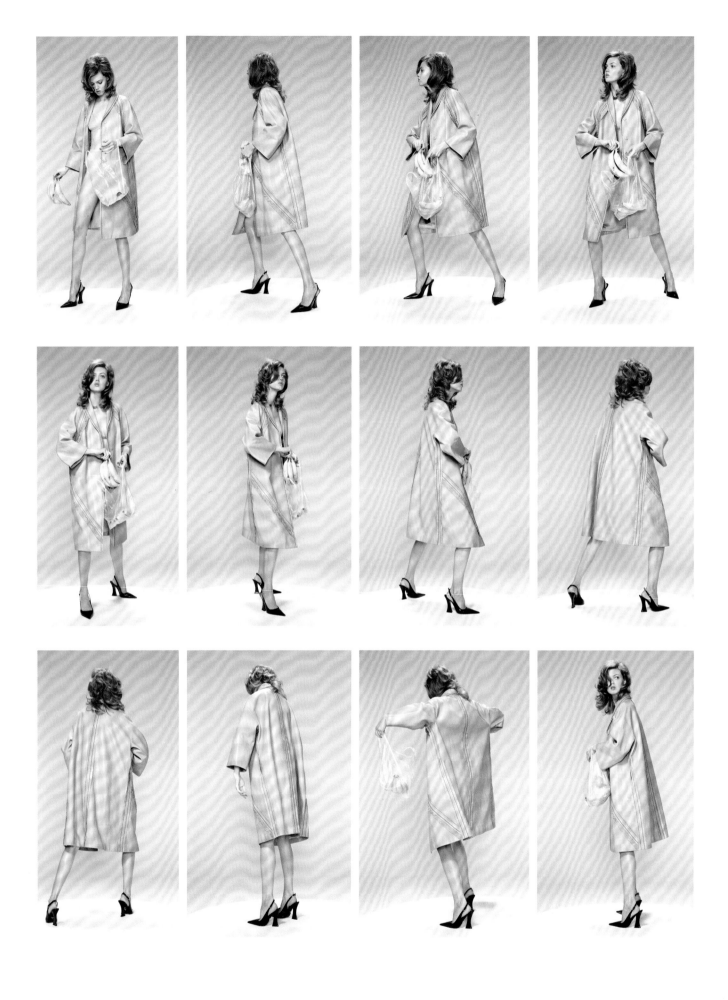

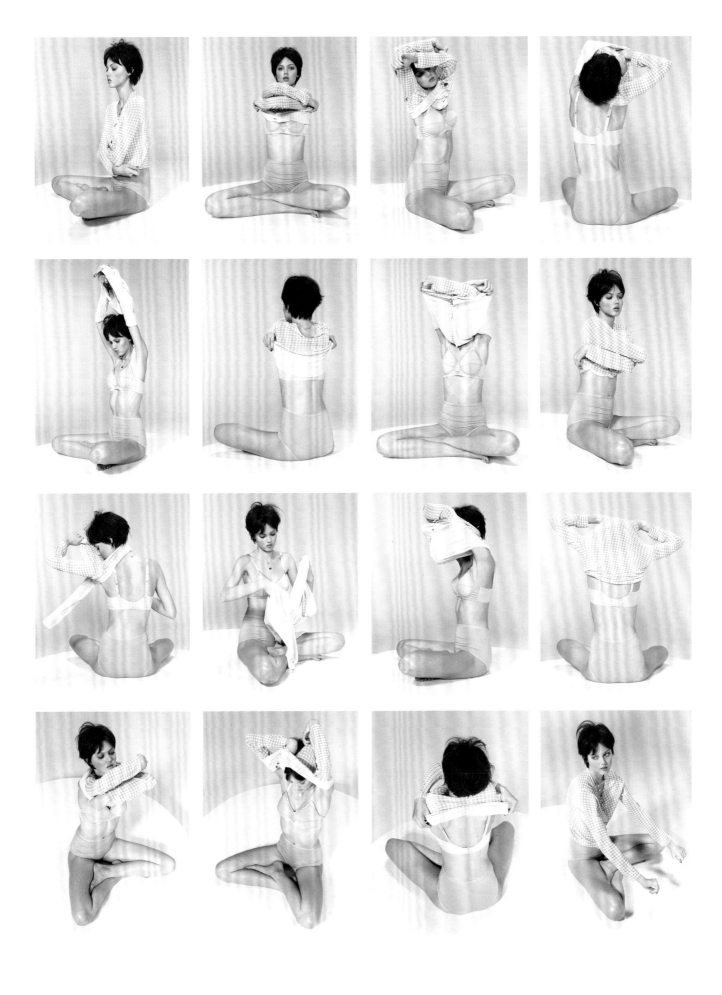

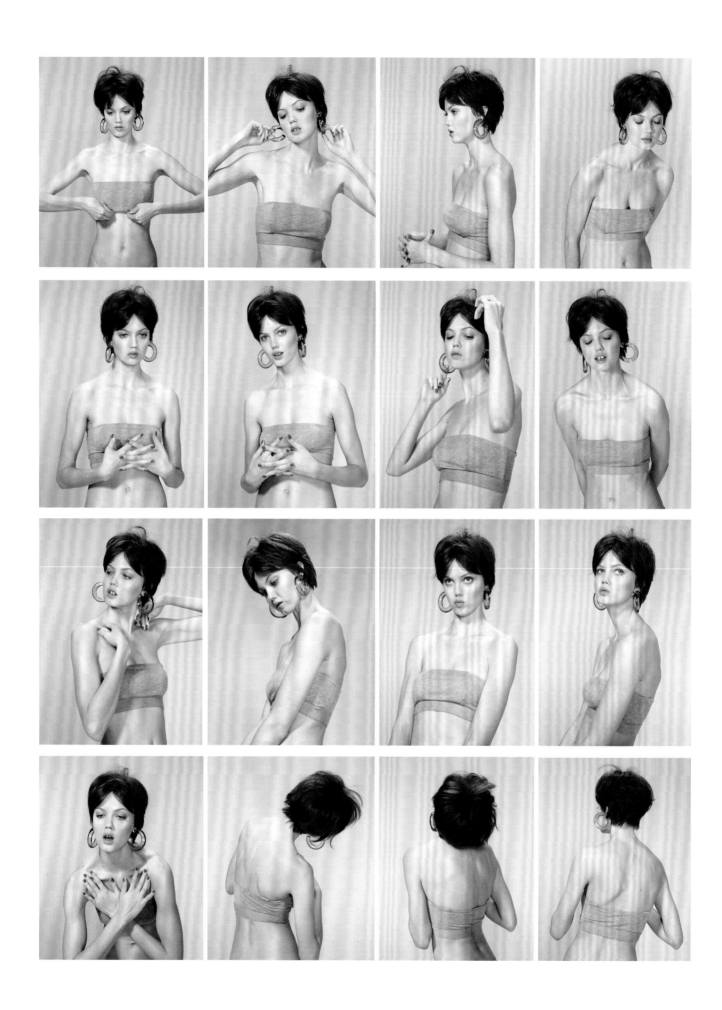

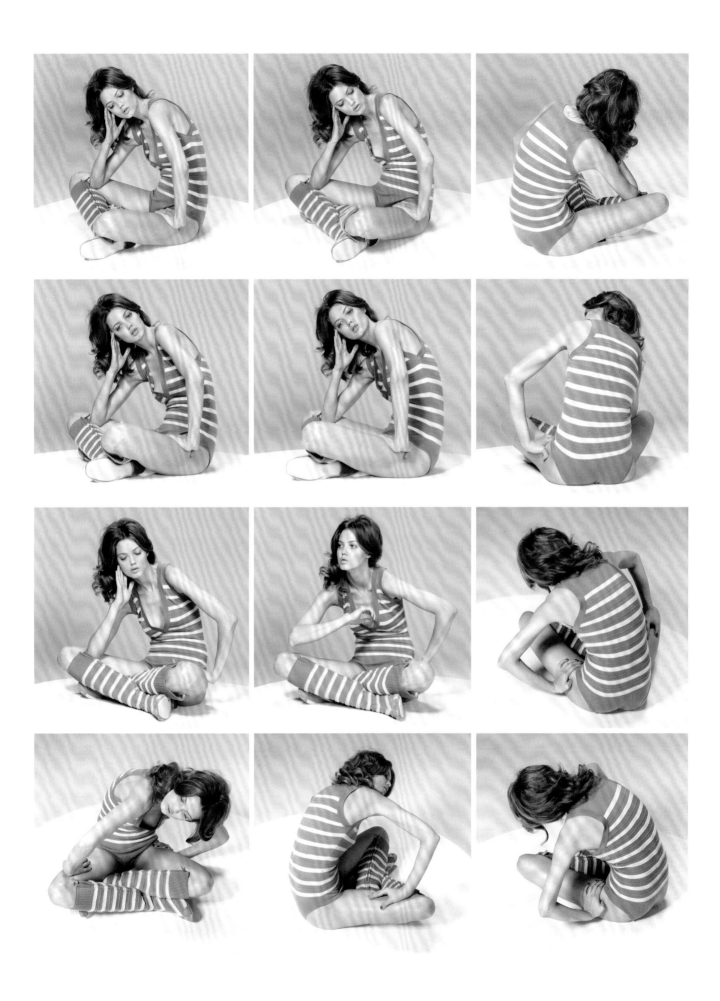

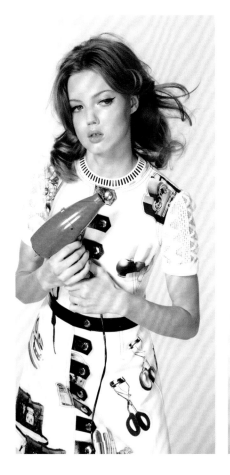
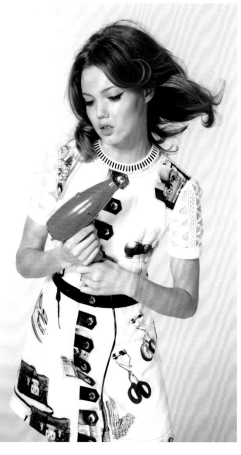
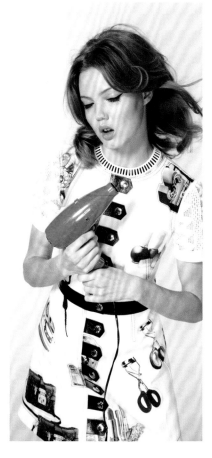
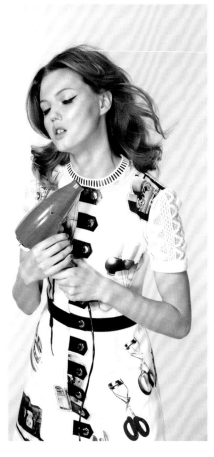
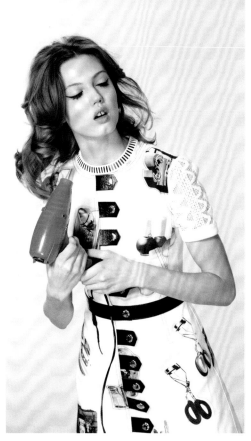
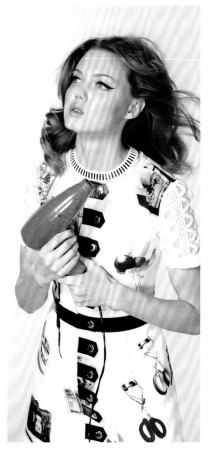

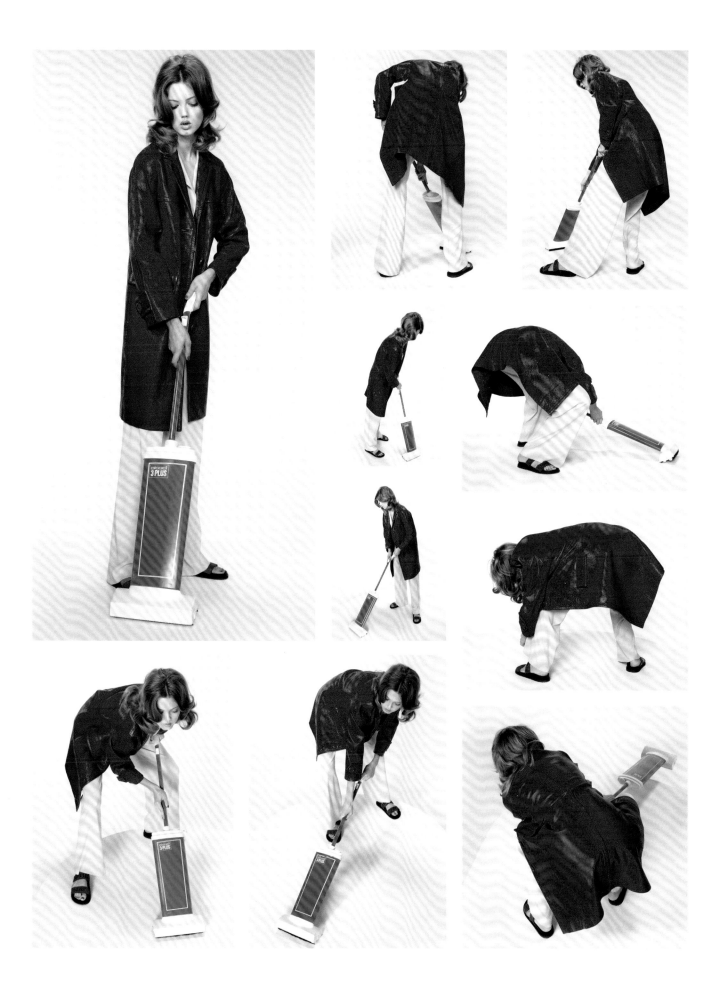

GLEN LUCHFORD

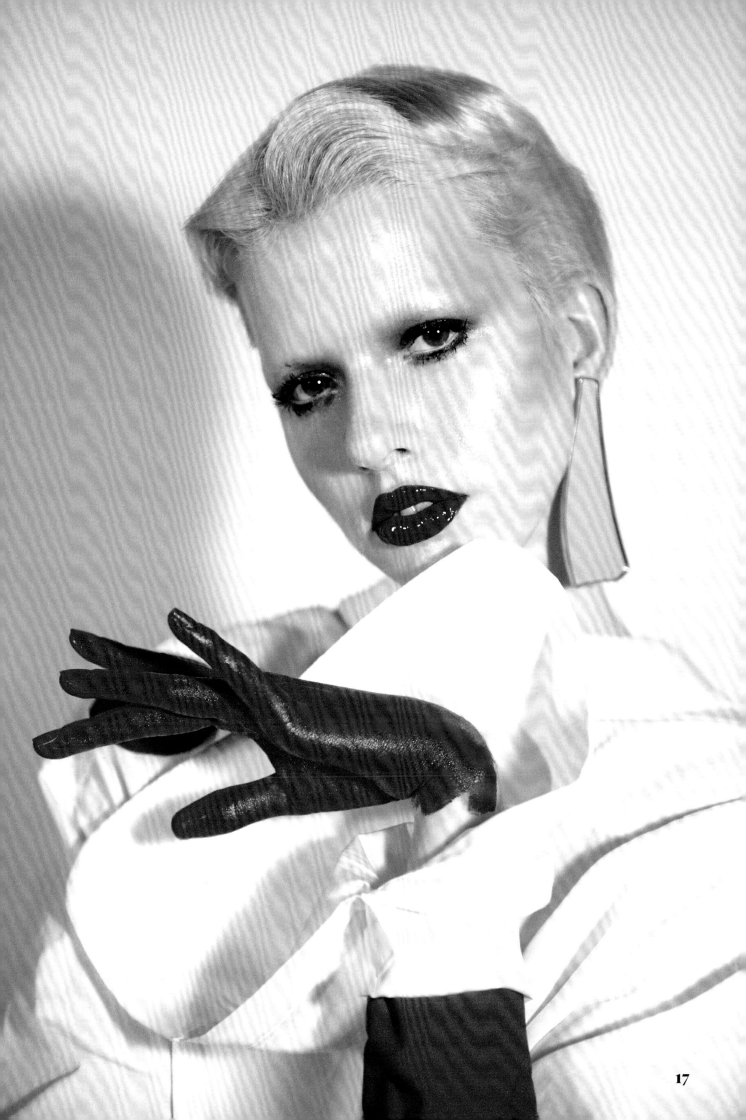

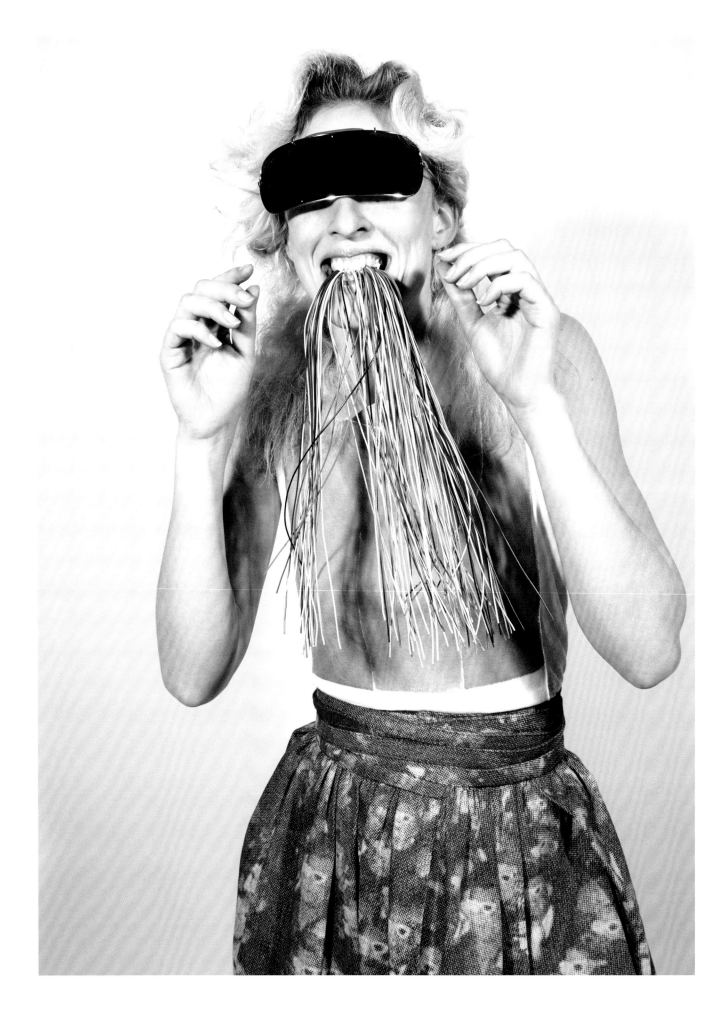

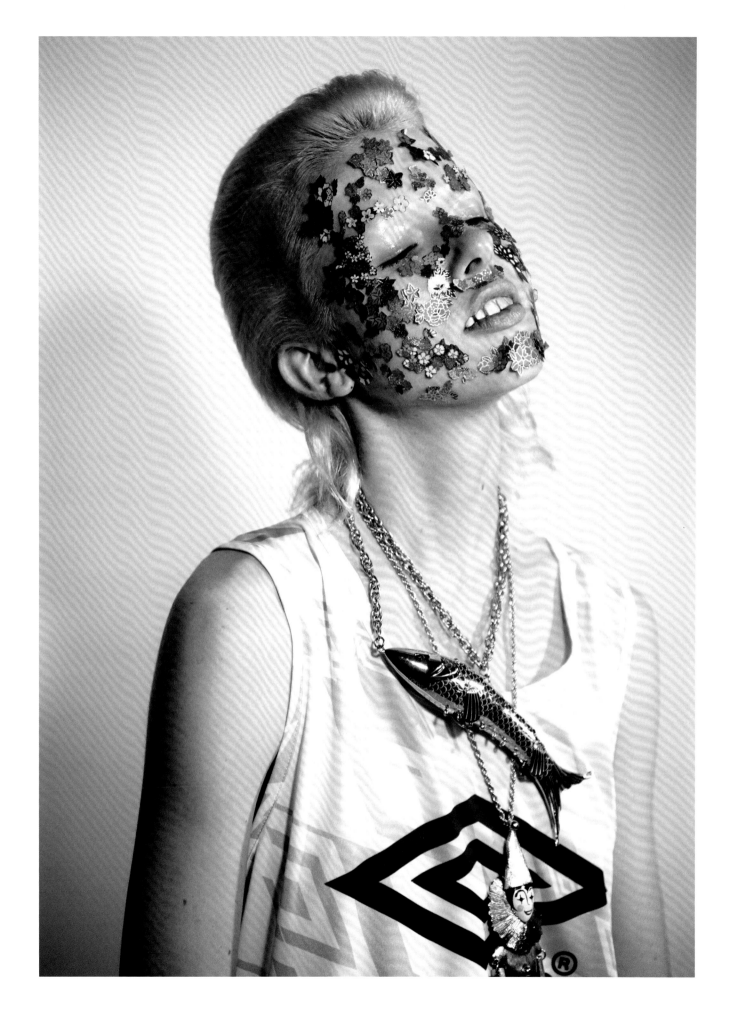

19

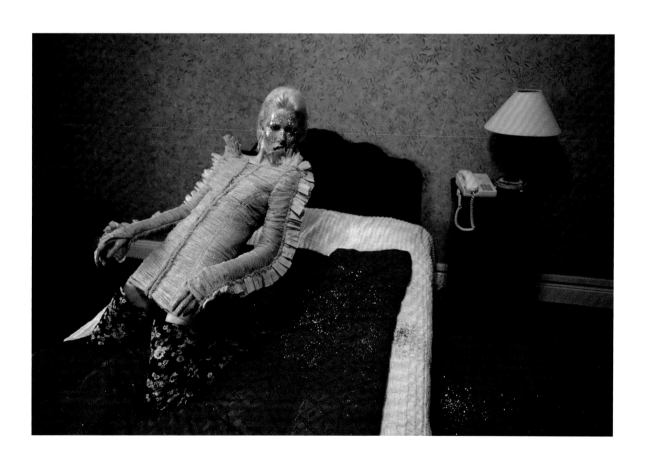

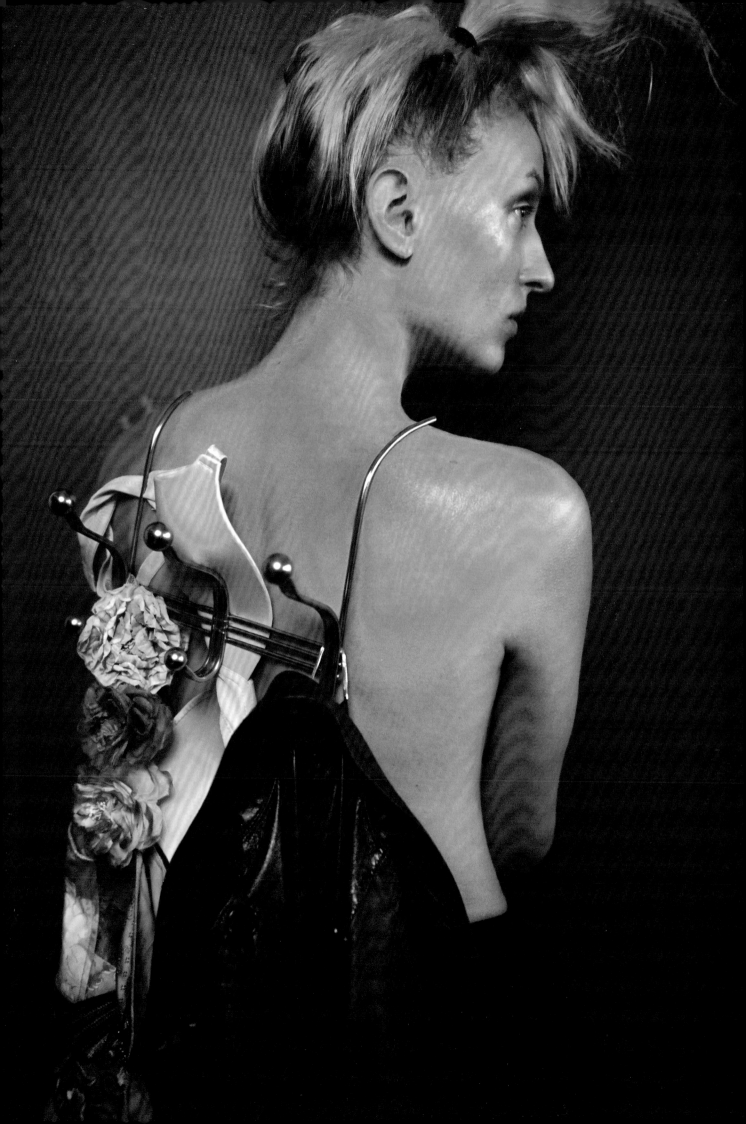

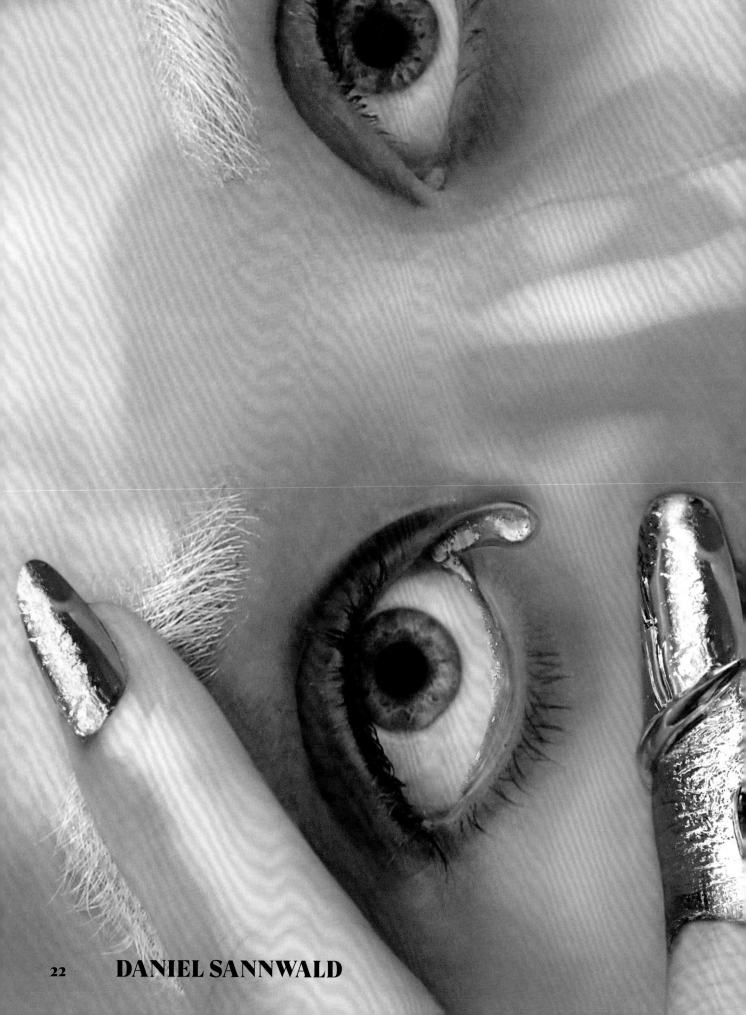

DANIEL SANNWALD

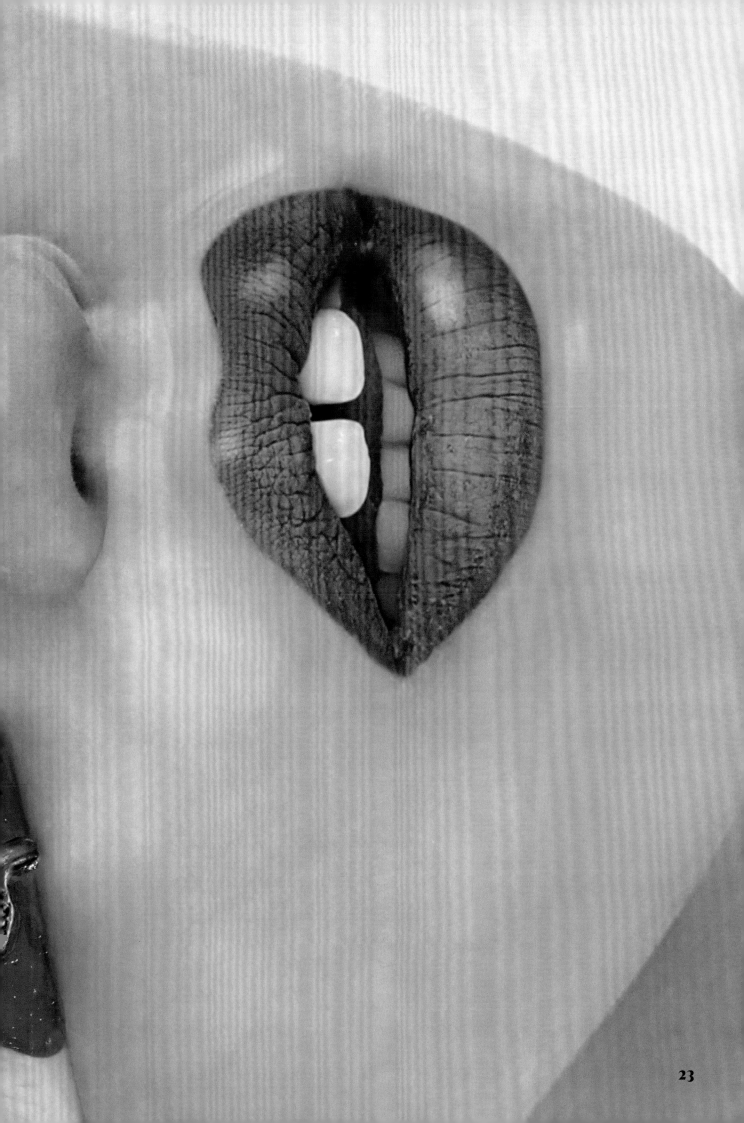

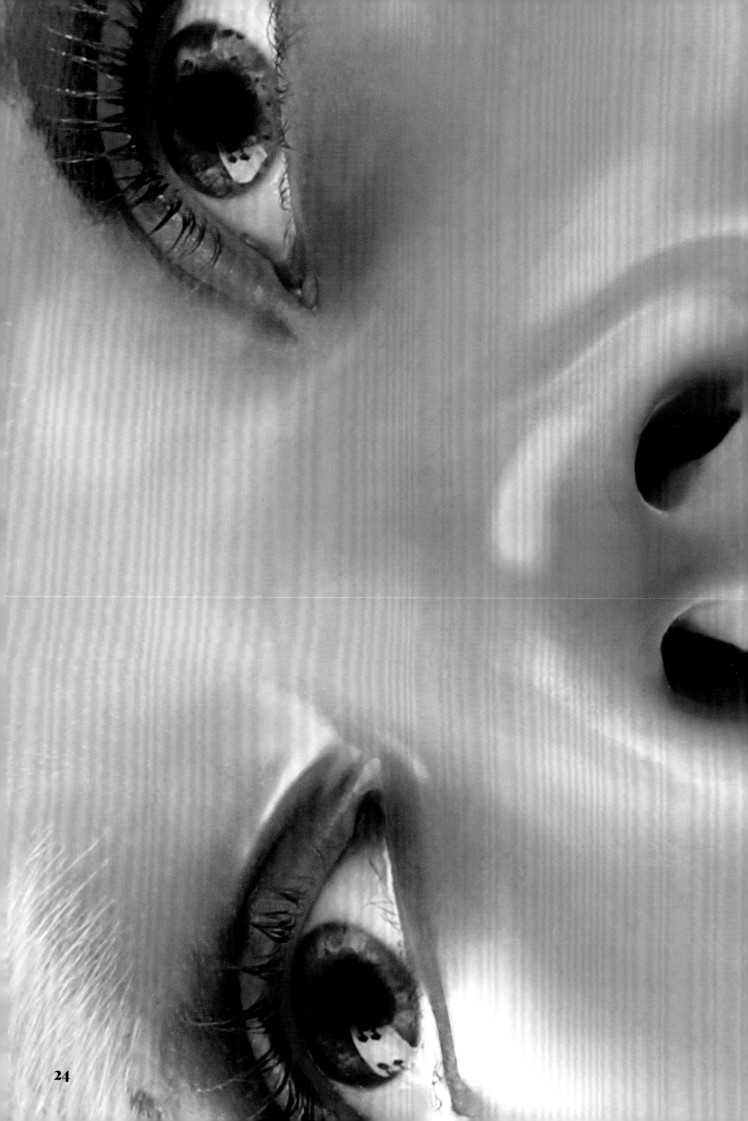

24

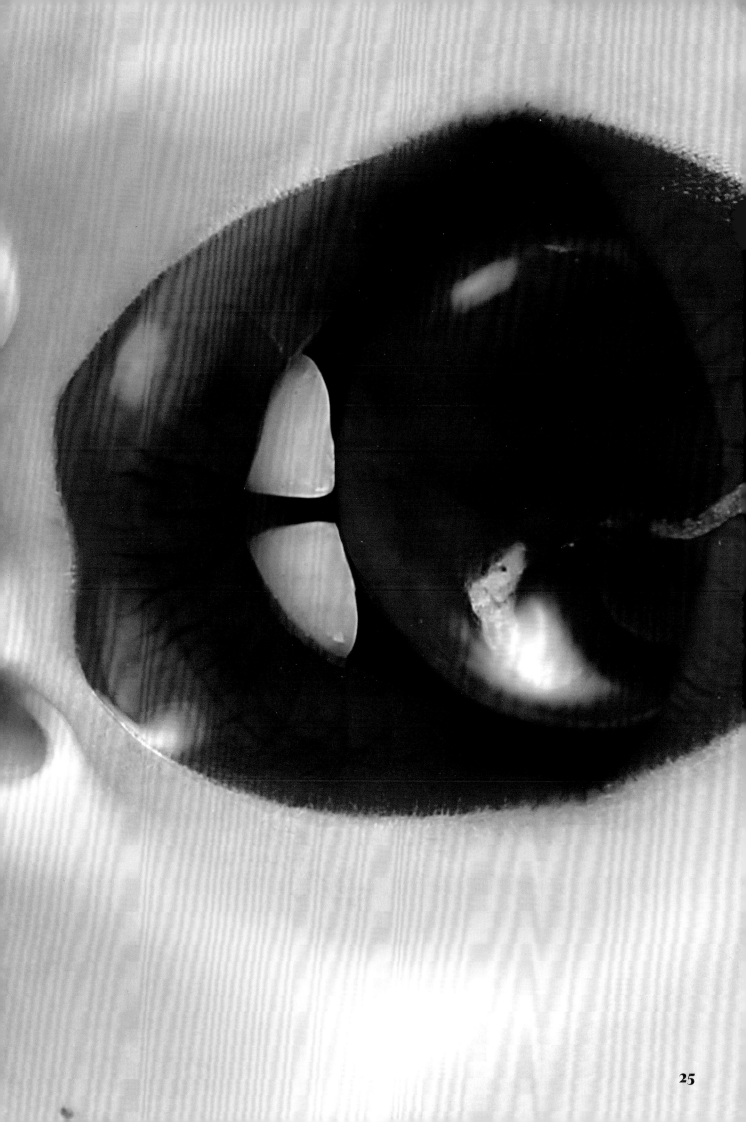

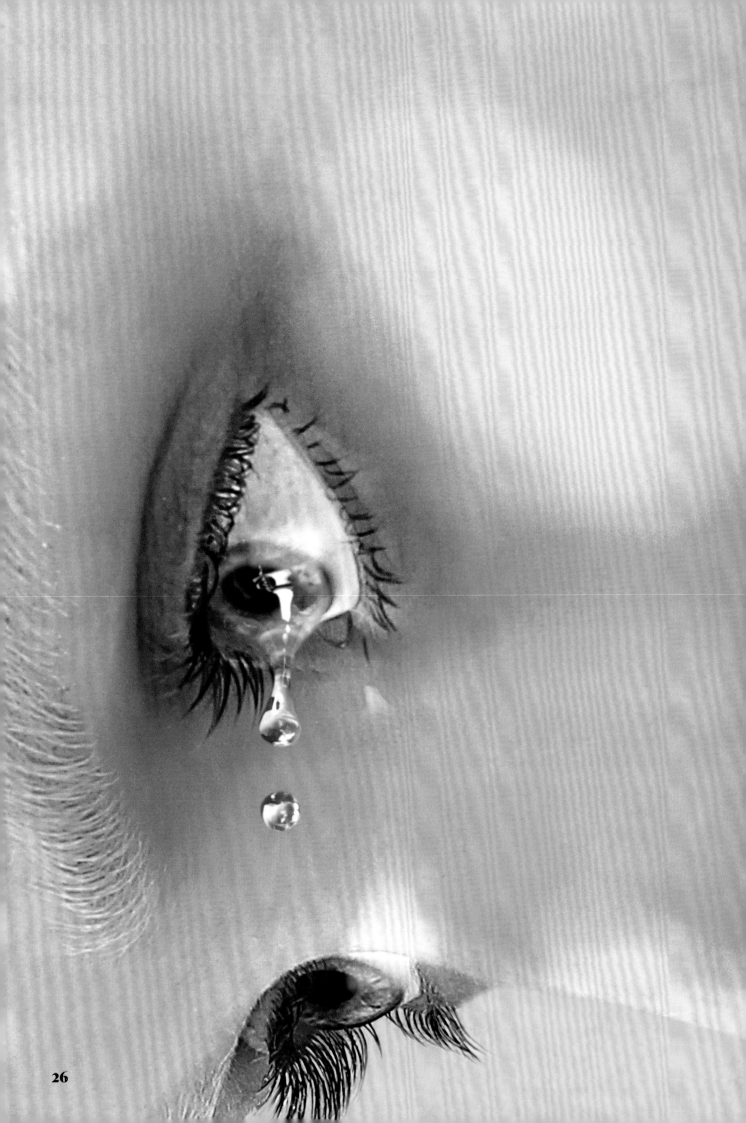

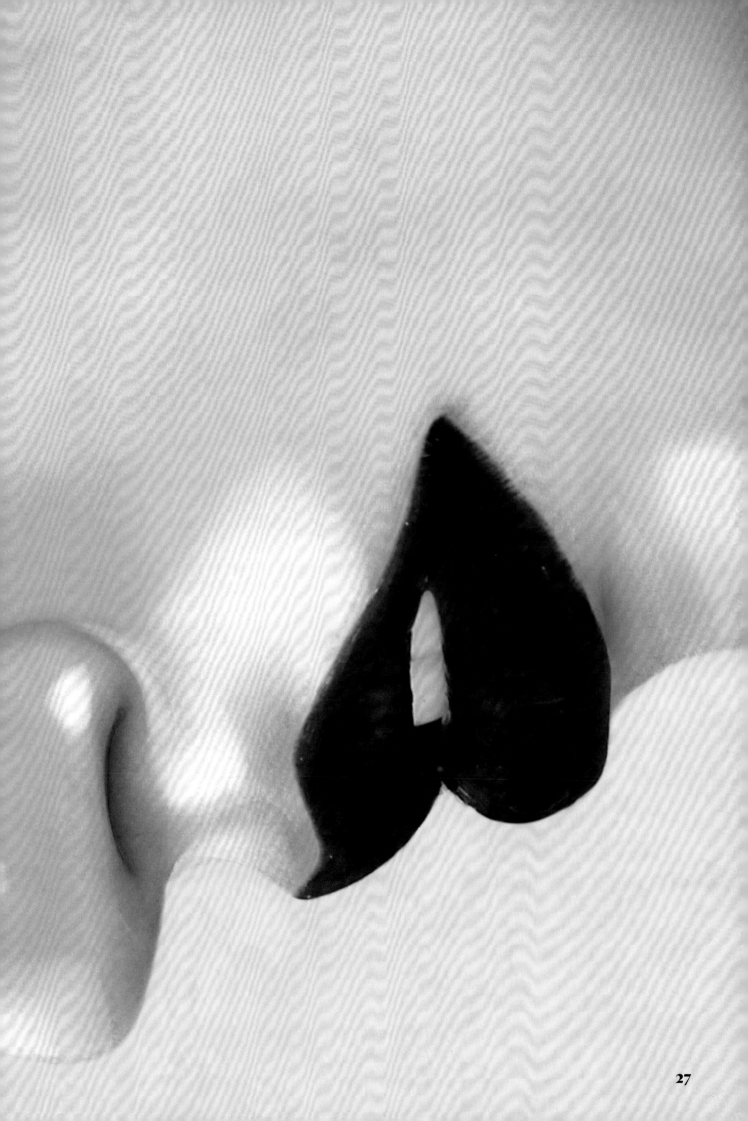

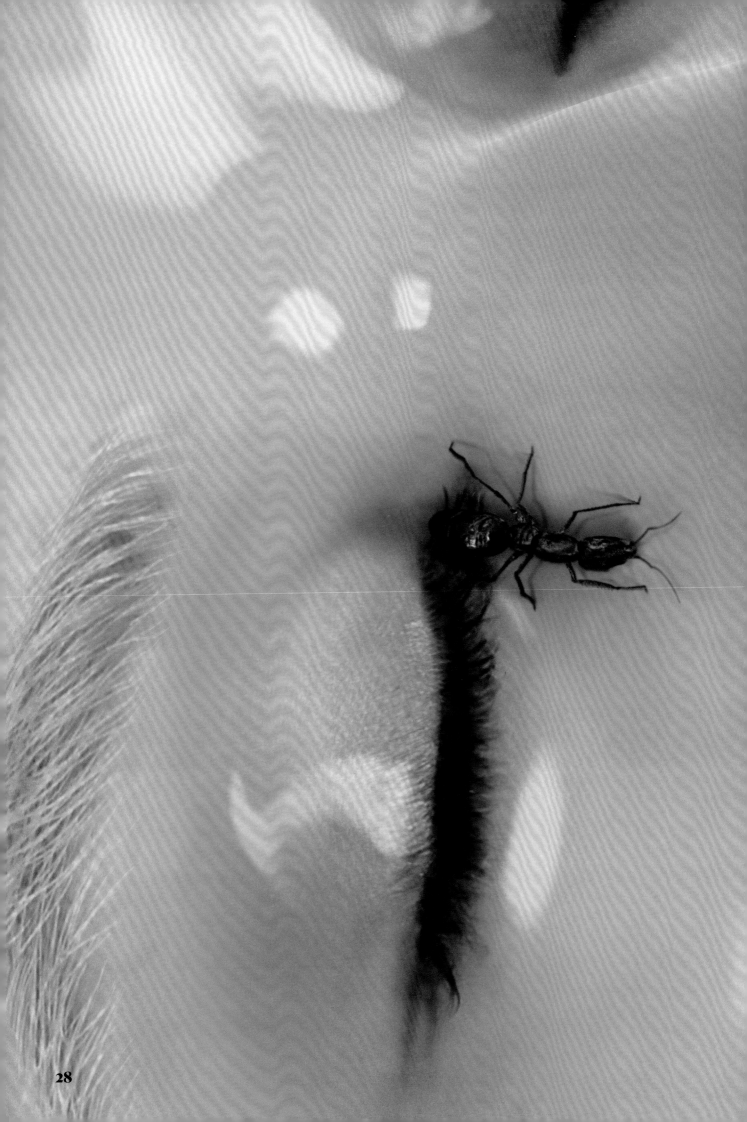

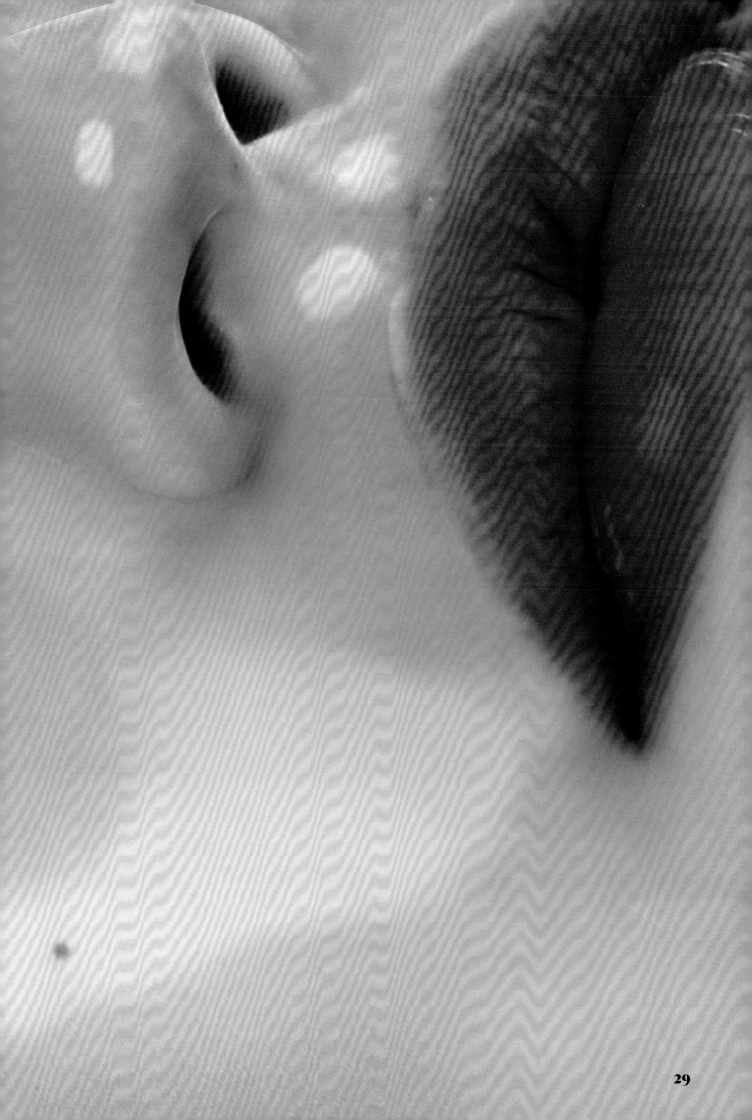

ERWIN WURM

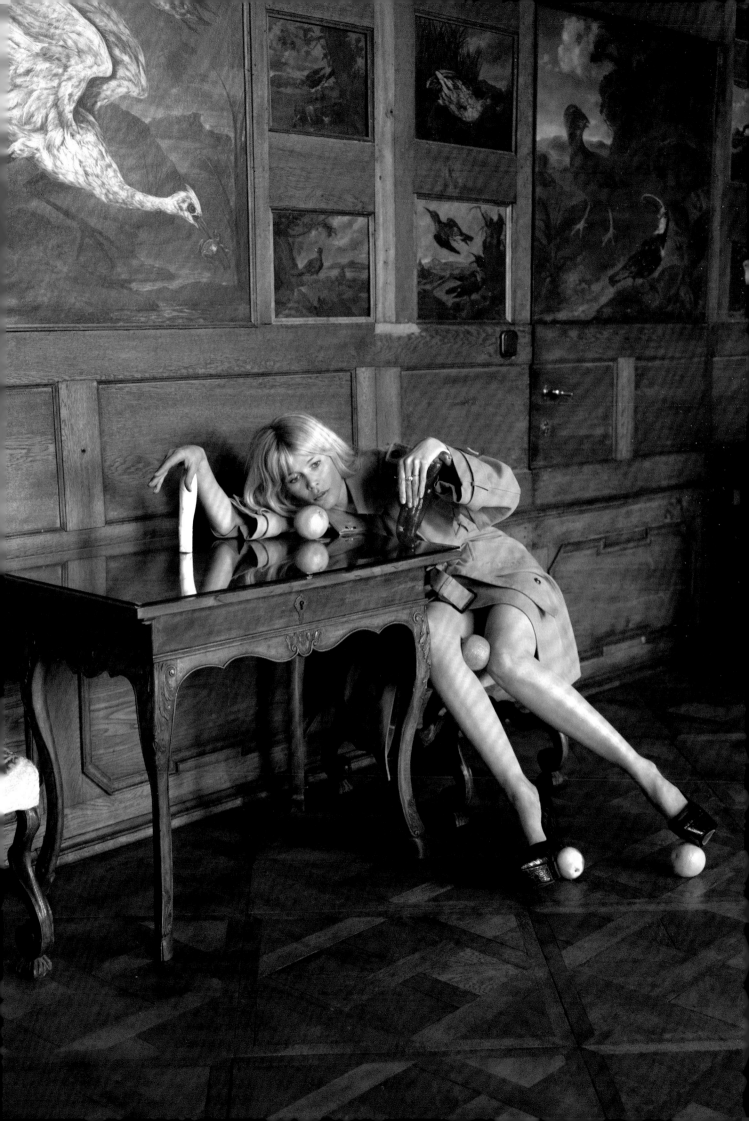

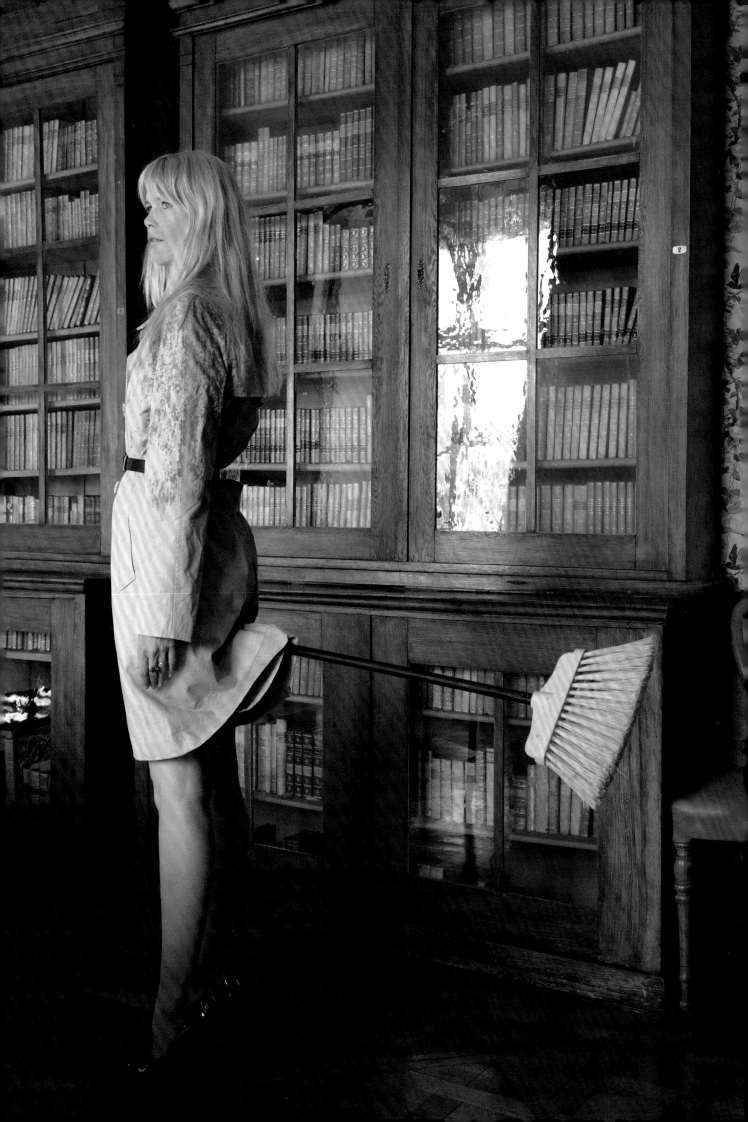

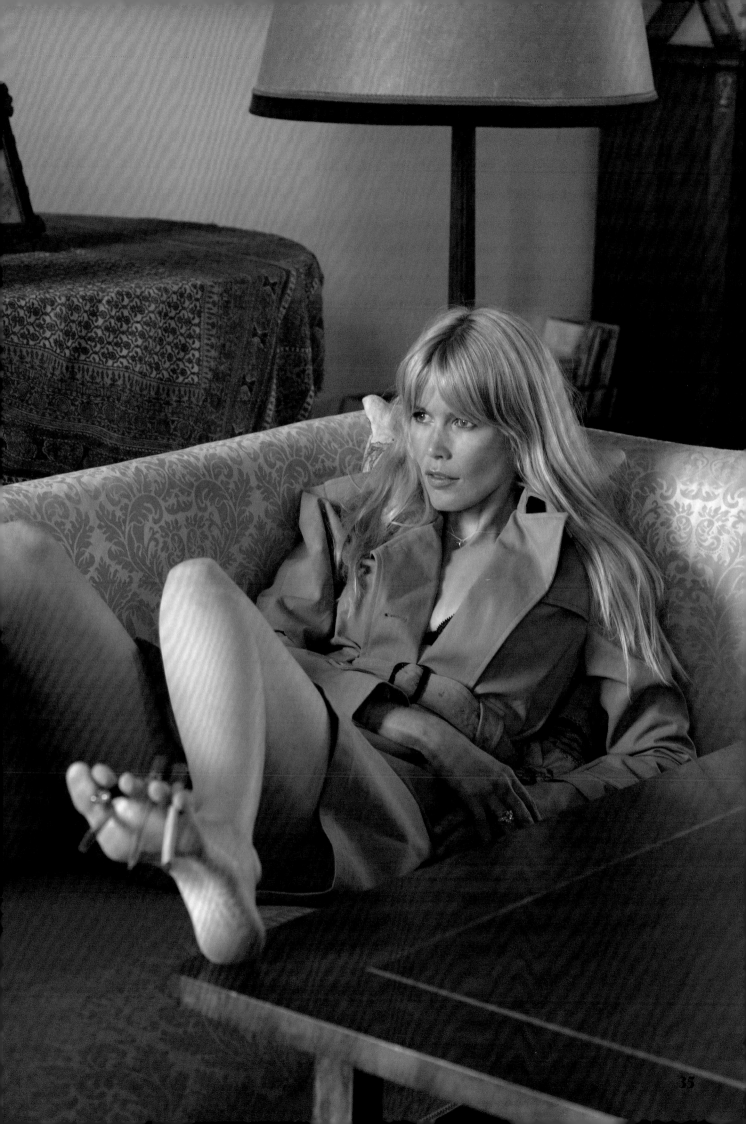

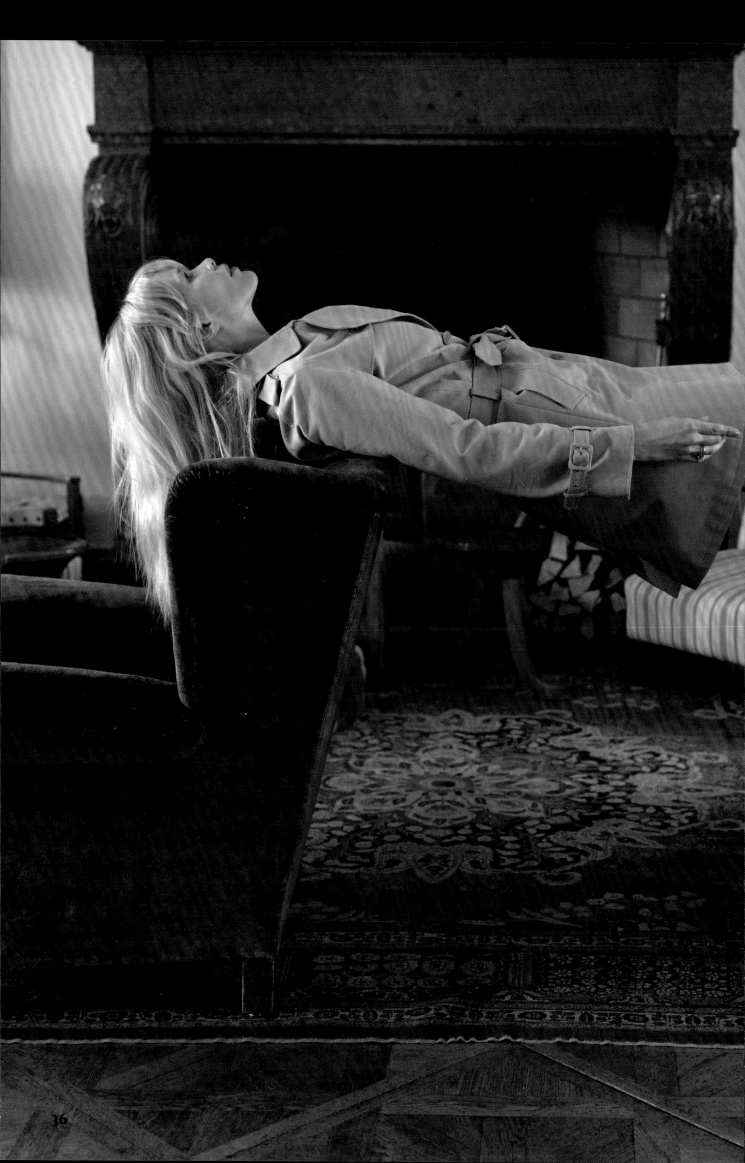

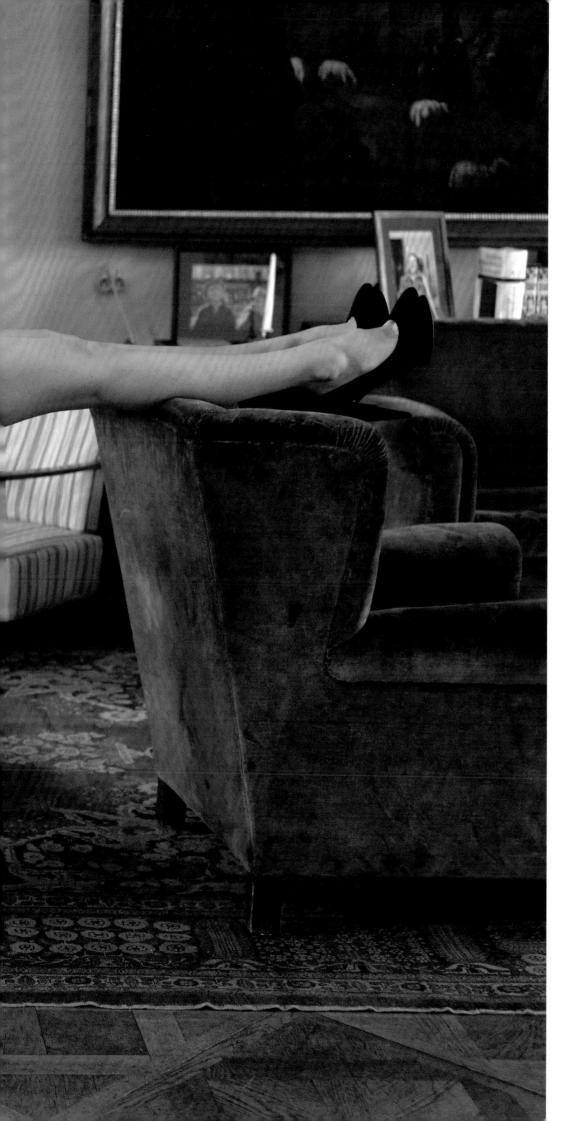

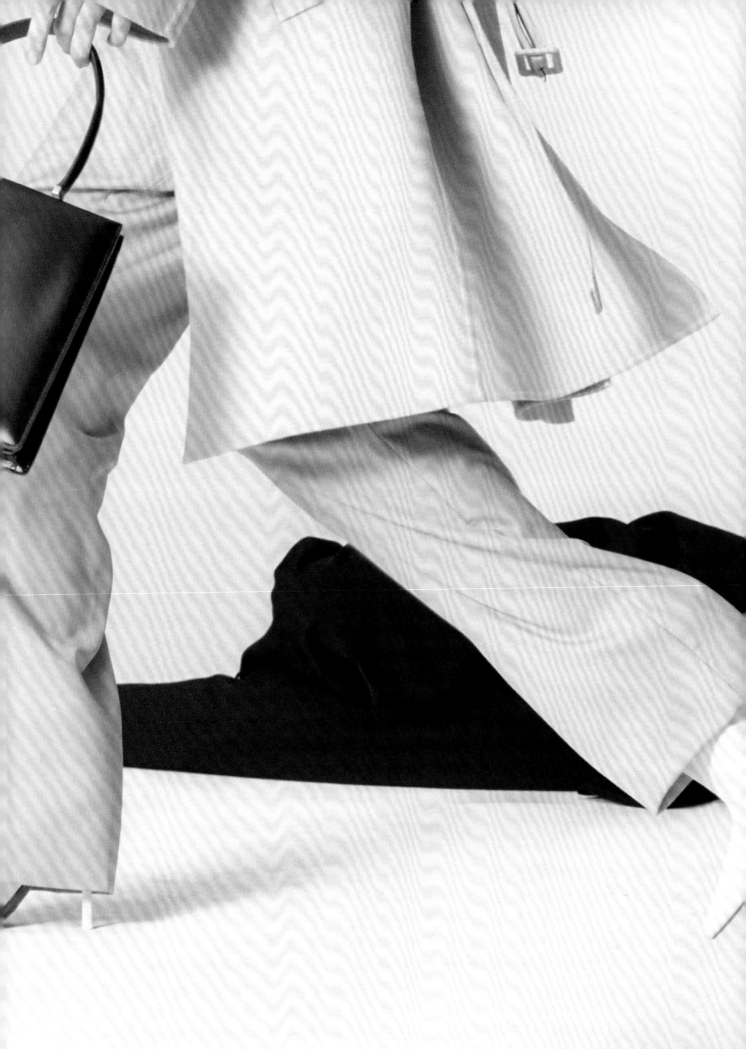

HEJI SHIN

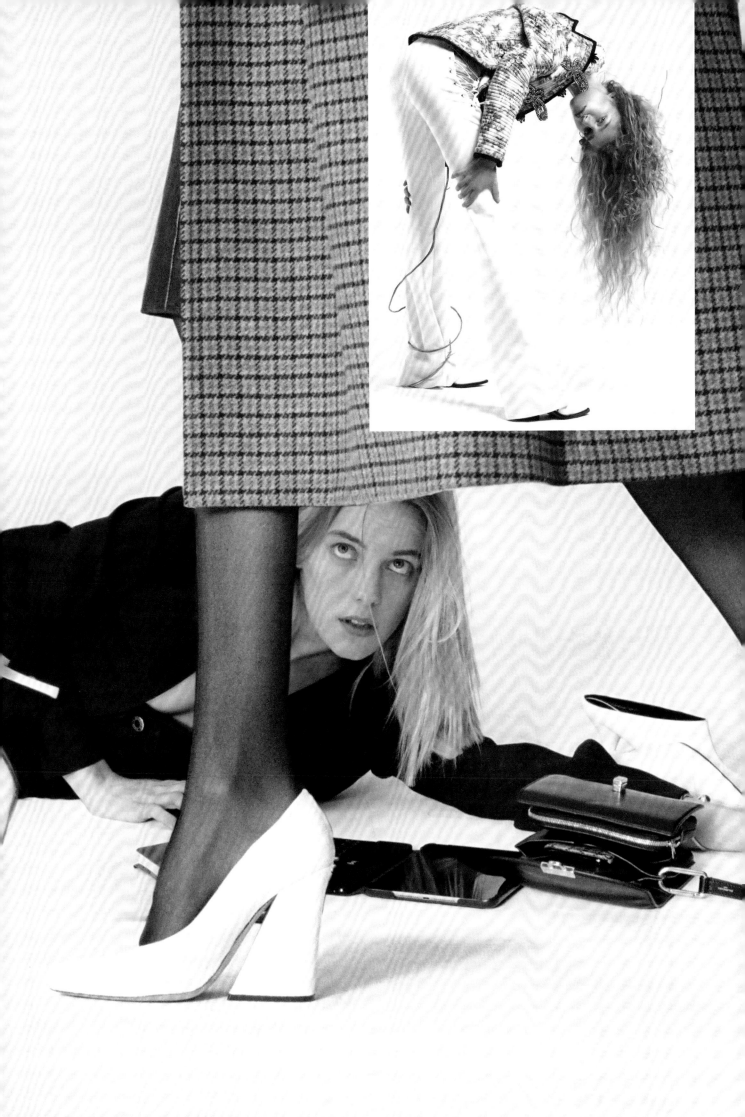

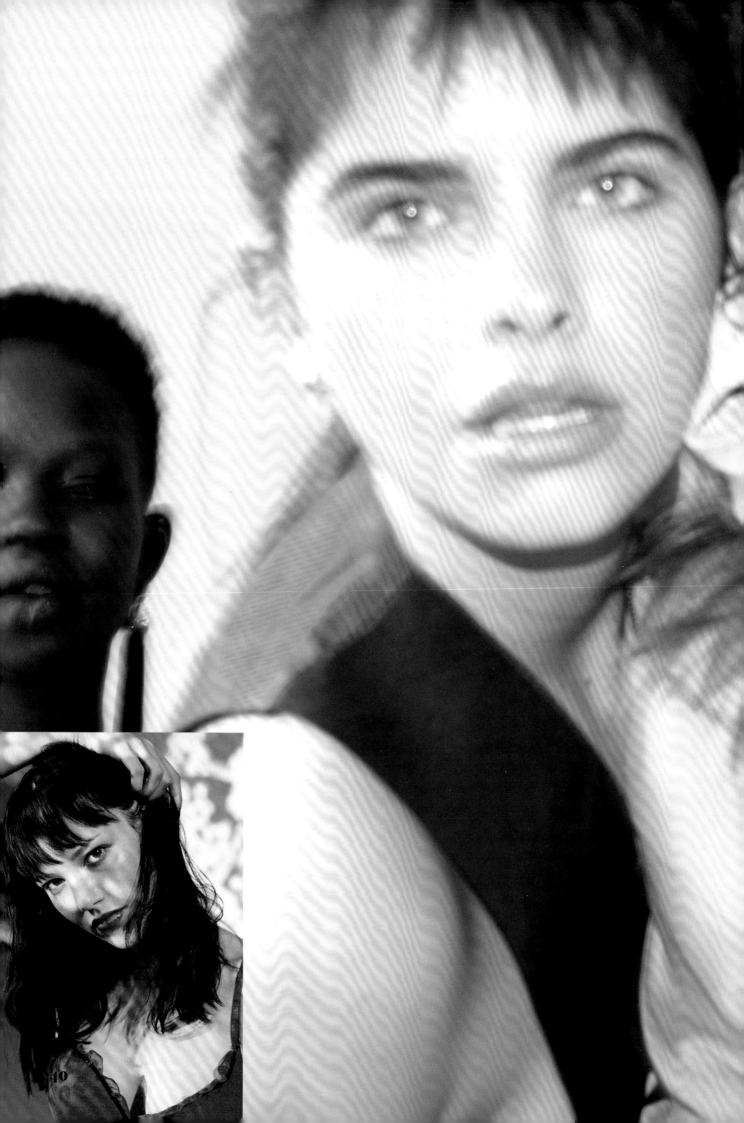

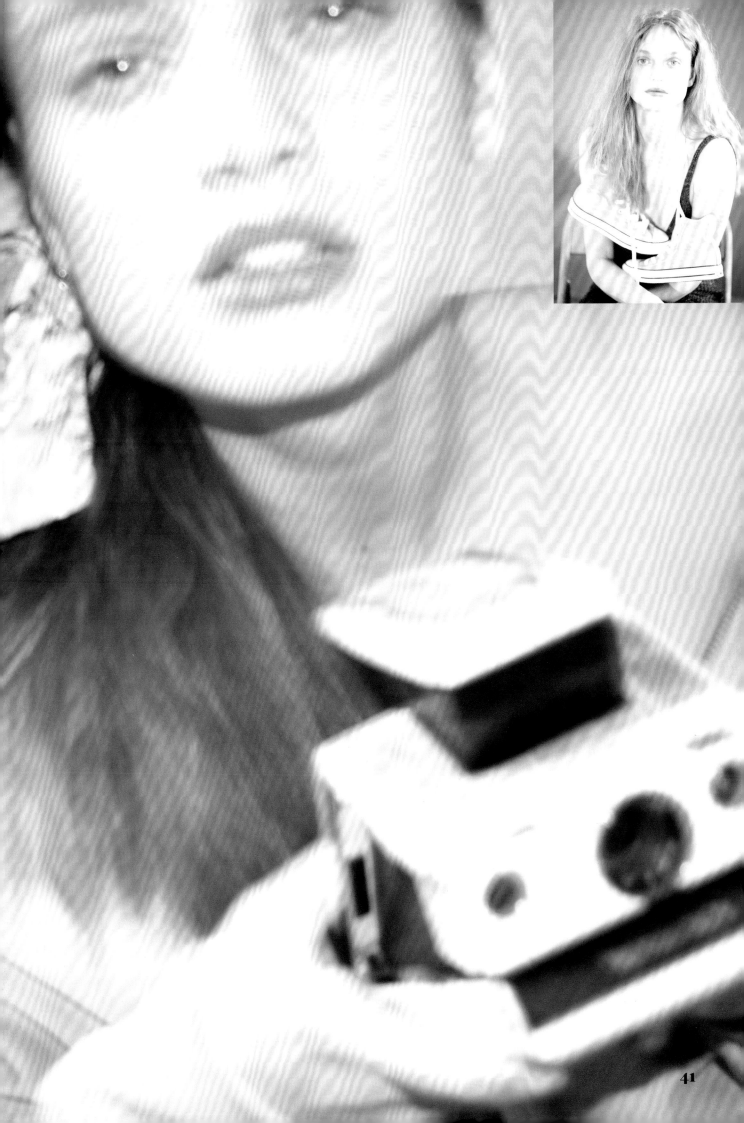

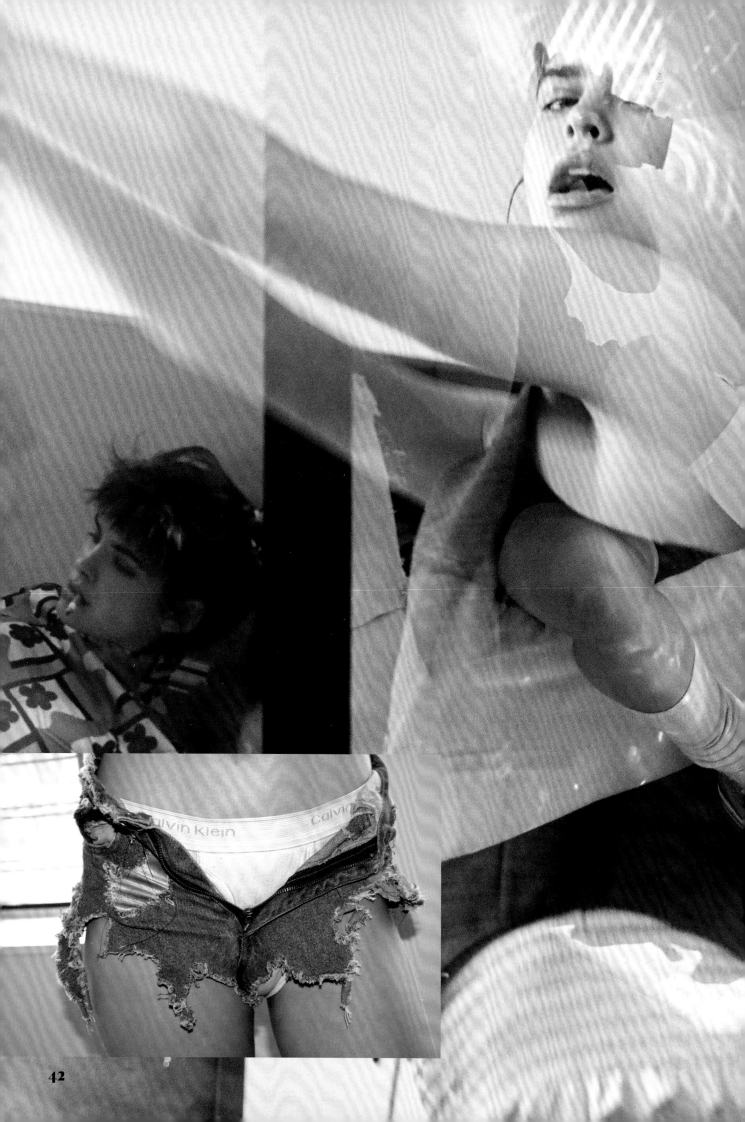

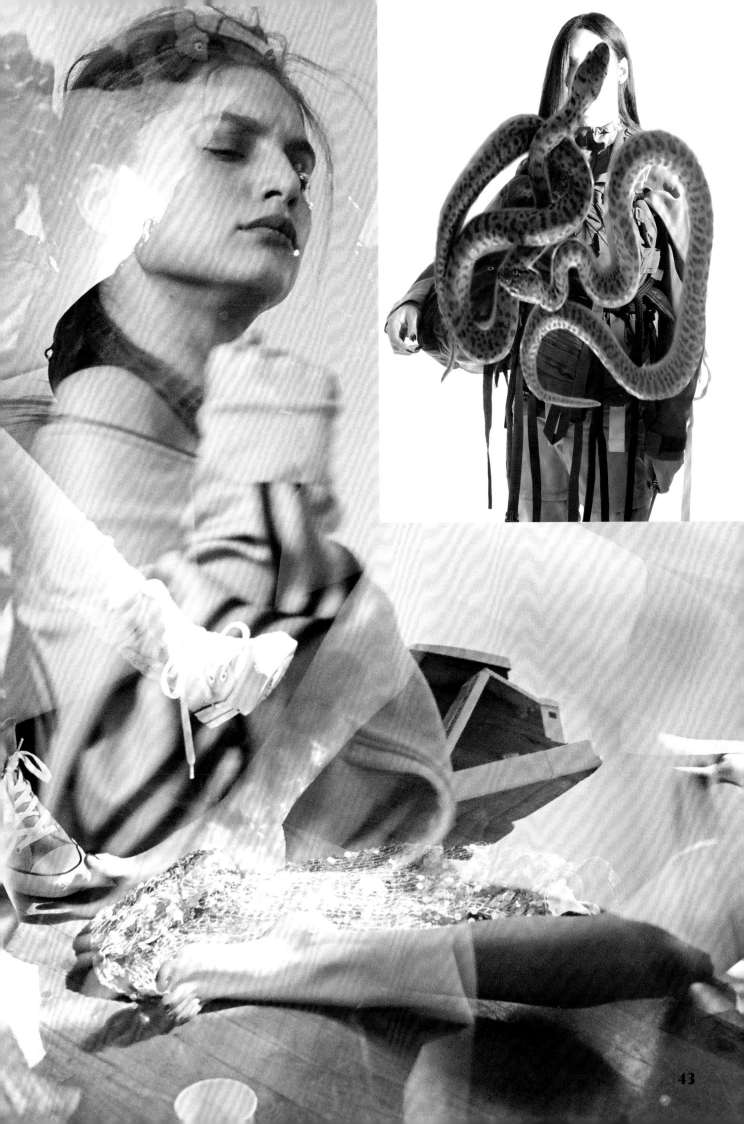

JUERGEN TELLER

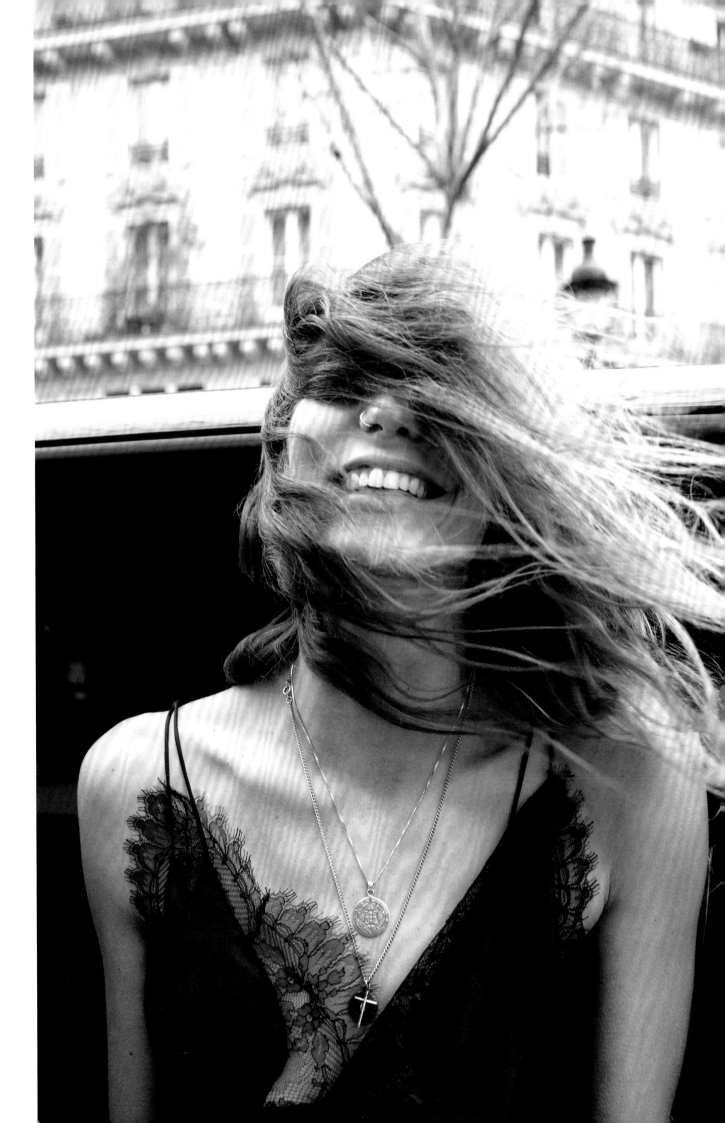

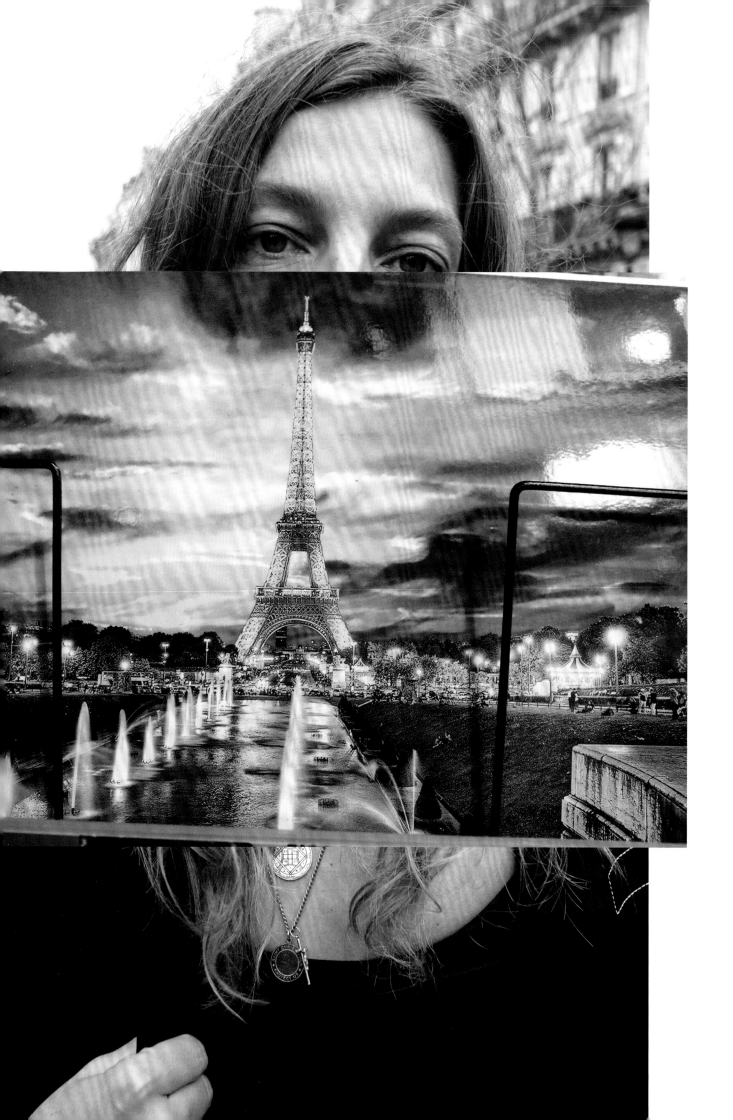

THE FACE

From Essex girls to serial killers: 1991 in review

VANESSA PARADIS
Femmes fatales: the new French starlets

SEAL talks dirty · NWA banned on the run
Fake! Madonna on Bondi Beach

Vanessa Paradis photographed by Juergen Teller

9 770263 121019 · 01

«UNE COUVERTURE DU *Face* PAR JUERGEN TELLER.
C'est la seule fois qu'on a travaillé ensemble. On s'était retrouvés dans un

«J'A
CH
des
sou
aut
nou
c'es
nuis

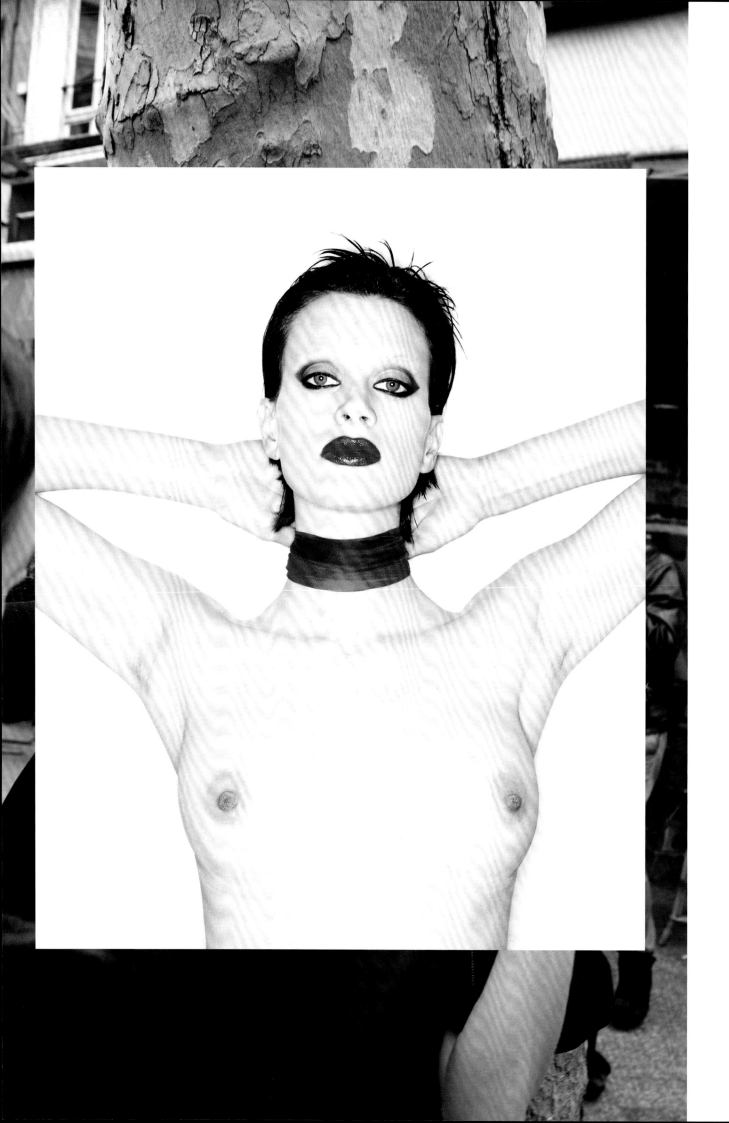

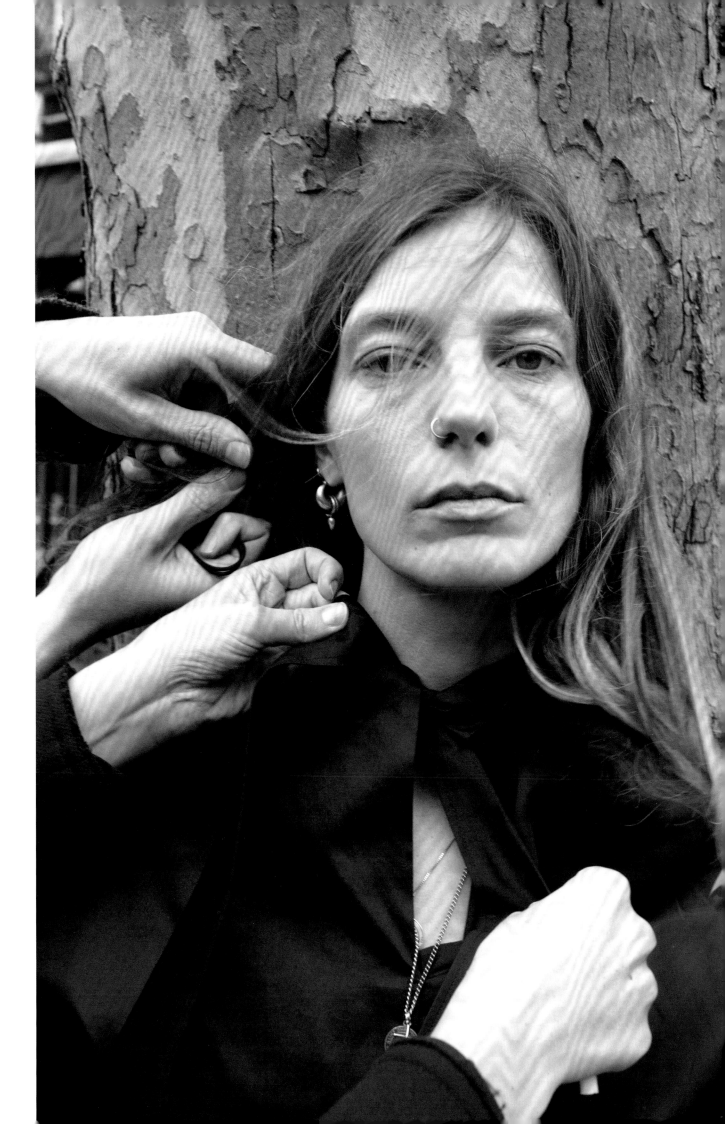

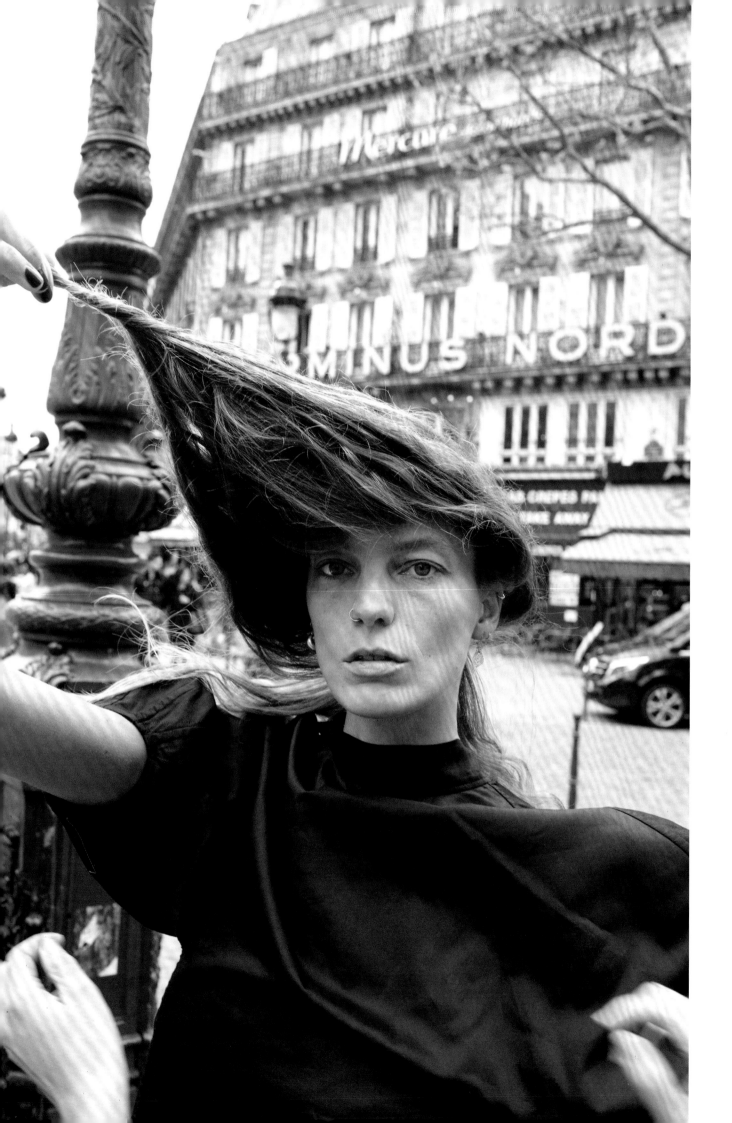

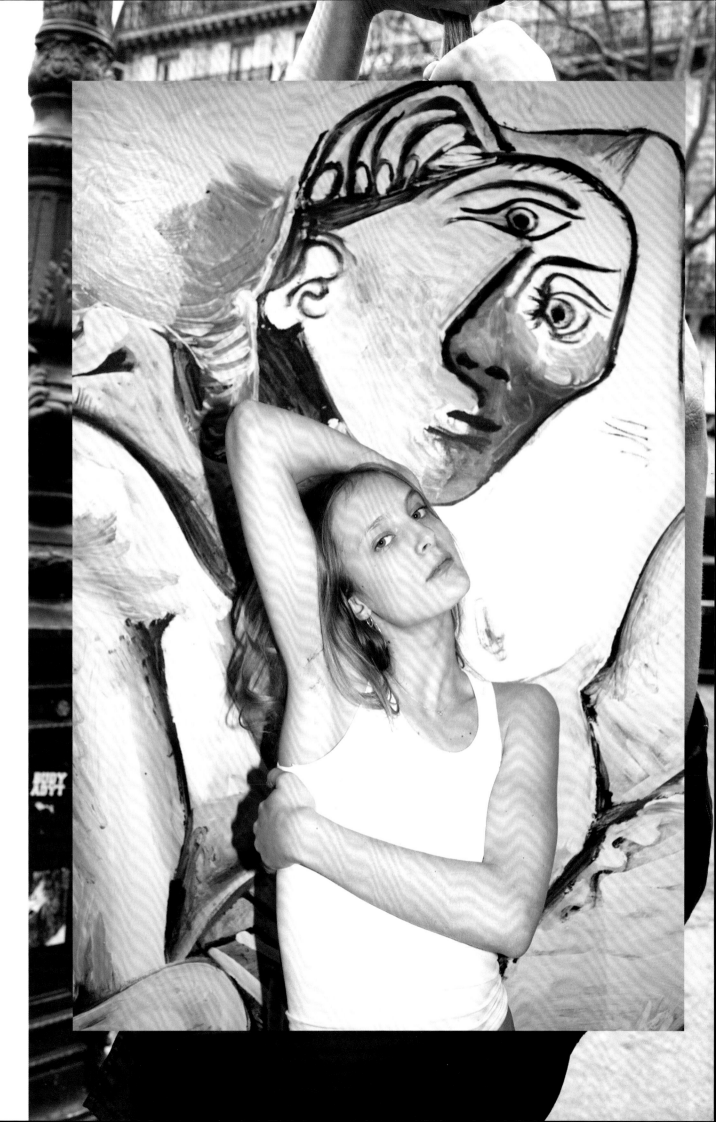

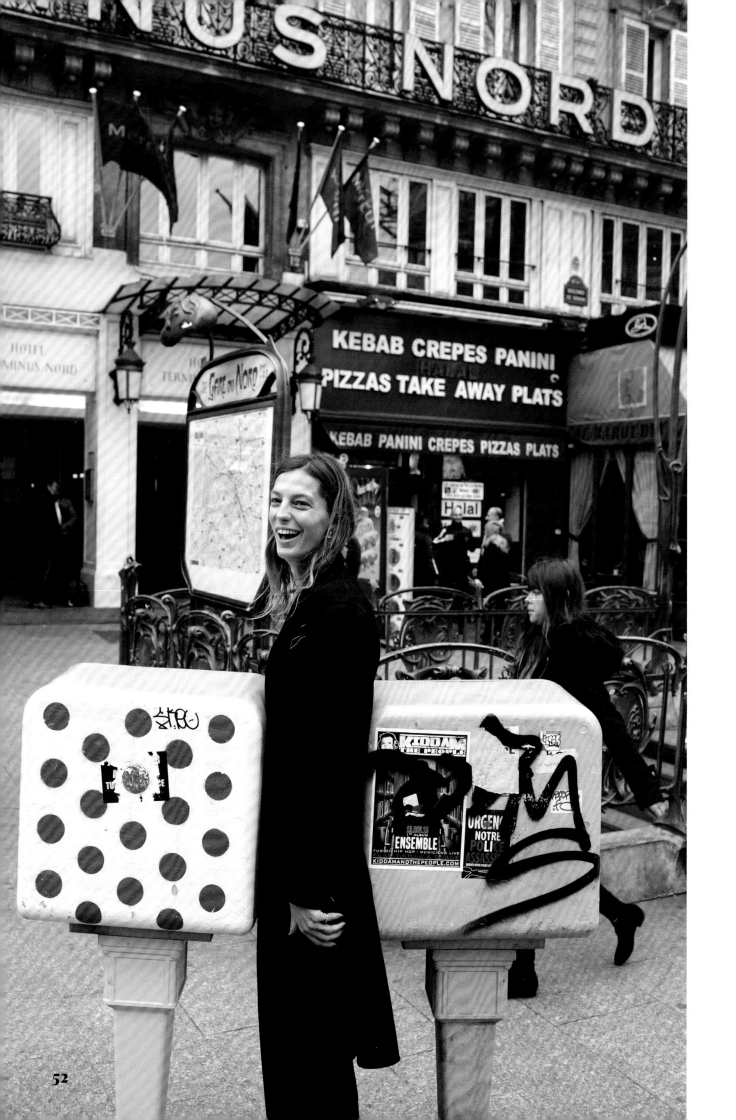

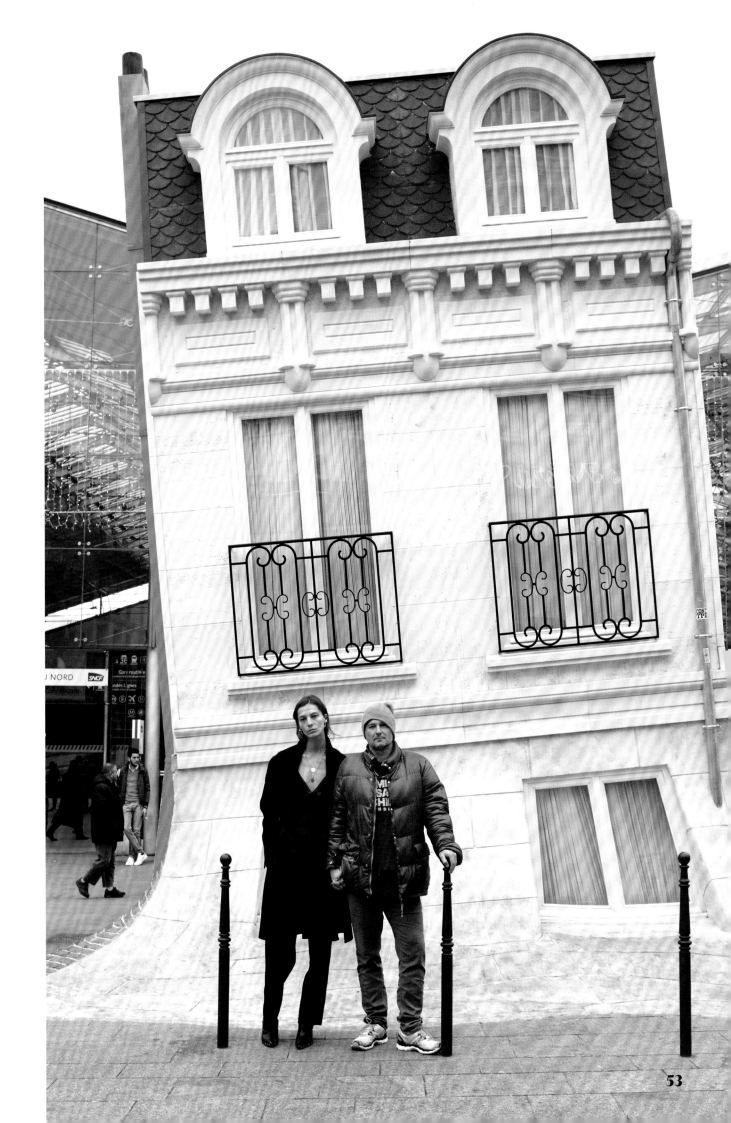

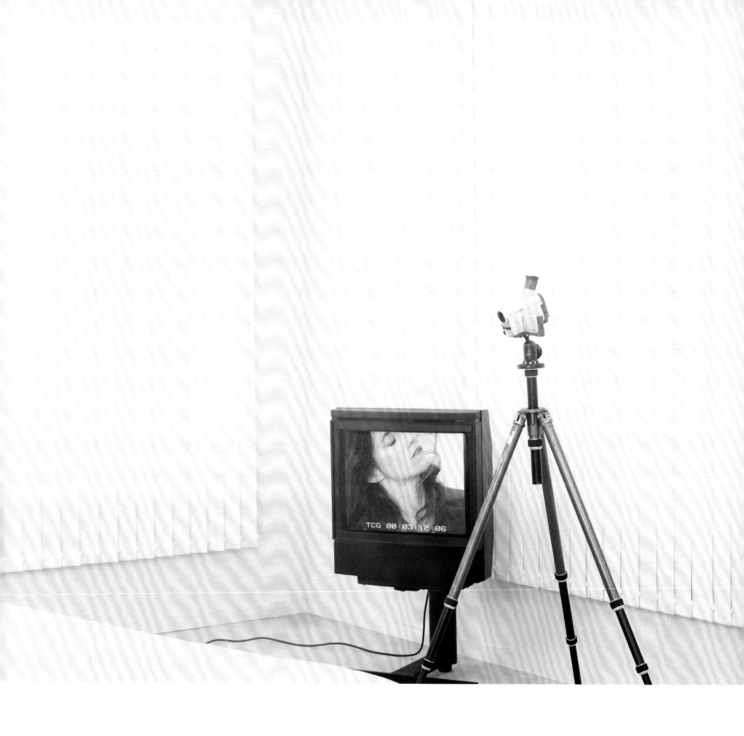

On screen: TCG 00:03:12:06

CASPER SEJERSEN

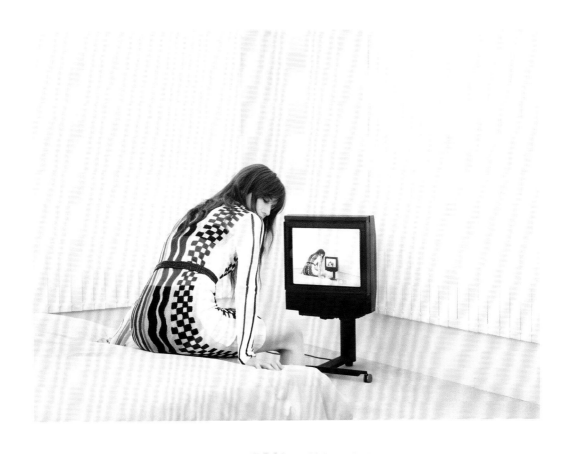

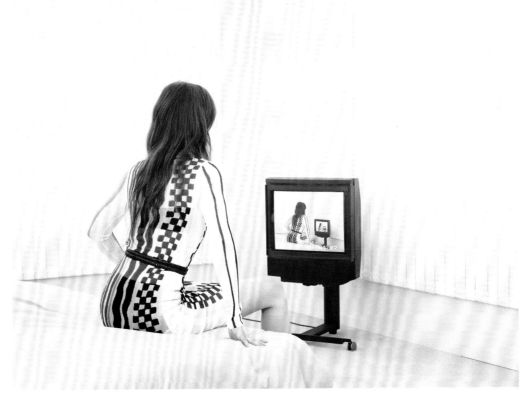

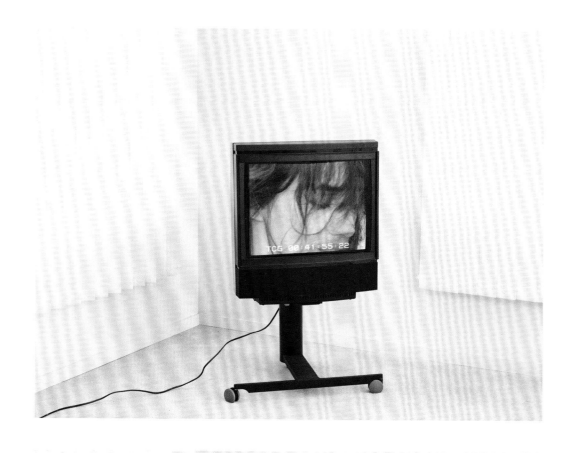

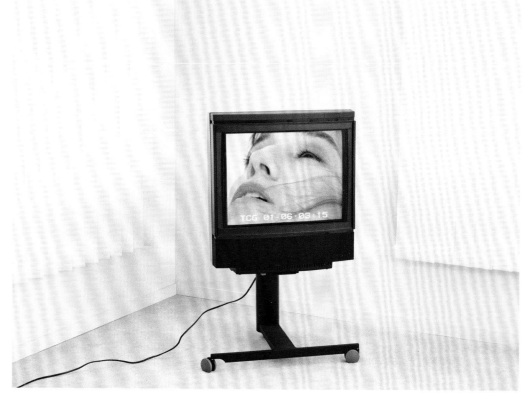

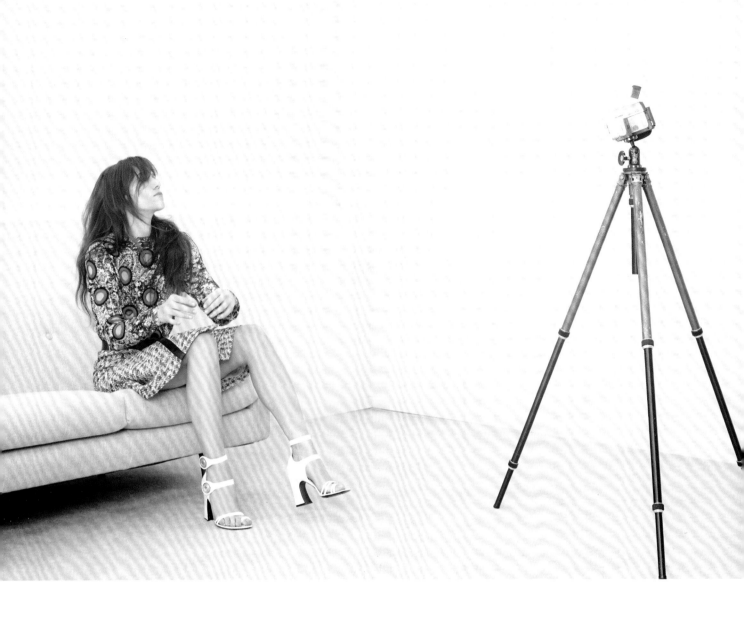

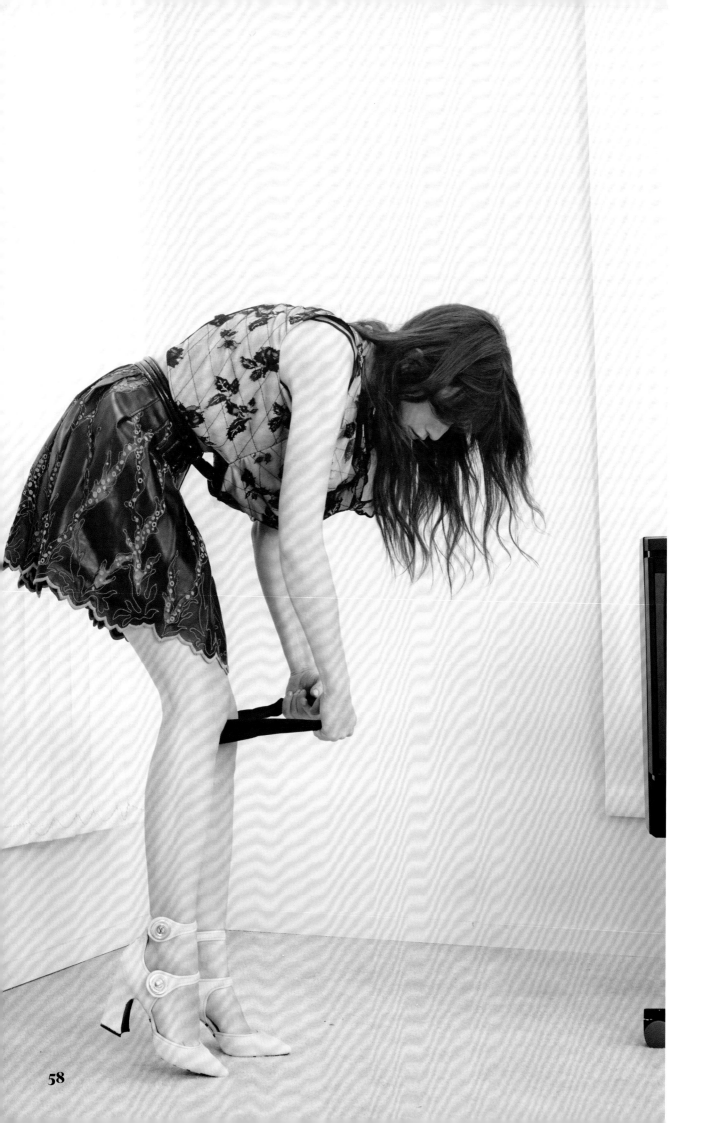

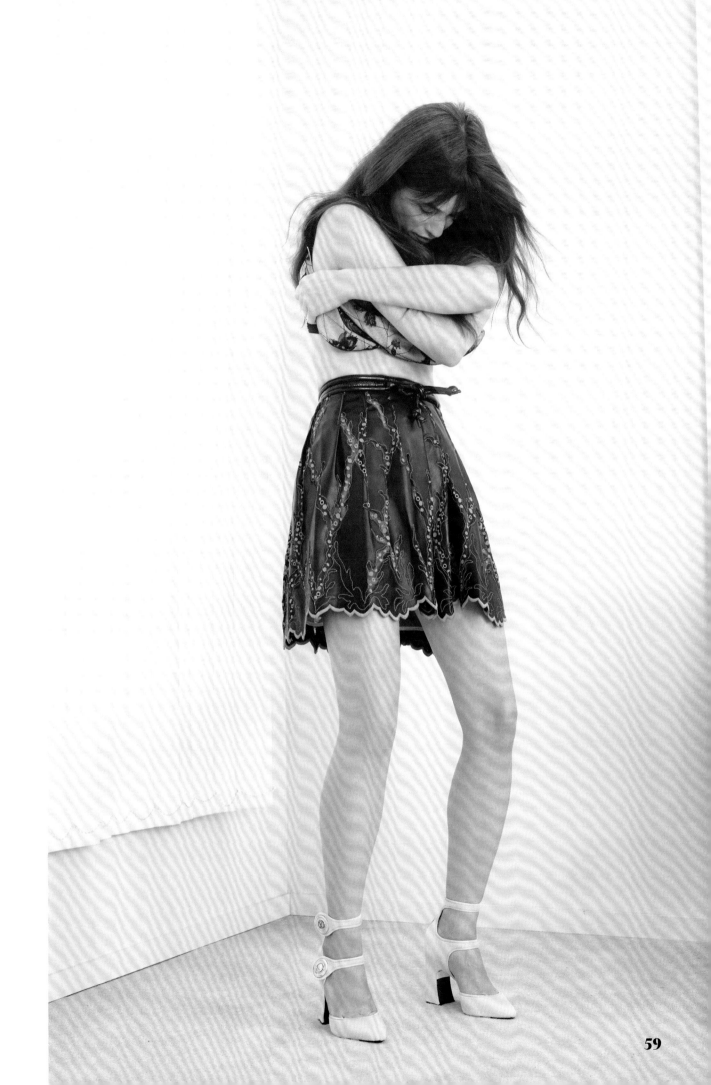

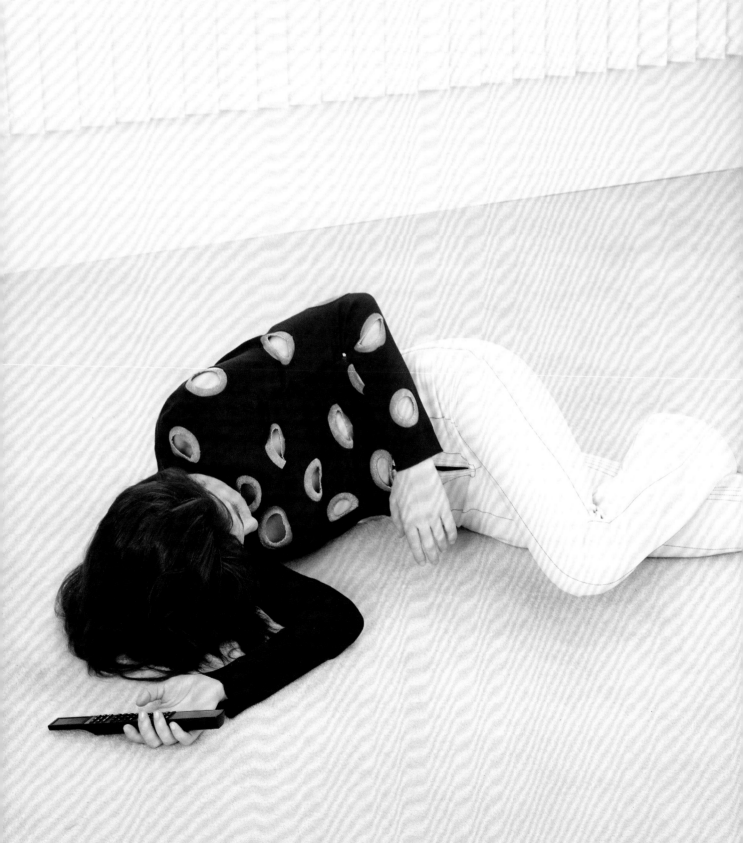

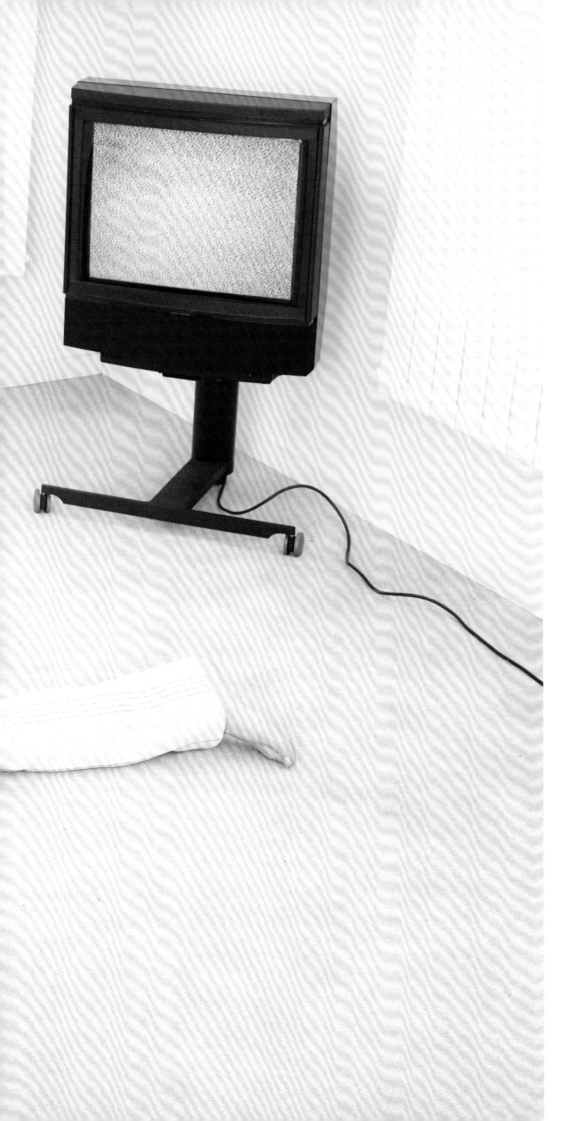

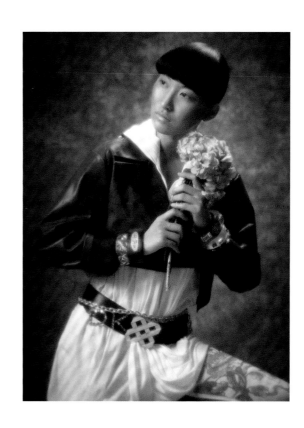
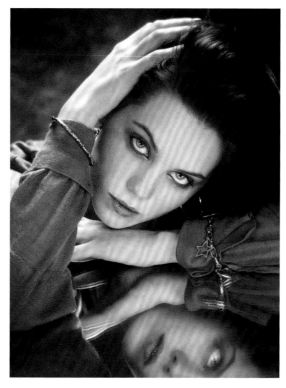

SEBASTIAN KIM

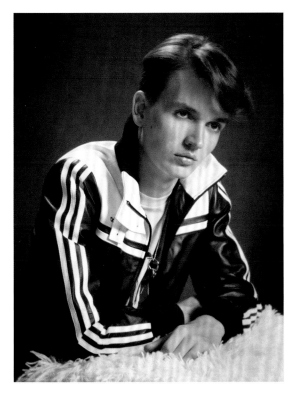
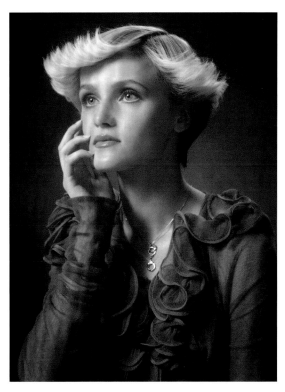
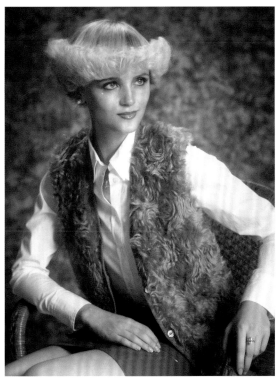
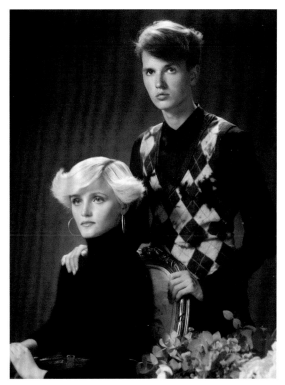

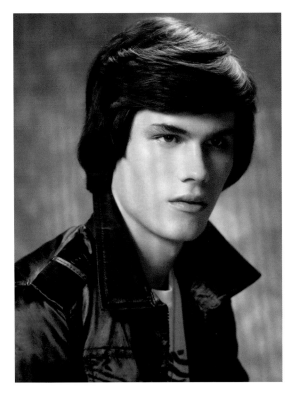
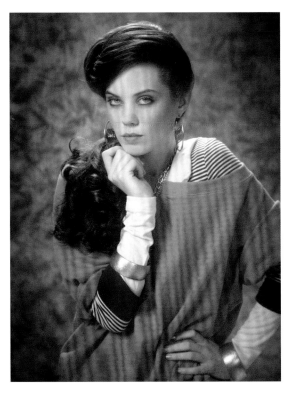
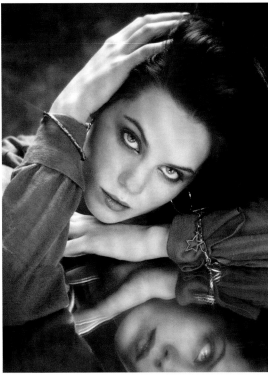
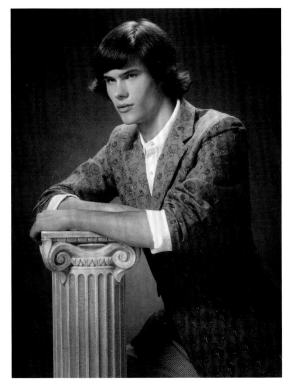

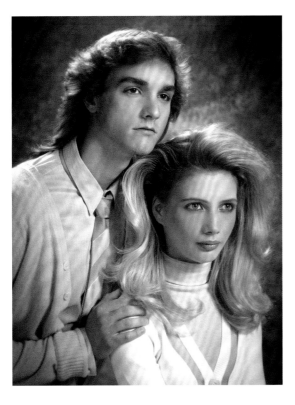
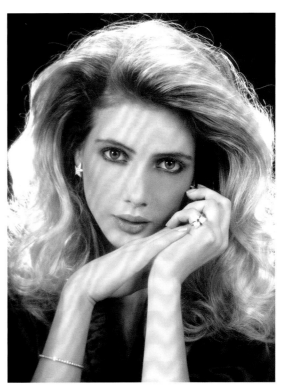
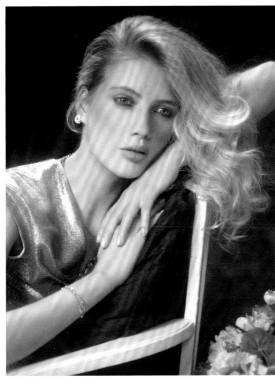
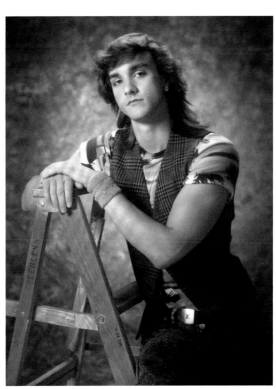

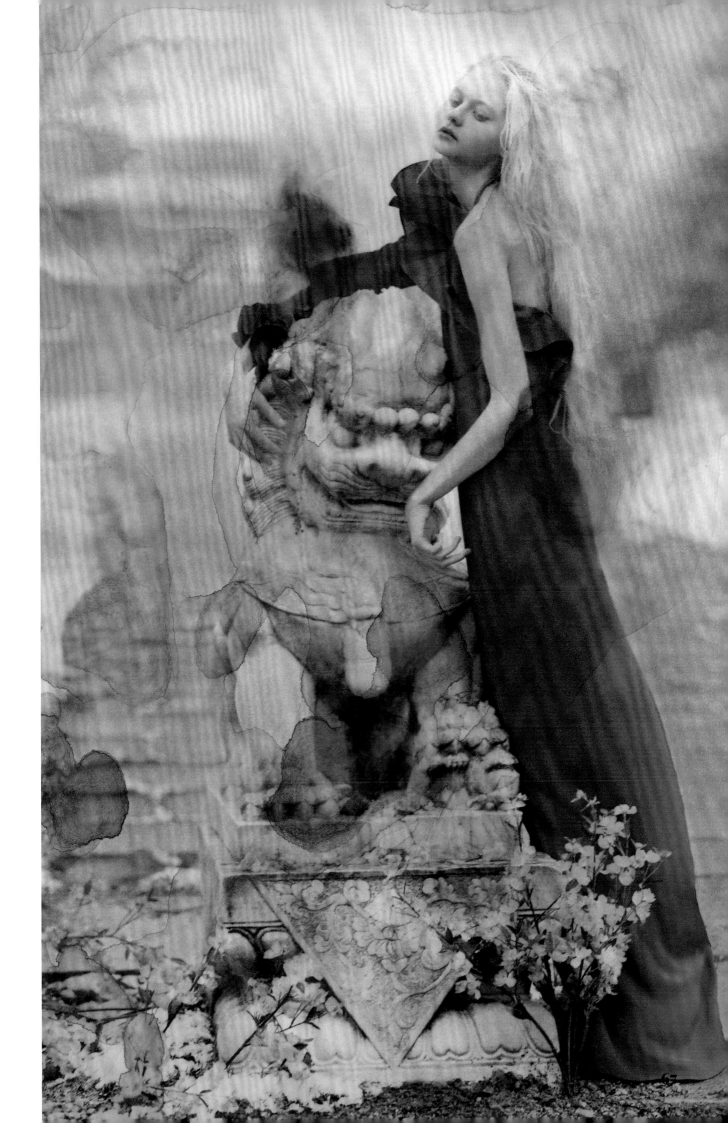

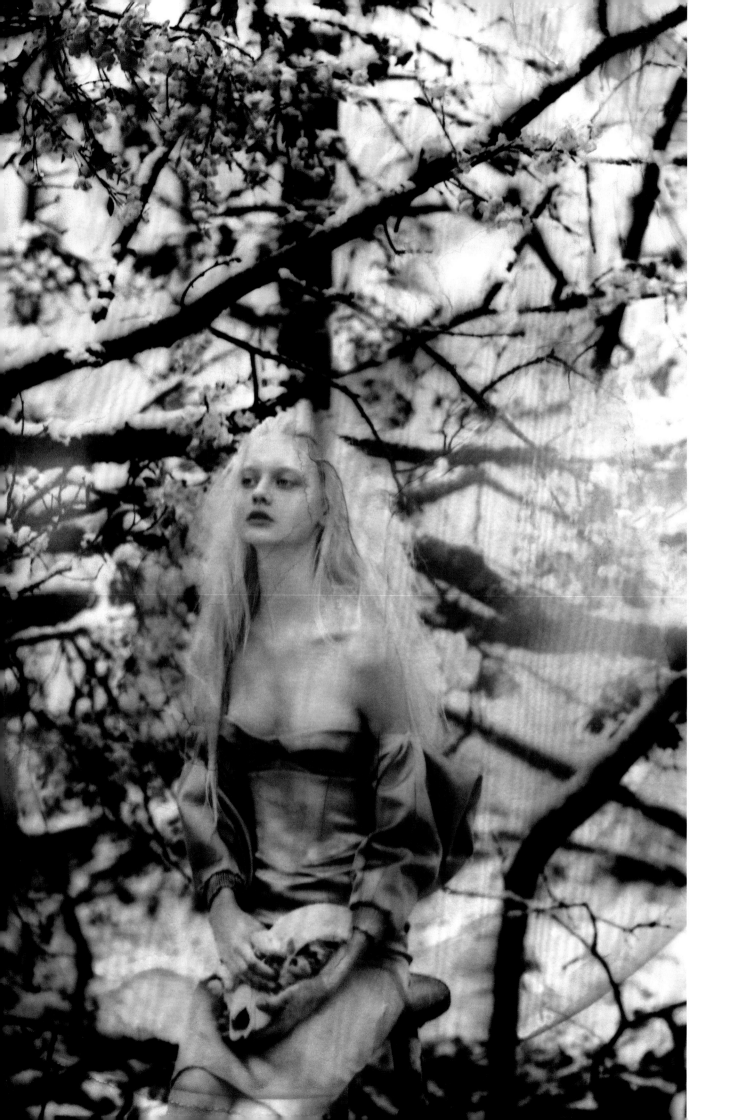

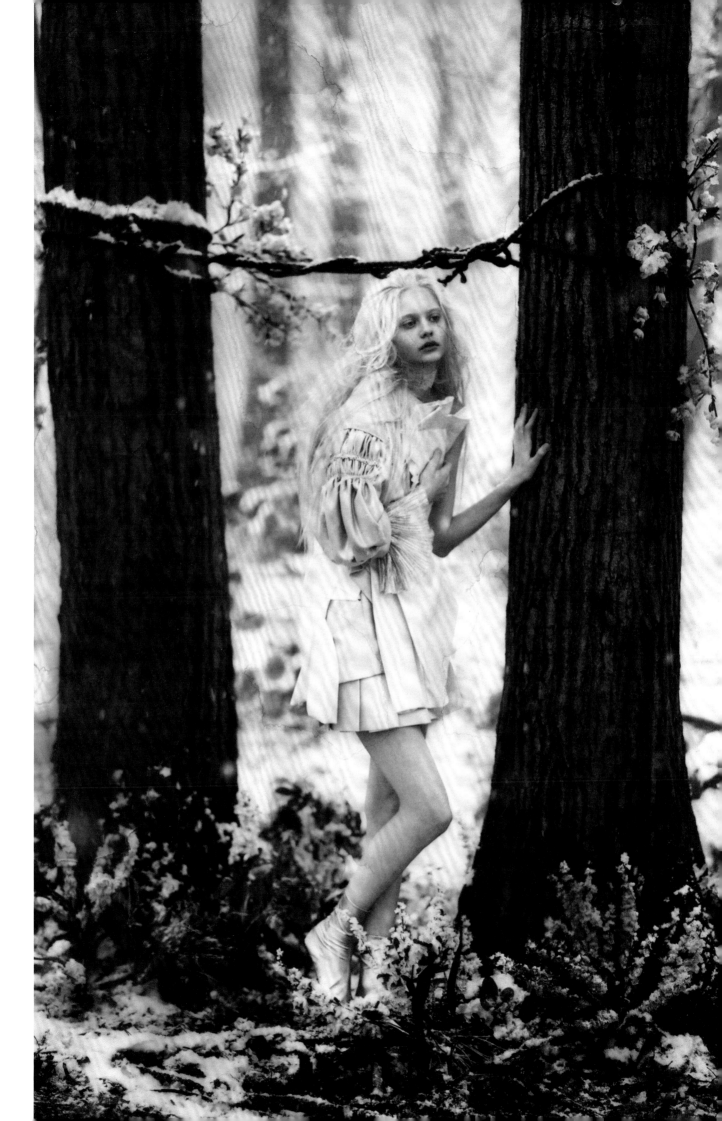

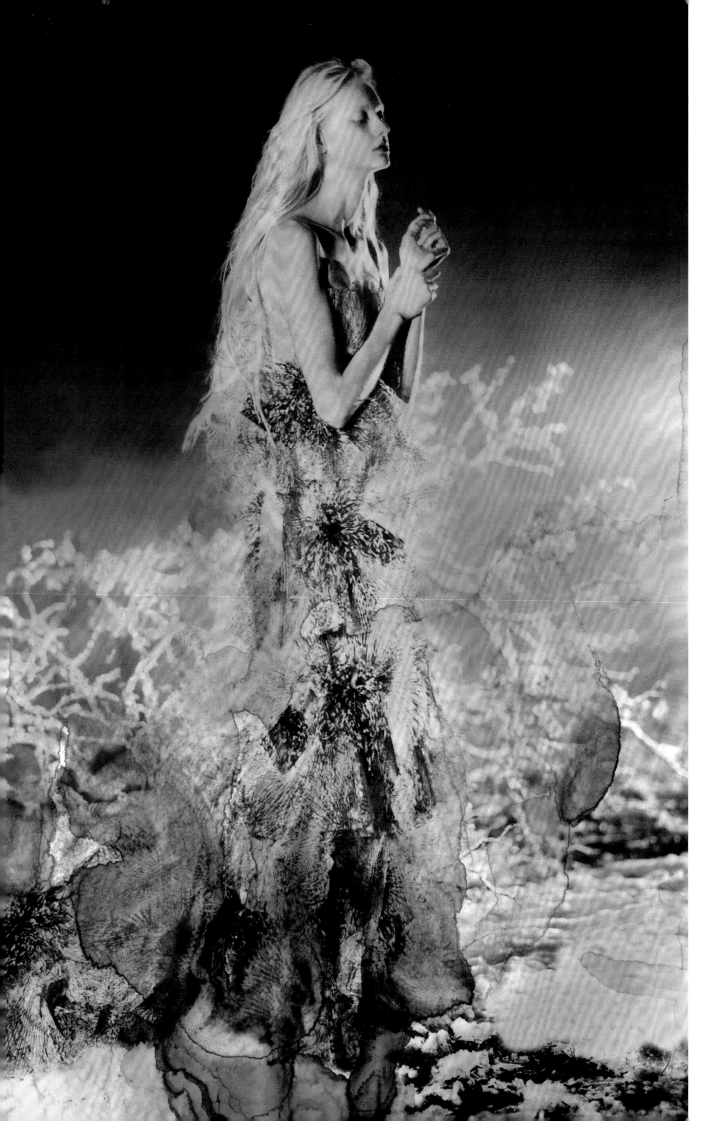

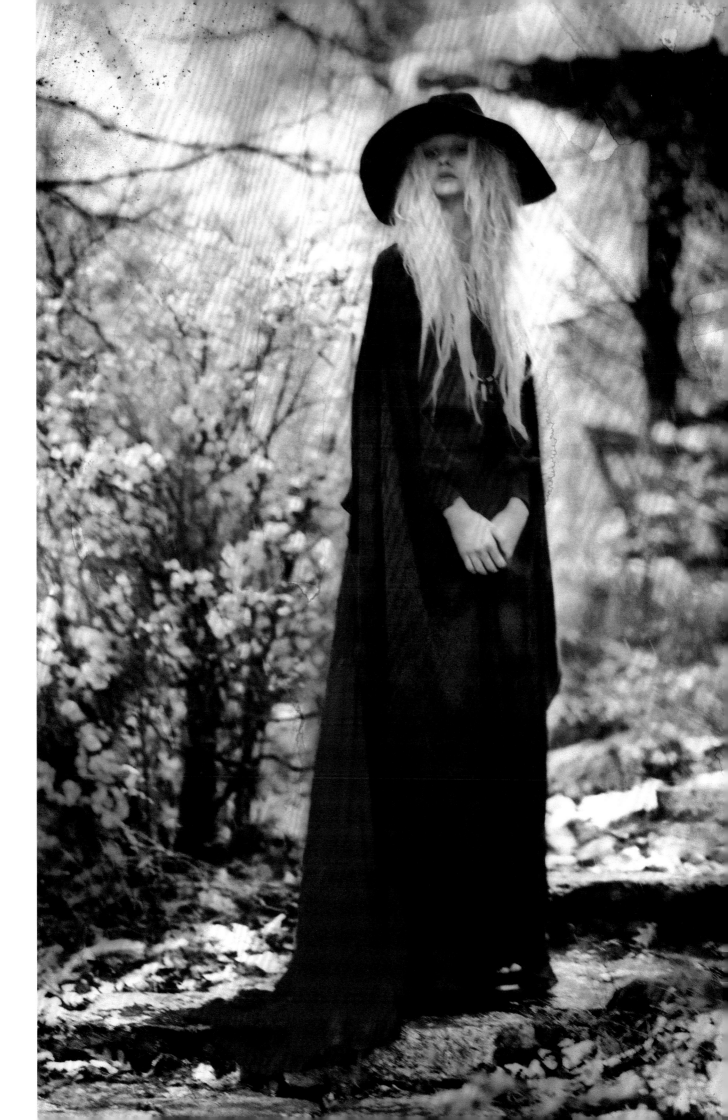

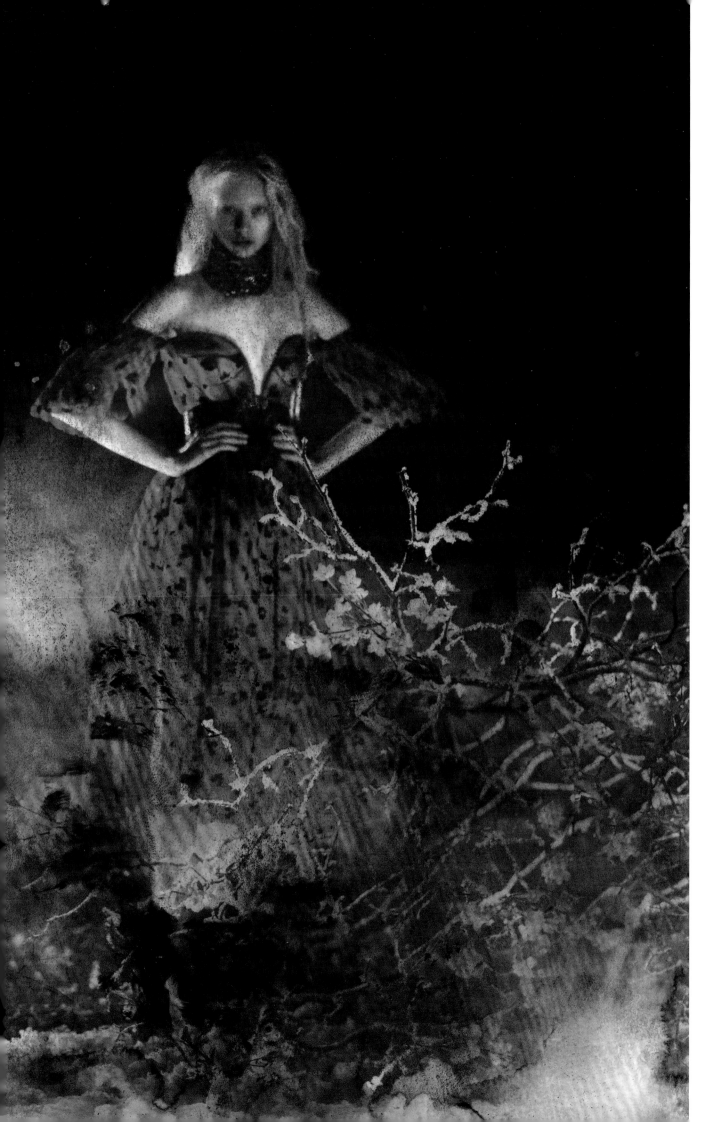

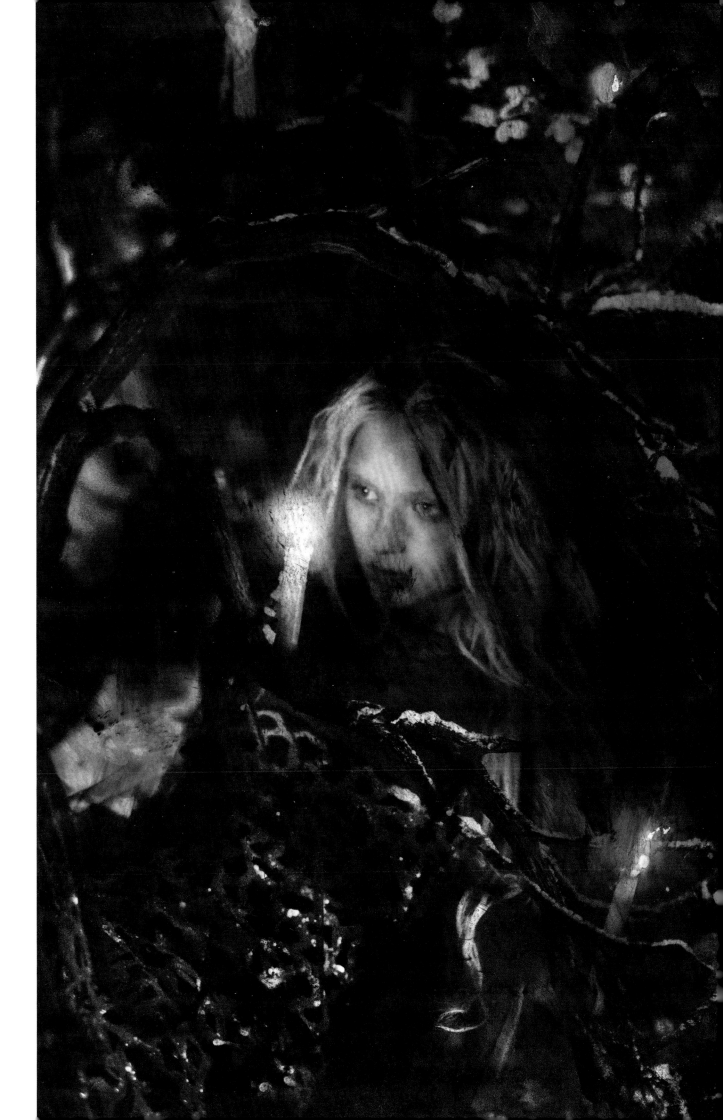

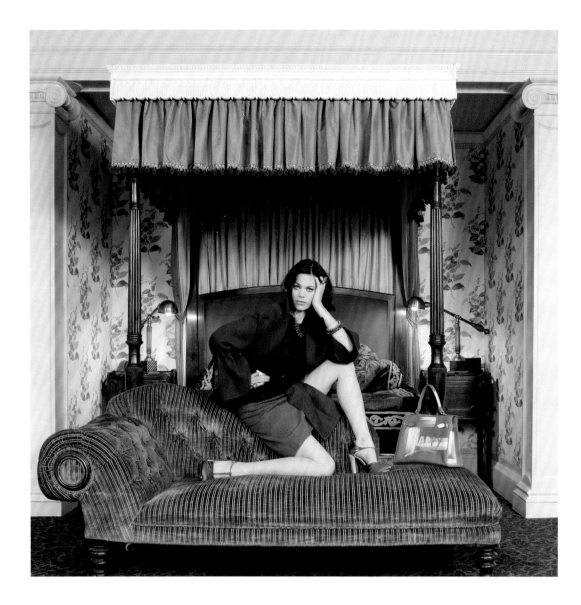

Globalisation
means that the World
is getting smaller,
the Rich getting richer,
the Poor getting poorer.

KAREN KNORR

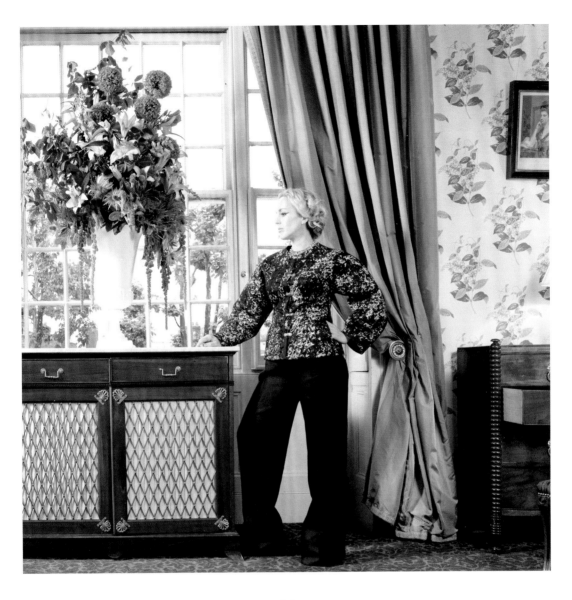

It is
a will'o the wisp
to be chased and enjoyed
but never taken too seriously.
Style, however,
has Grit.

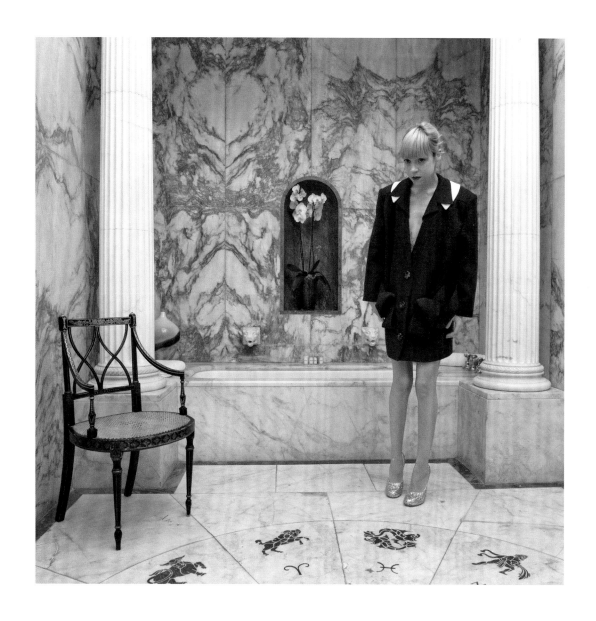

I dress for
Confidence and Insecurity.

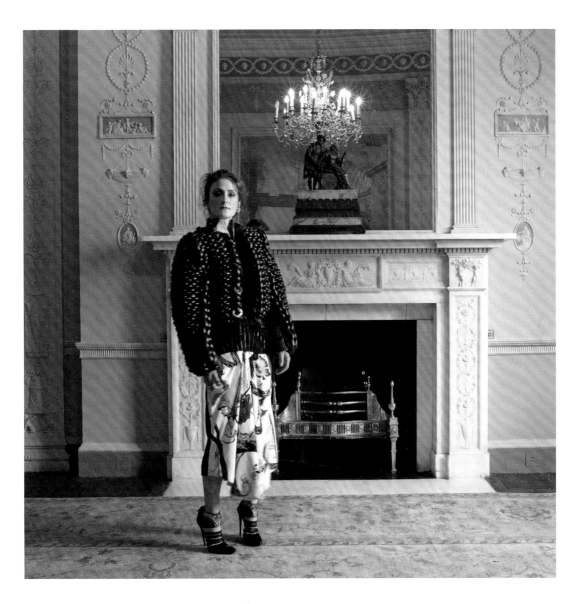

The old Class system
has withered but there is a
Massive economic Divide,
the biggest gap ever
between
Rich and Poor.

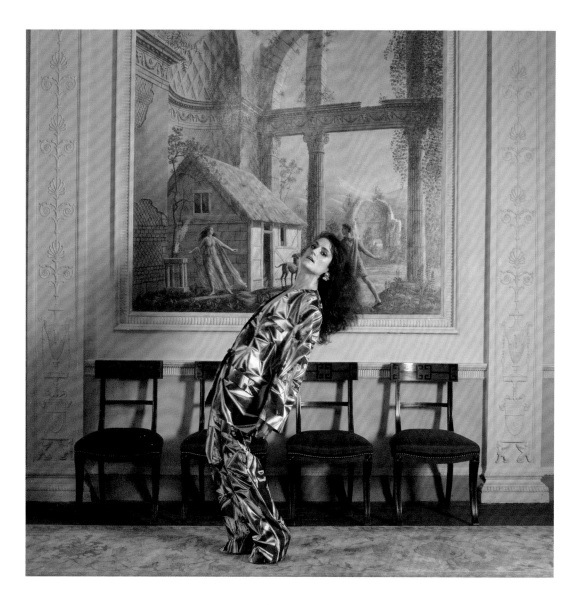

Everyone
is Afraid of Something.
Some have real
Reason.

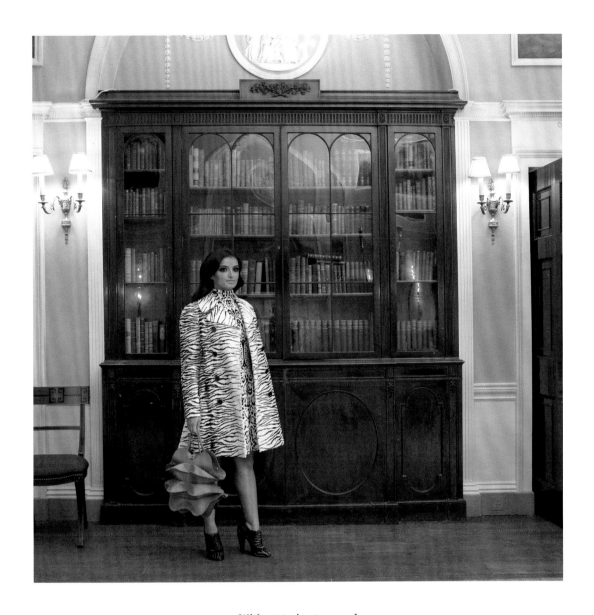

Without trying to sound
too much like a
contestant of a beauty pageant;
Women all across the globe
should be empowered
through Education and Culture.
Knowledge is Power.

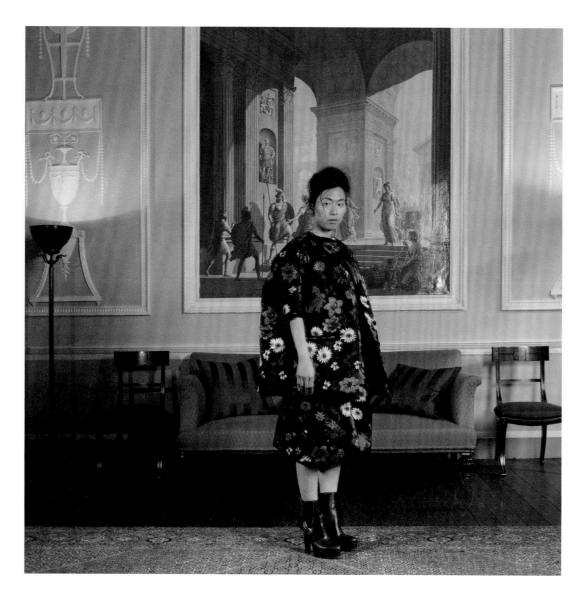

I think Poverty
will always exist as long as
We are willing to feel
Better about Ourselves
at the Expense
of other people.

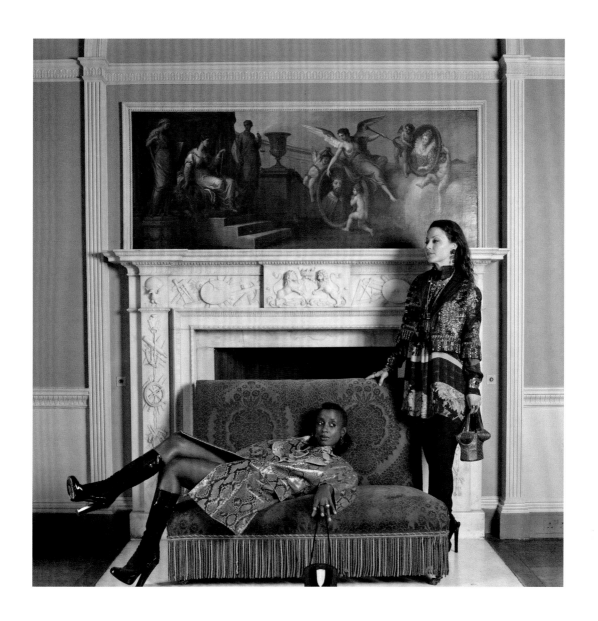

China will rule
the World.

ETHAN JAMES GREEN

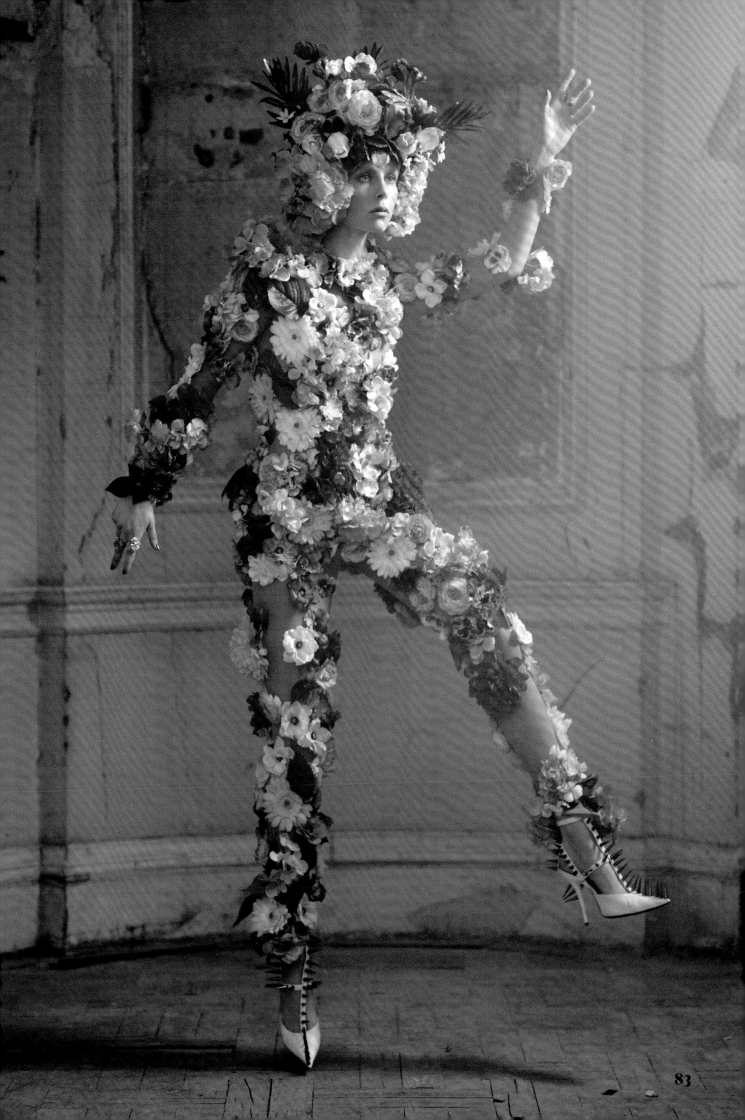

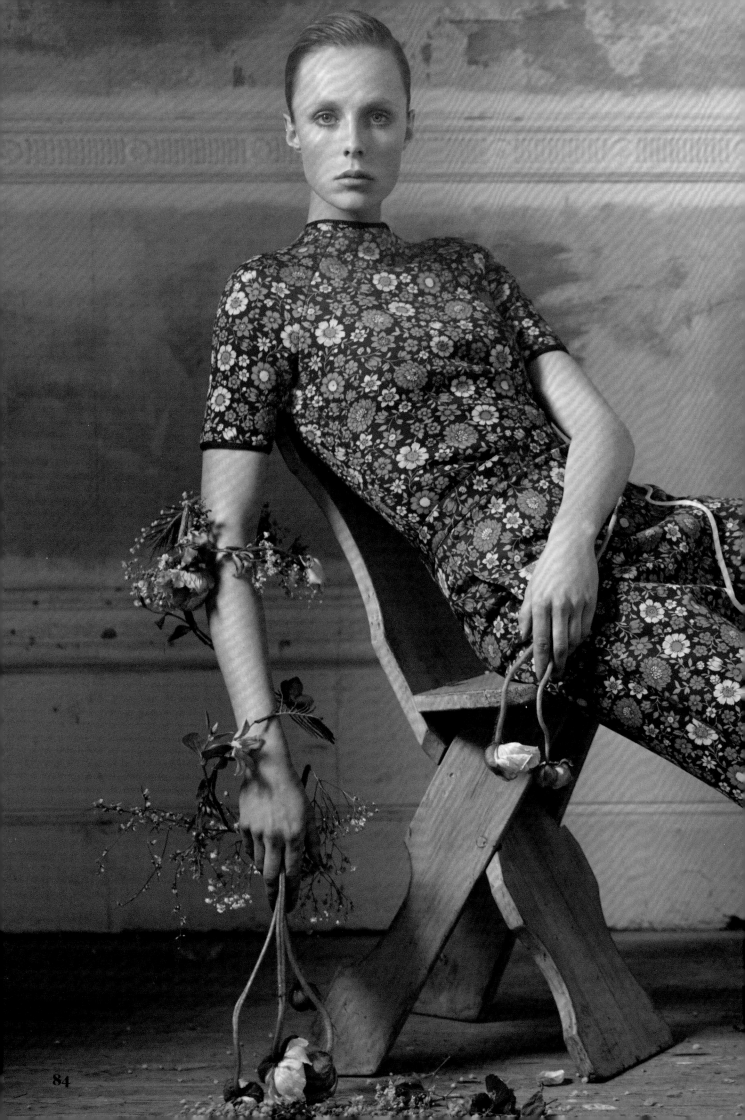

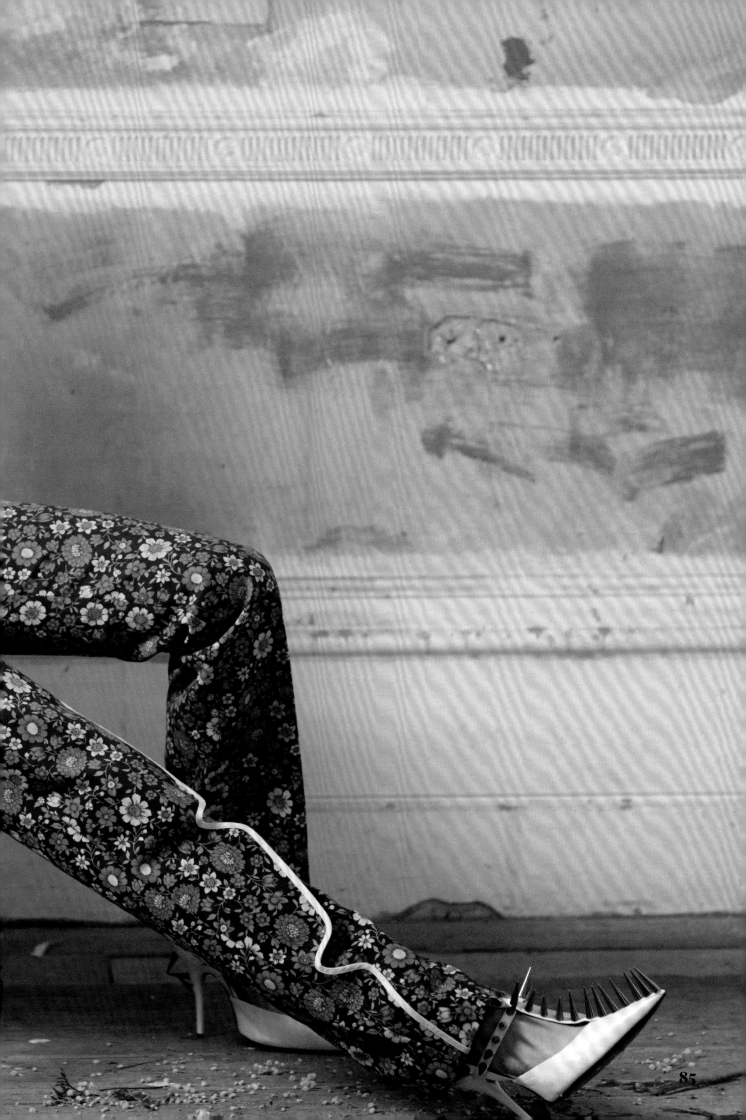

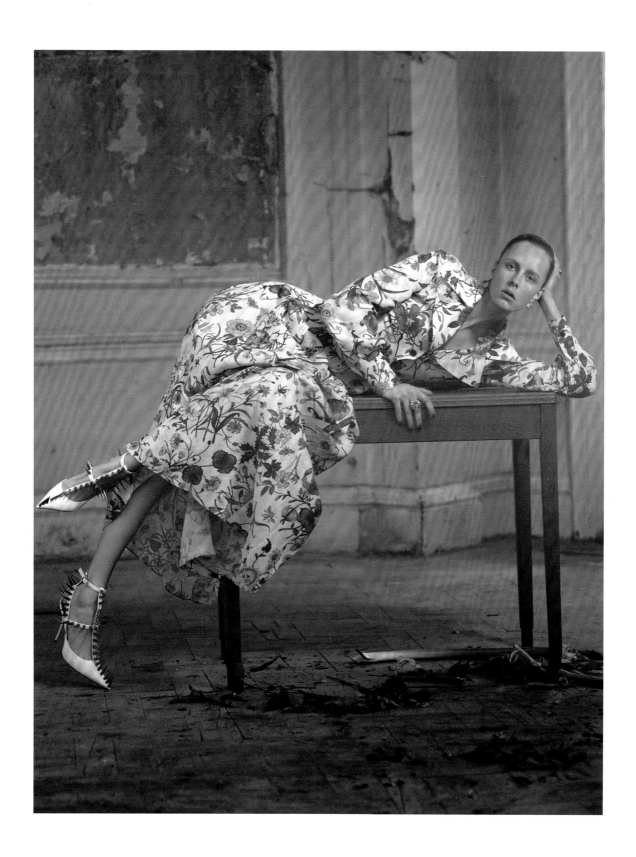

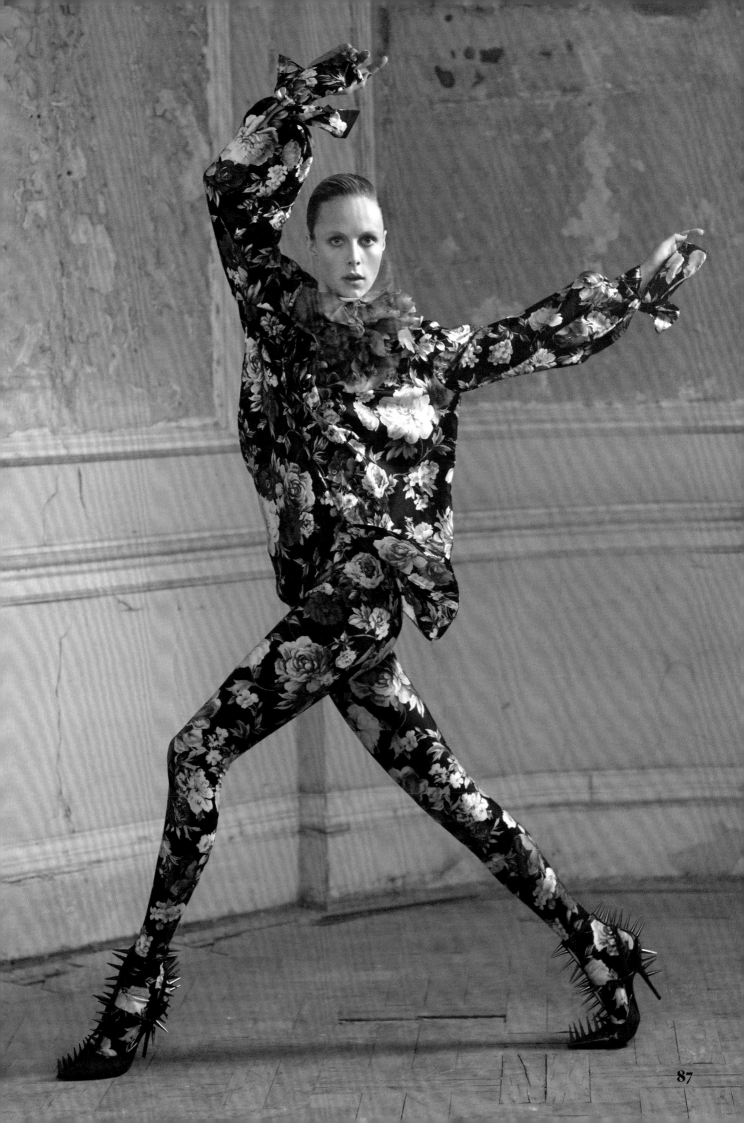

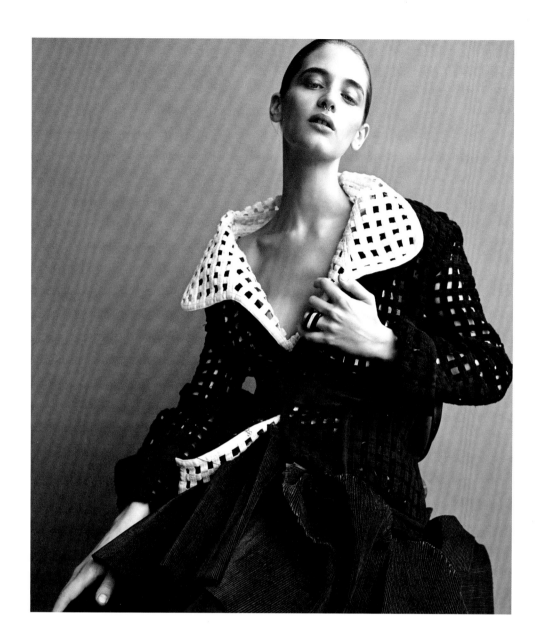

JOSH OLLINS

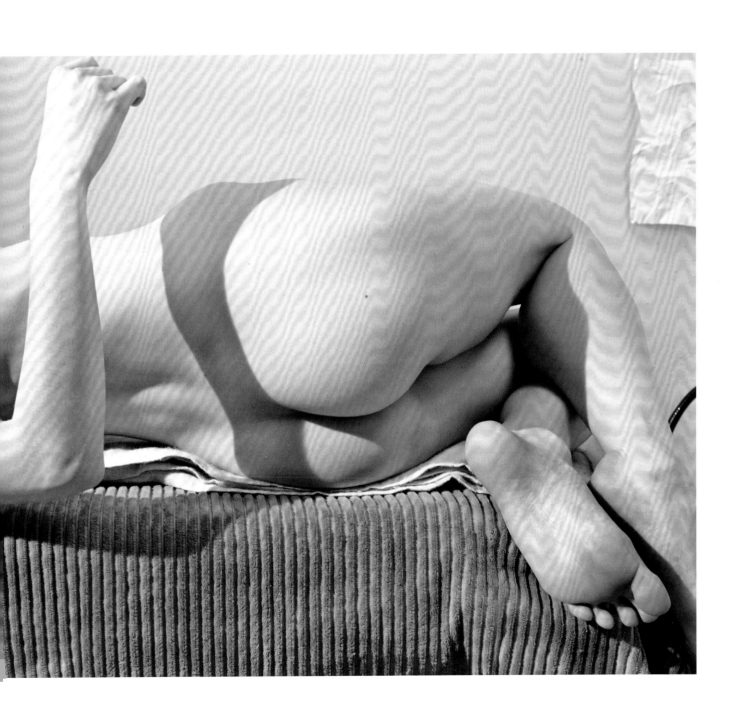

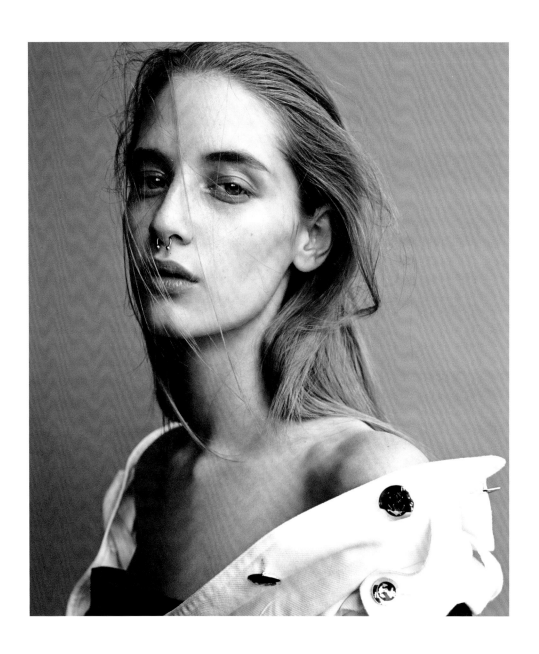

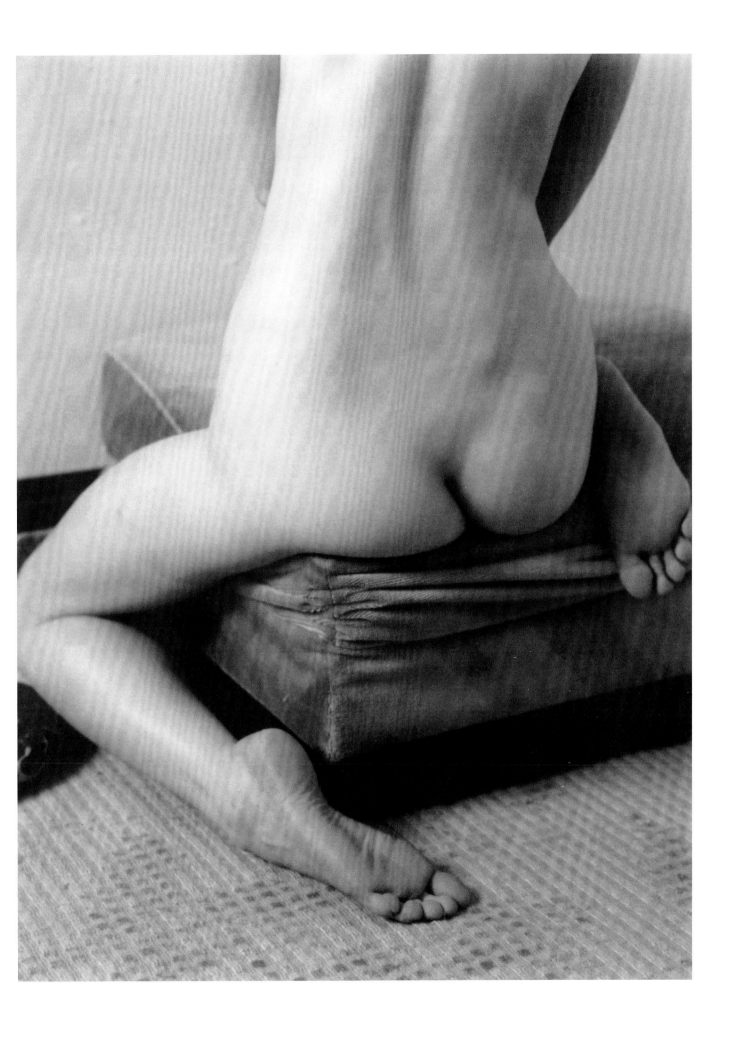

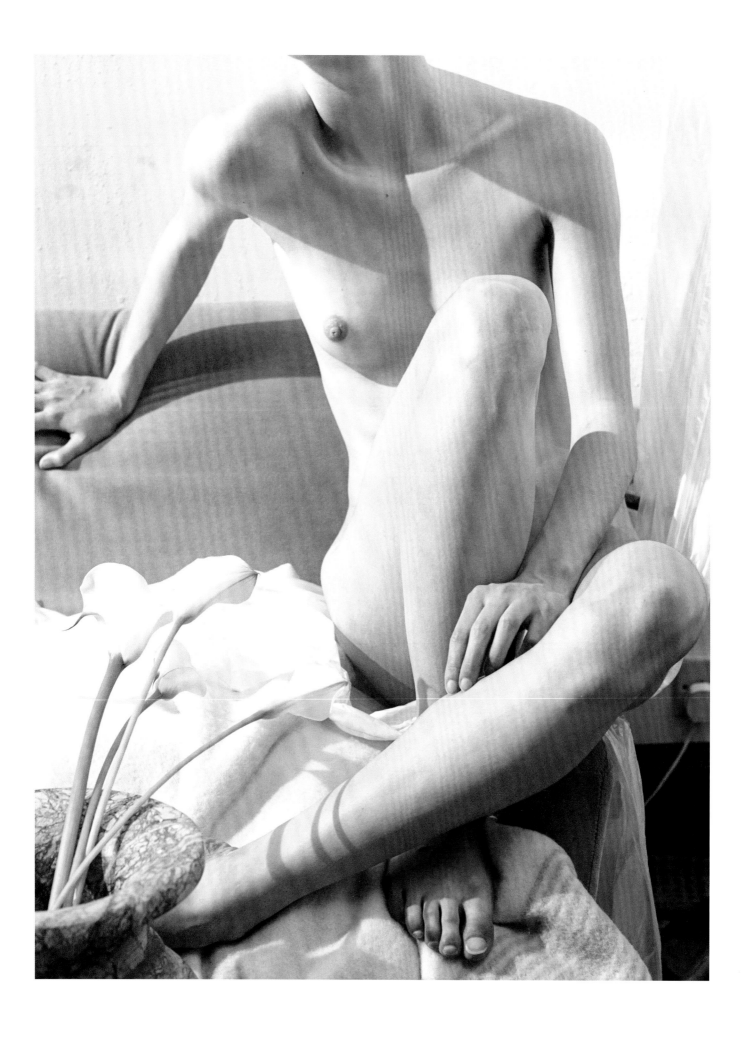

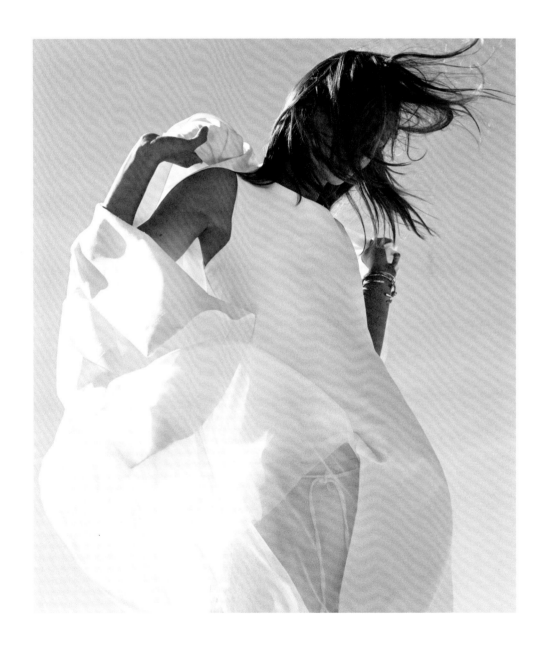

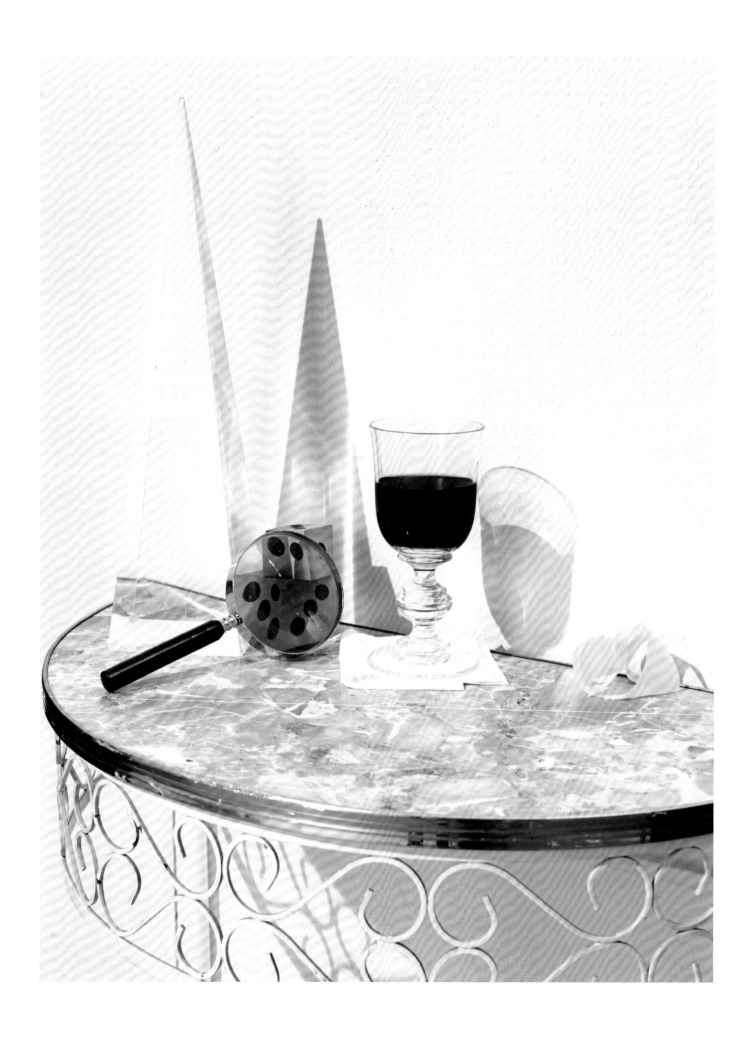

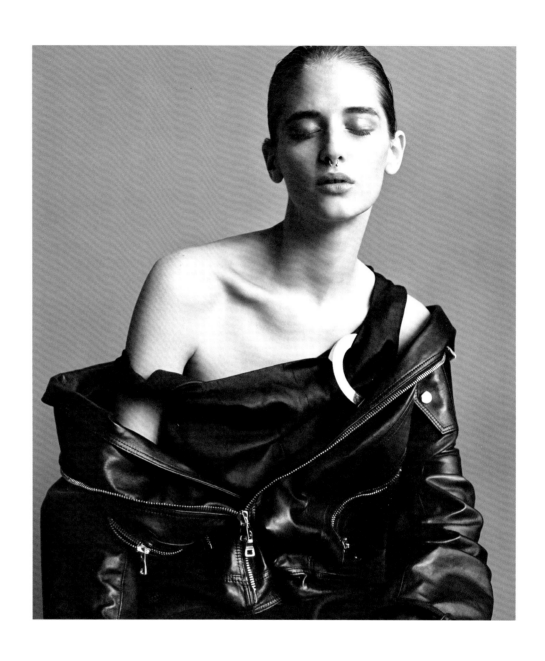

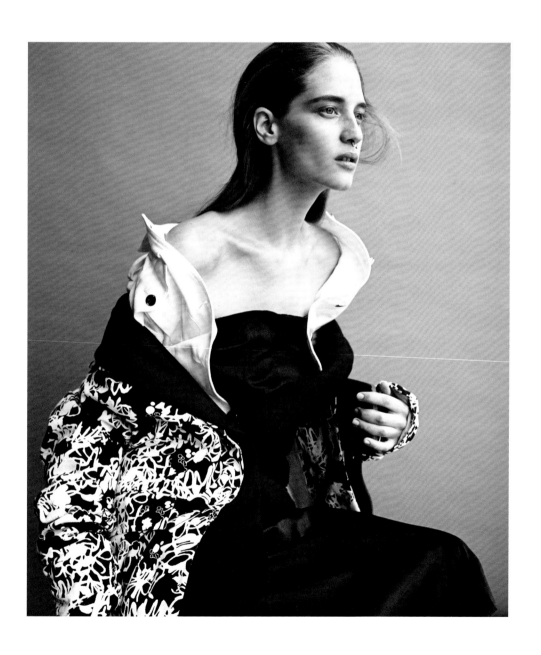

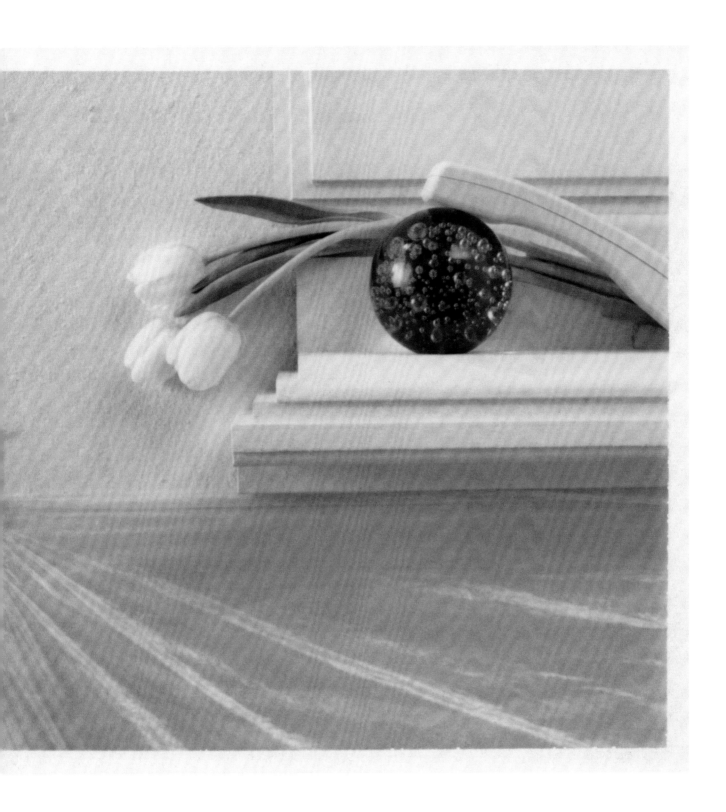

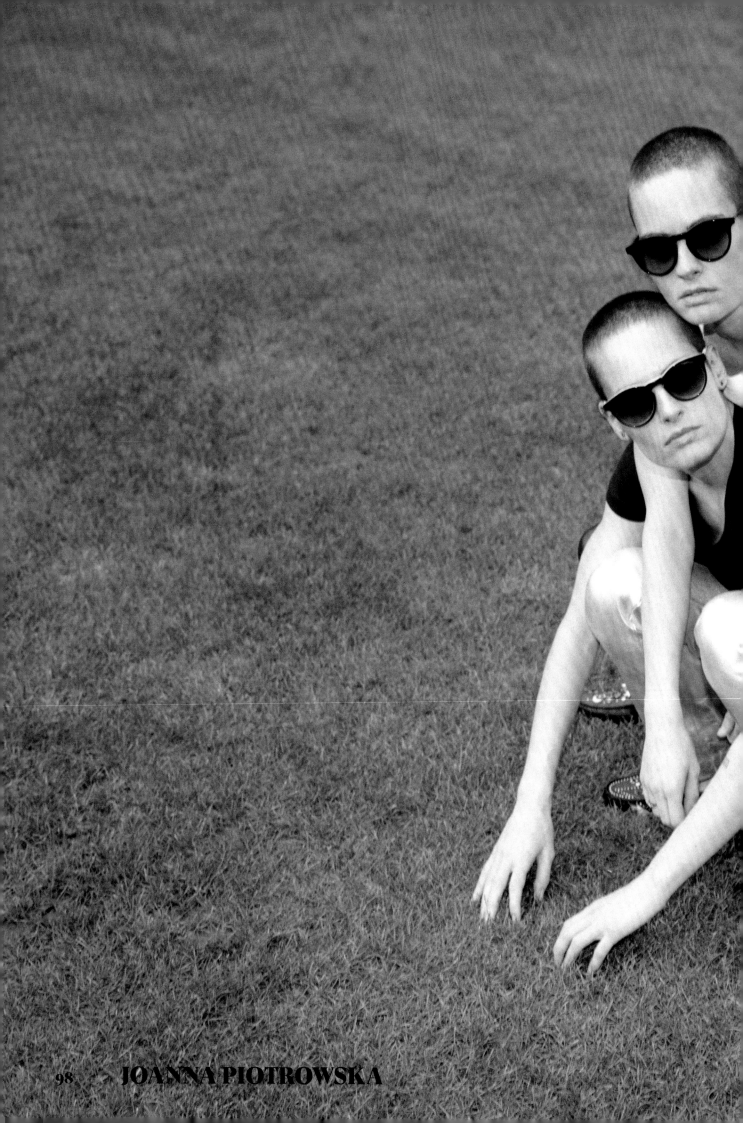

JOANNA PIOTROWSKA

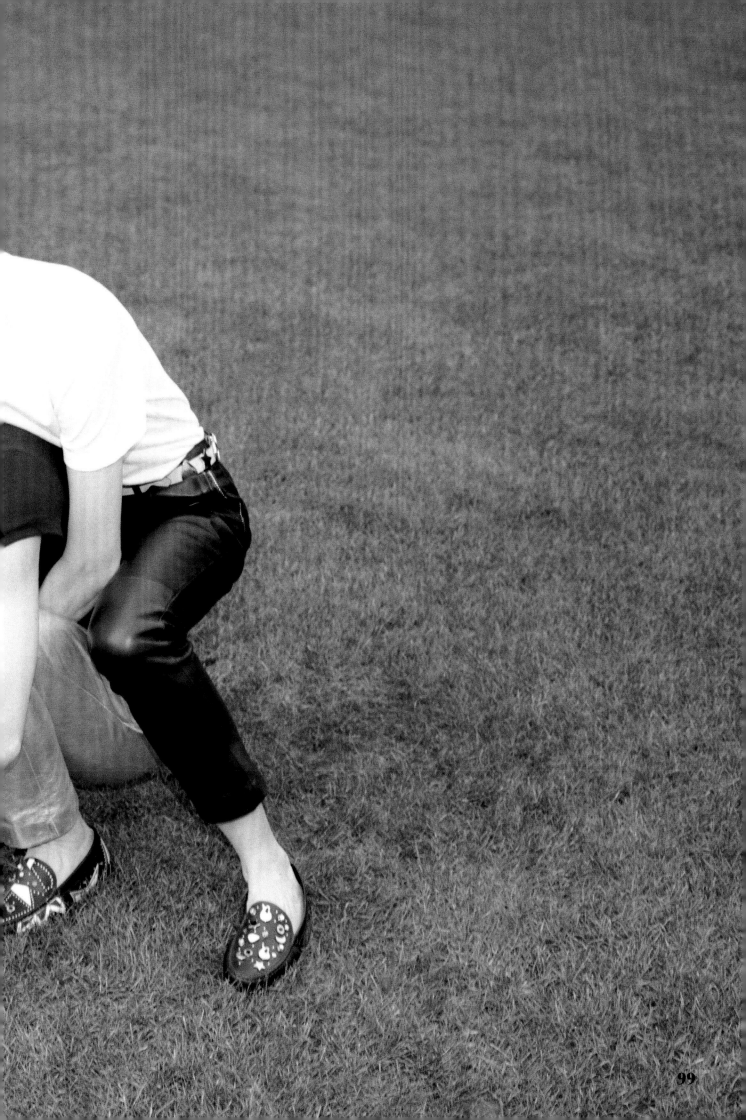

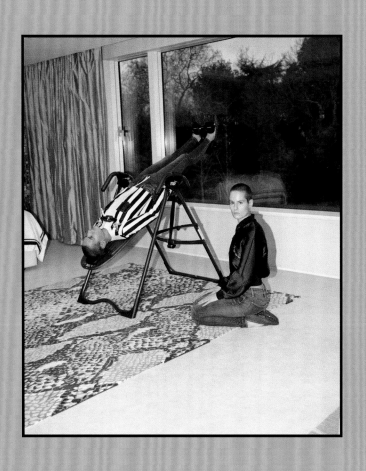

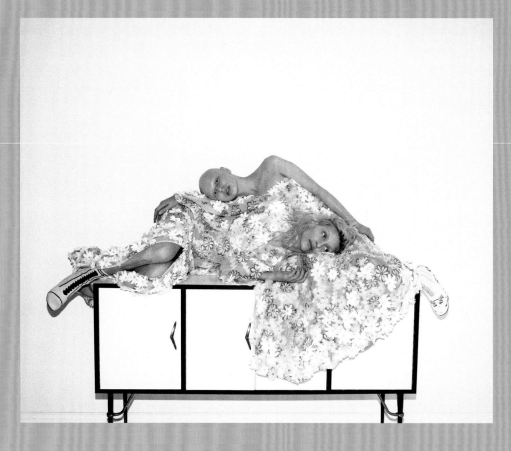

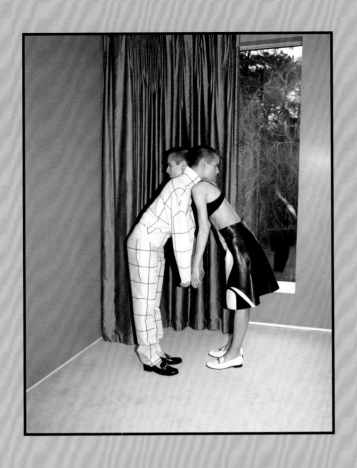
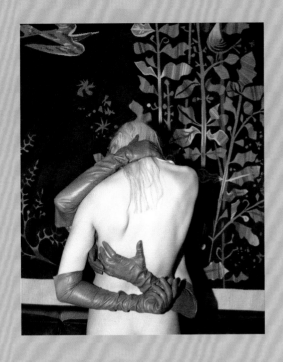
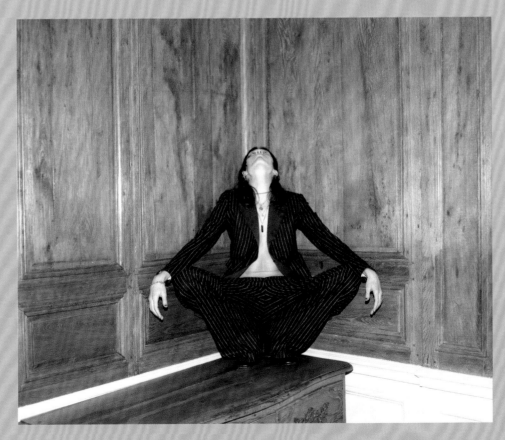

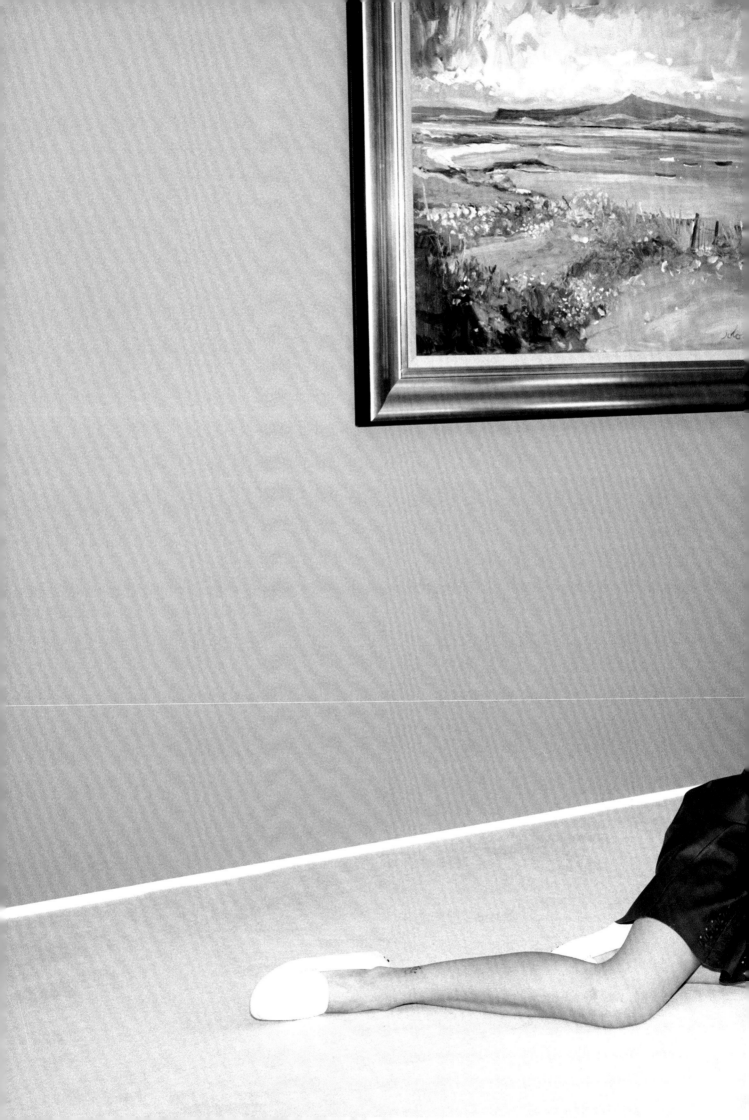

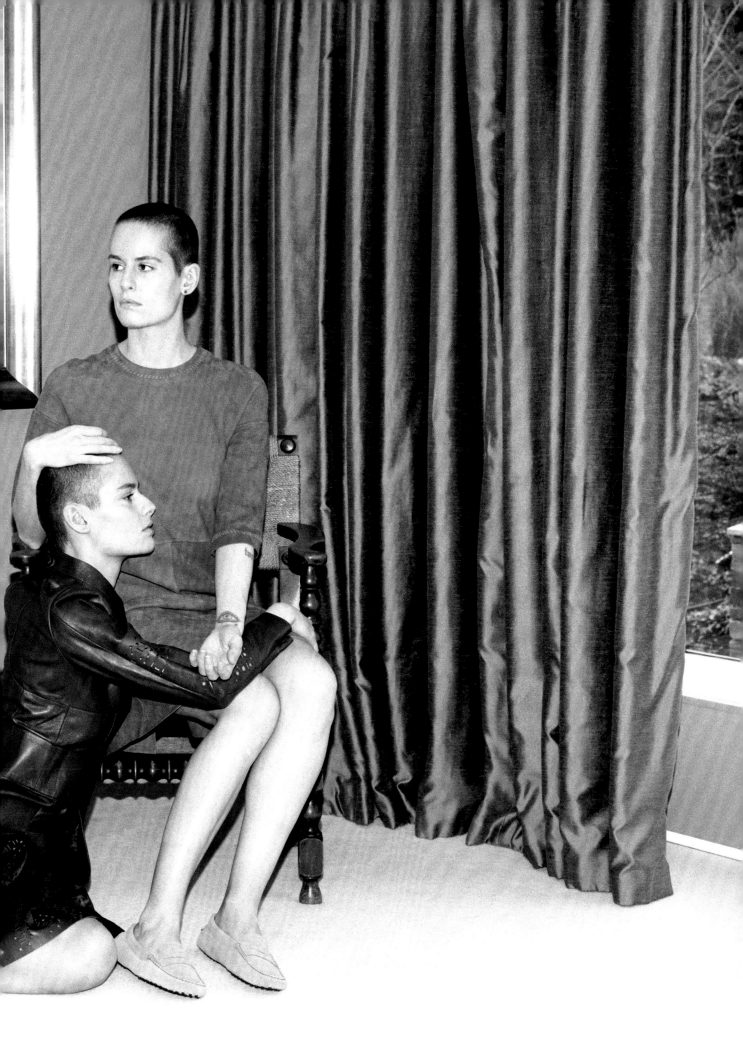

SARAH PIANTADOSI

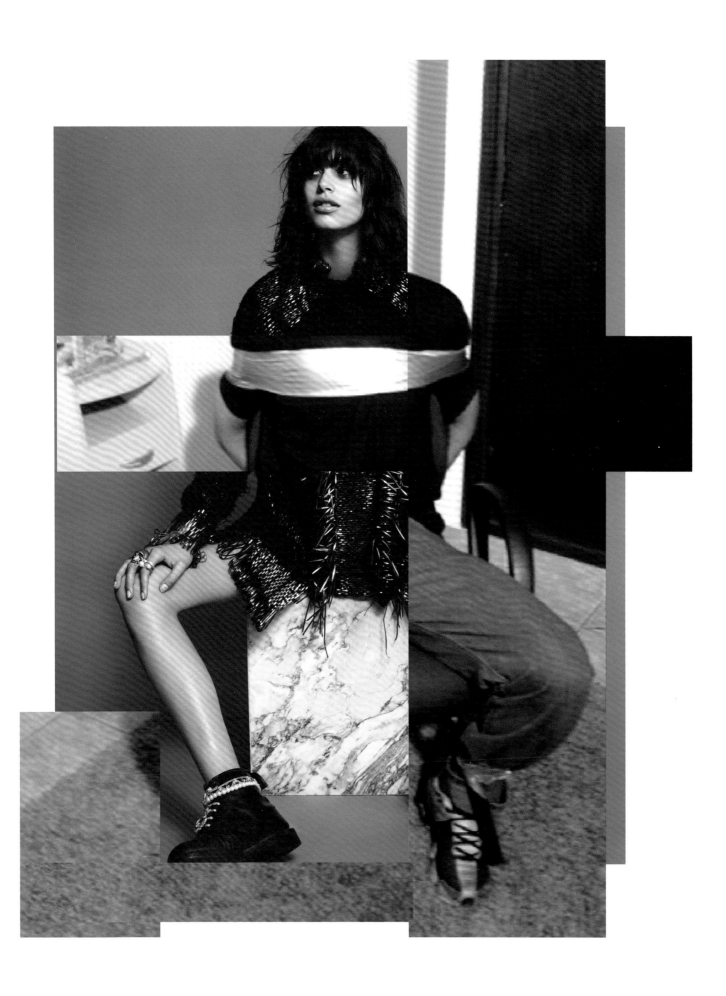

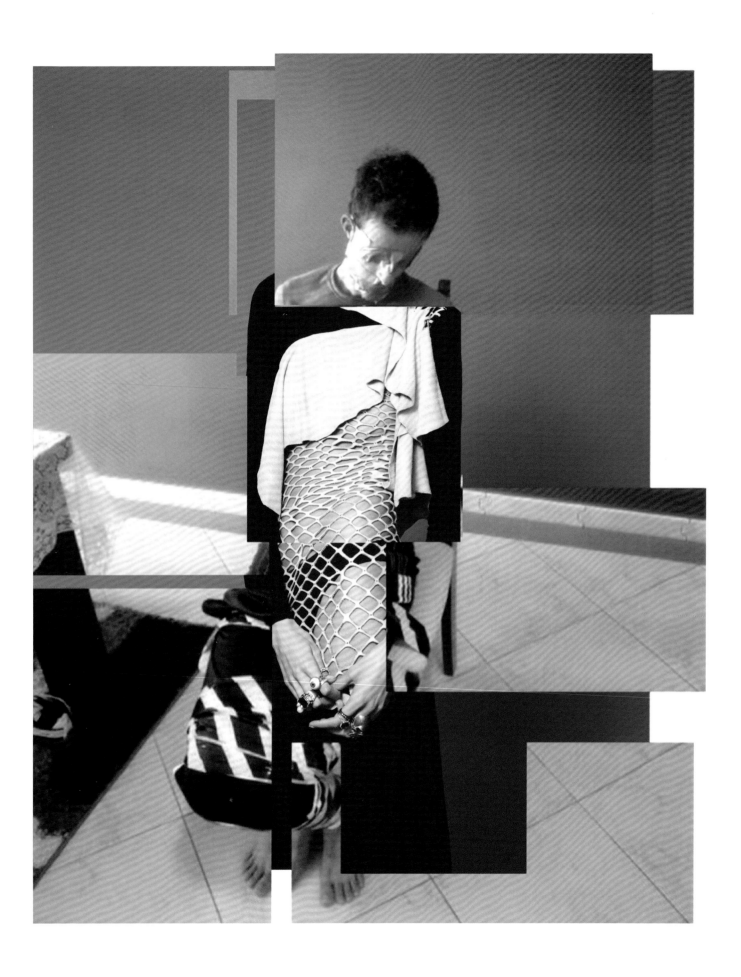

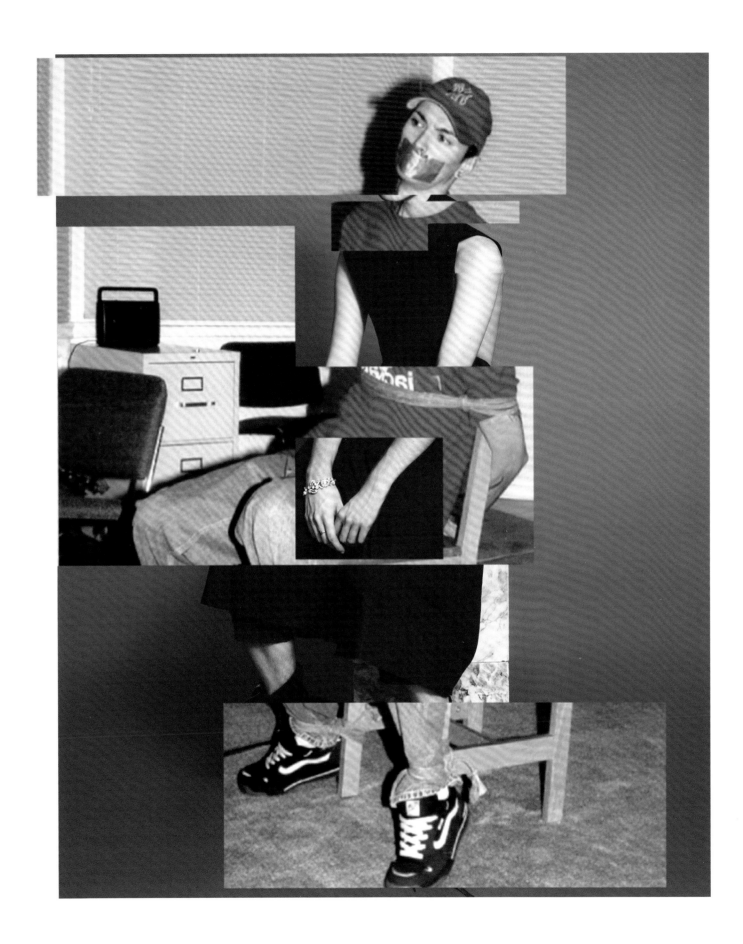

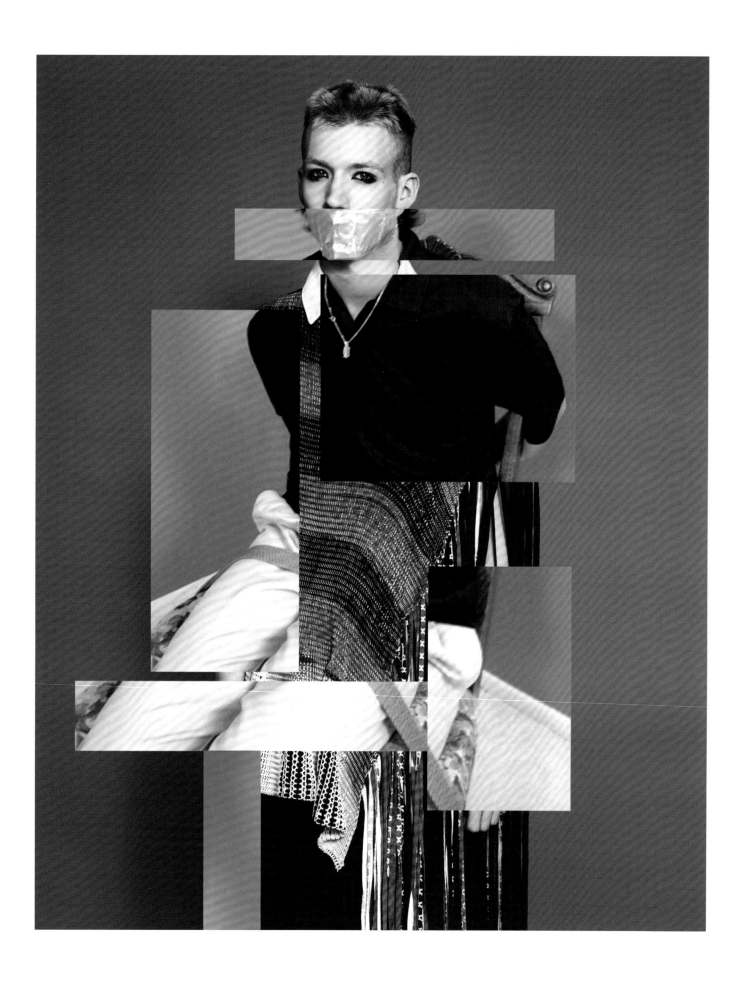

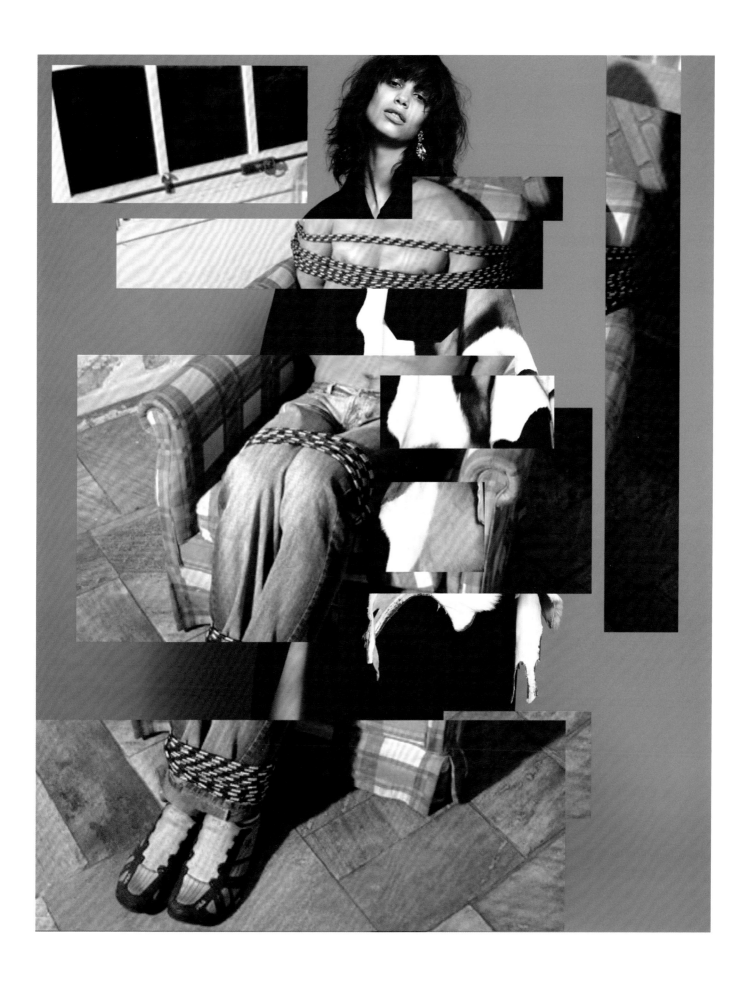

110 **ANNEMARIEKE VAN DRIMMELEN**

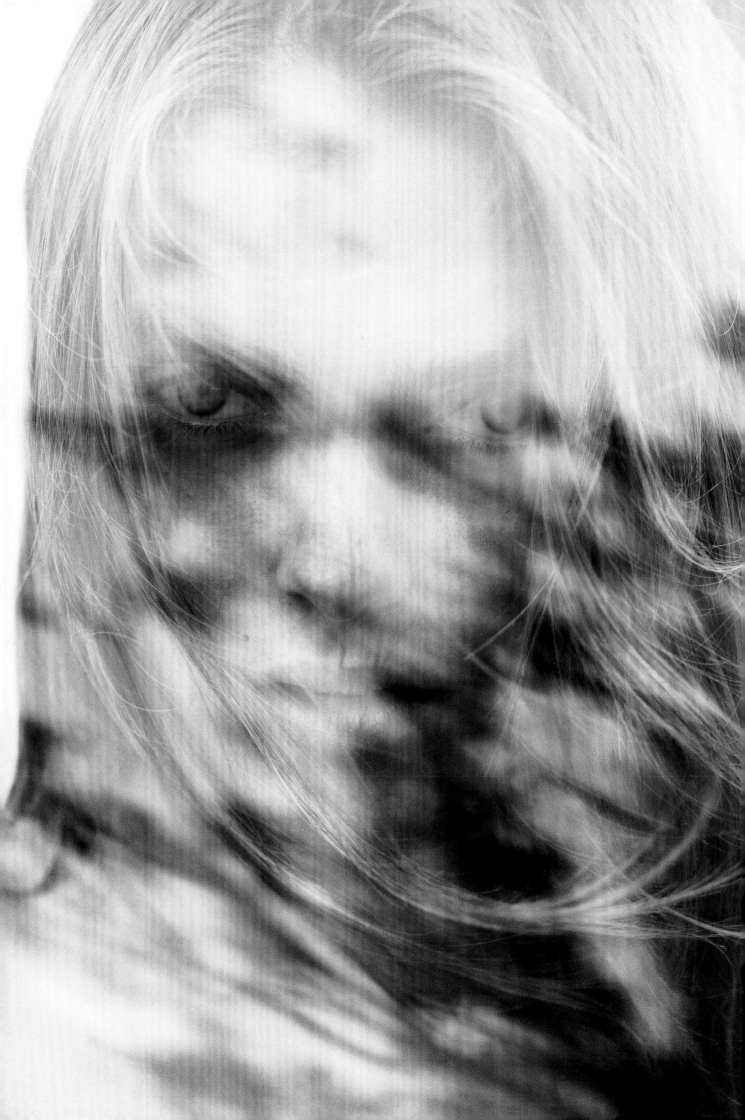

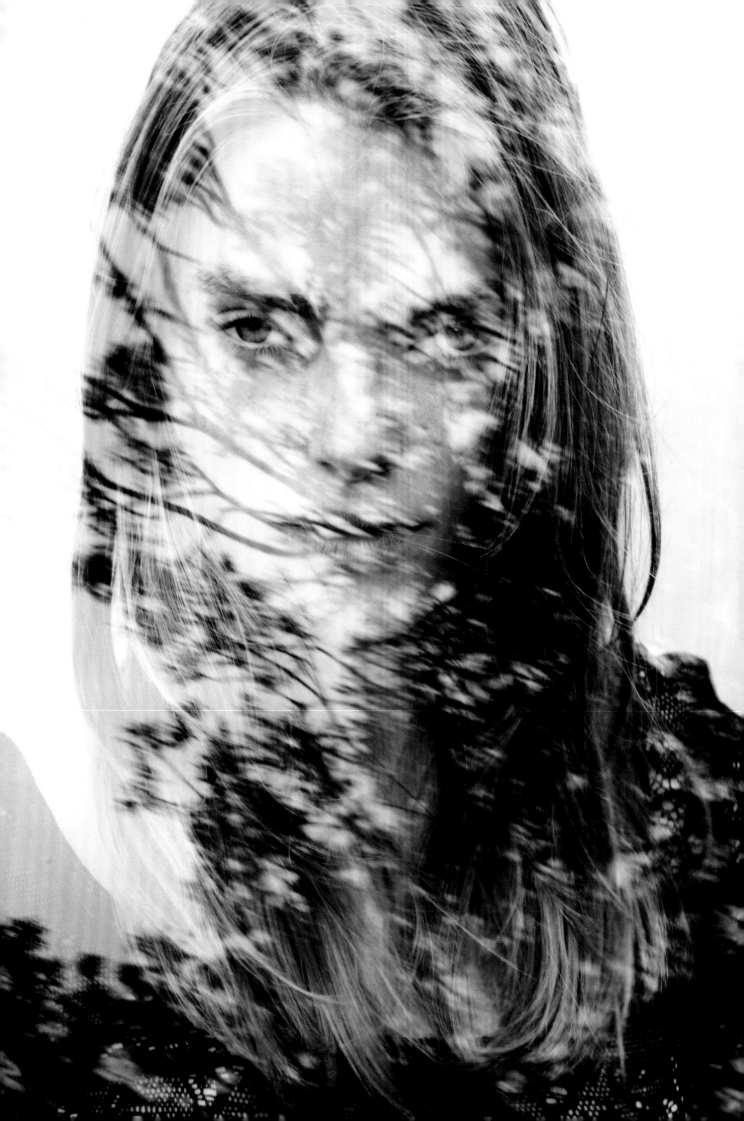

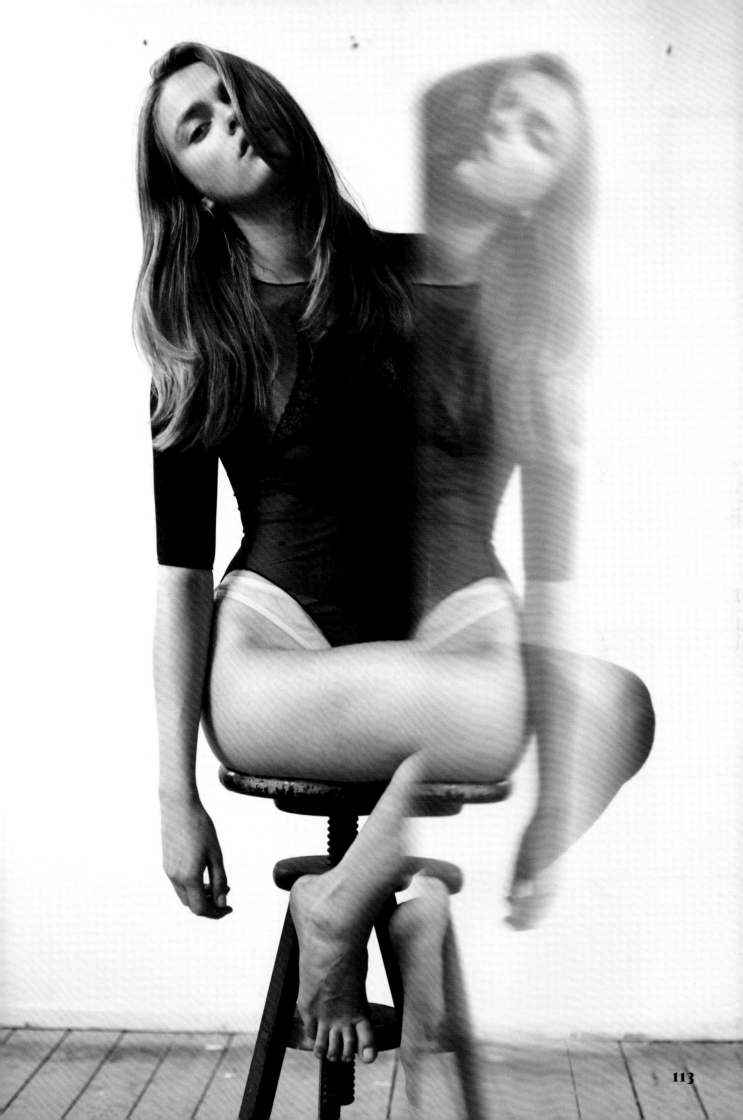

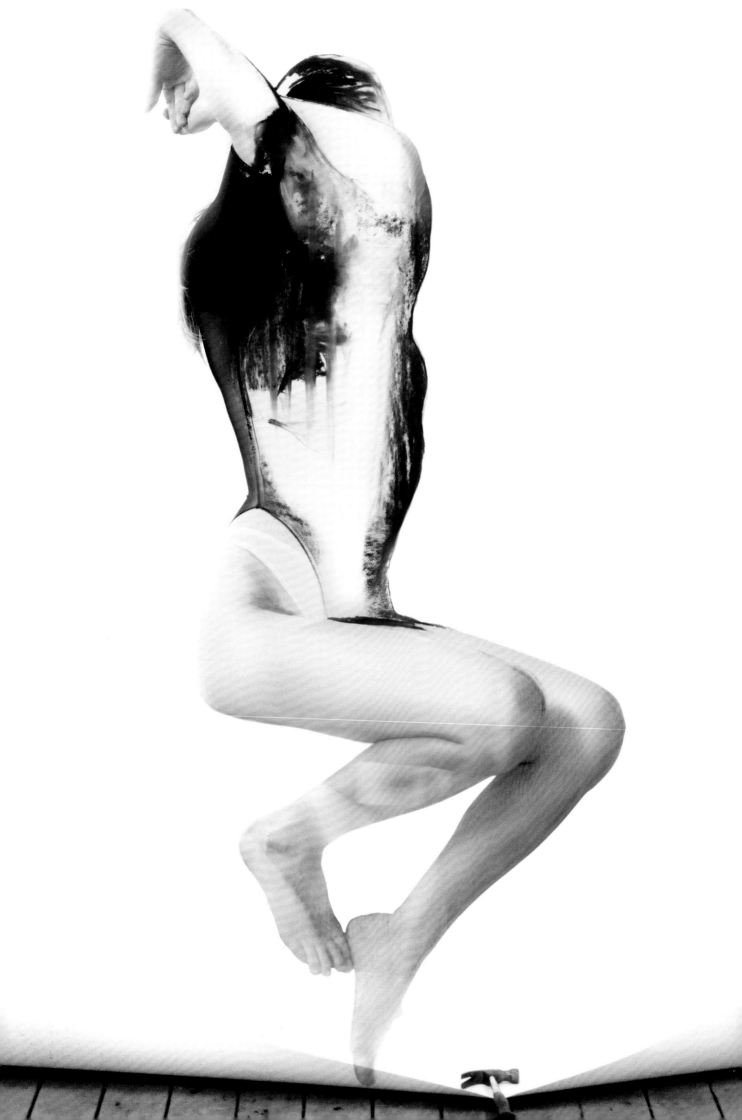

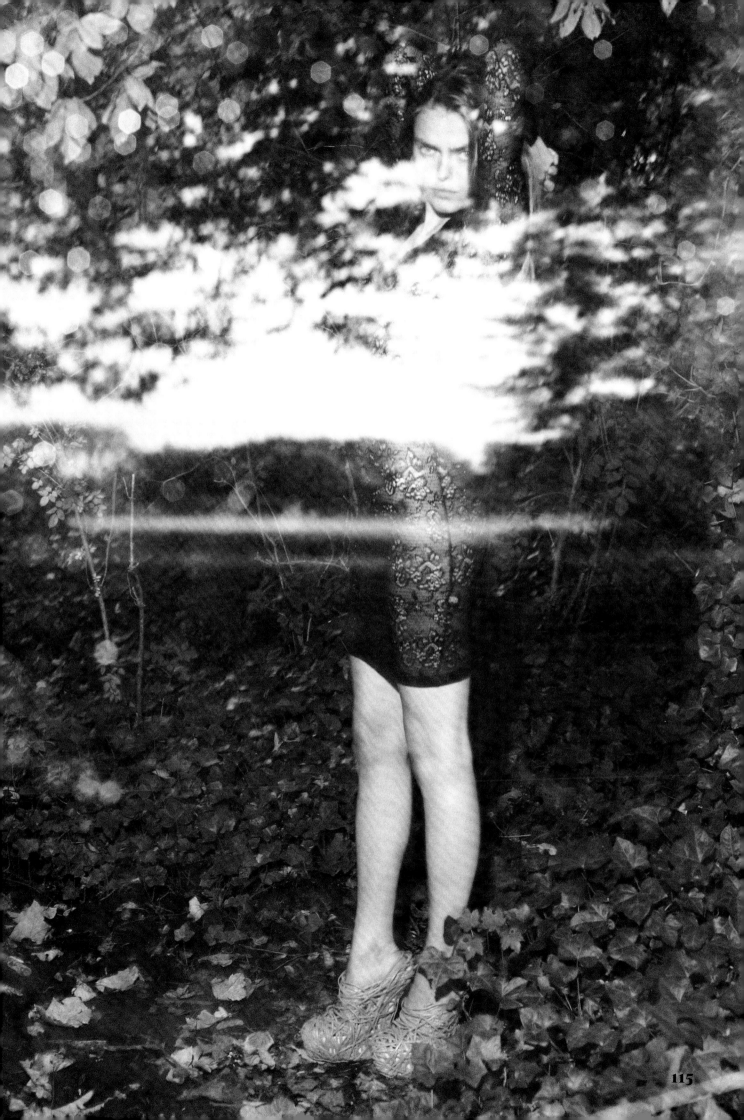

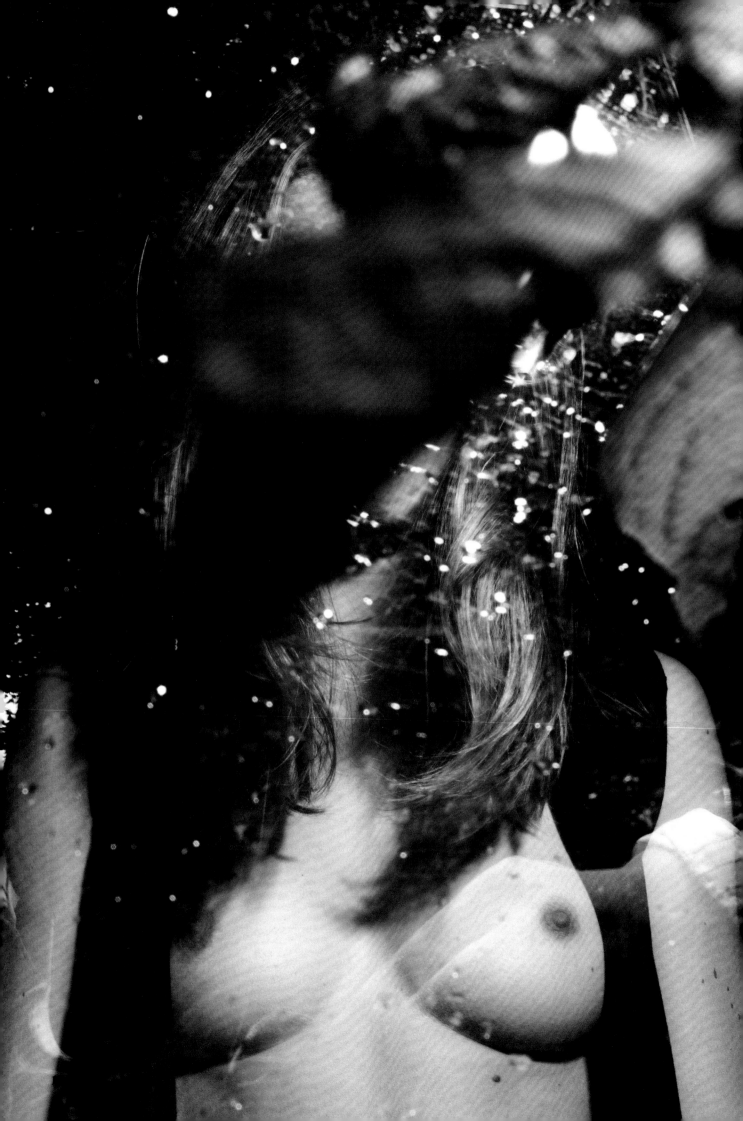

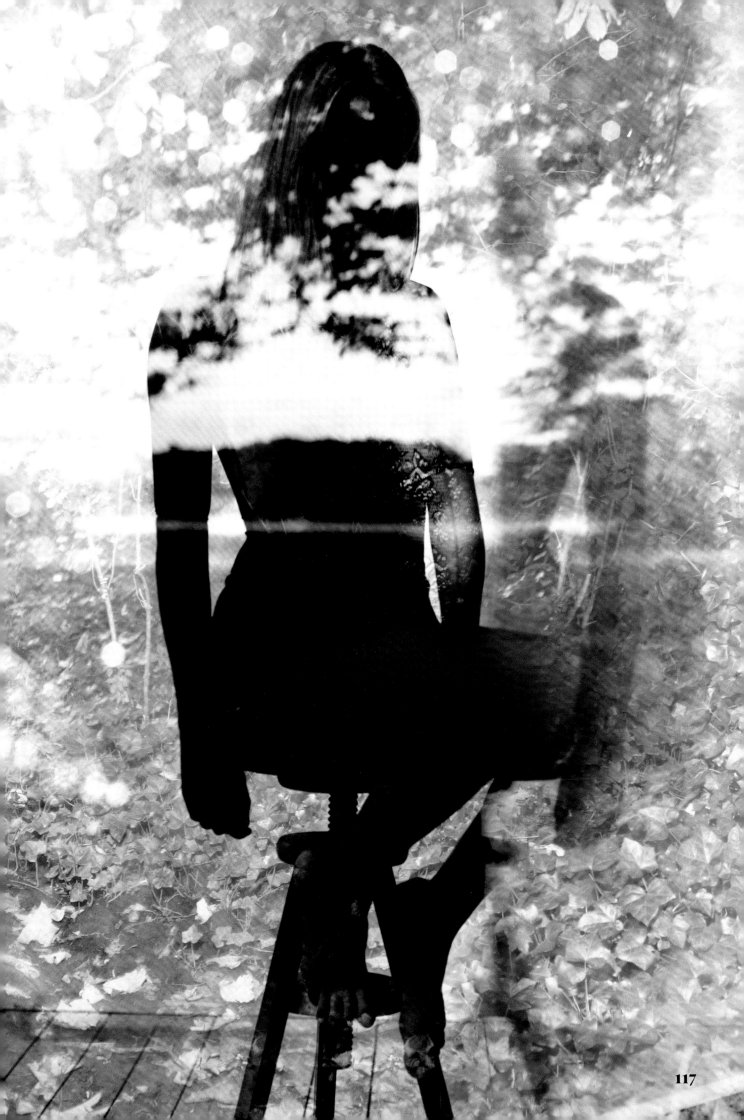

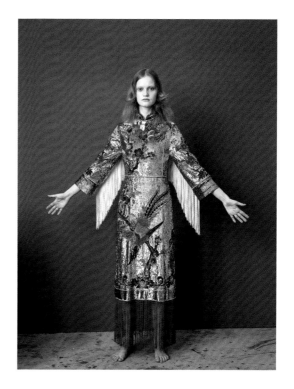

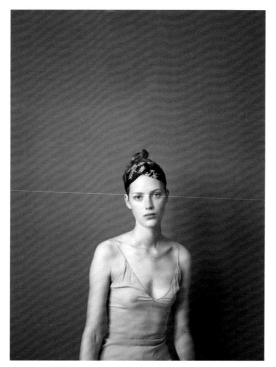

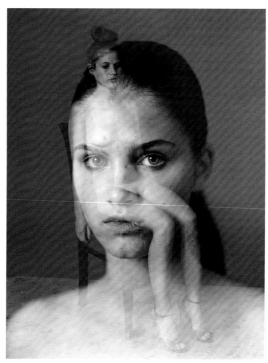

THOMAS HAUSER

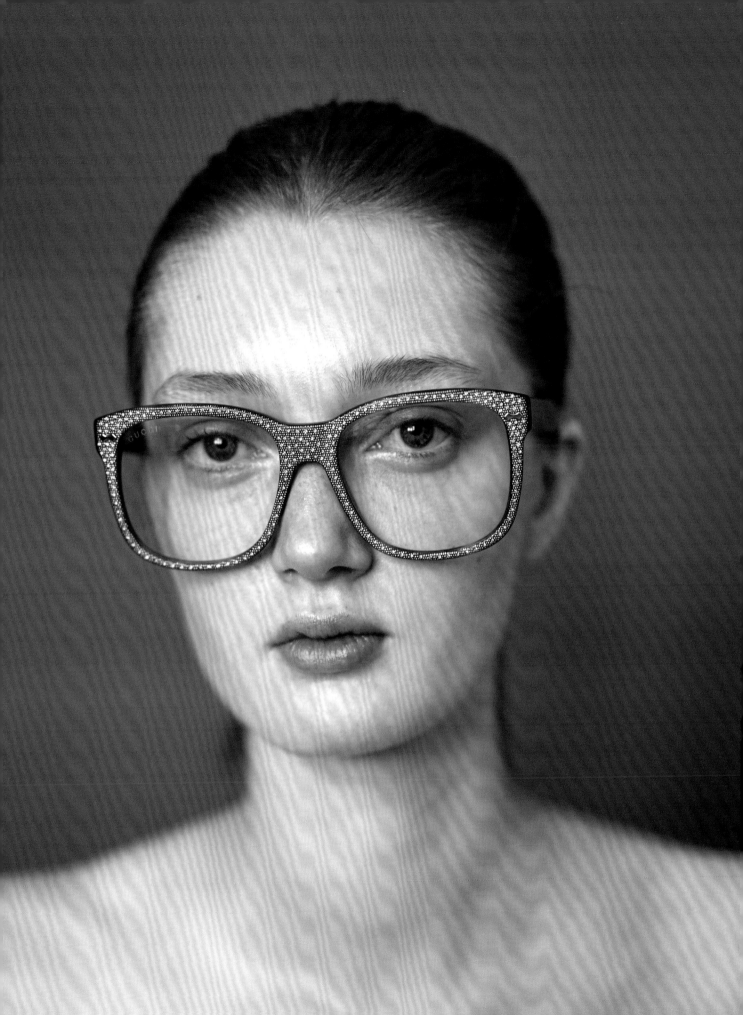

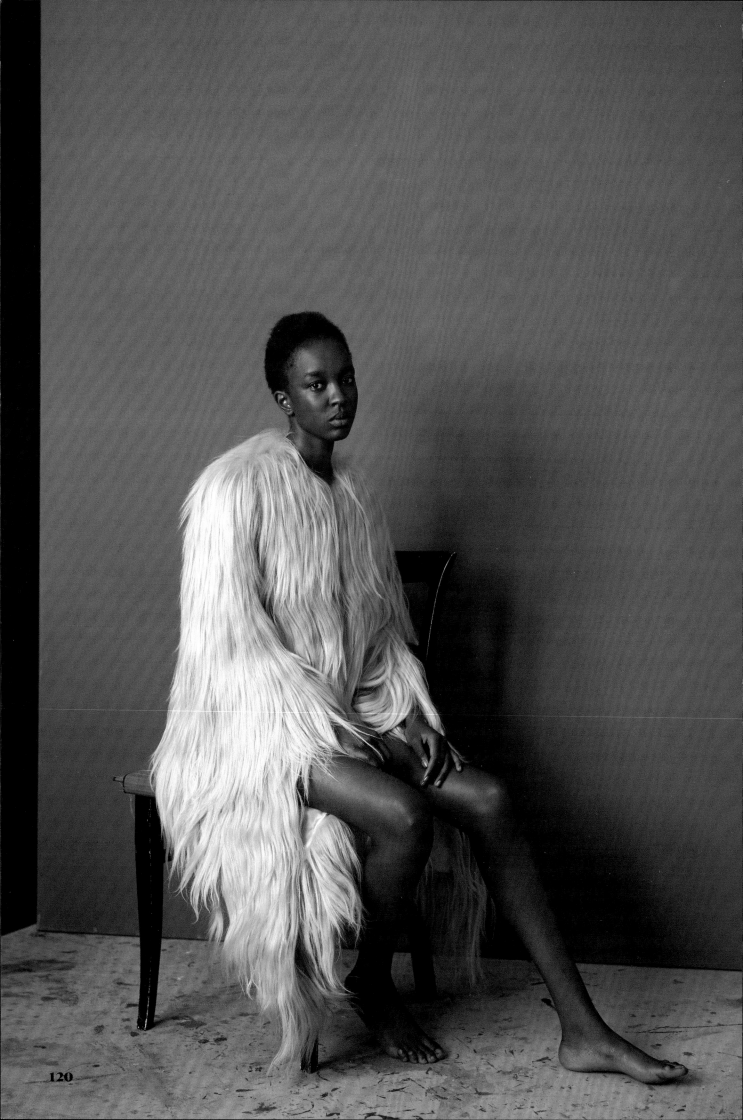

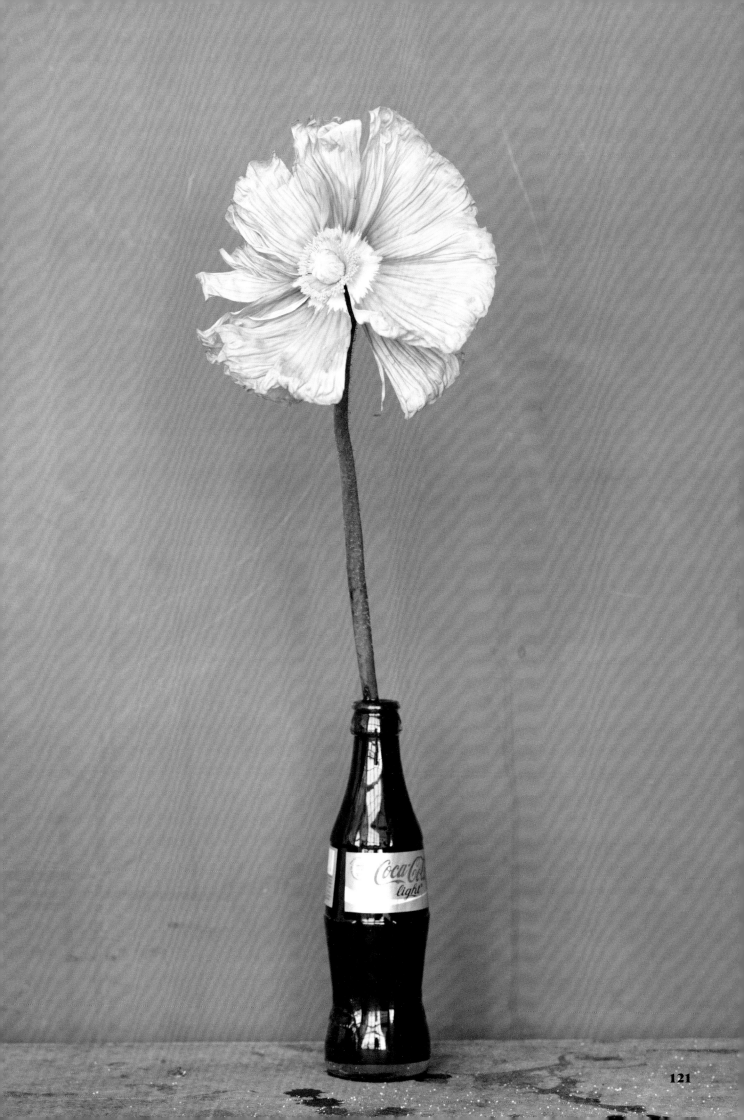

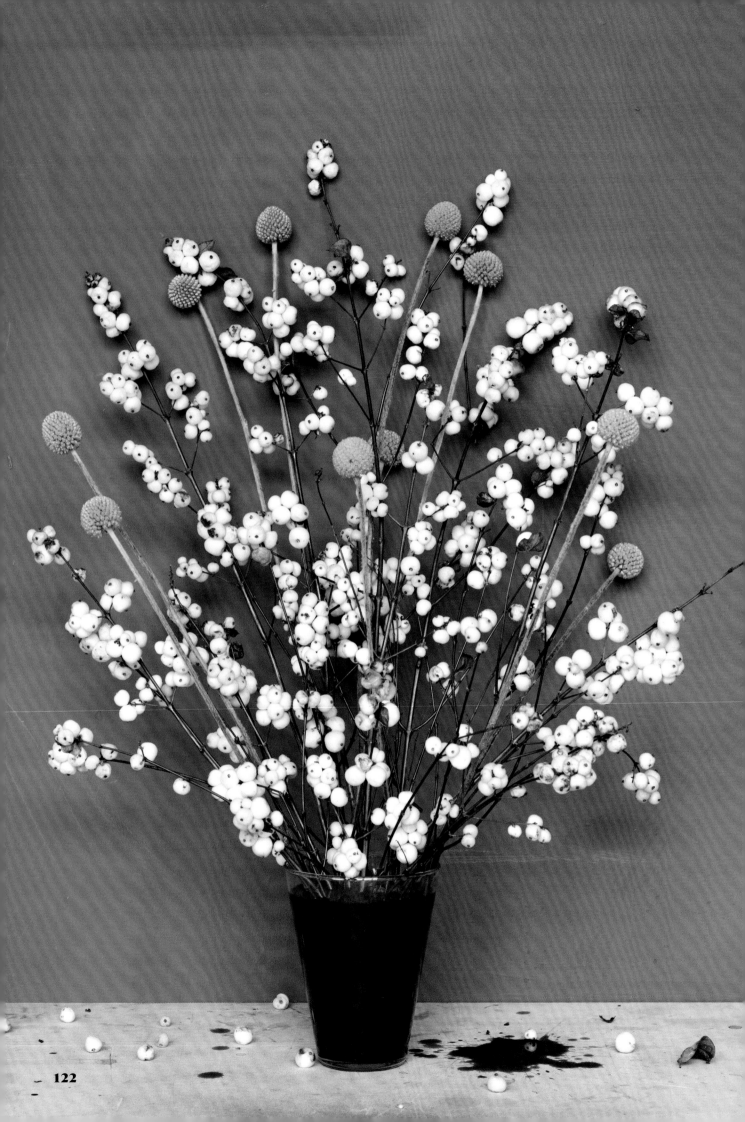

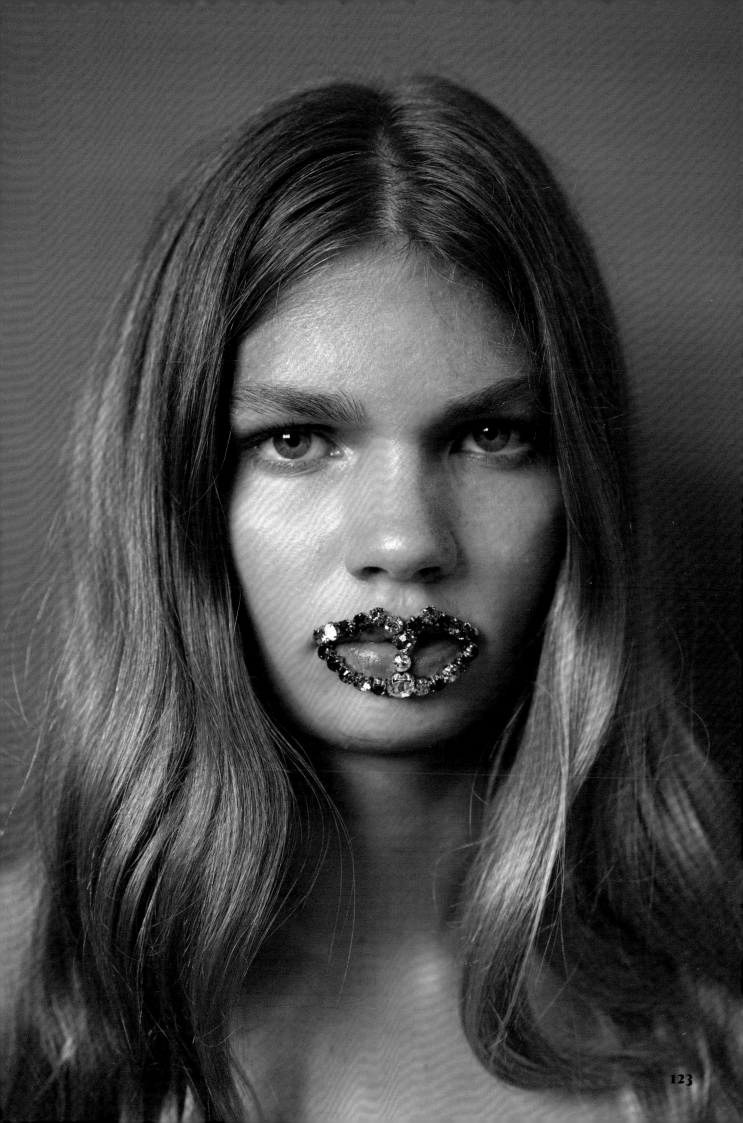

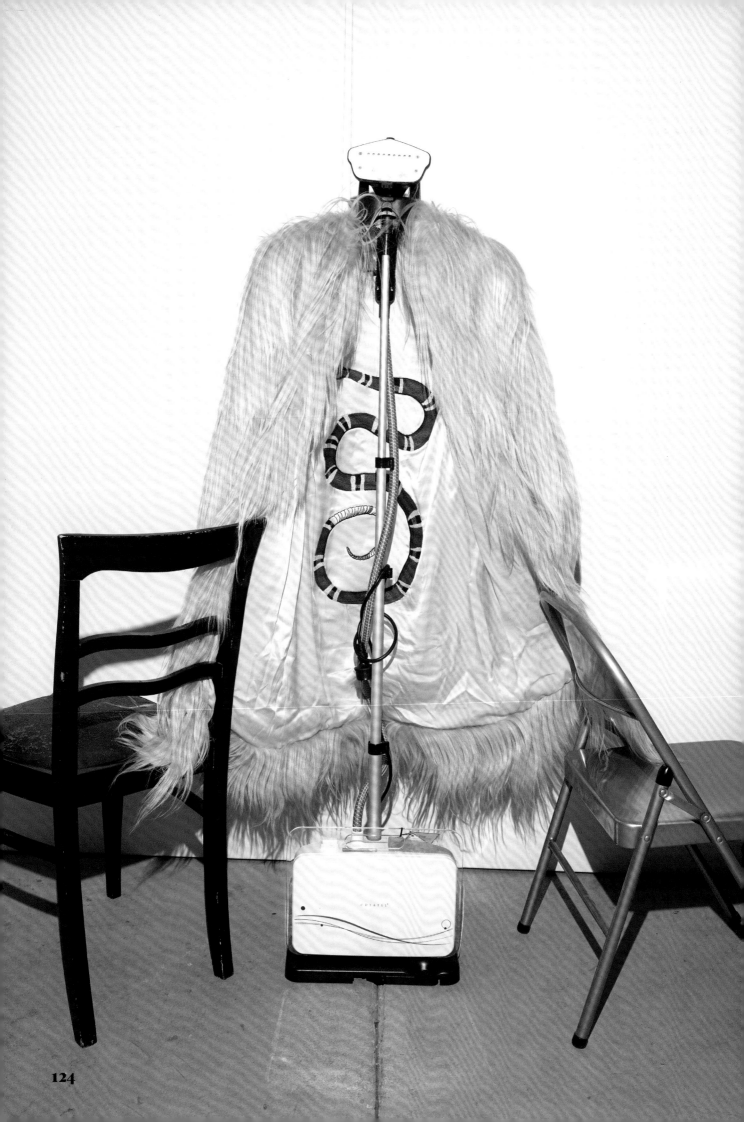

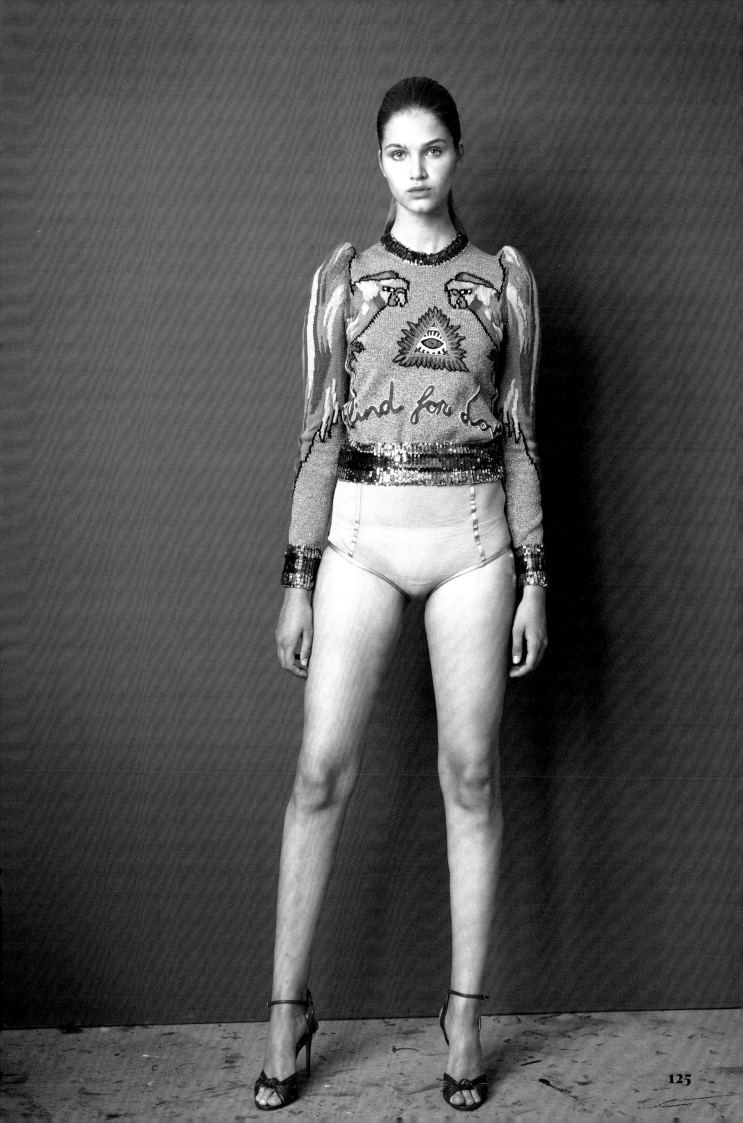

125

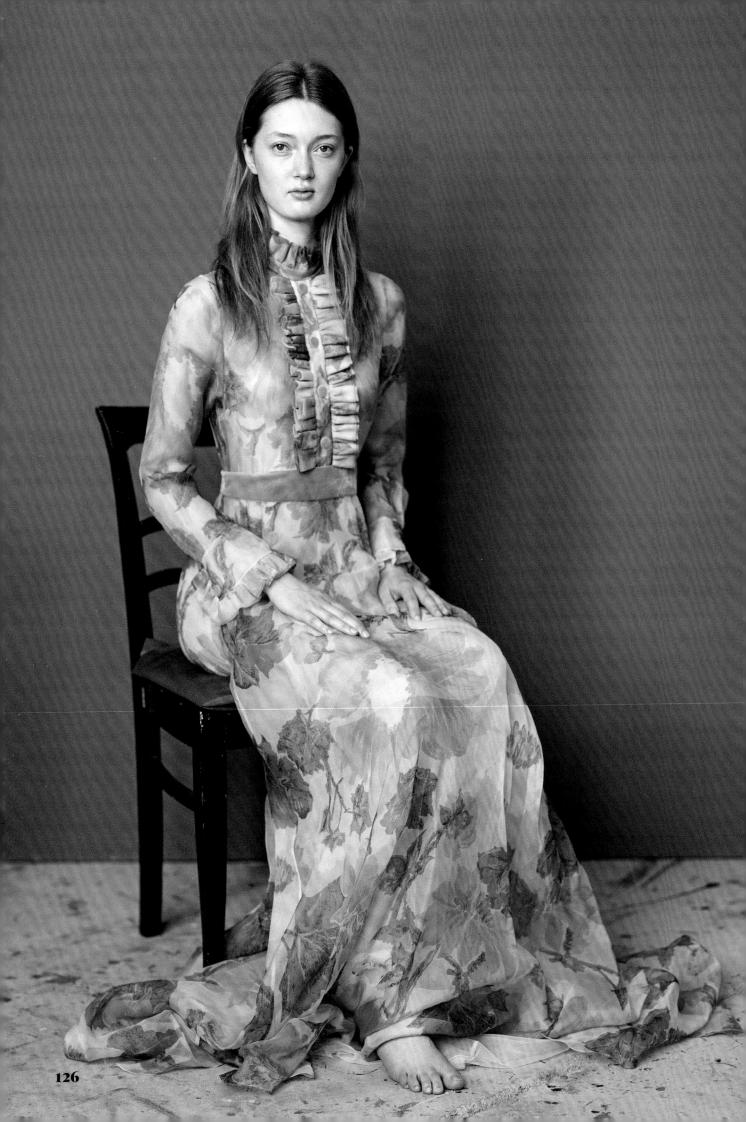

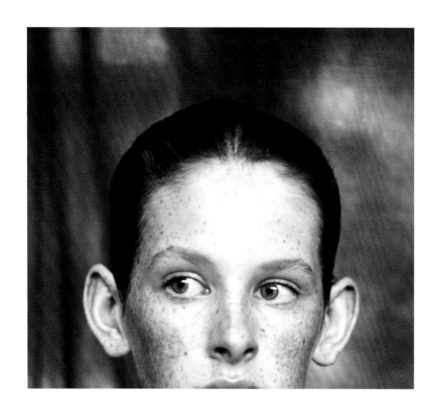

JACK DAVISON

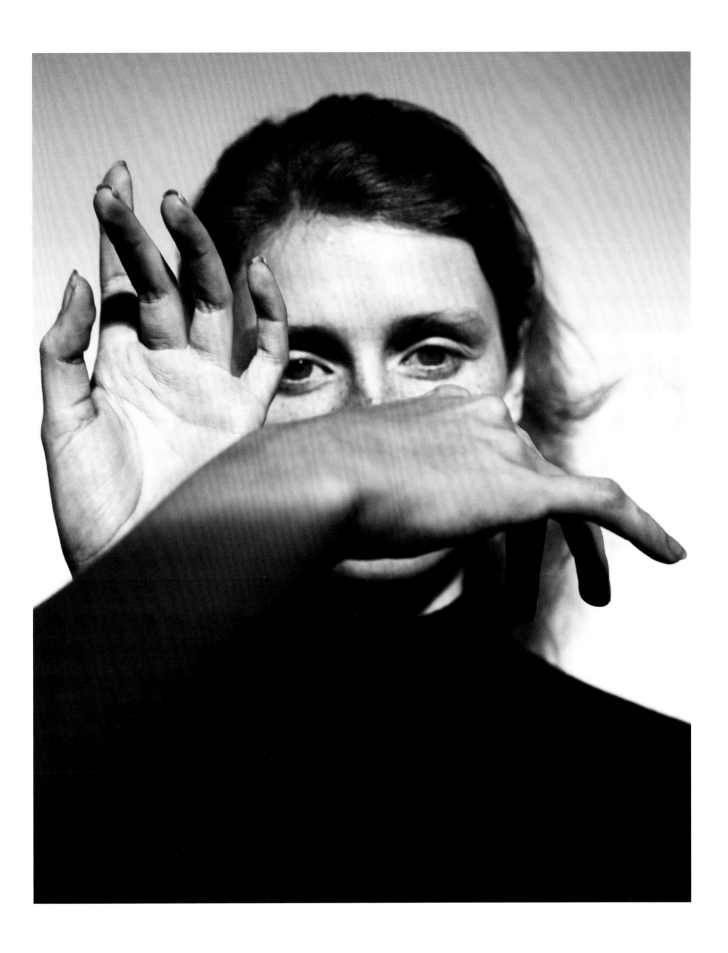

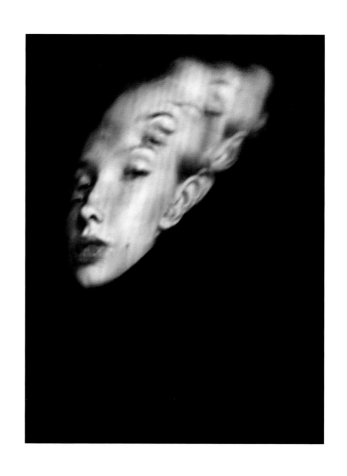

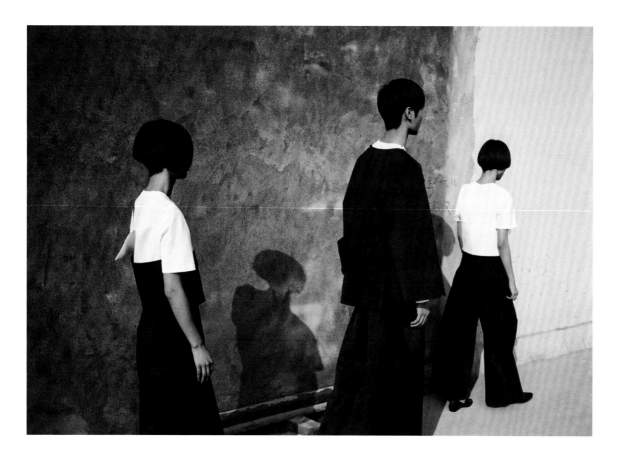

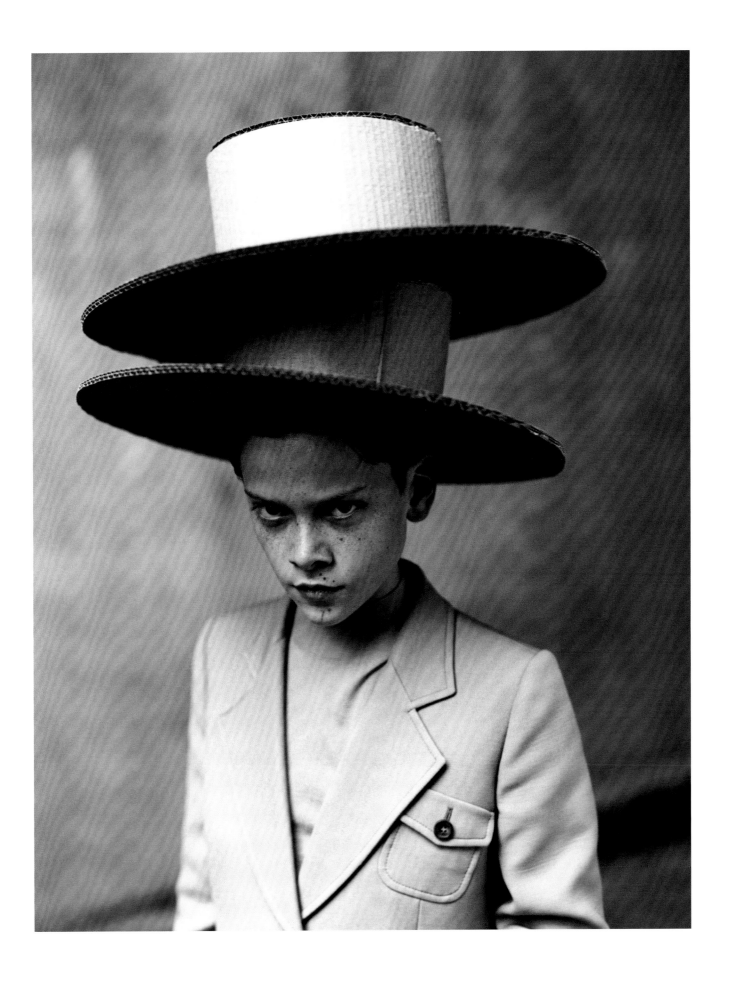

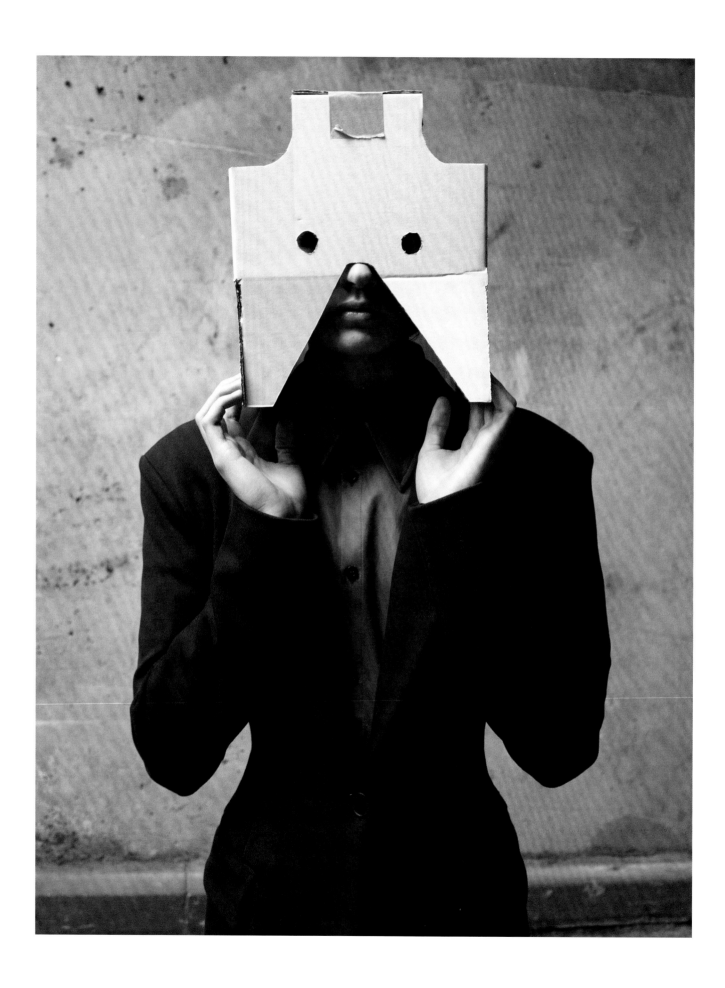

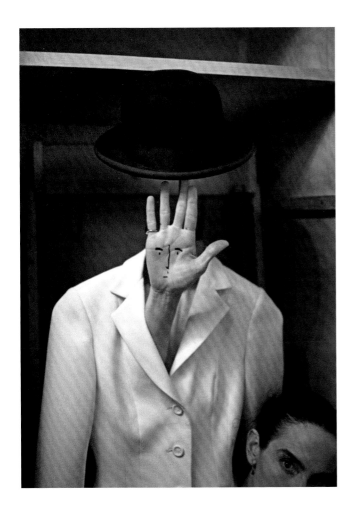

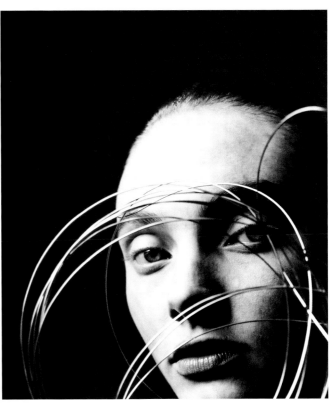

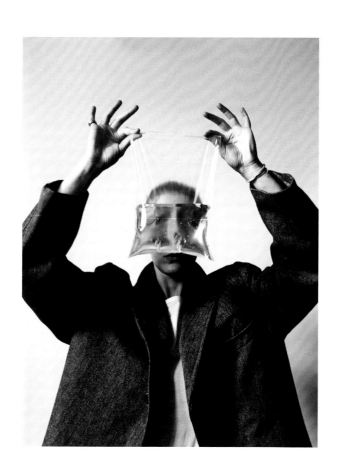
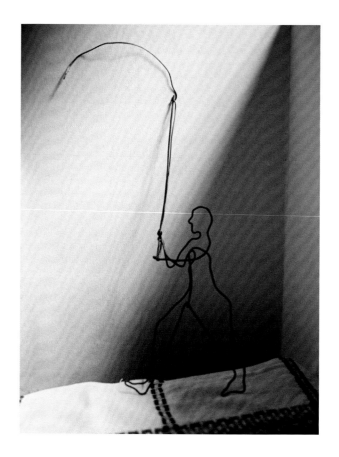

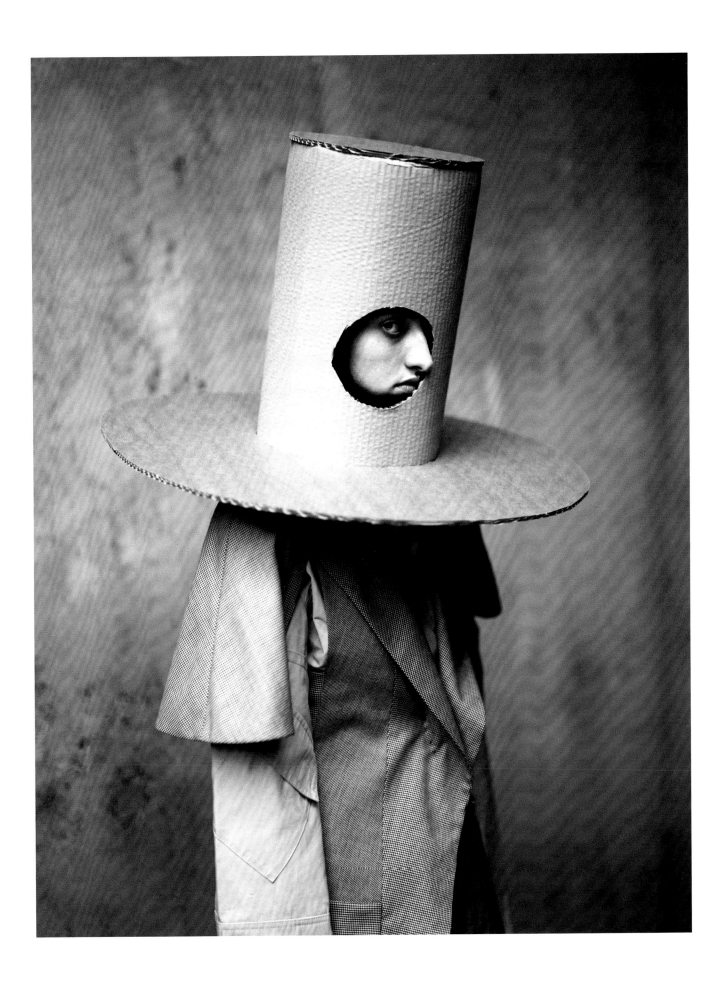

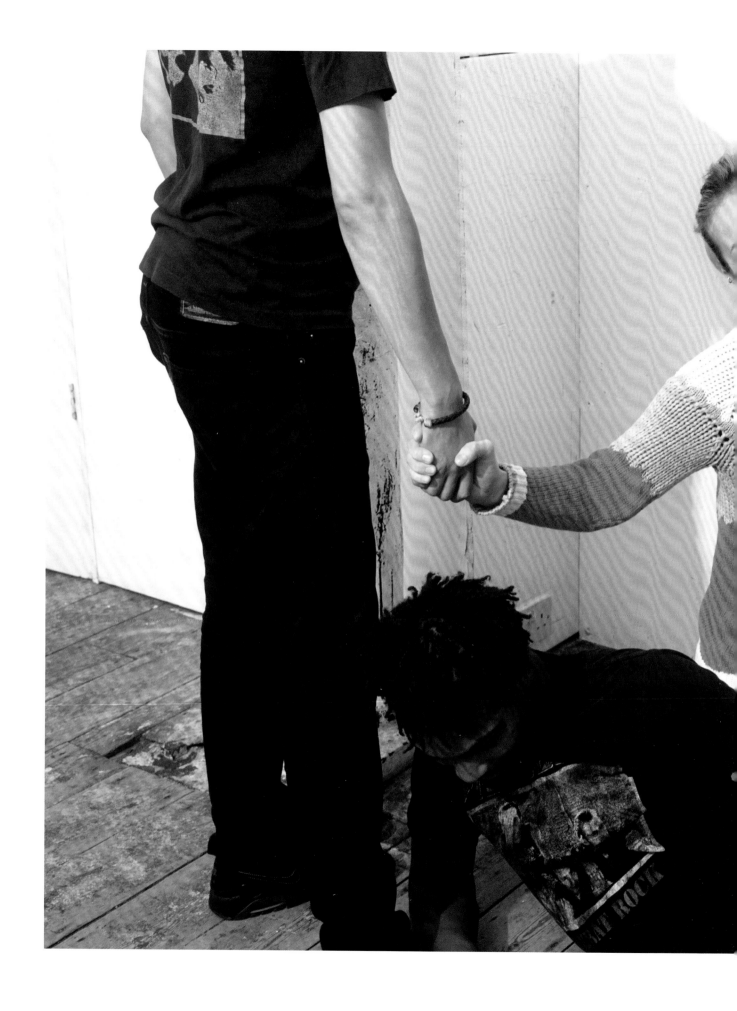

JASON EVANS

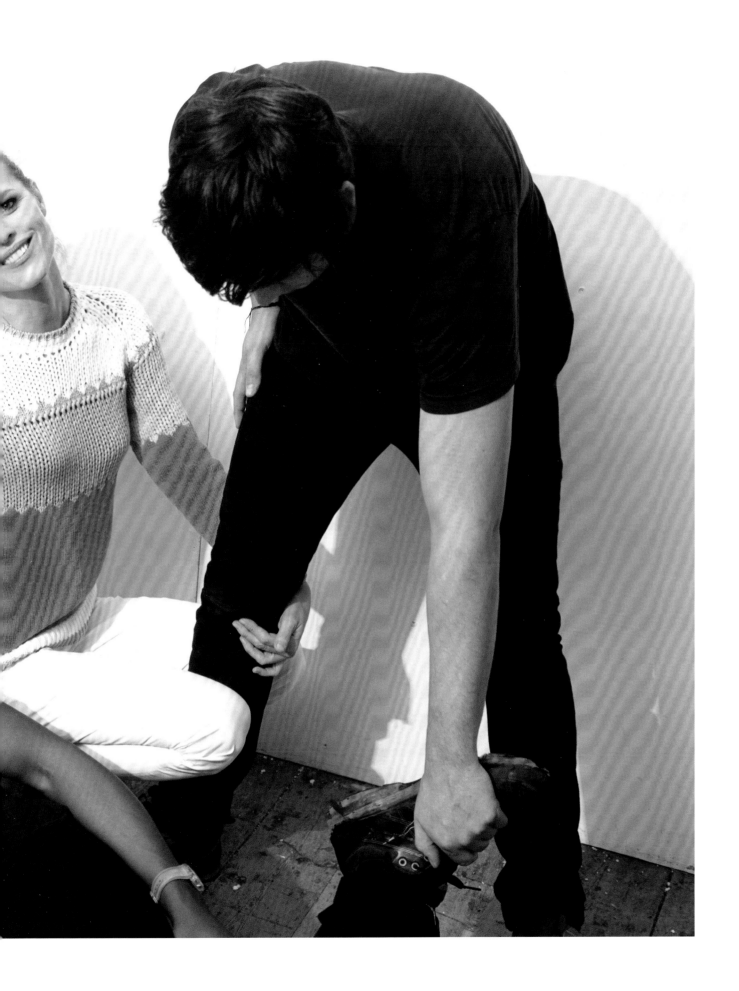

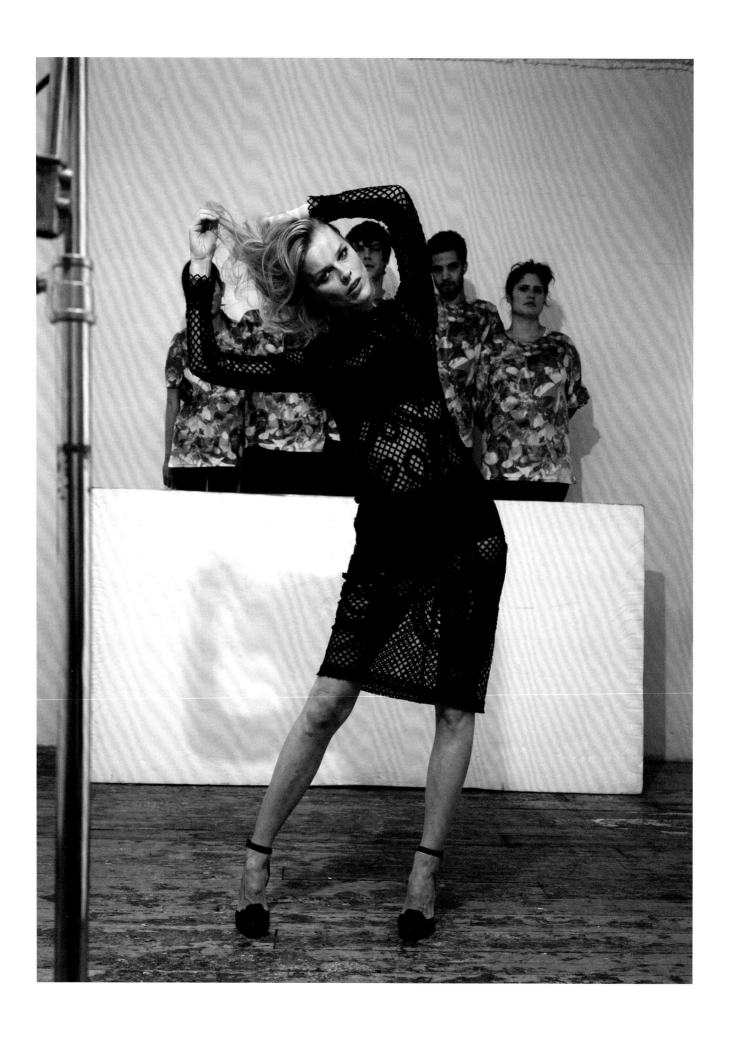

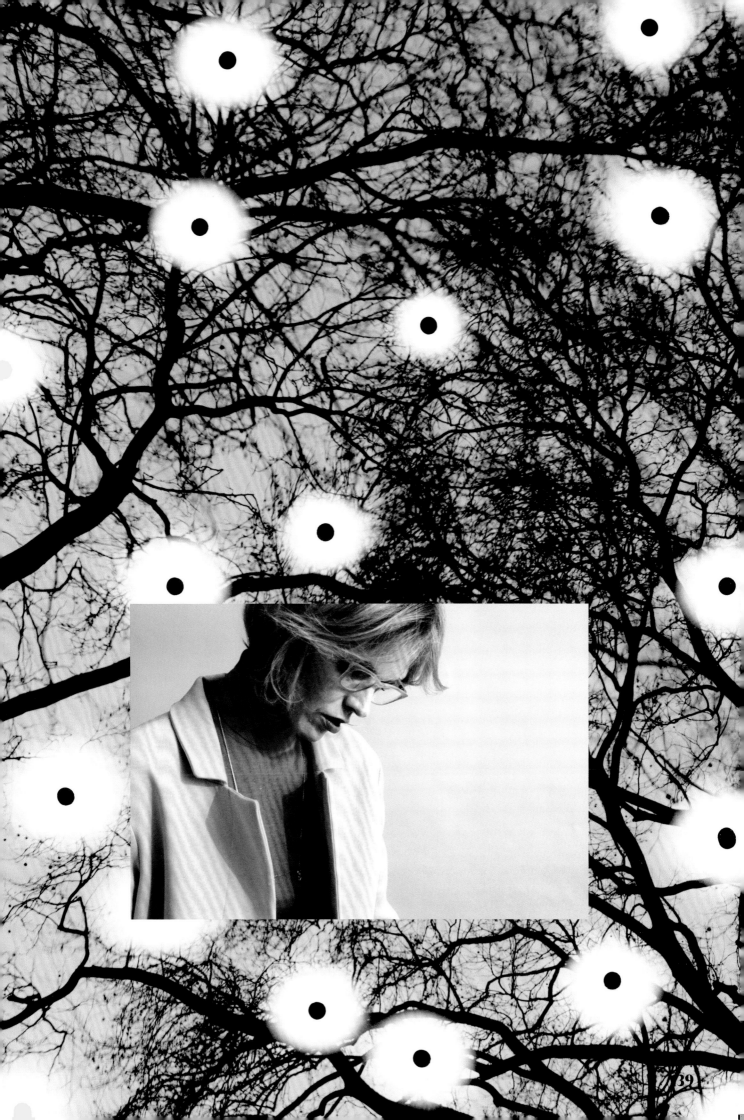

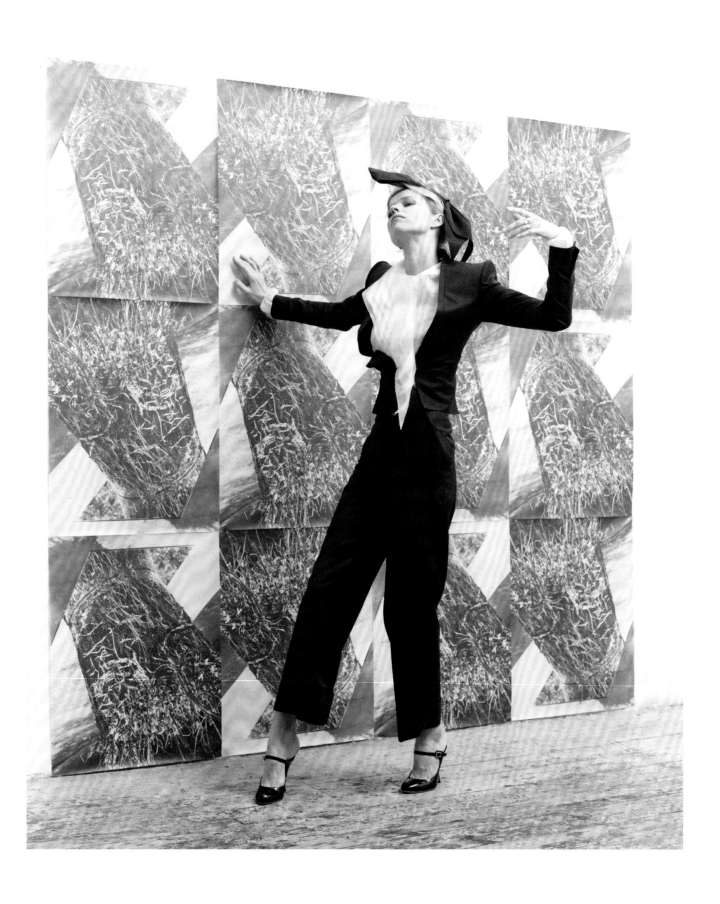

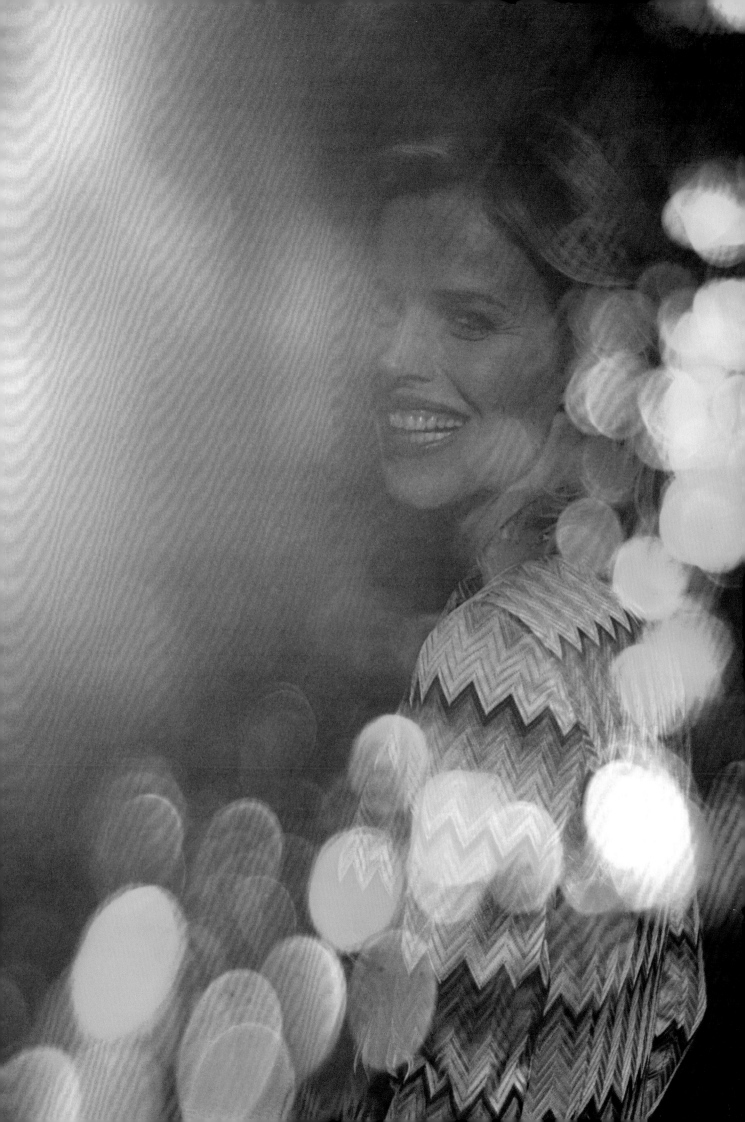

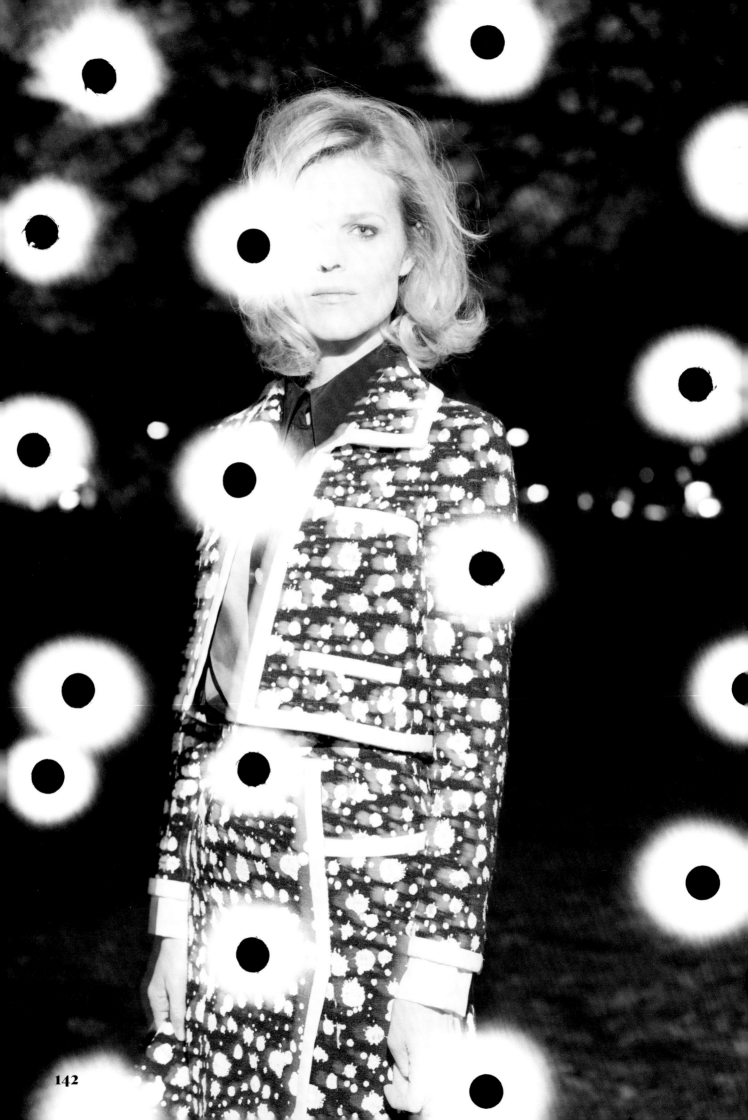

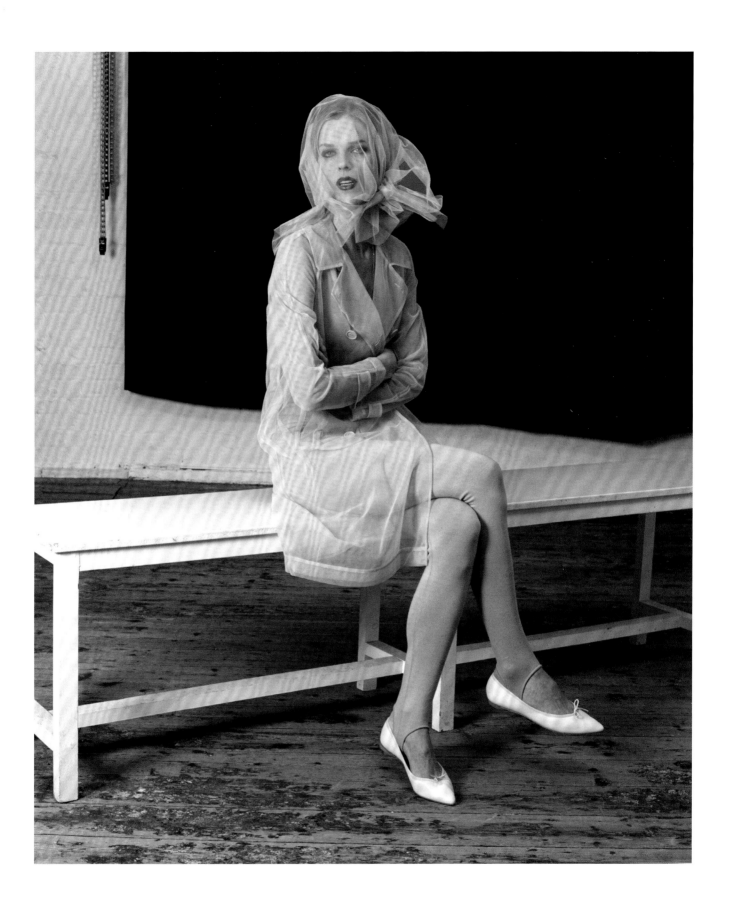

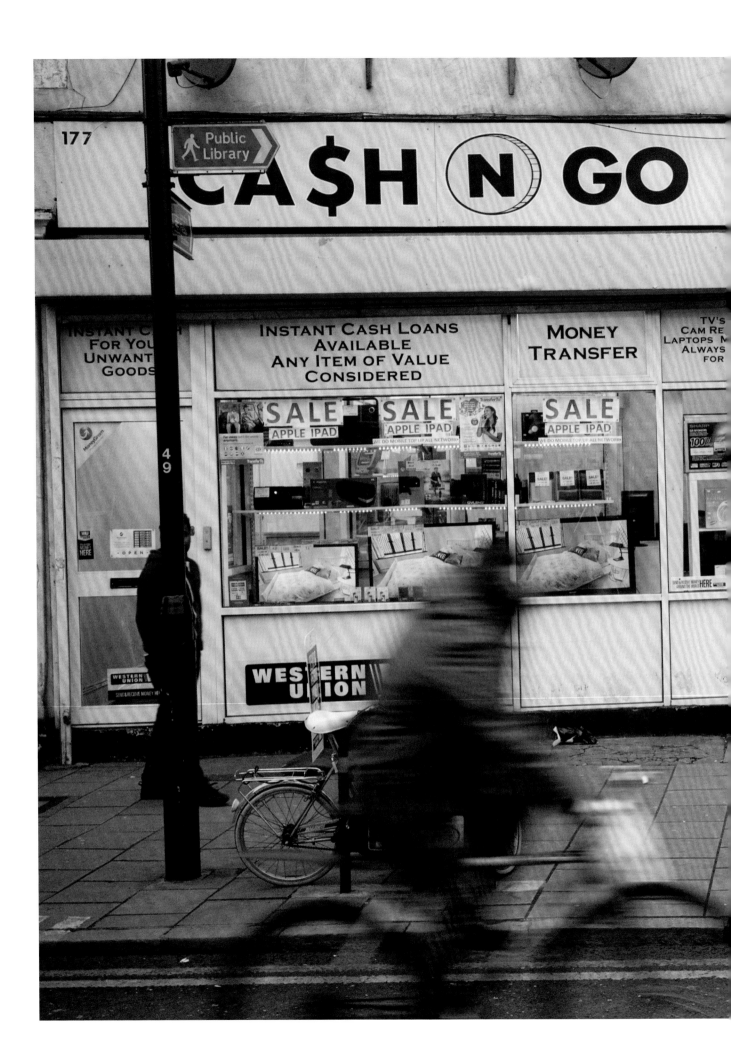

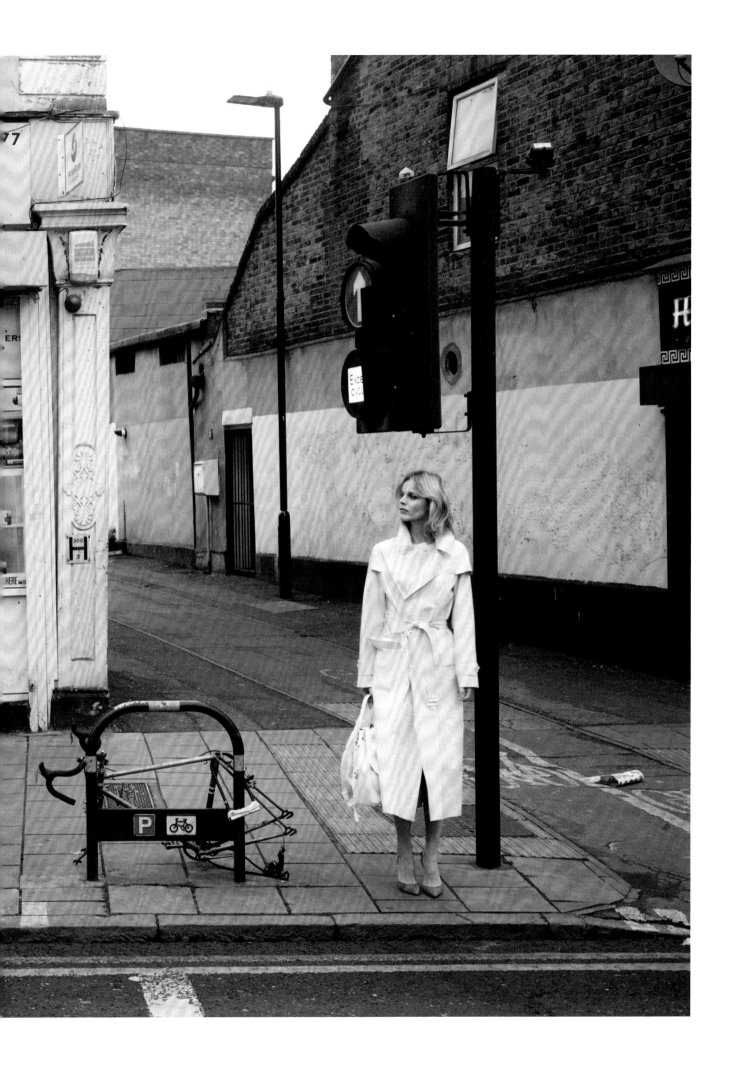

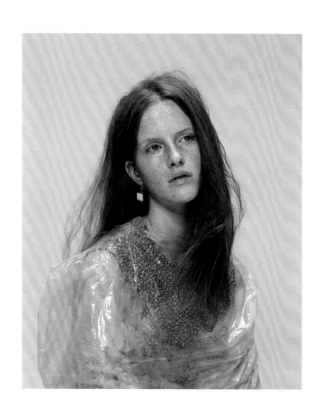

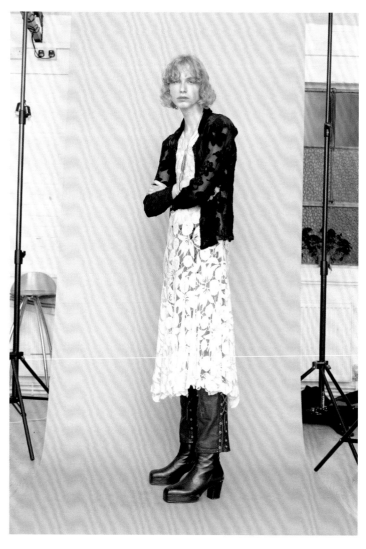

MARK PECKMEZIAN

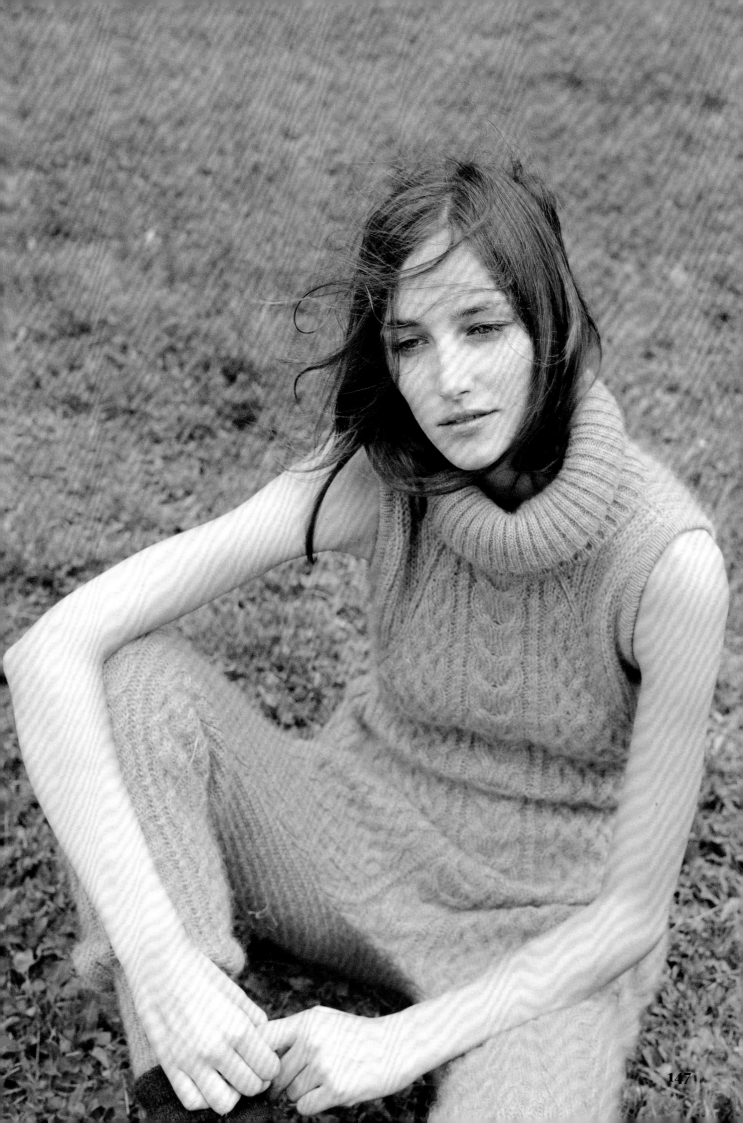

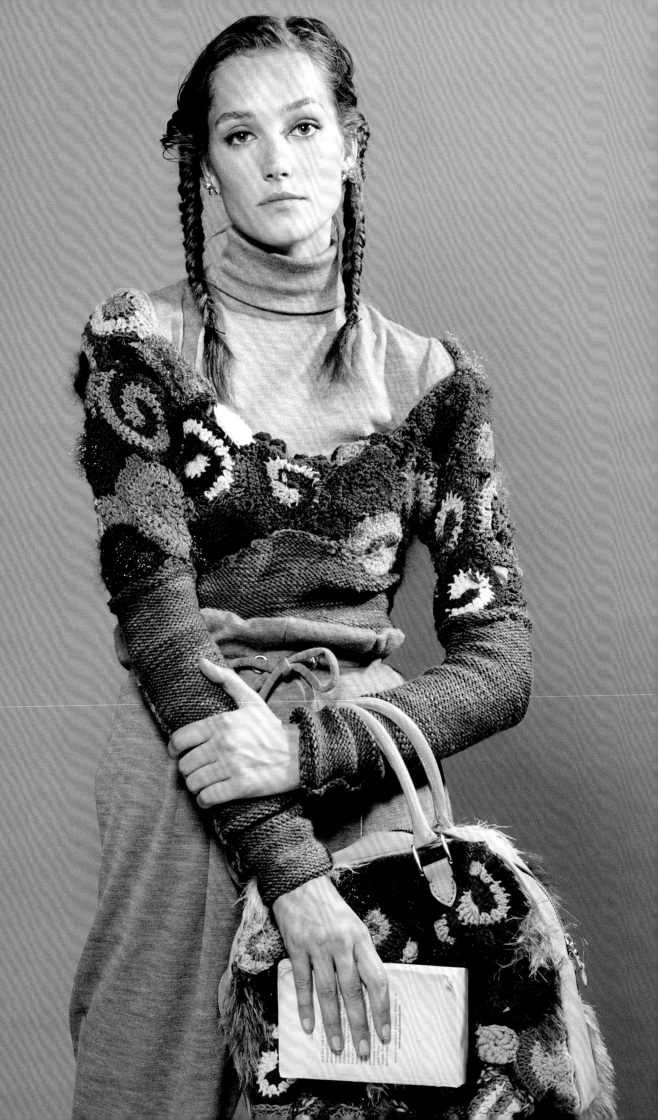

148

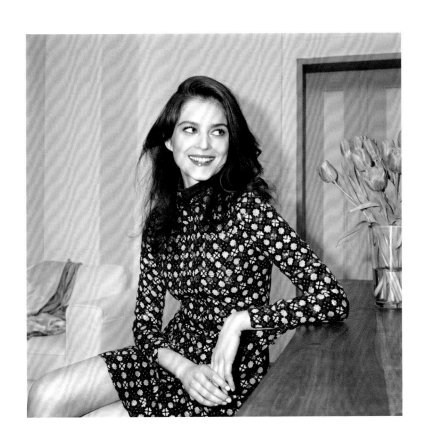

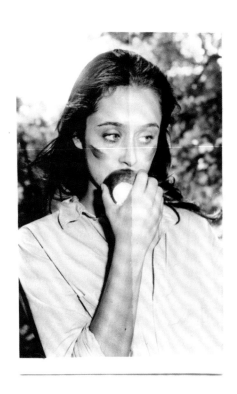

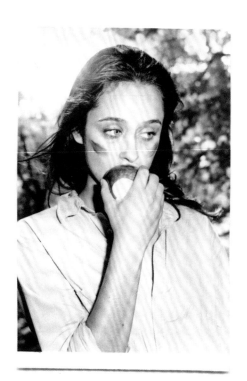

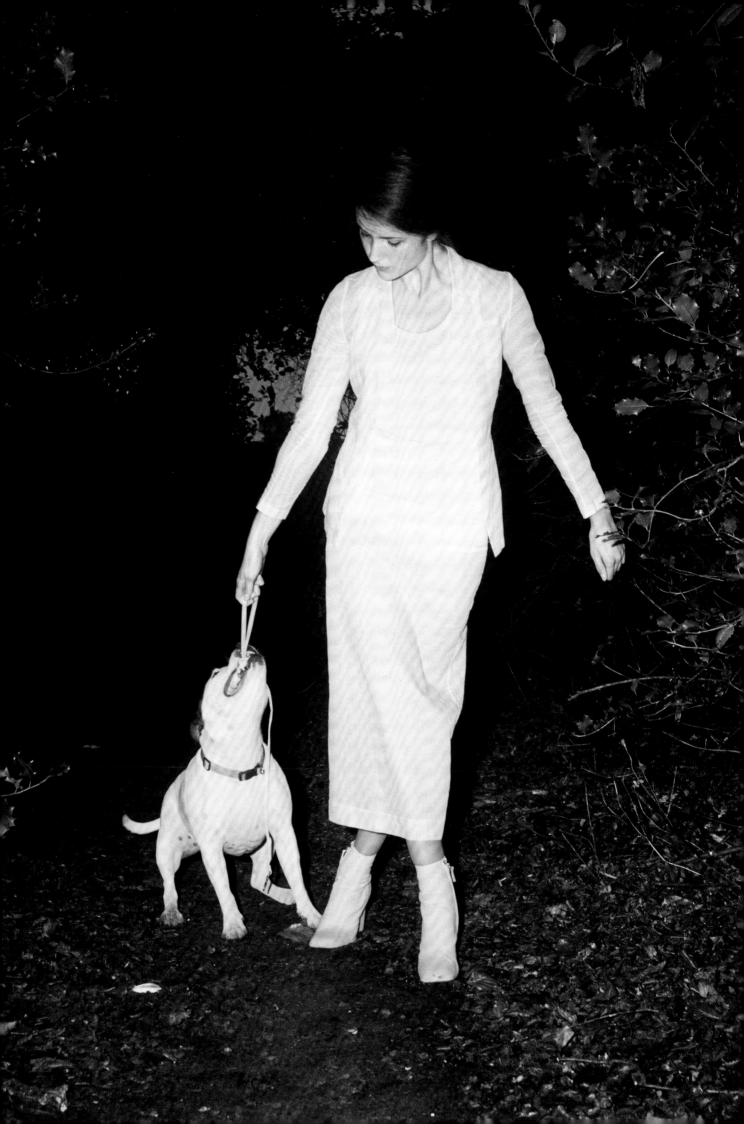

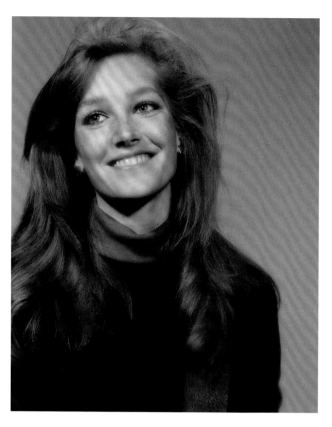

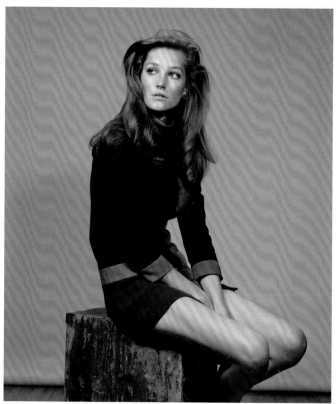

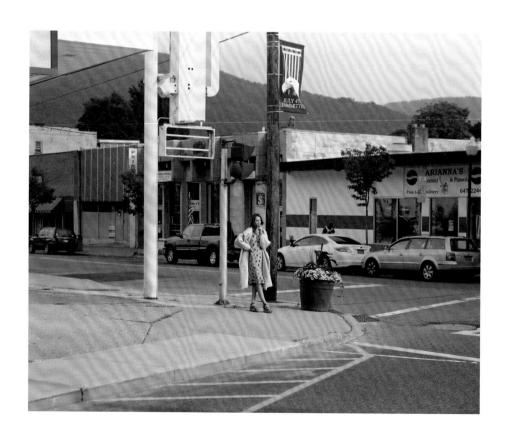

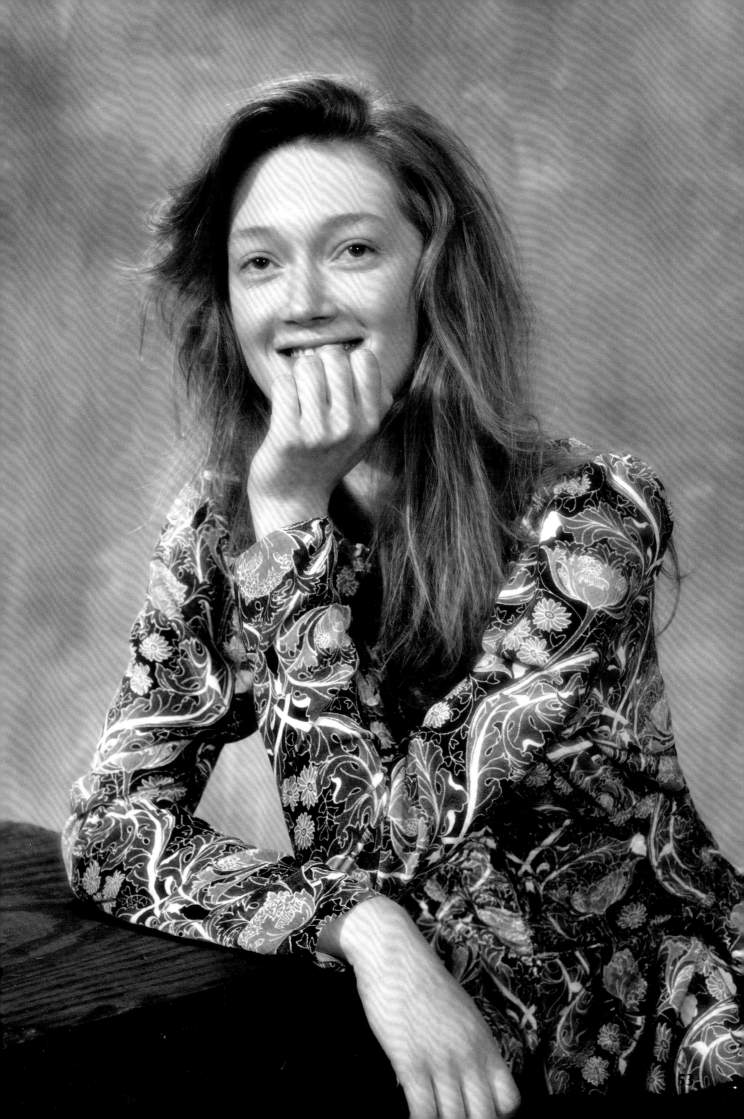

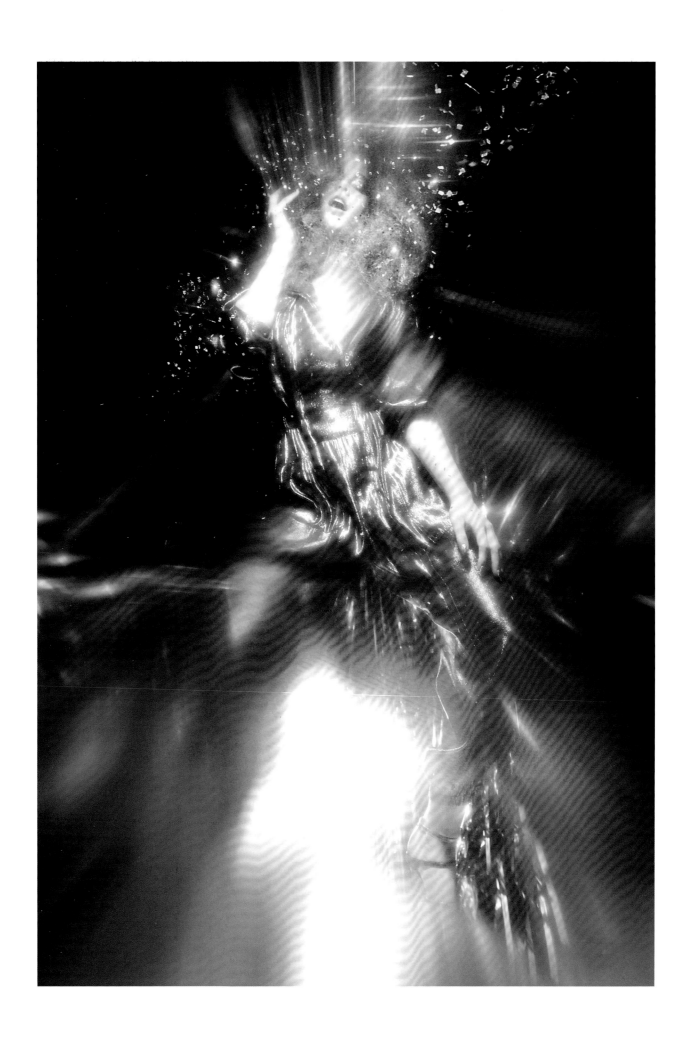

RUTH HOGBEN

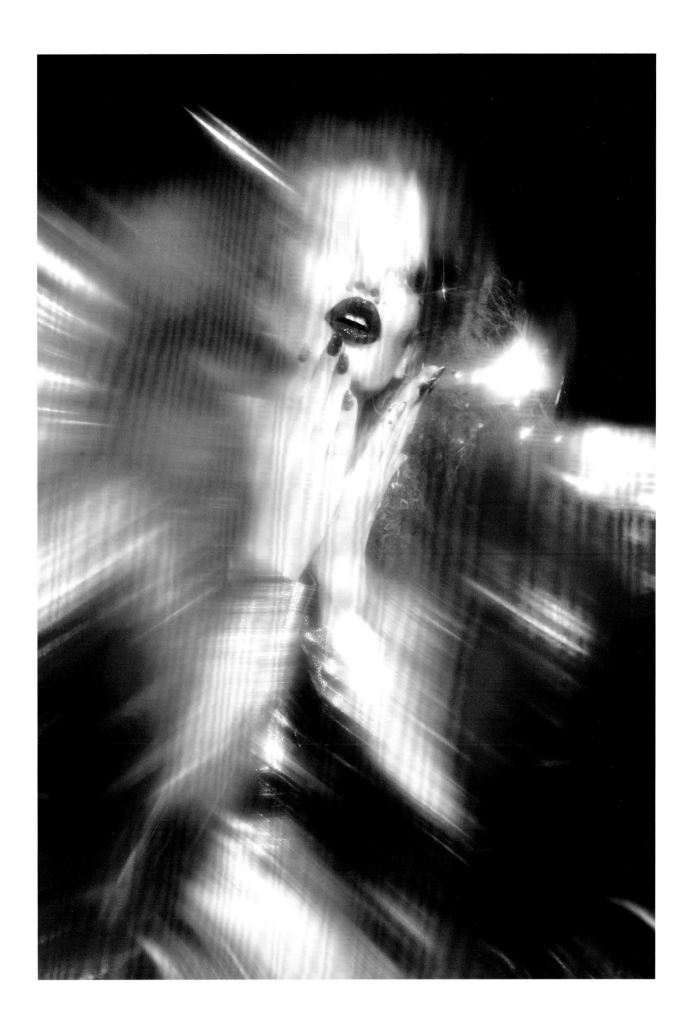

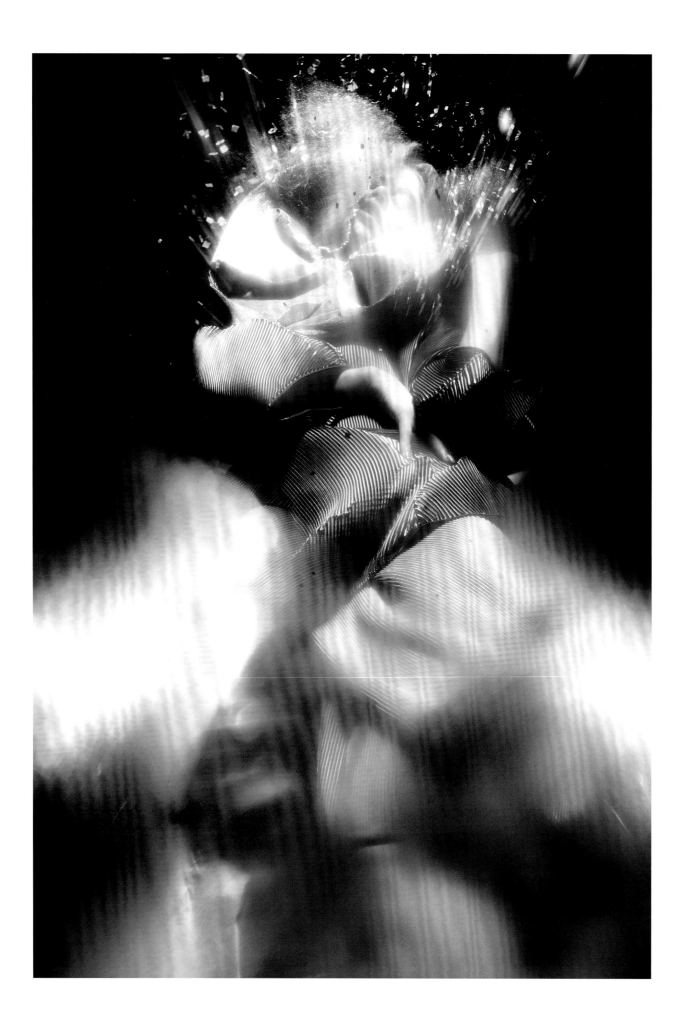

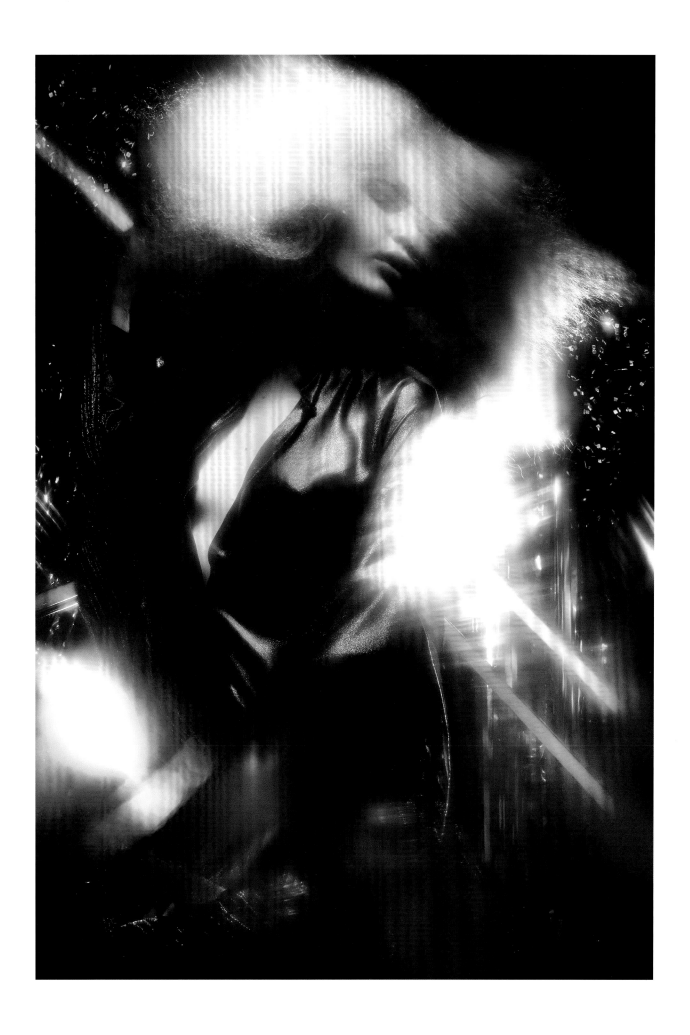

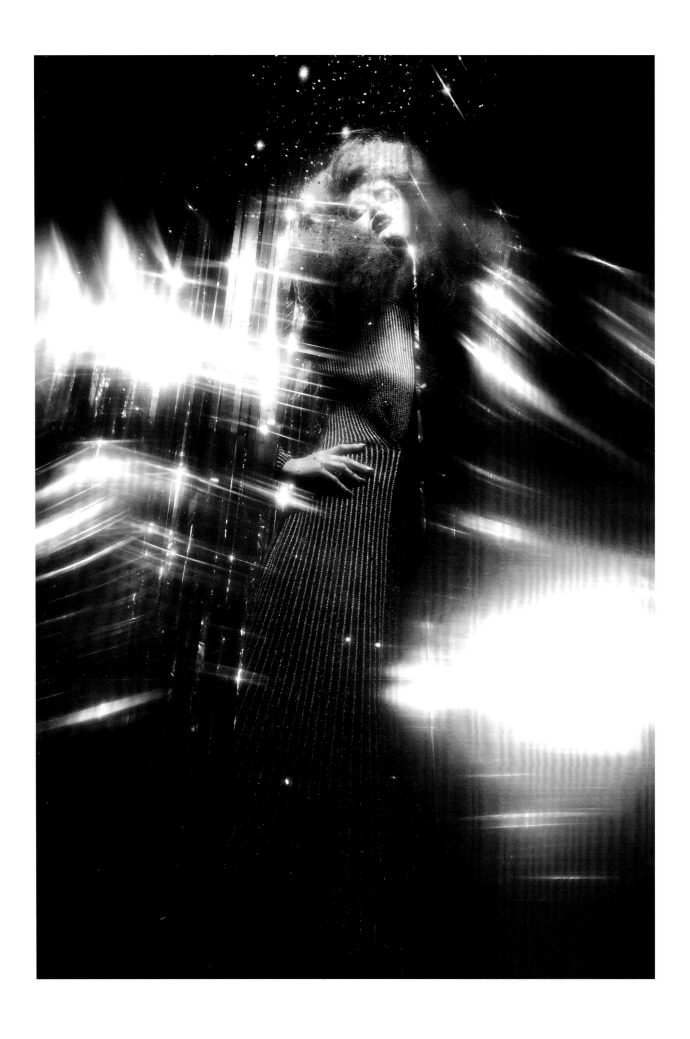

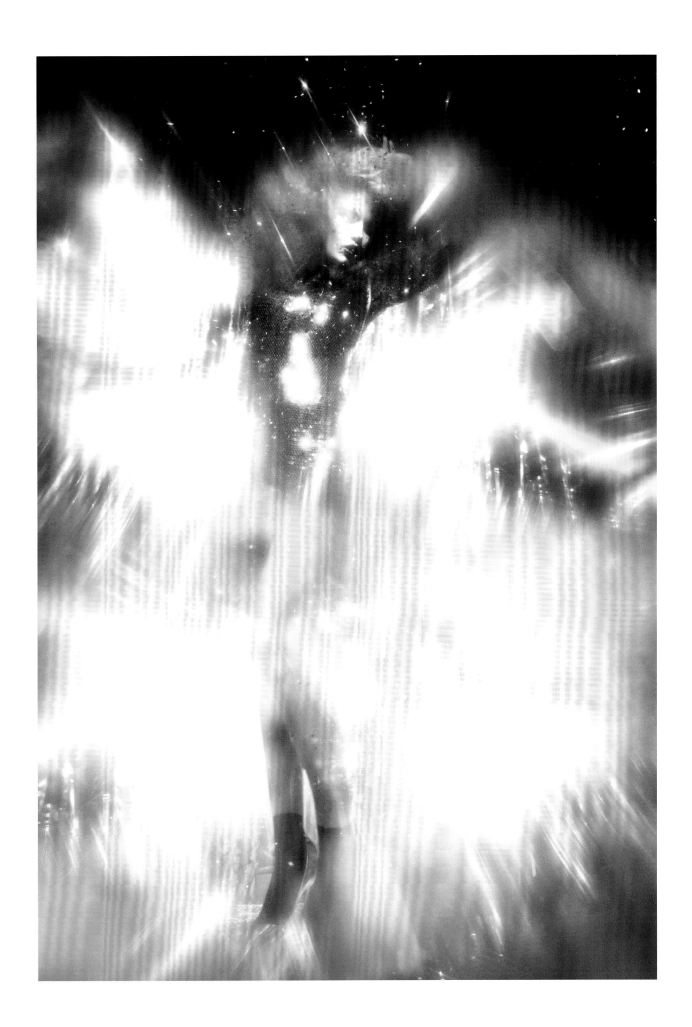

TODD HIDO

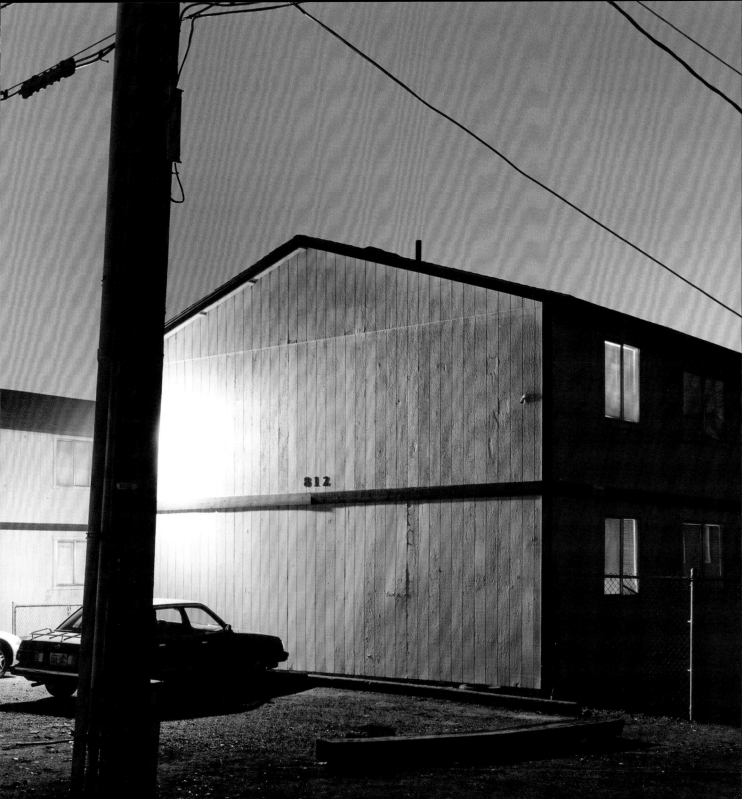

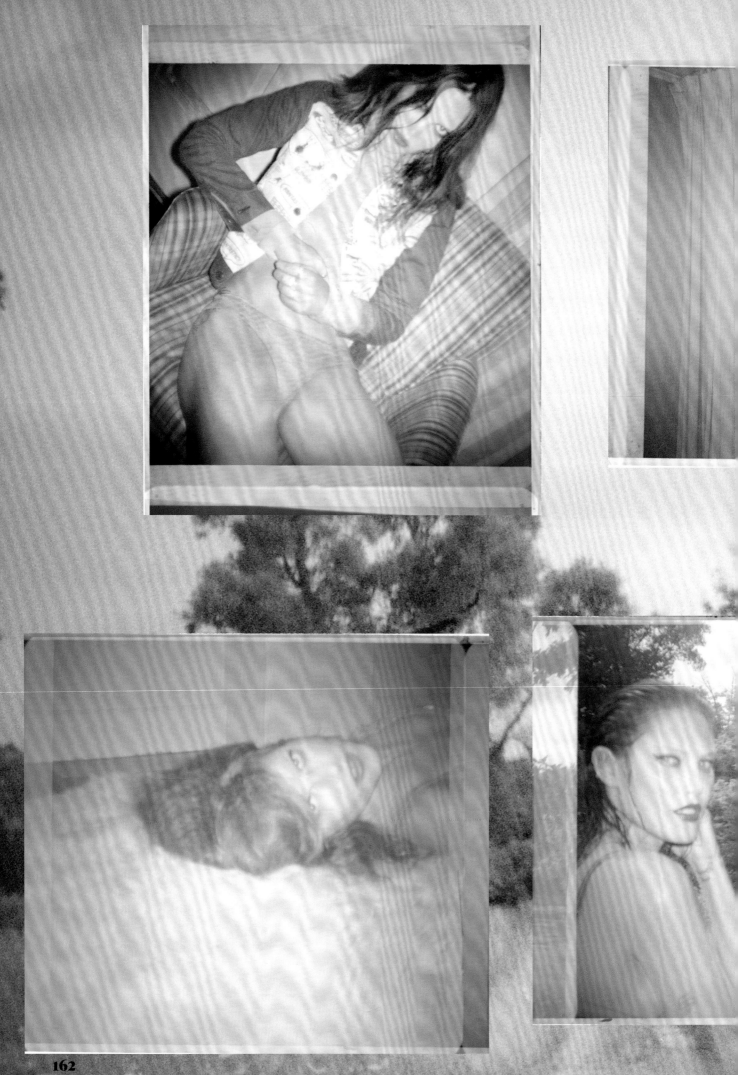

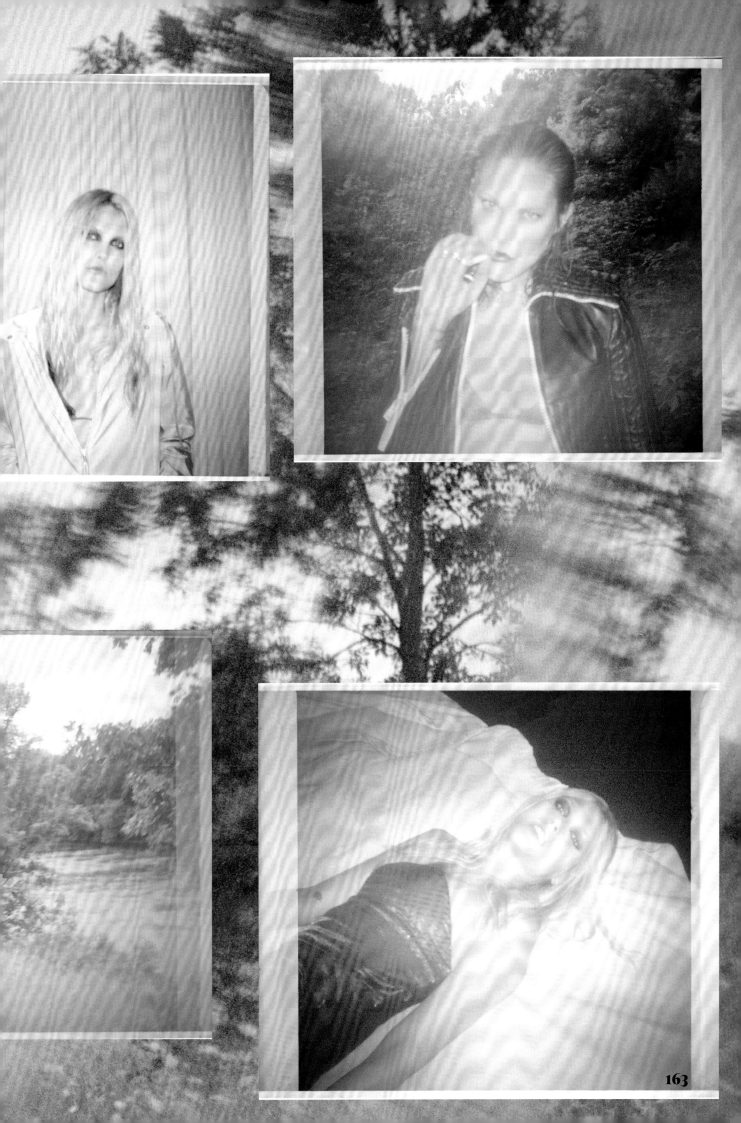

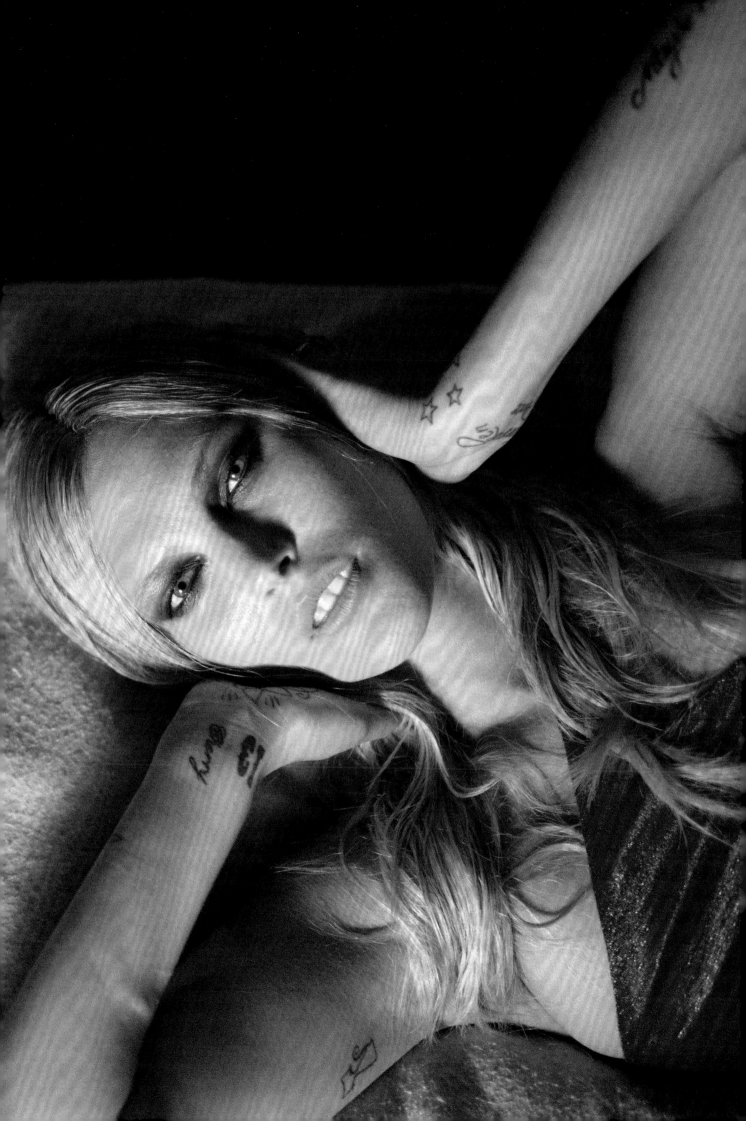

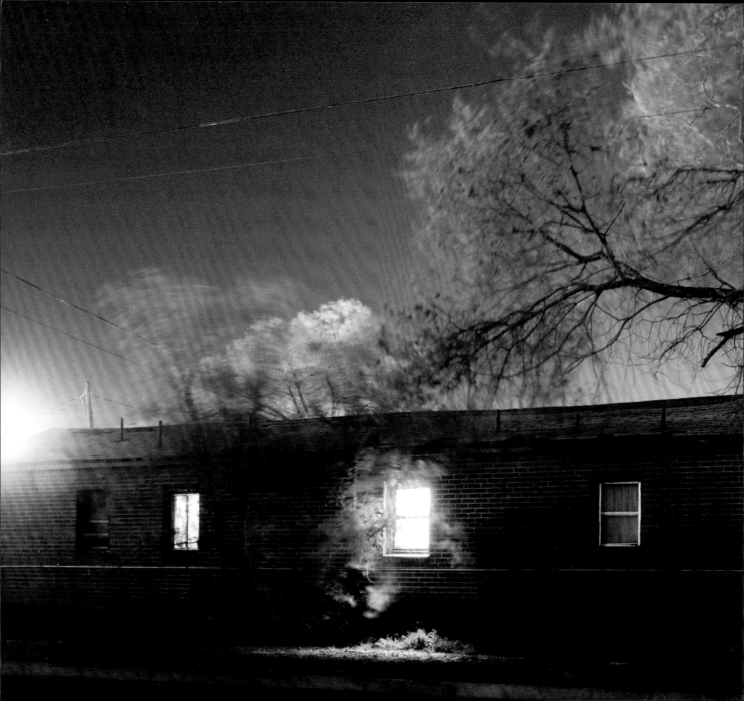

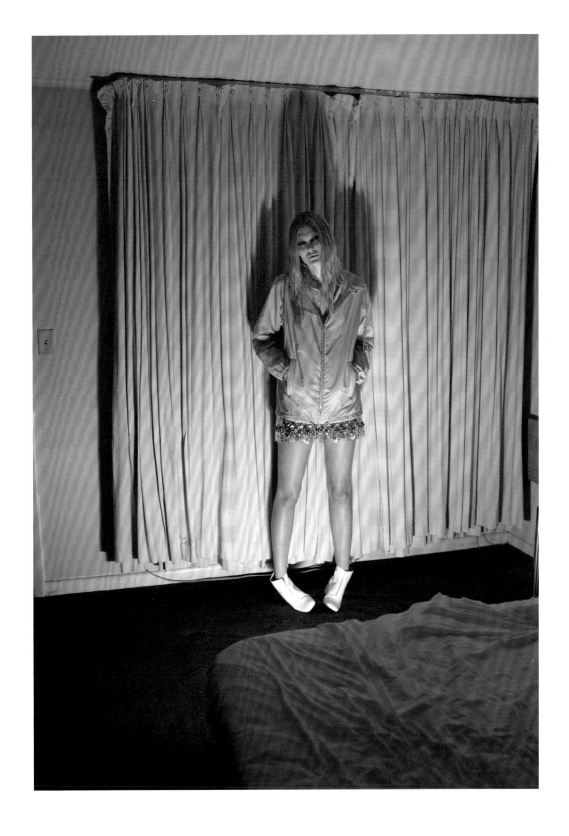

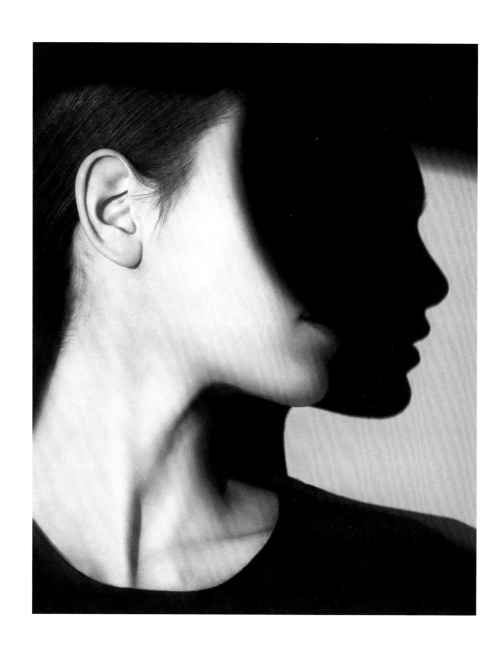

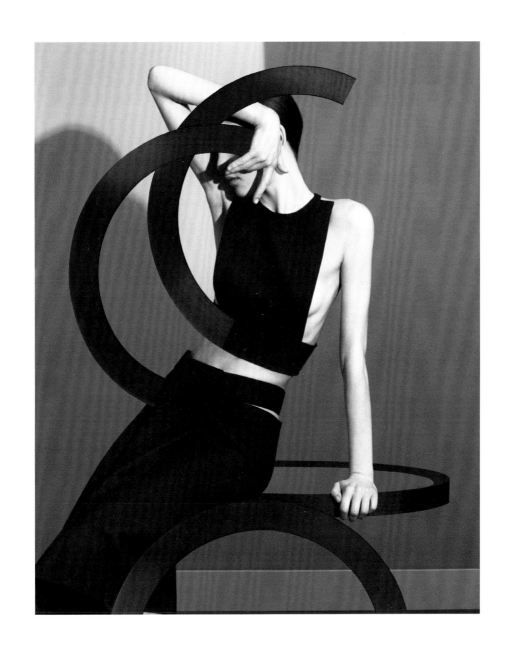

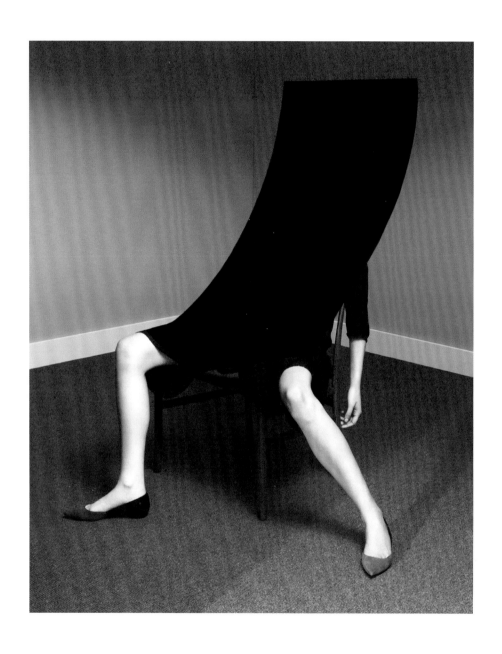

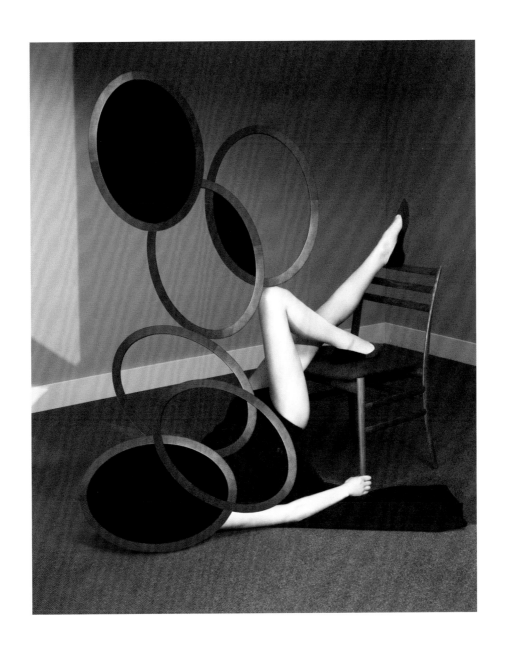

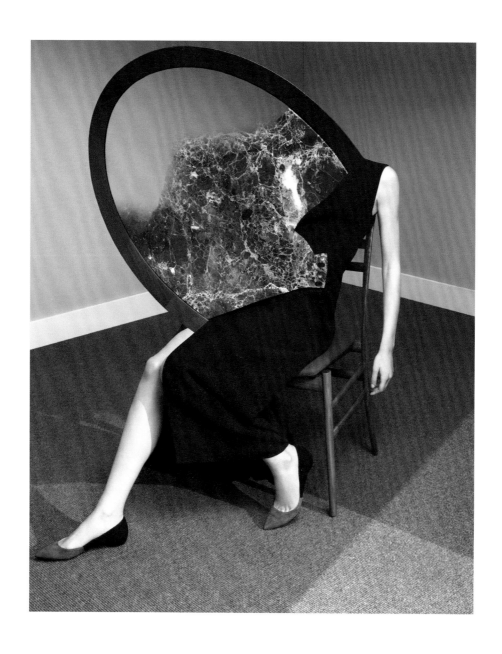

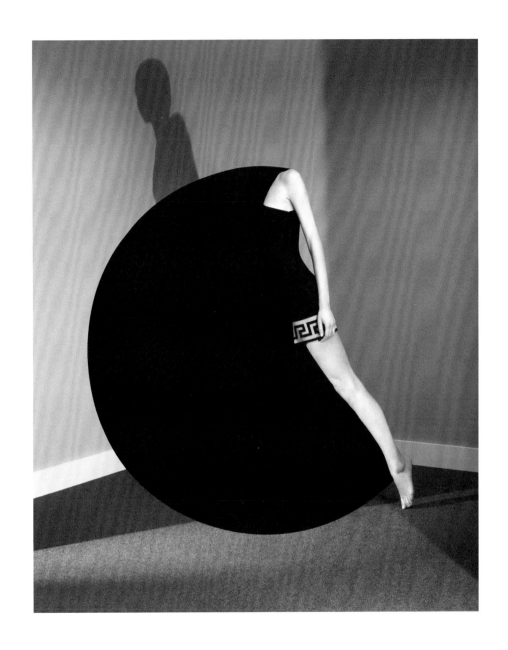

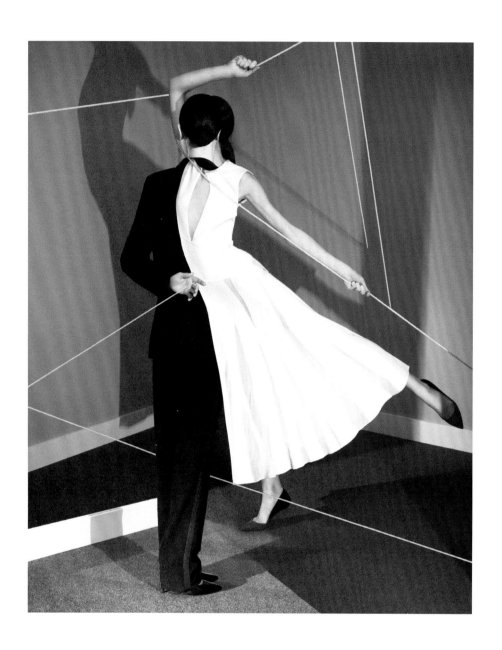

174

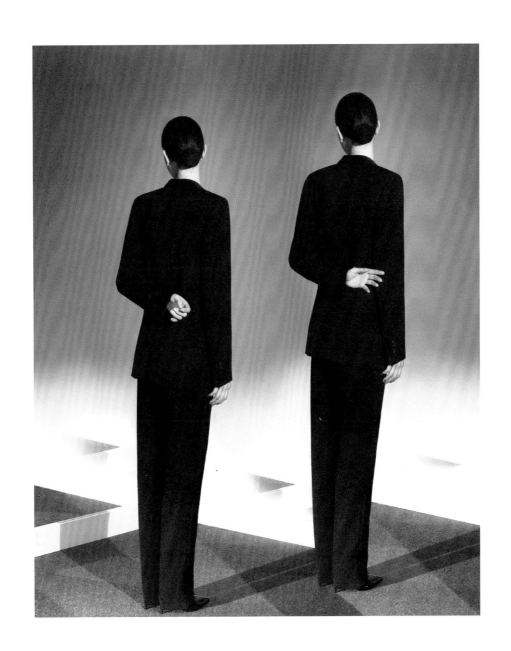

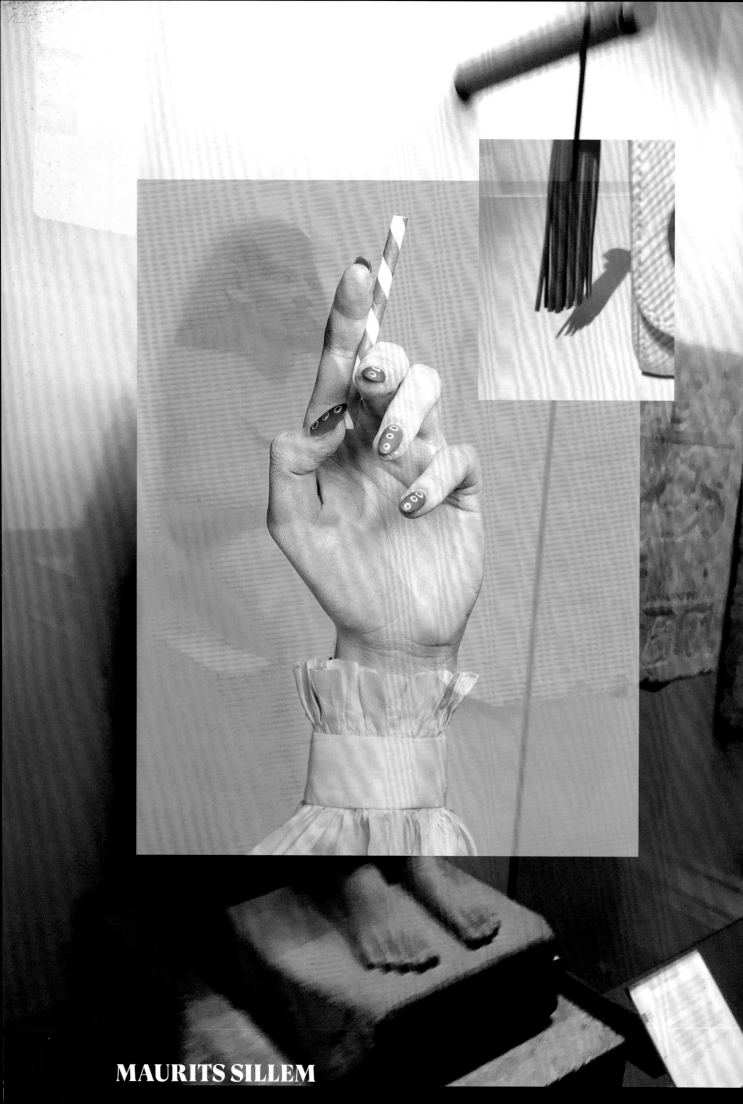

MAURITS SILLEM

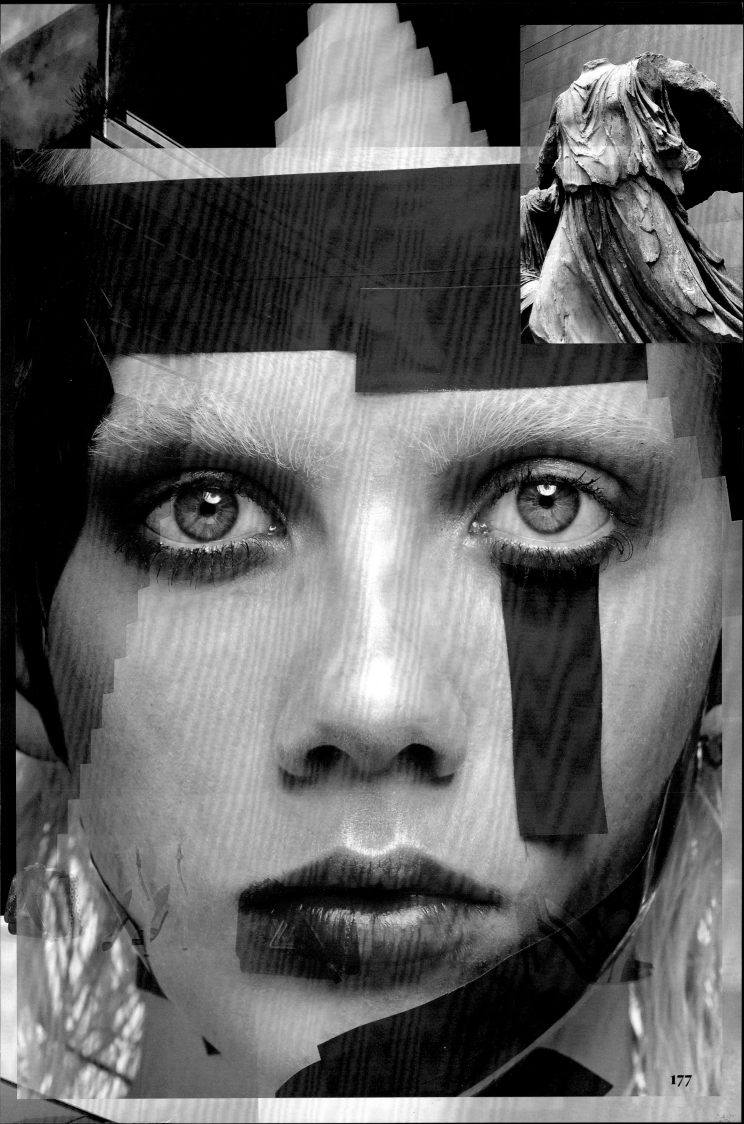

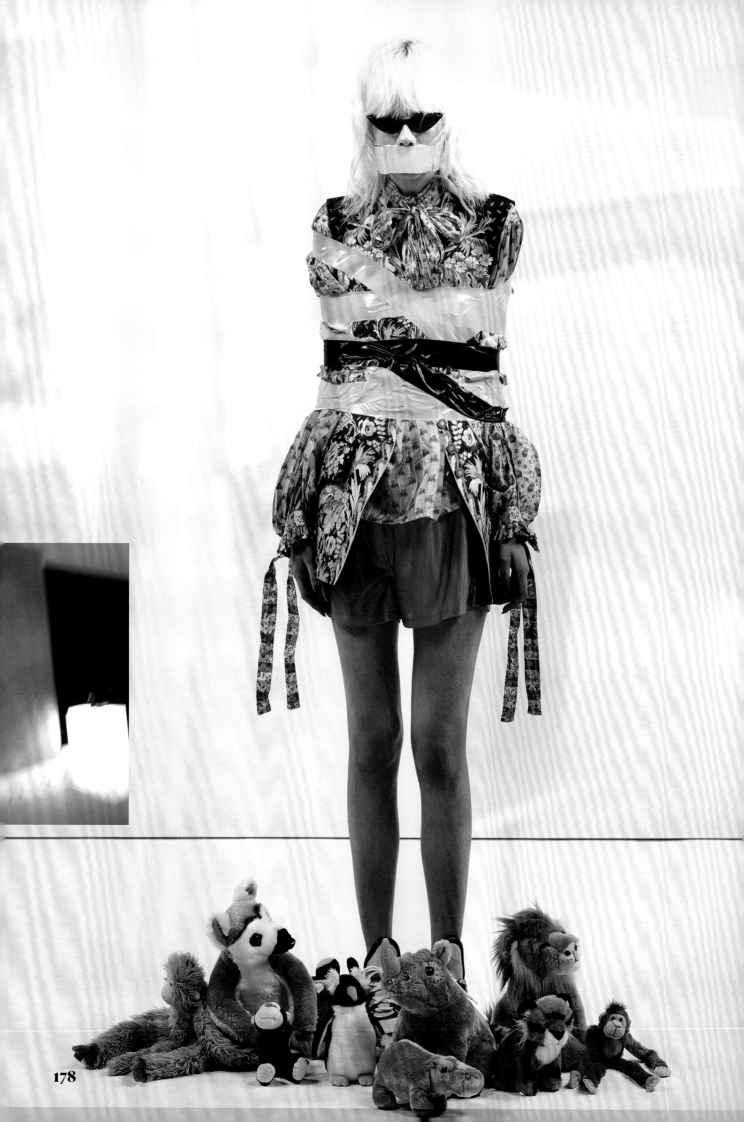

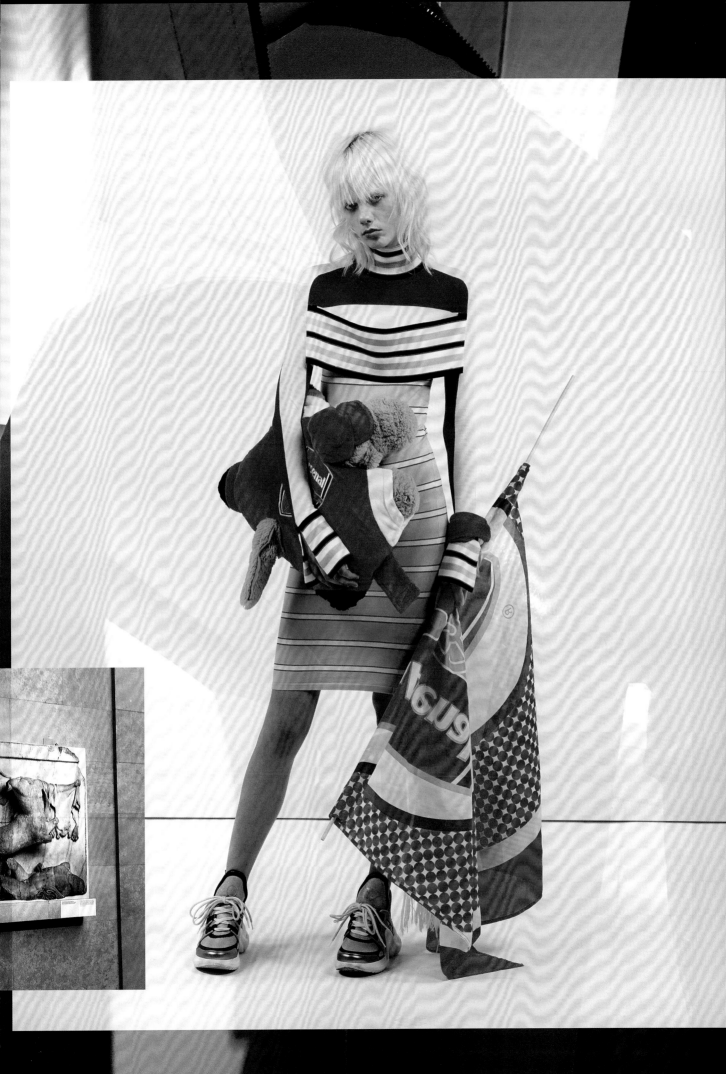

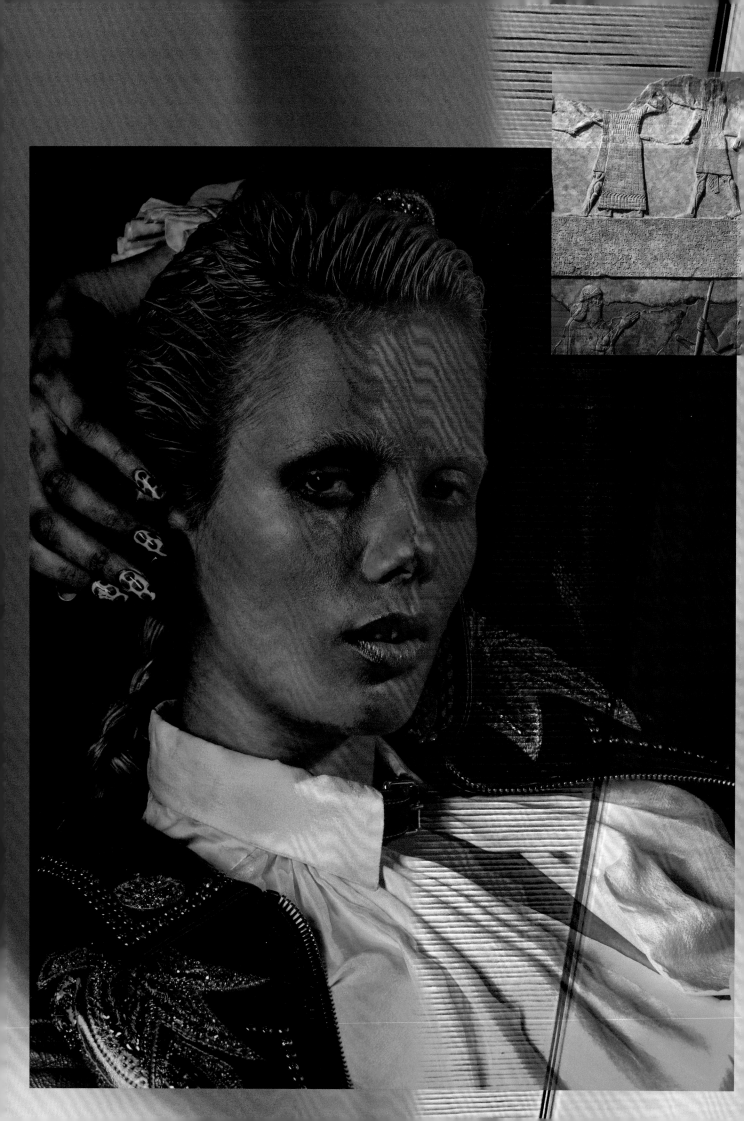

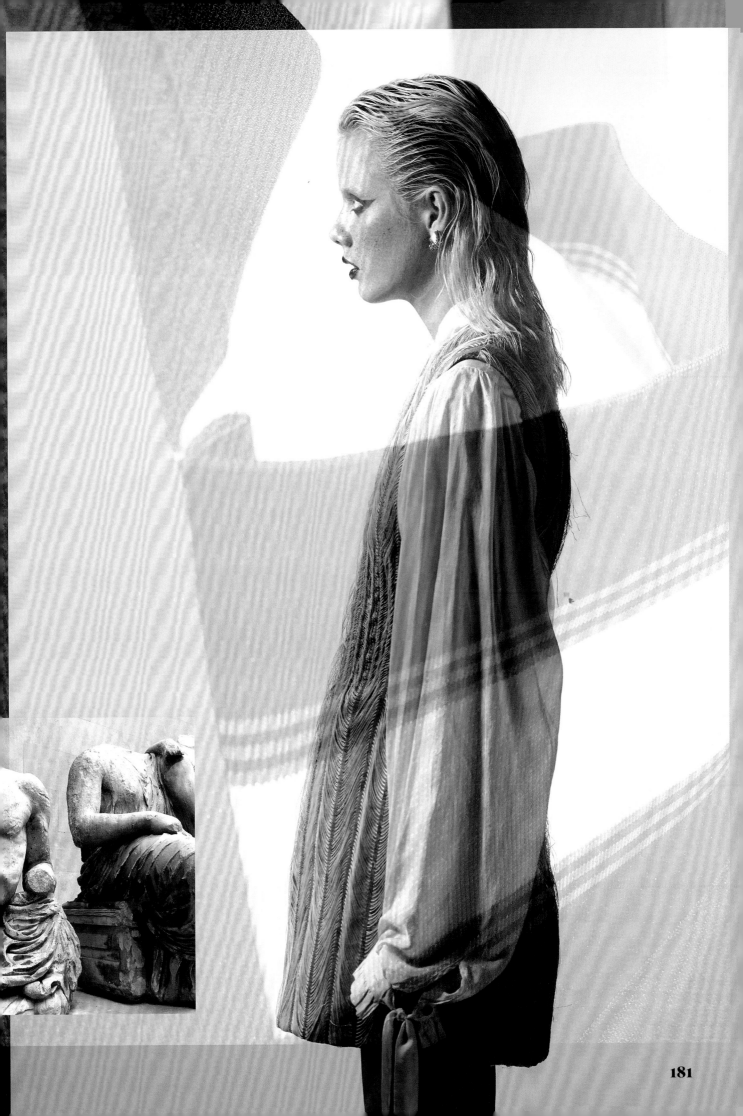

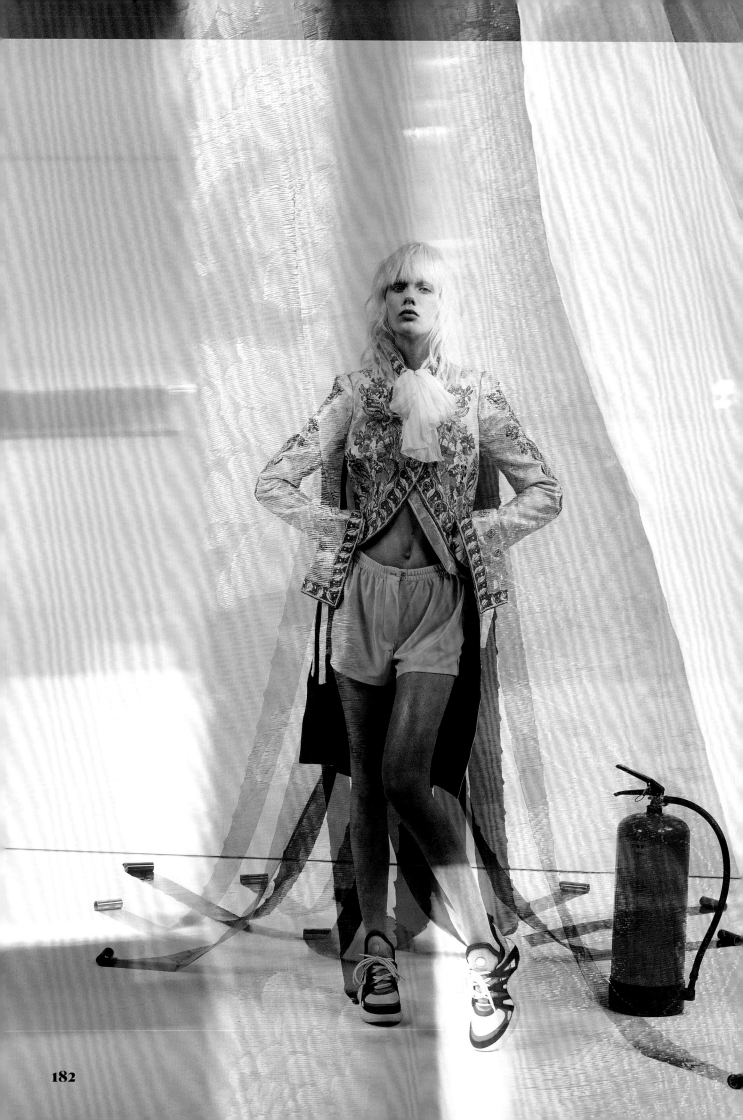

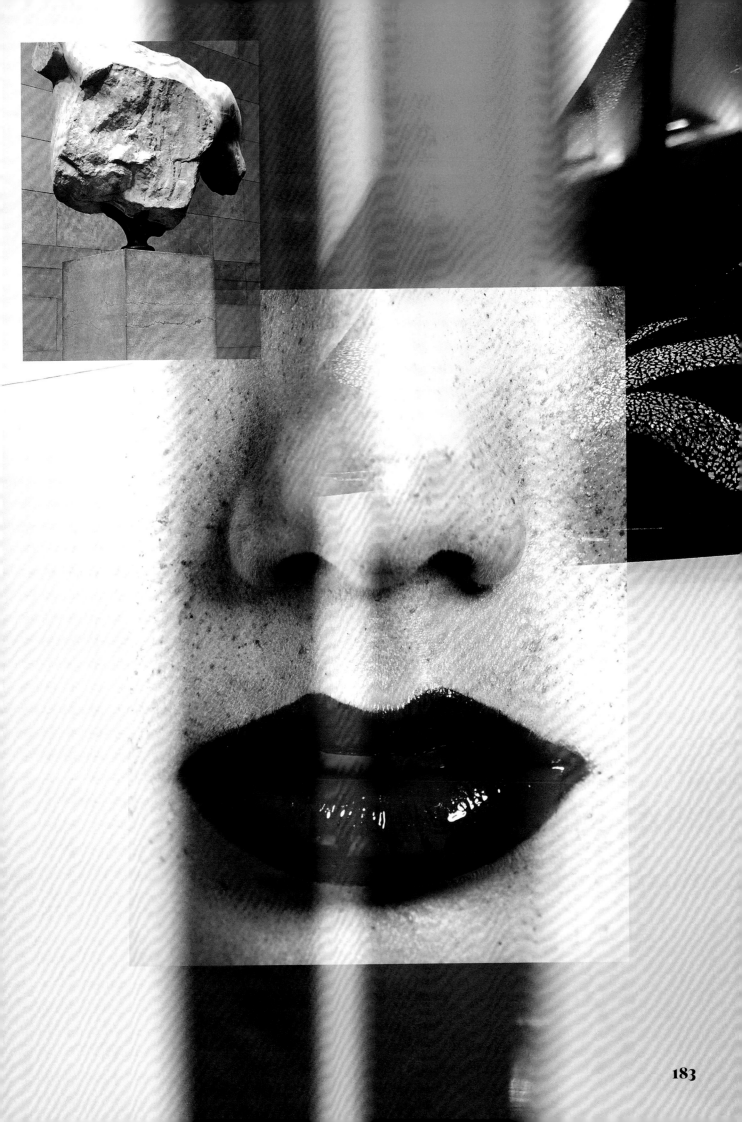

CHARLIE ENGMAN

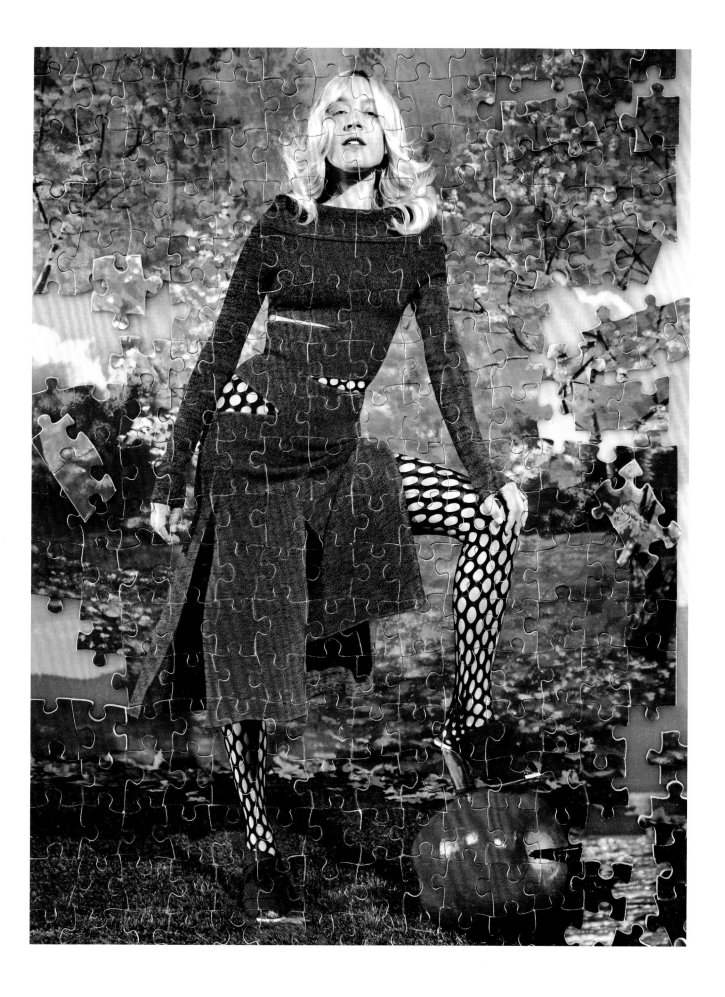

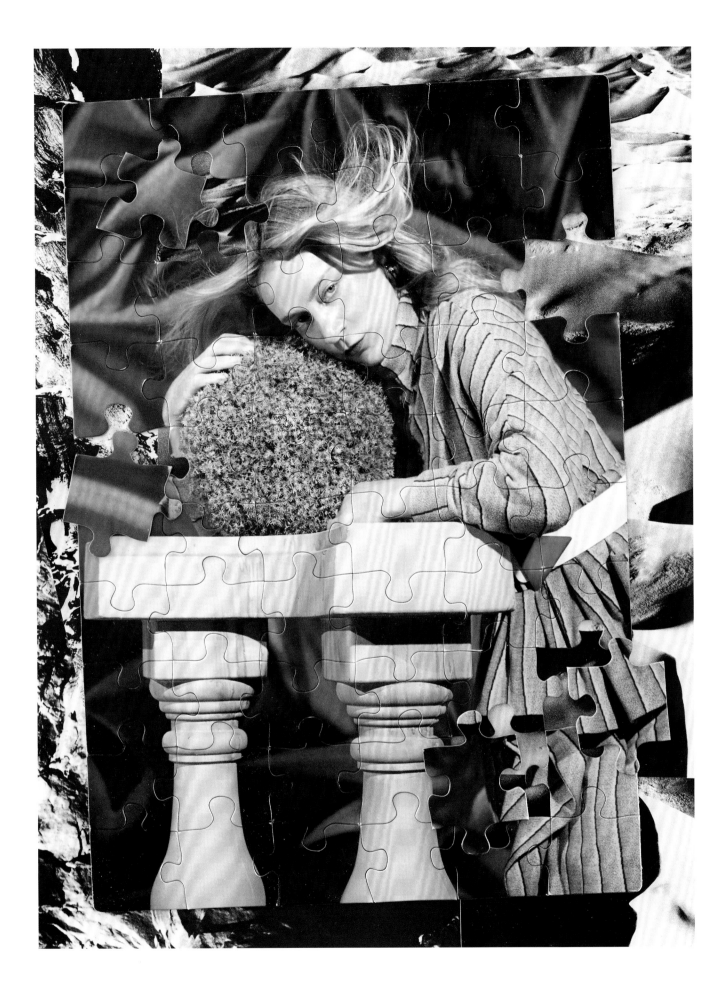

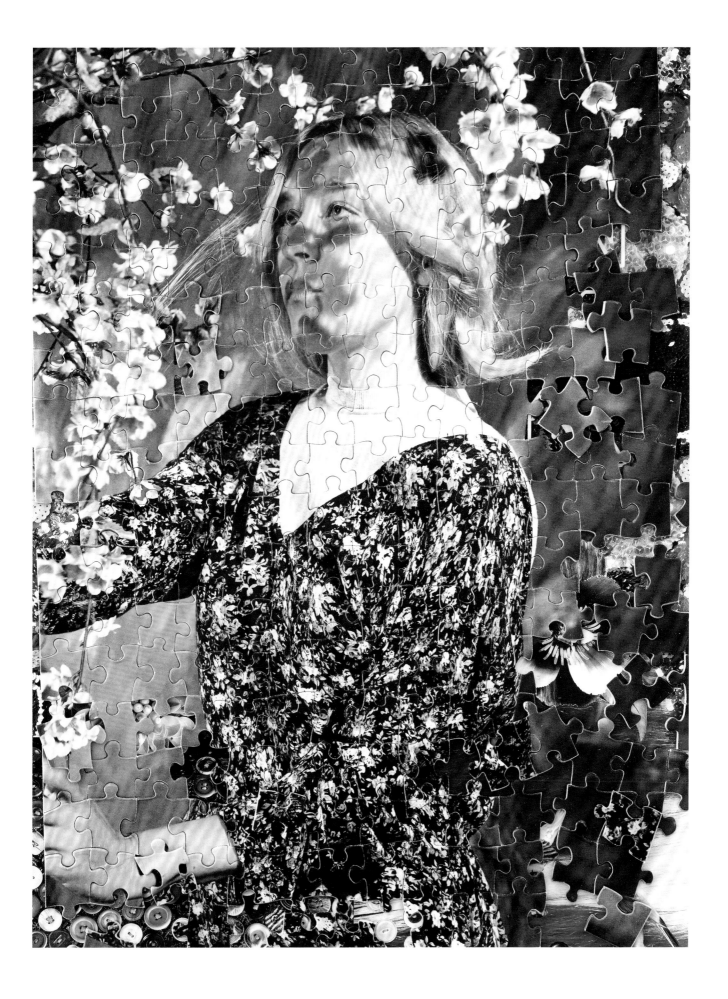

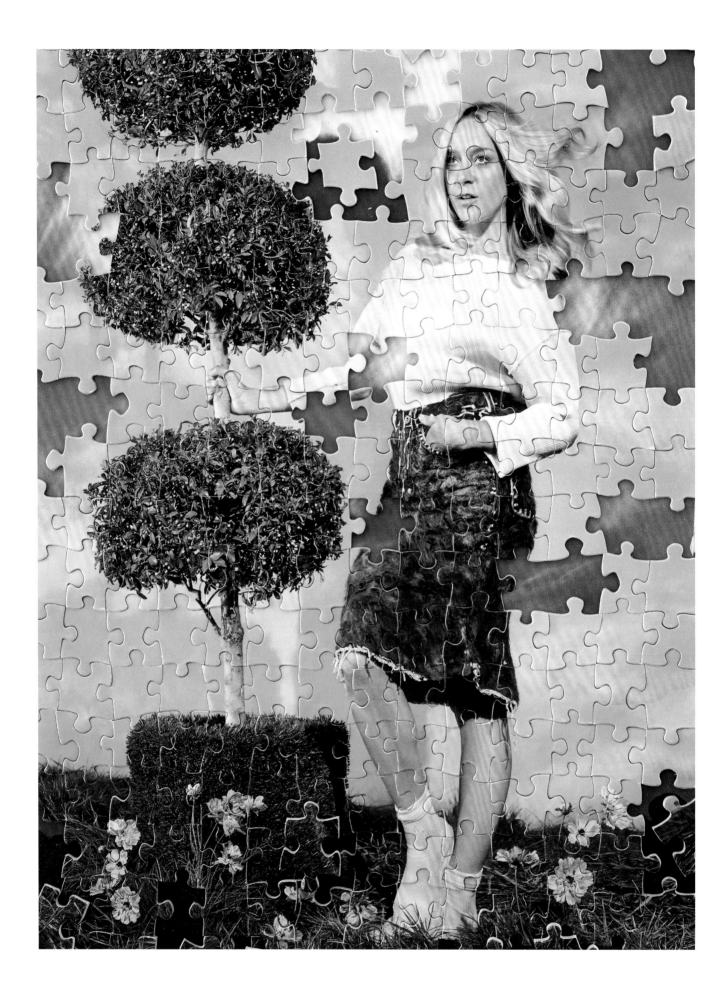

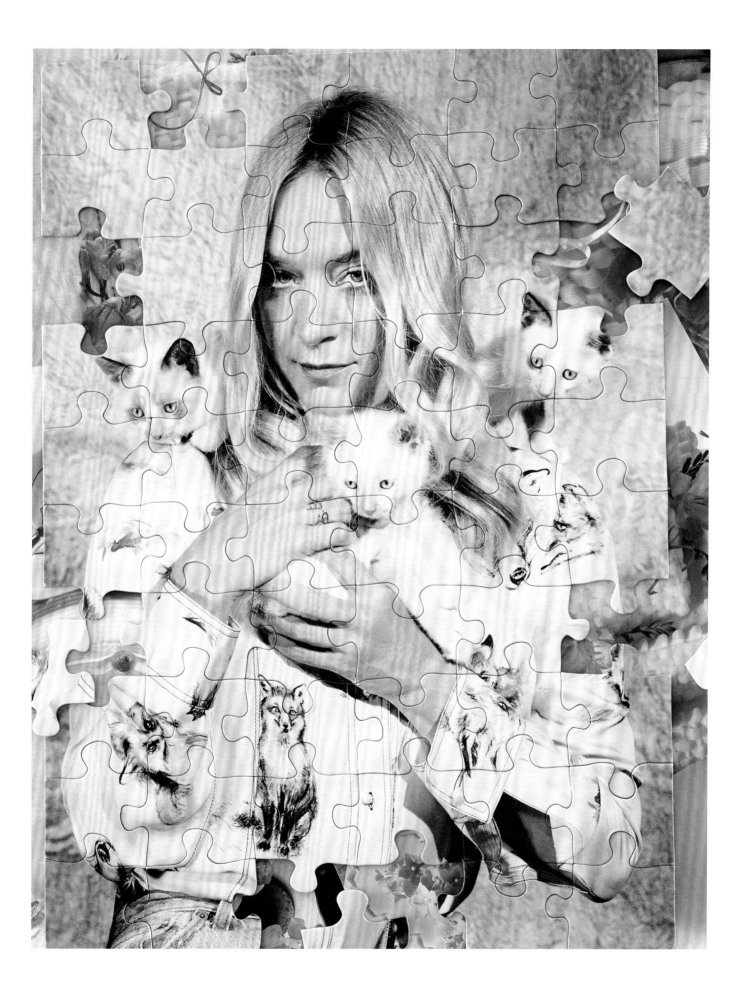

ROBI RODRIGUEZ

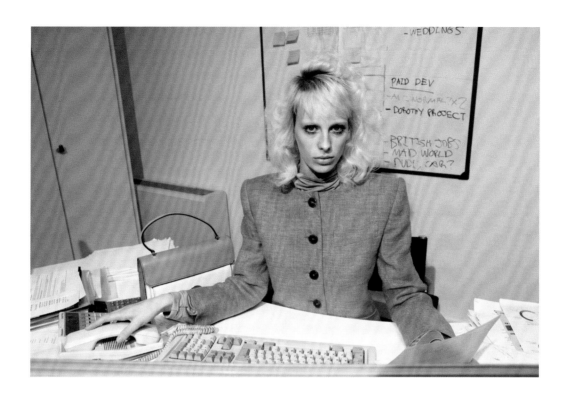

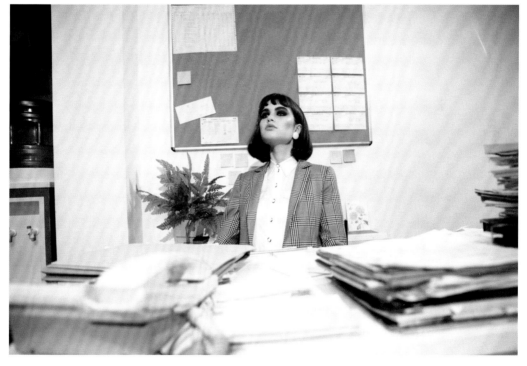

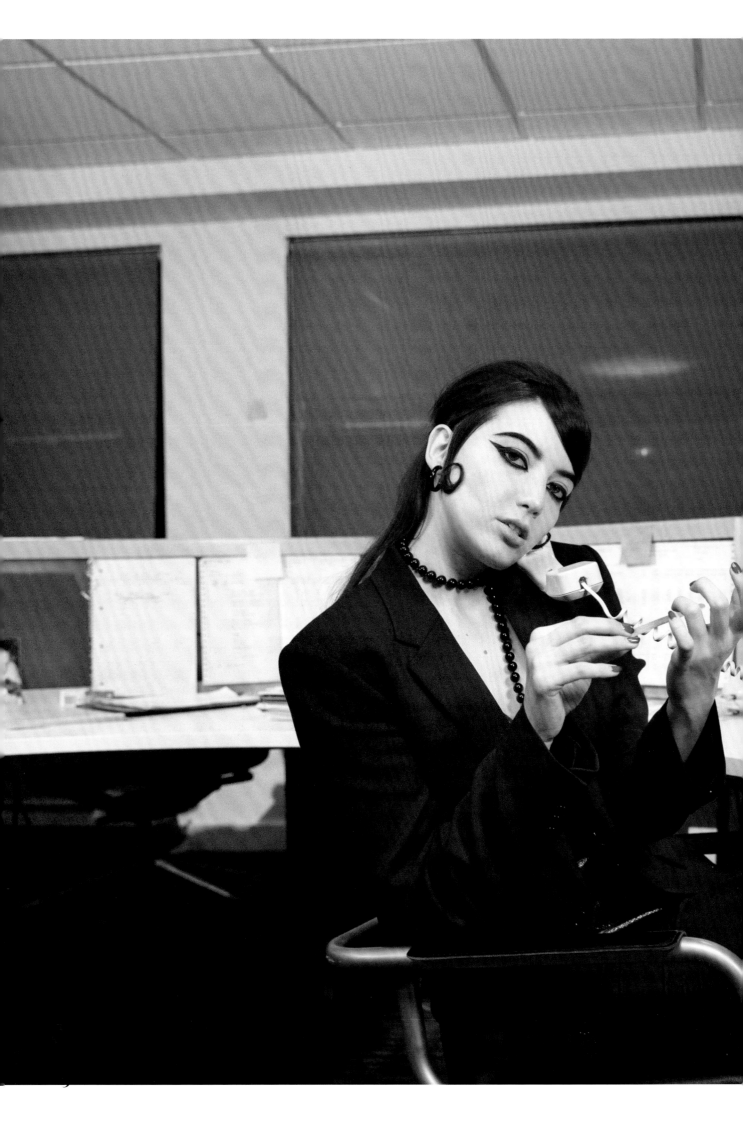

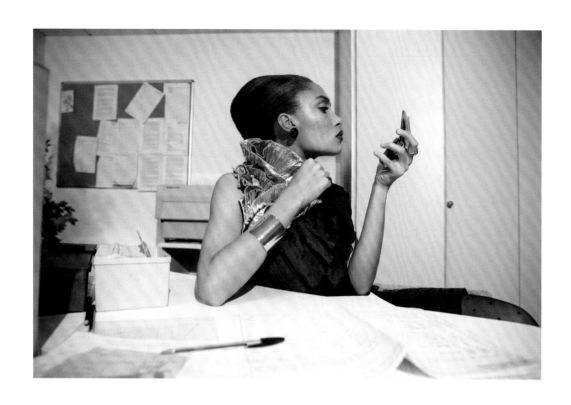

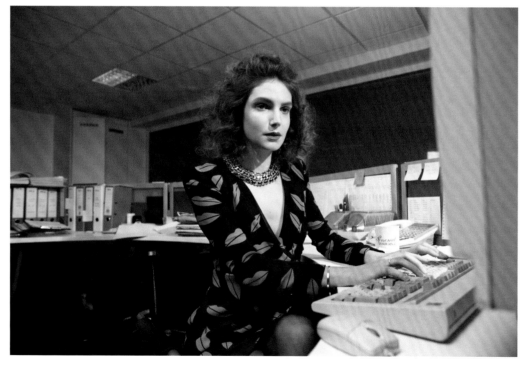

194

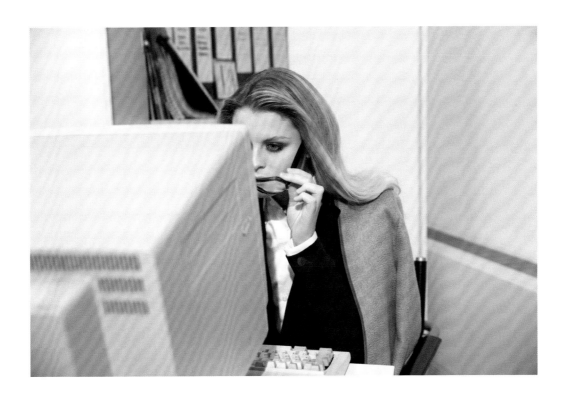

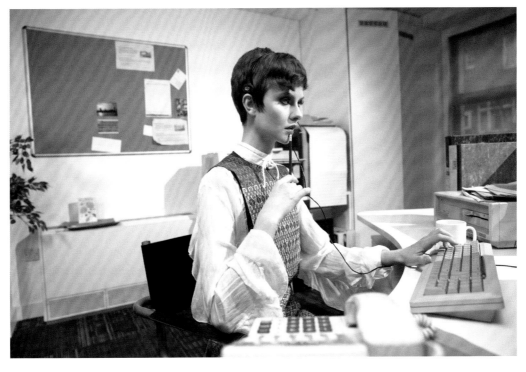

CHARLOTTE WALES

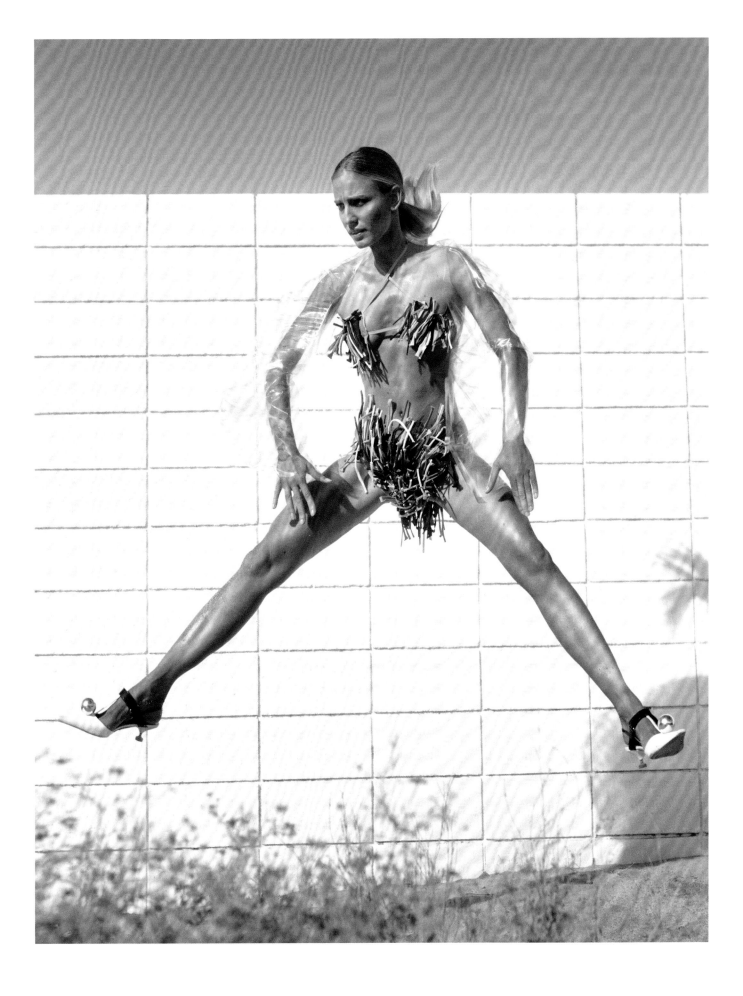

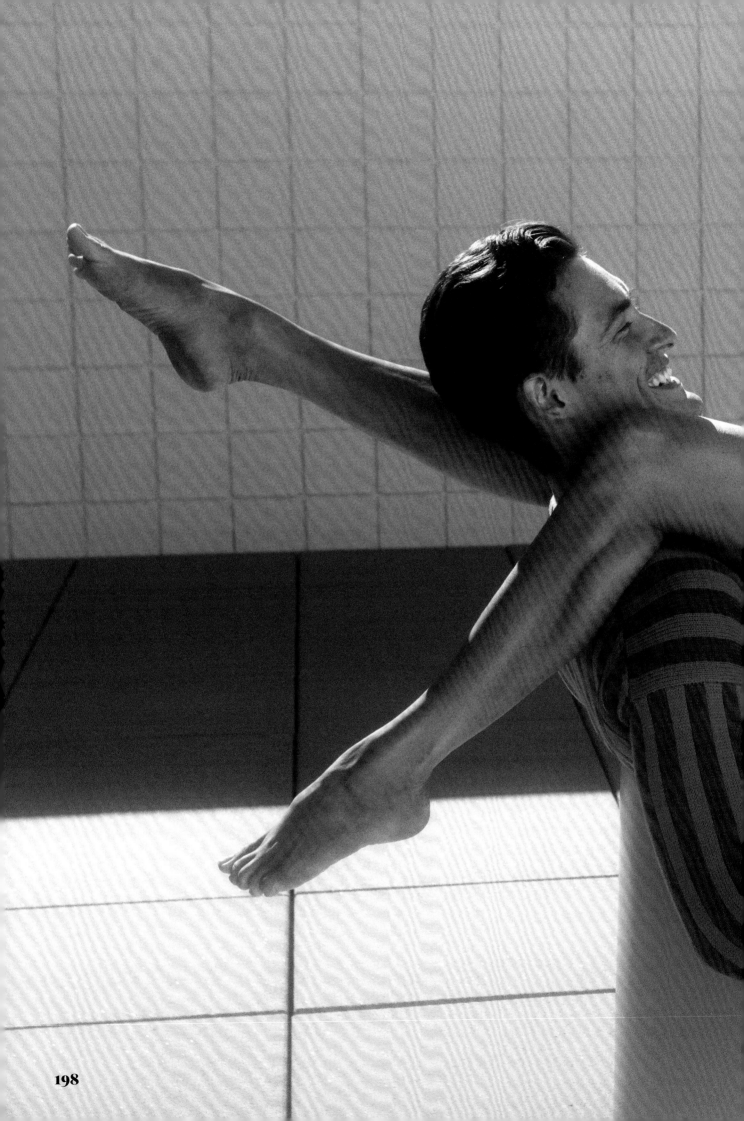

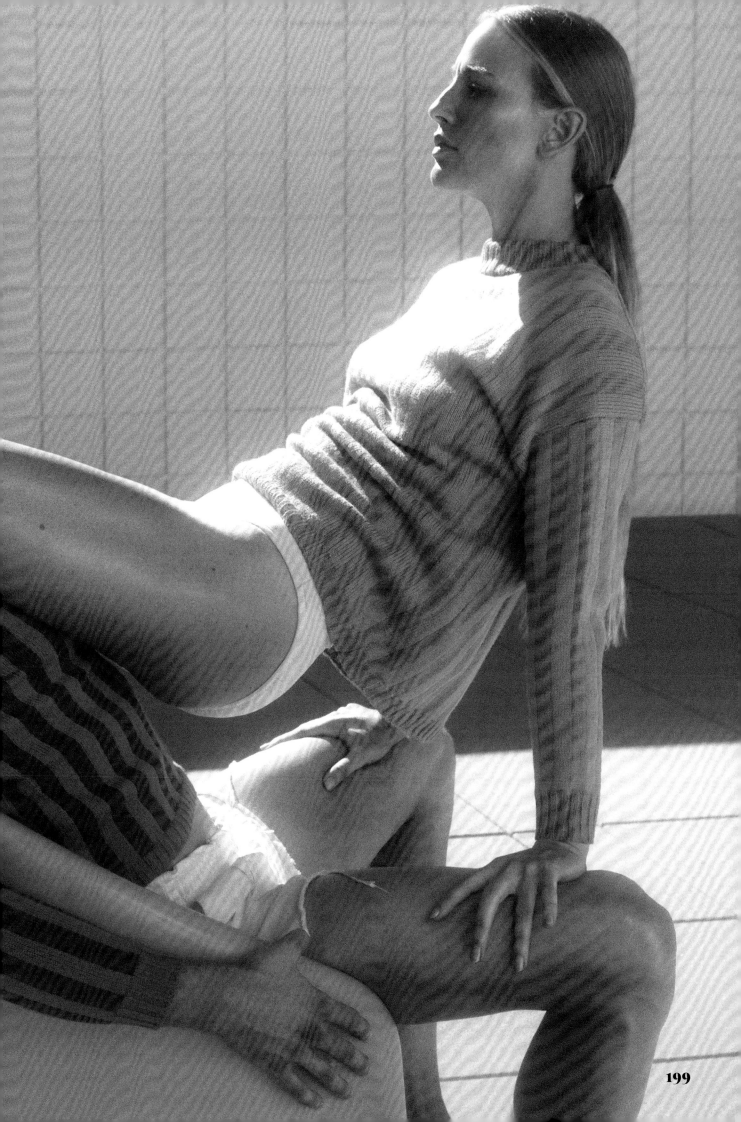

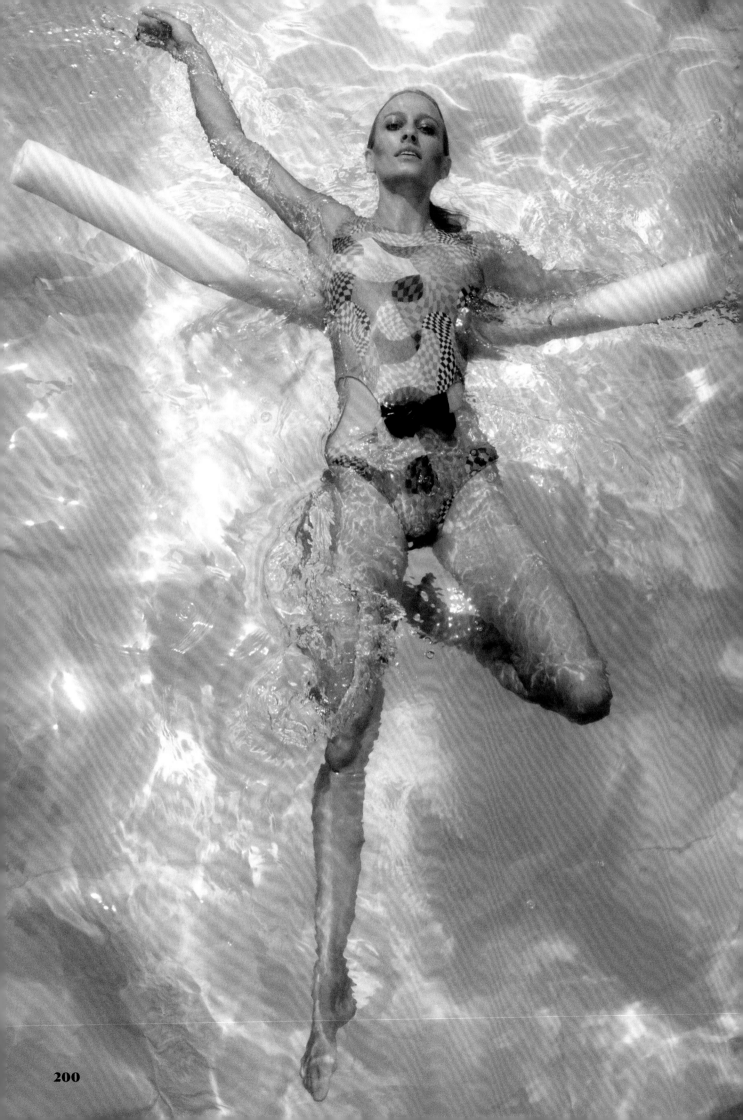

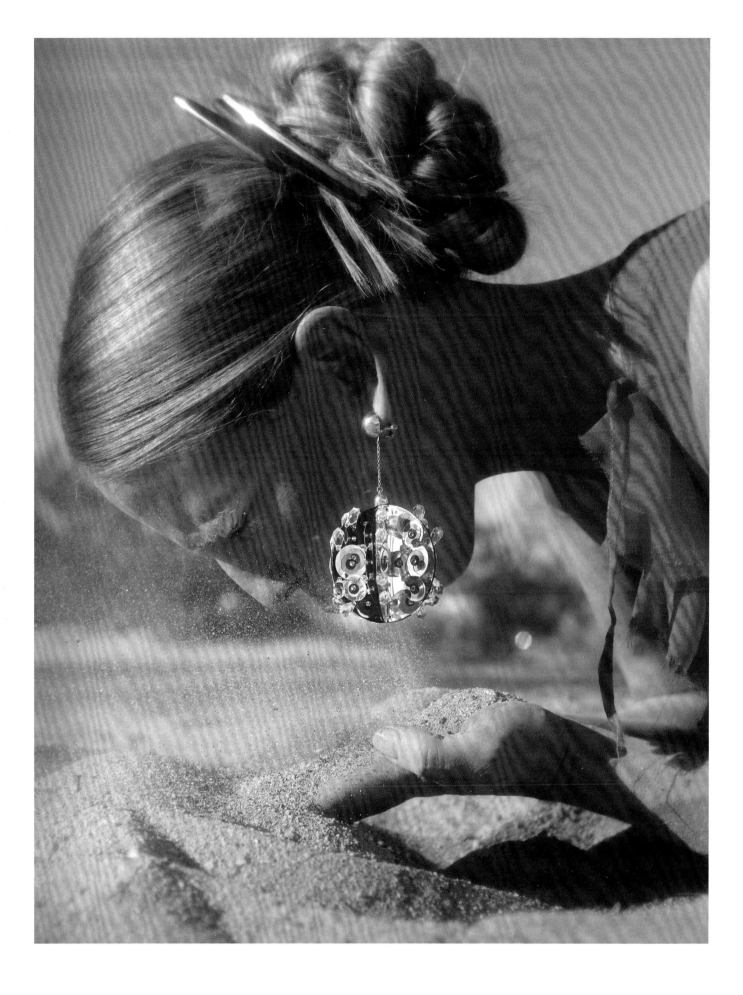

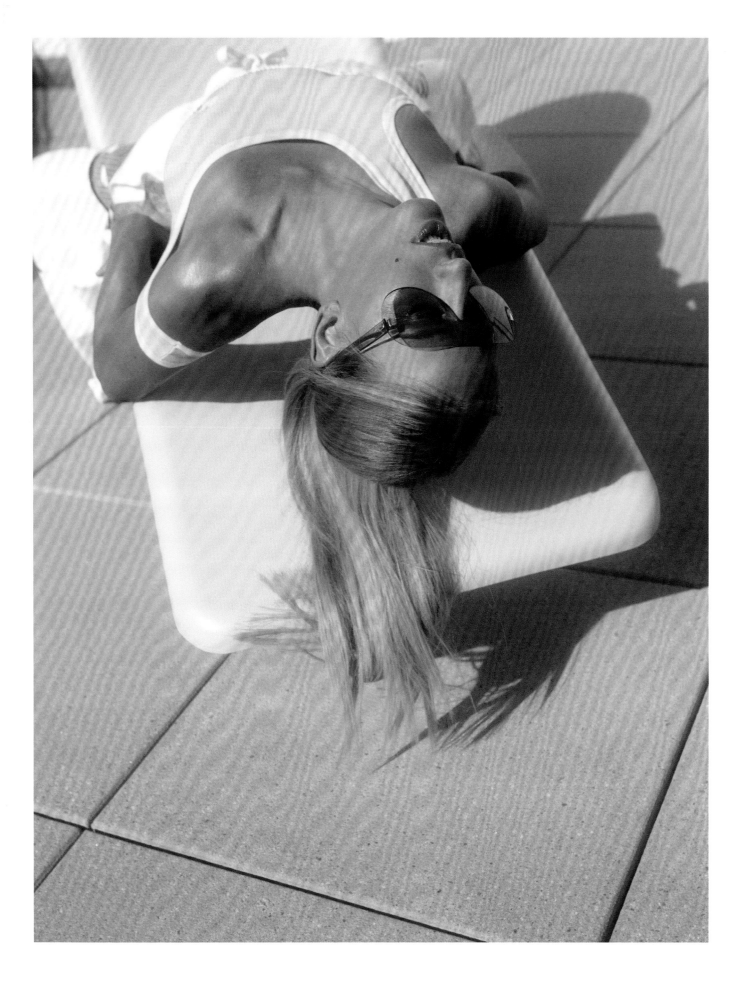

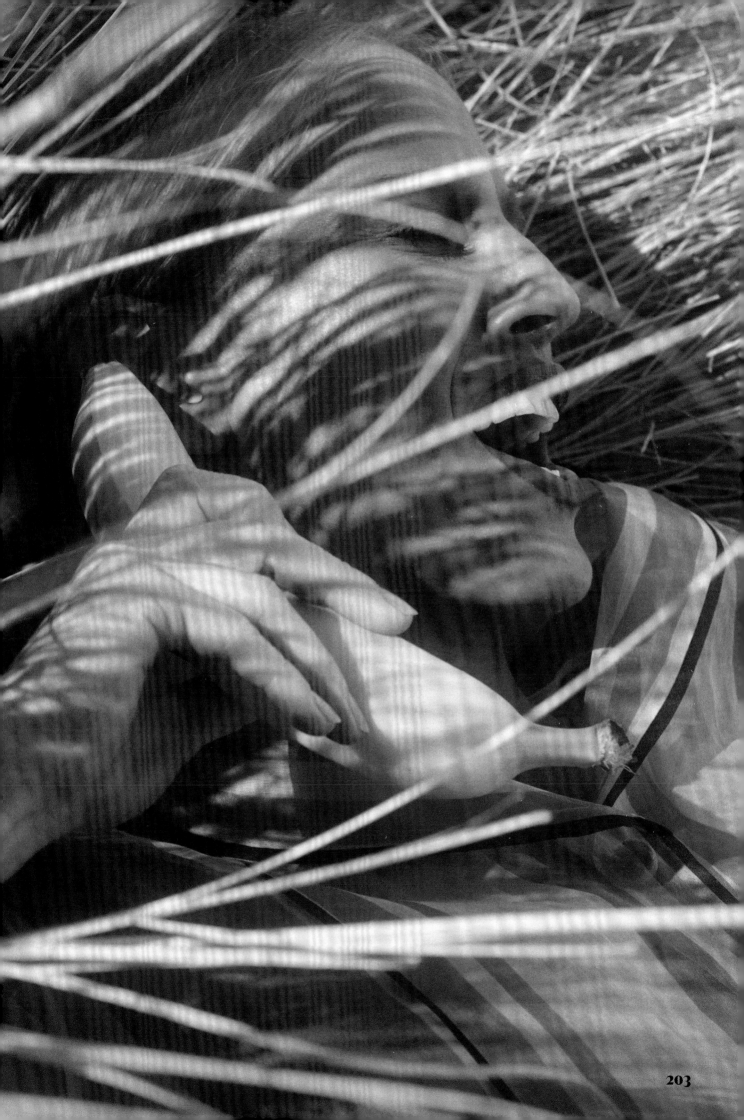

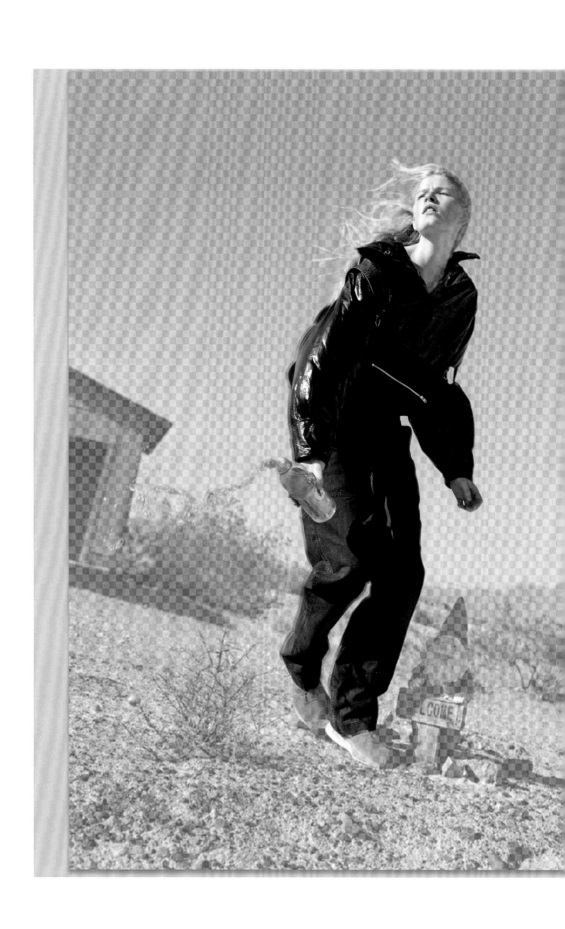

CHARLIE ENGMAN

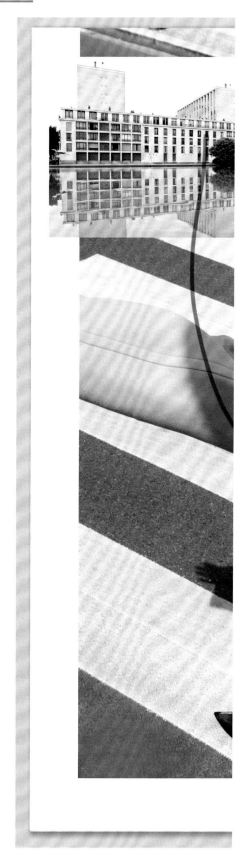

LAYERS CHANNELS

Normal

Lock:

Background
Background
Background
Background

Screen Shot 201

Doc 19

66.67

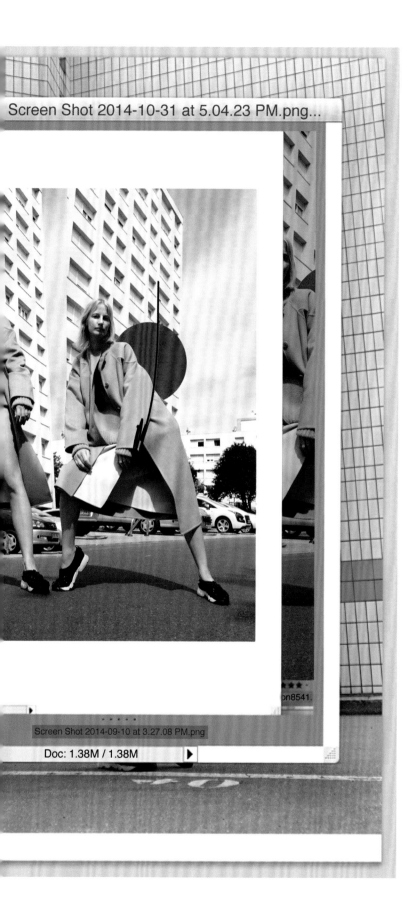

on8541.

Screen Shot 2014-09-10 at 3.27.08 PM.png

Doc: 1.38M / 1.38M

12.5% Doc: 72.0M / 72.0M

50%

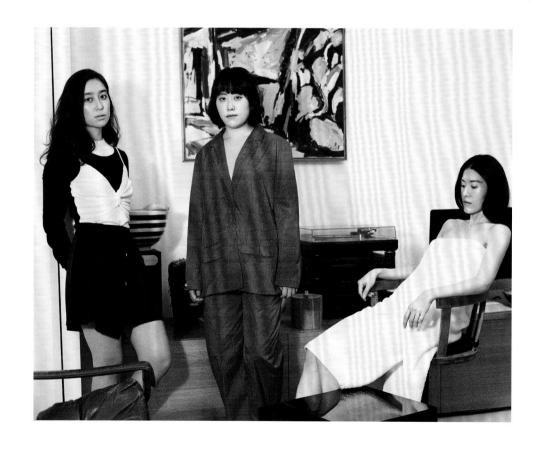

LENA C EMERY

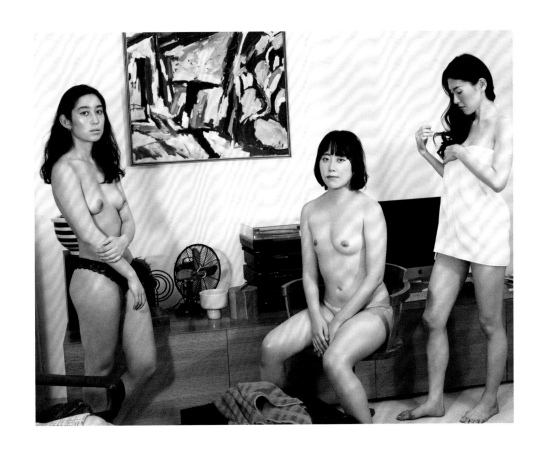

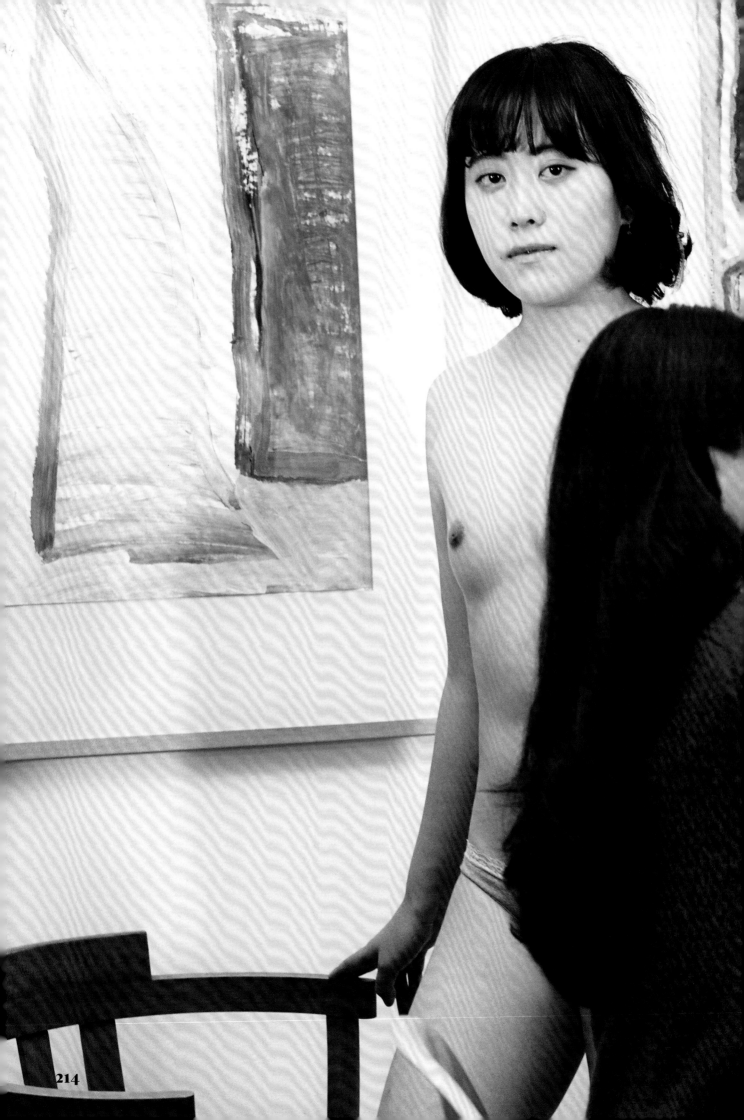

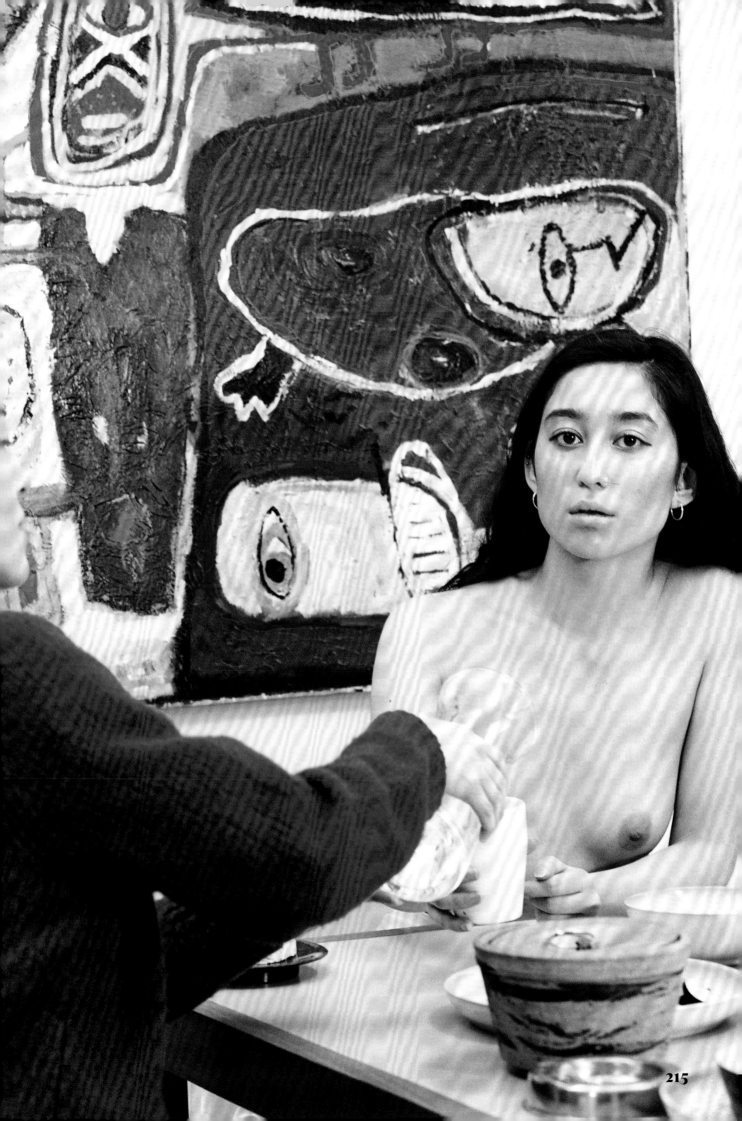

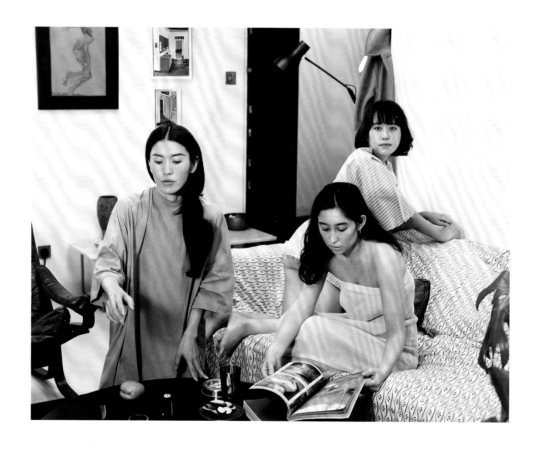

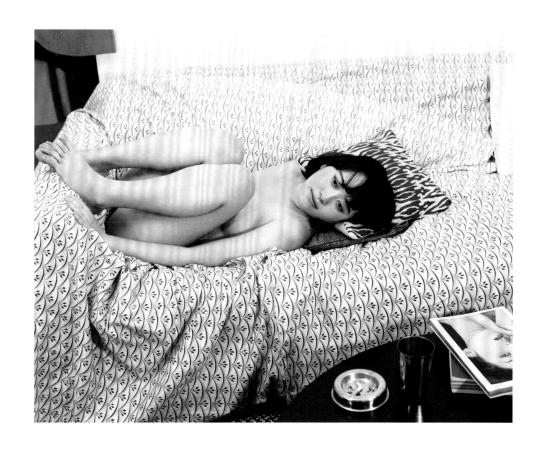

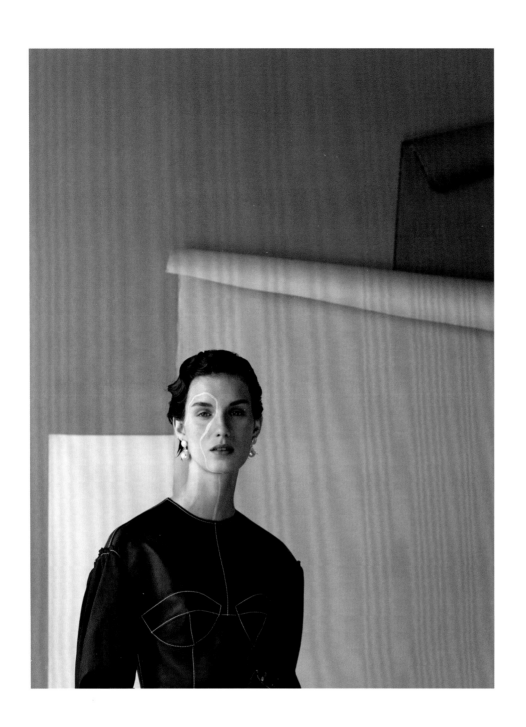

JULIA HETTA

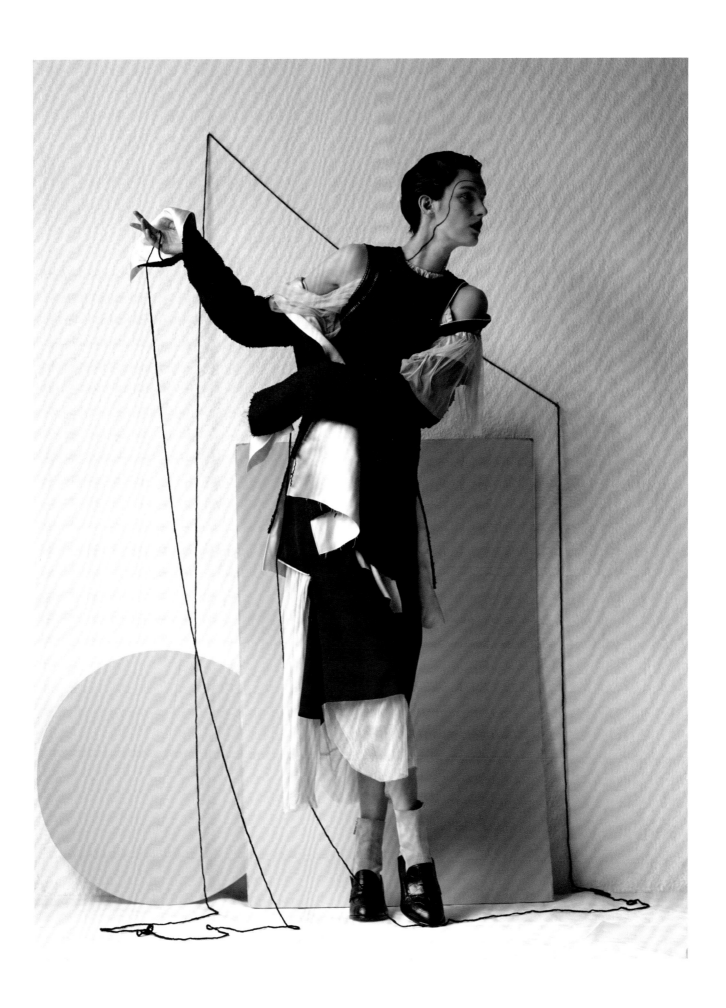

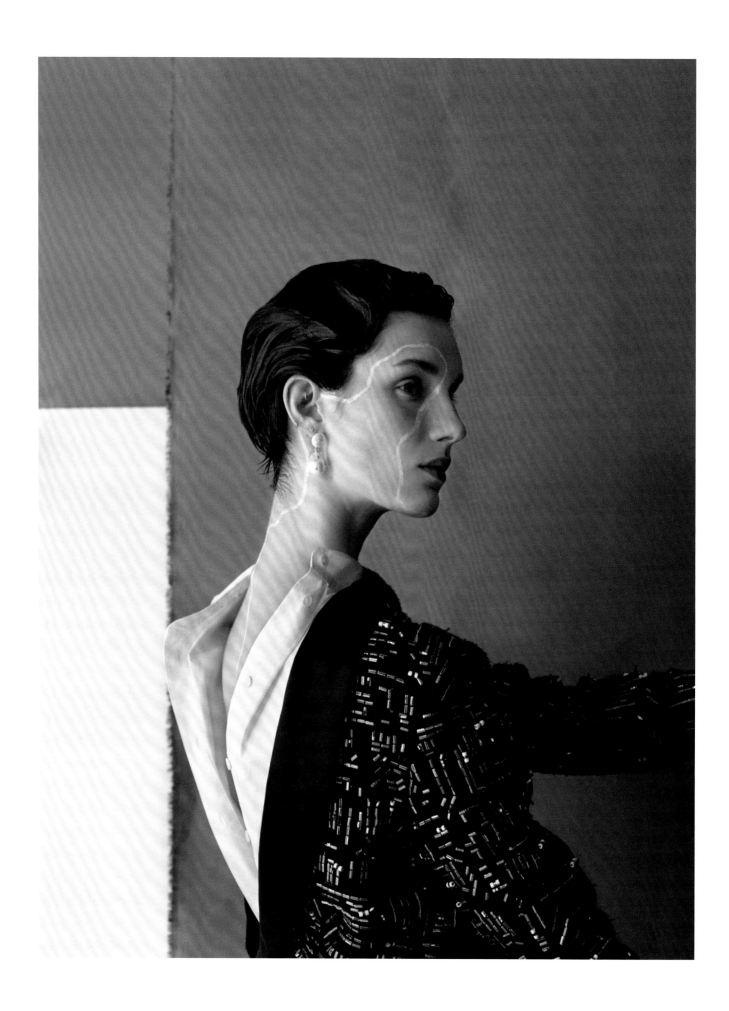

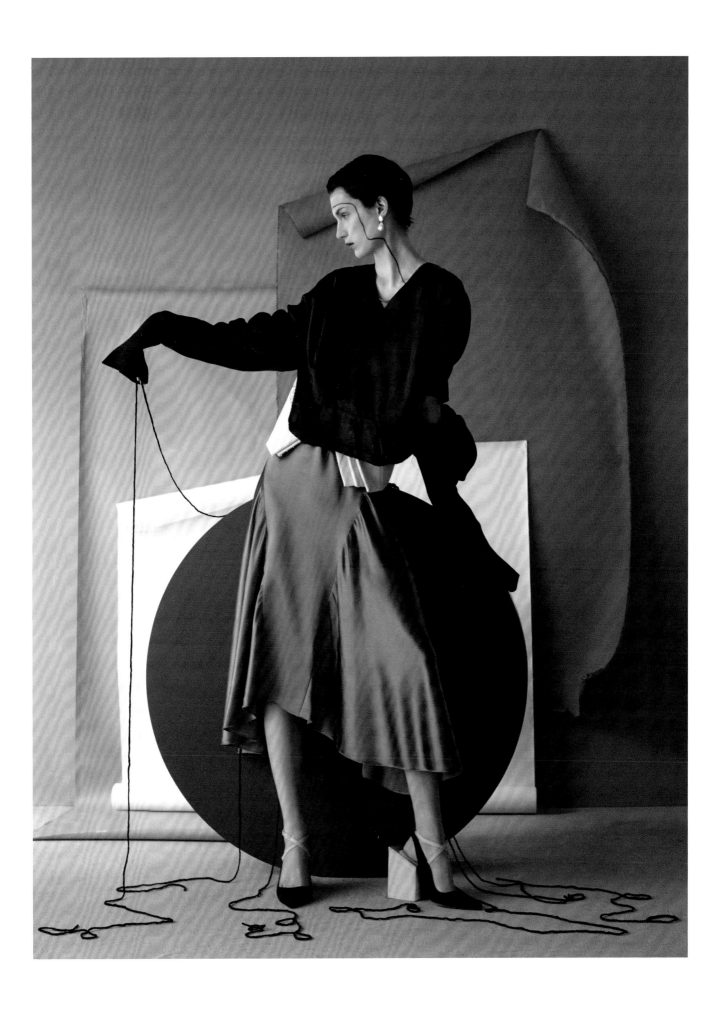

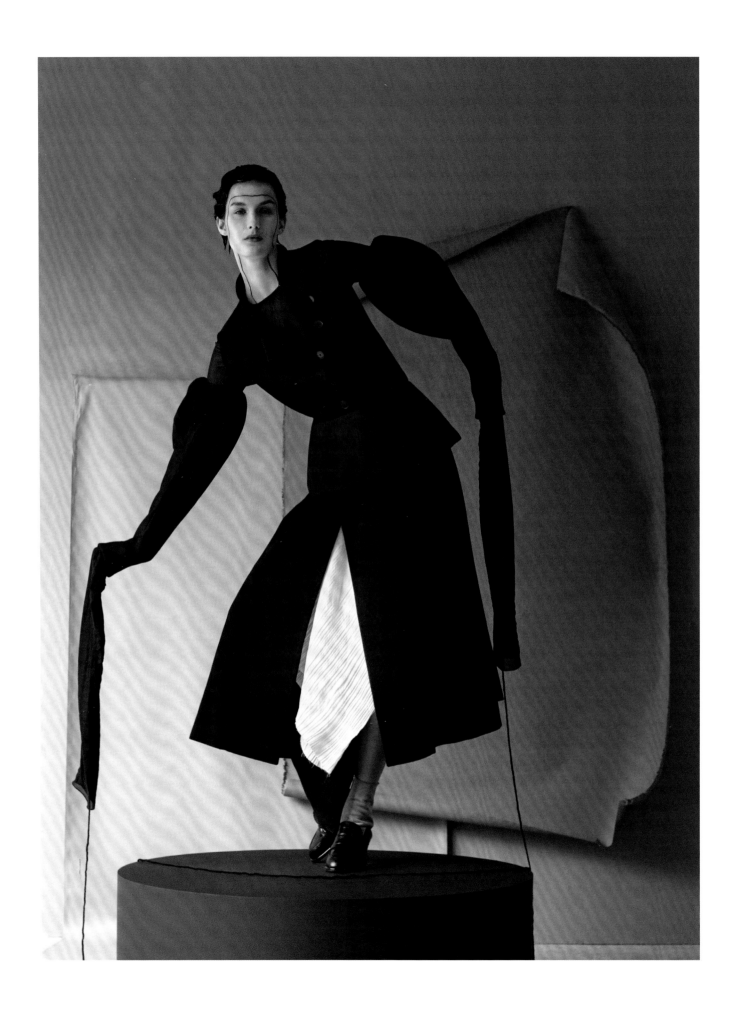

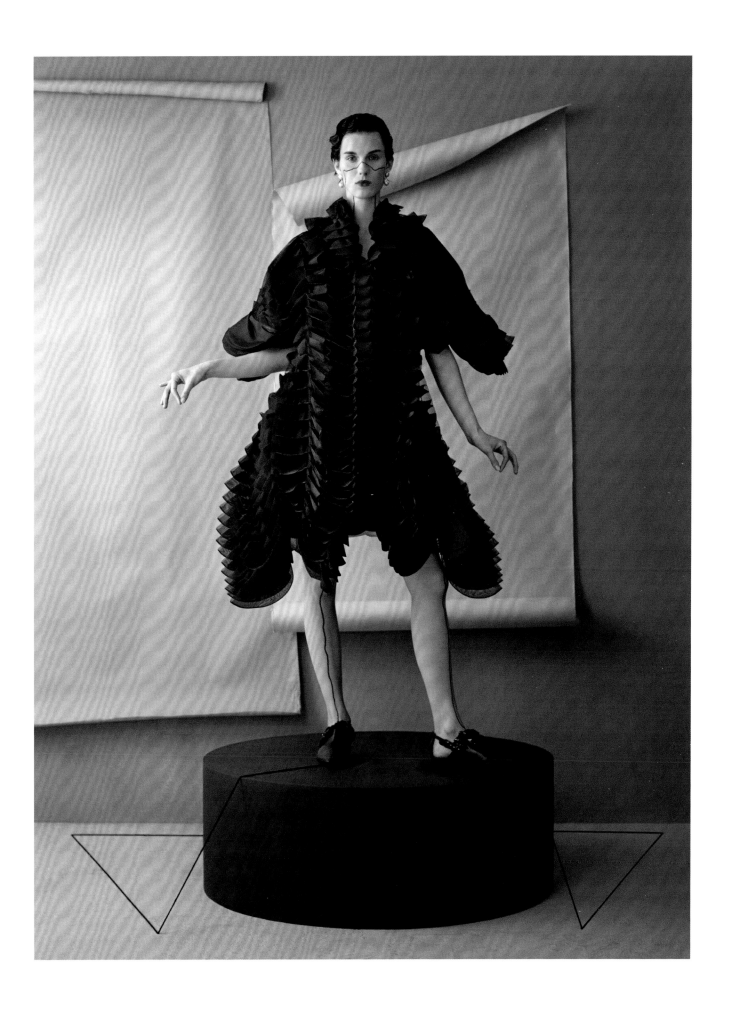

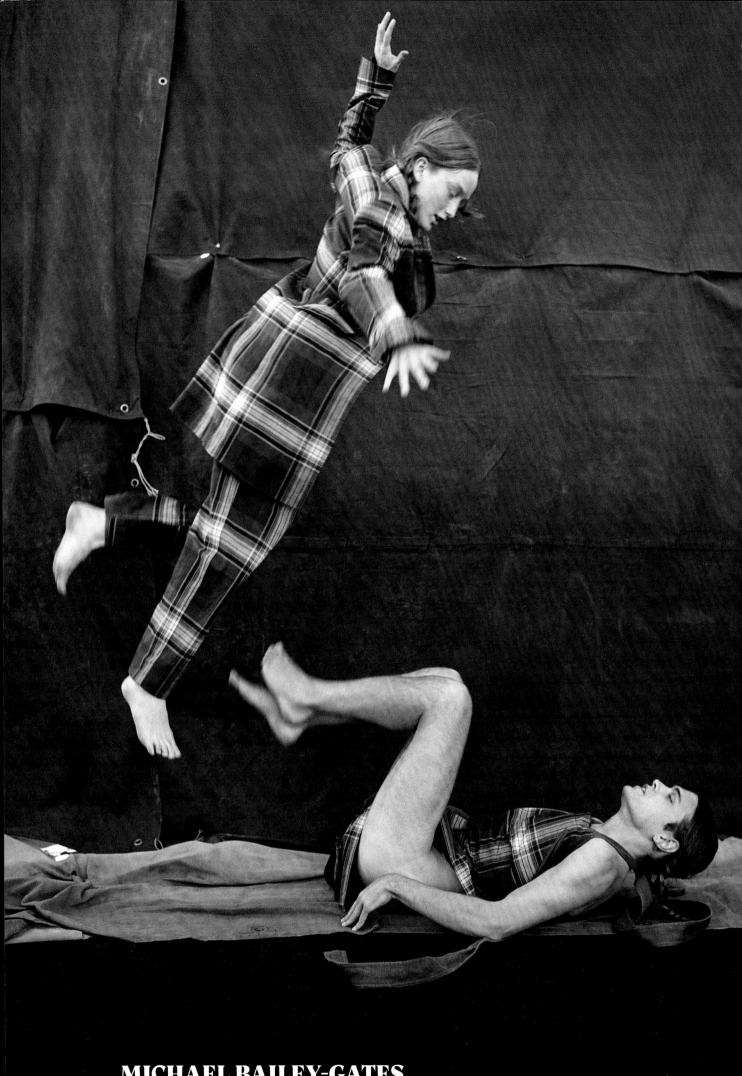

MICHAEL BAILEY-GATES

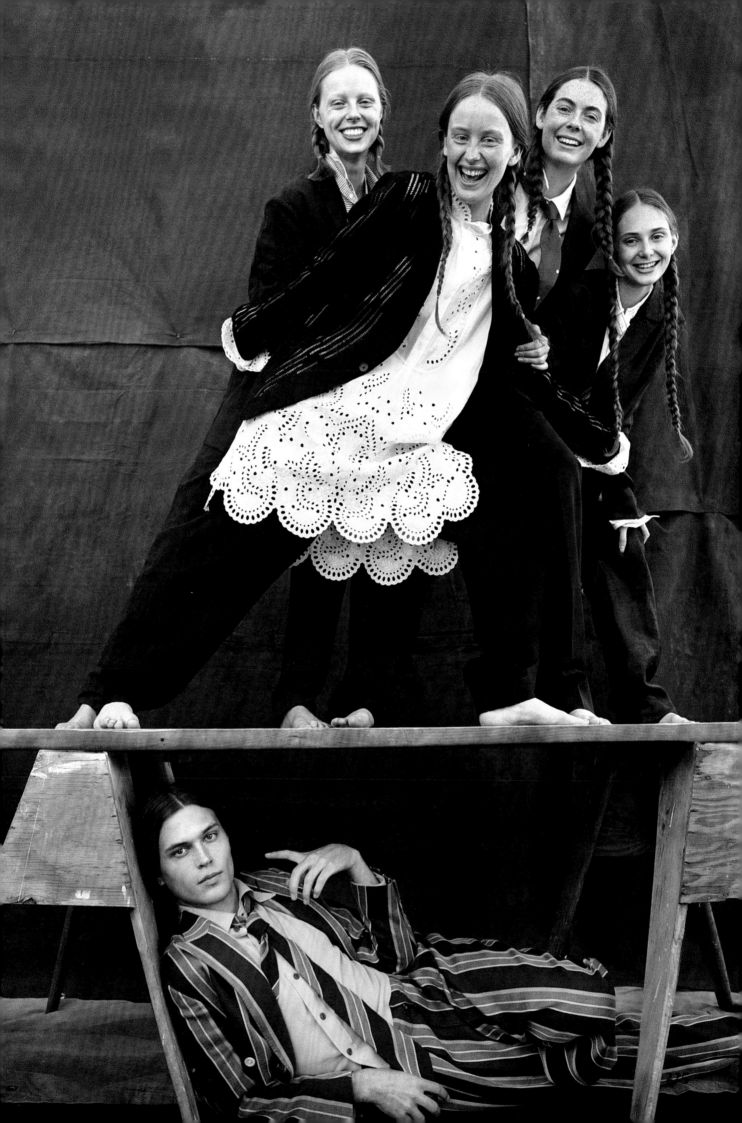

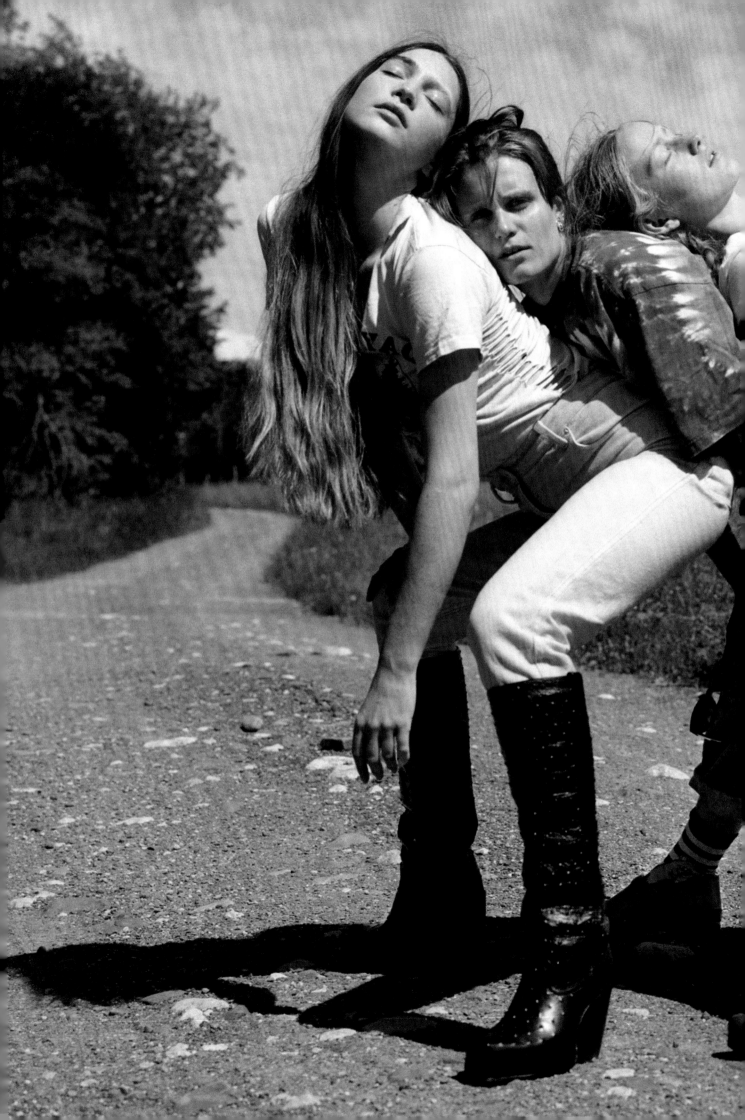

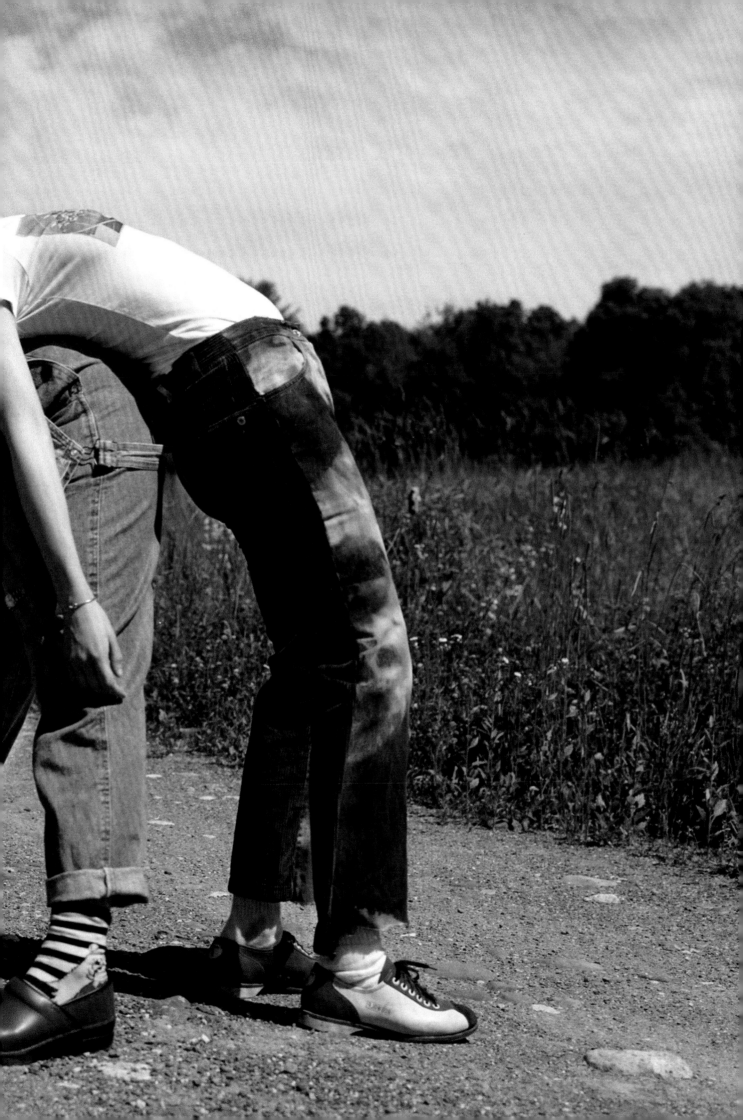

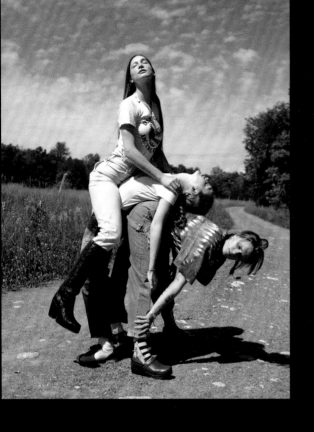
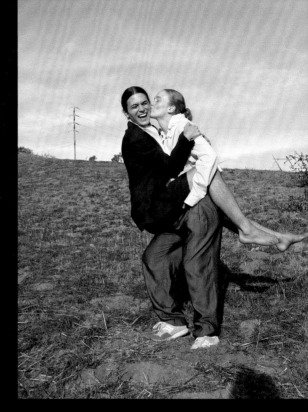
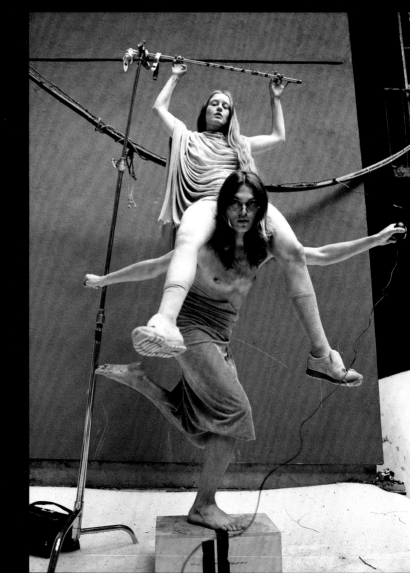

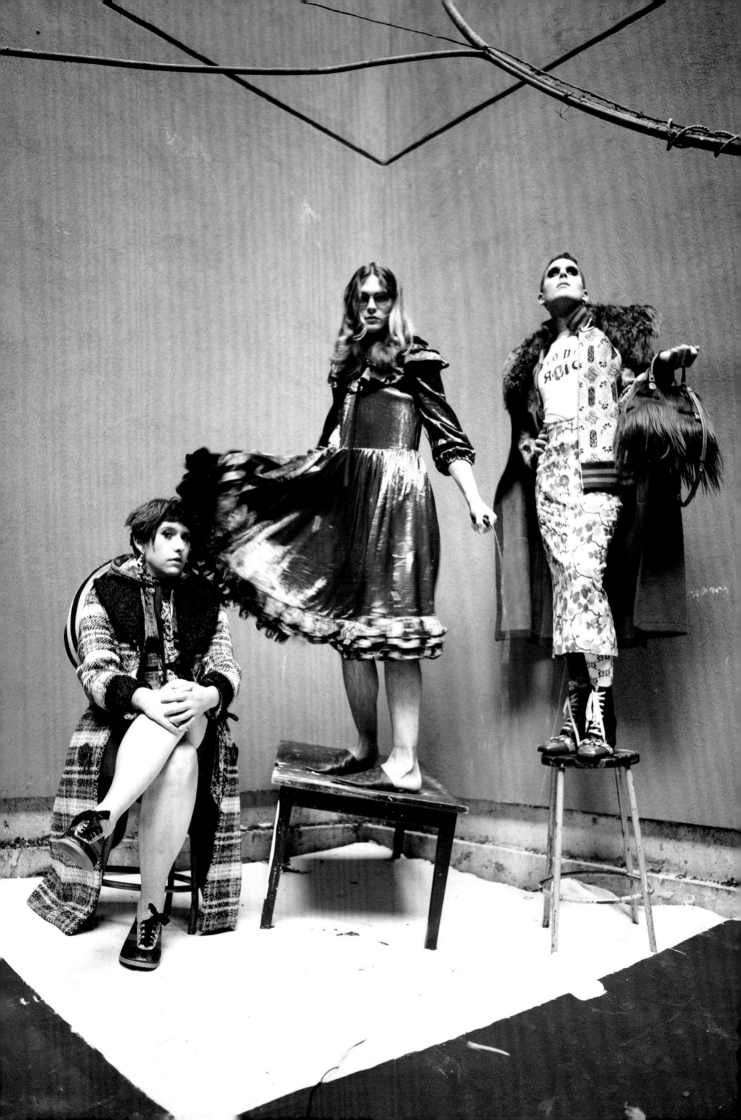

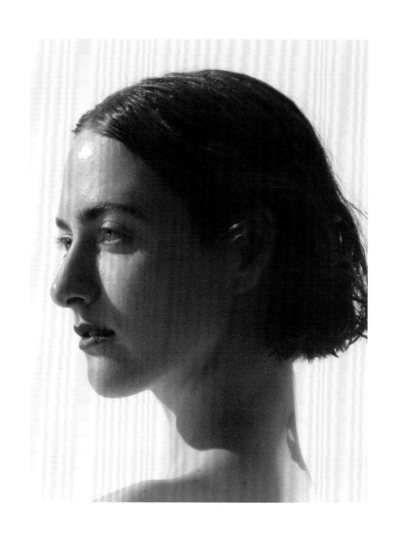

JANNEKE VAN DER HAGEN

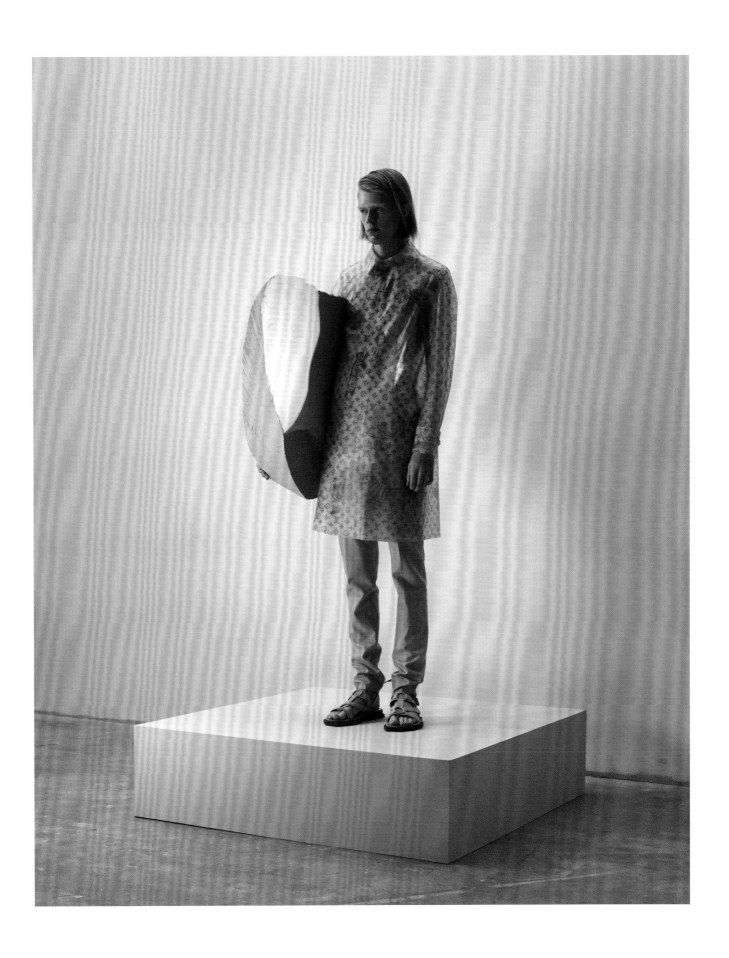

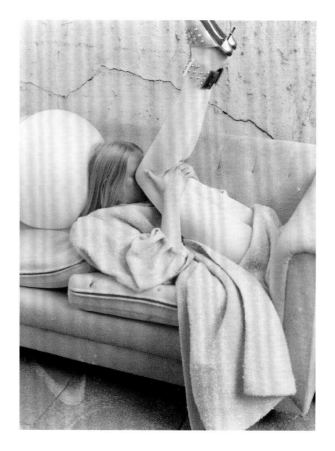
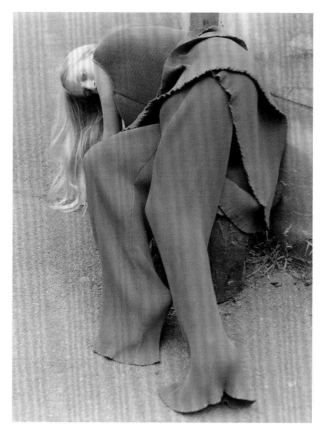
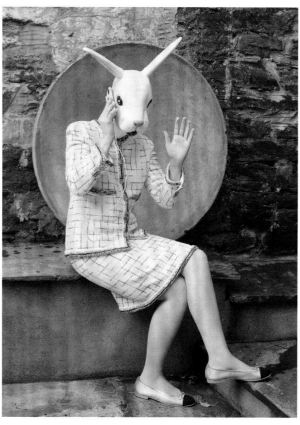
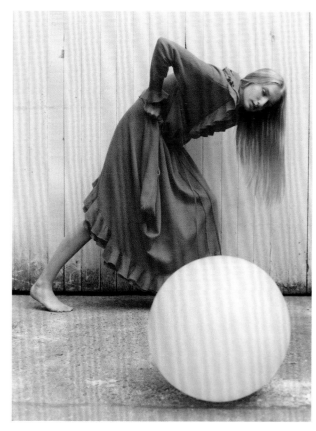

232

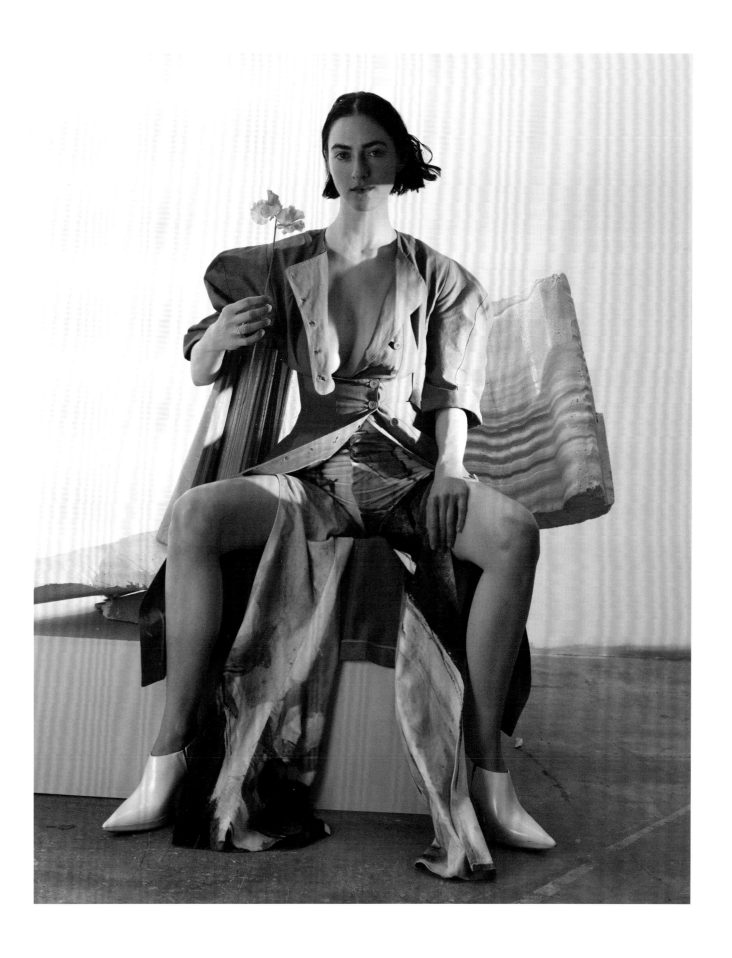

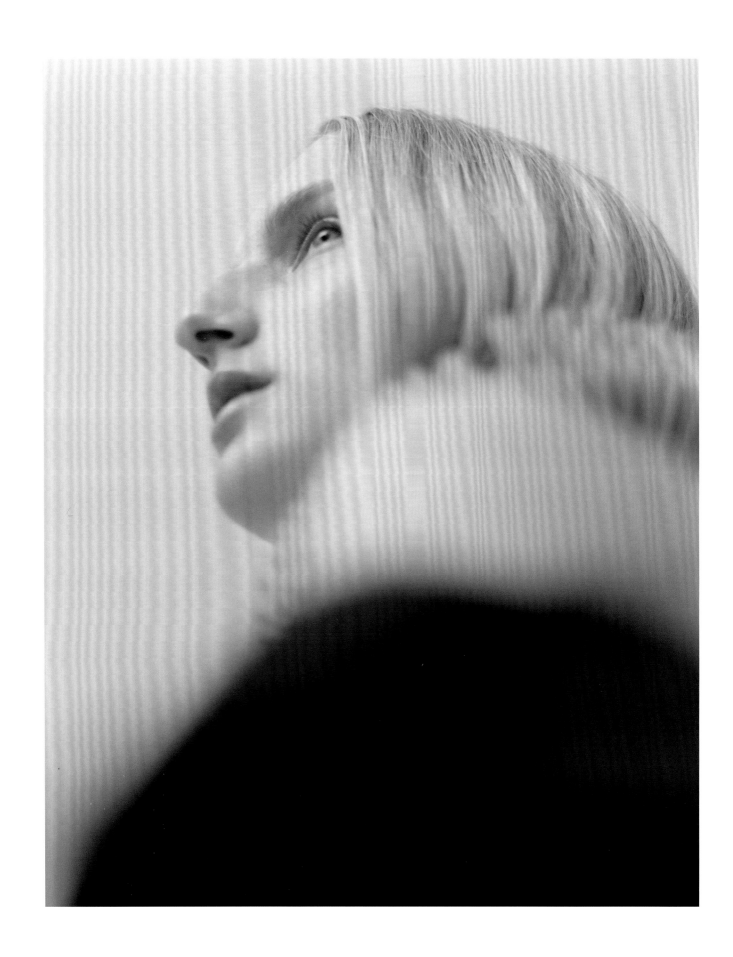

234

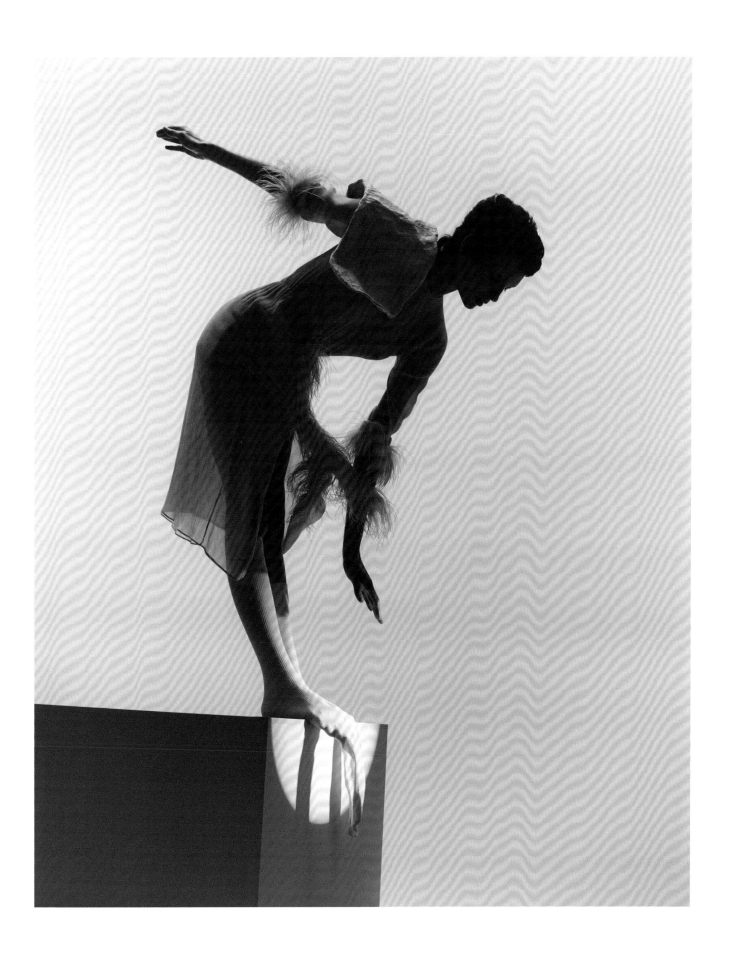

CHARLOTTE WALES

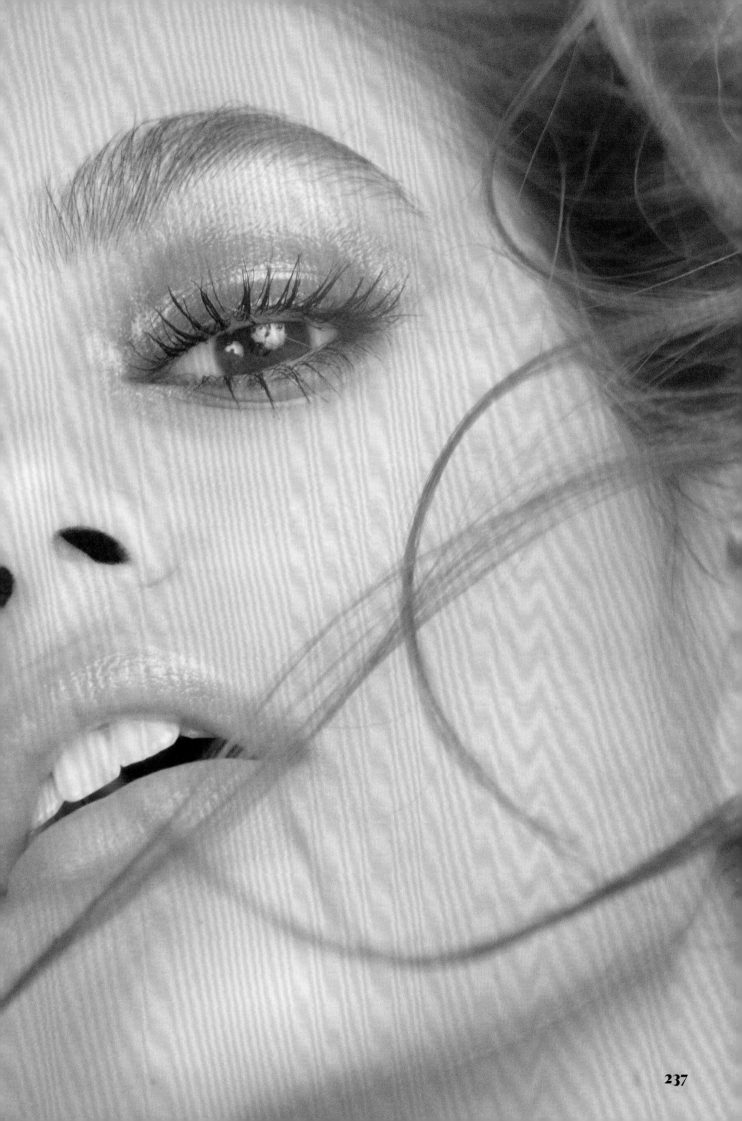

237

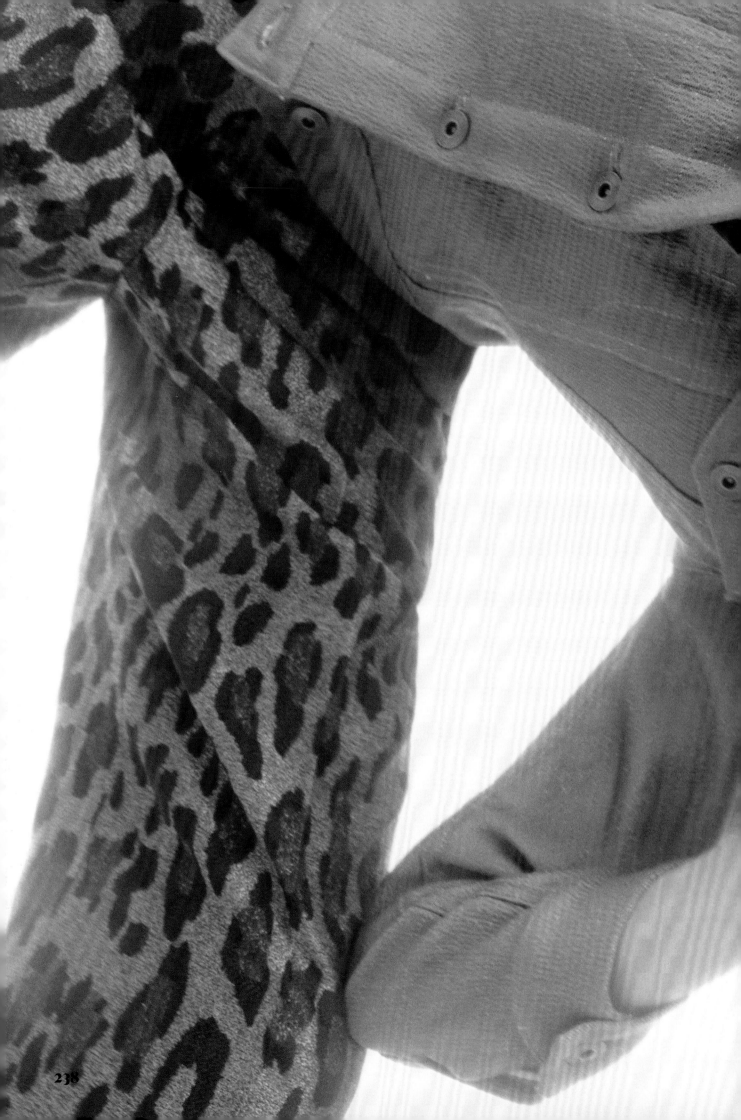

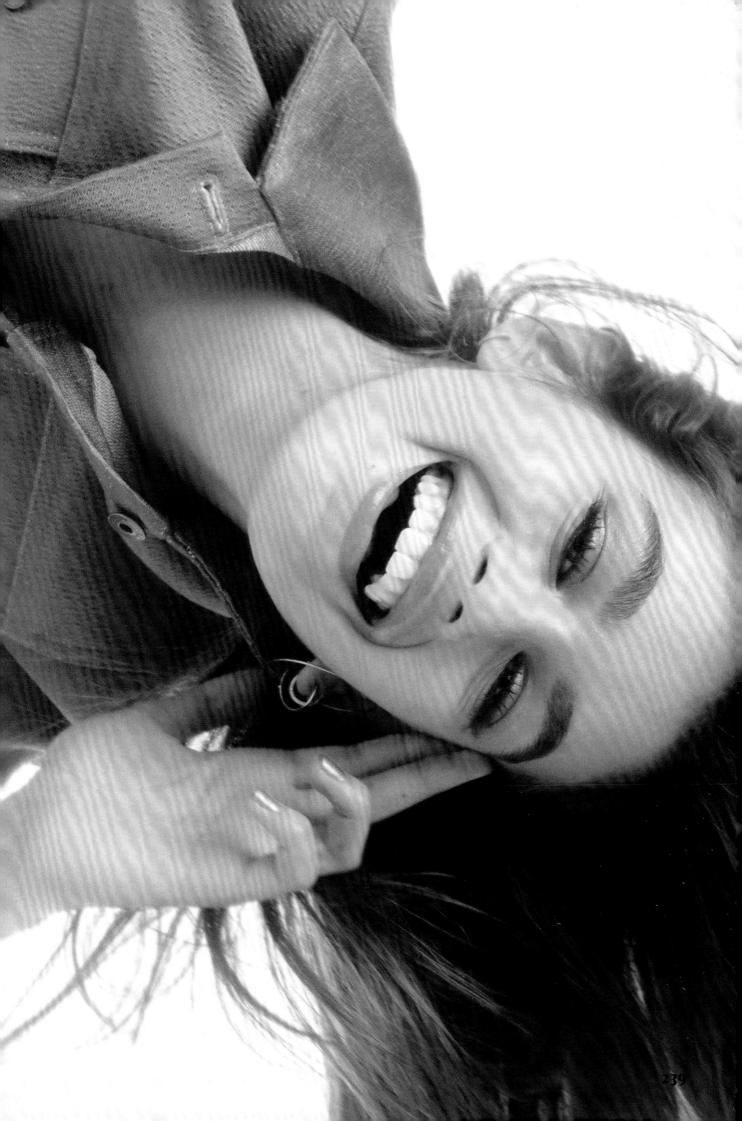

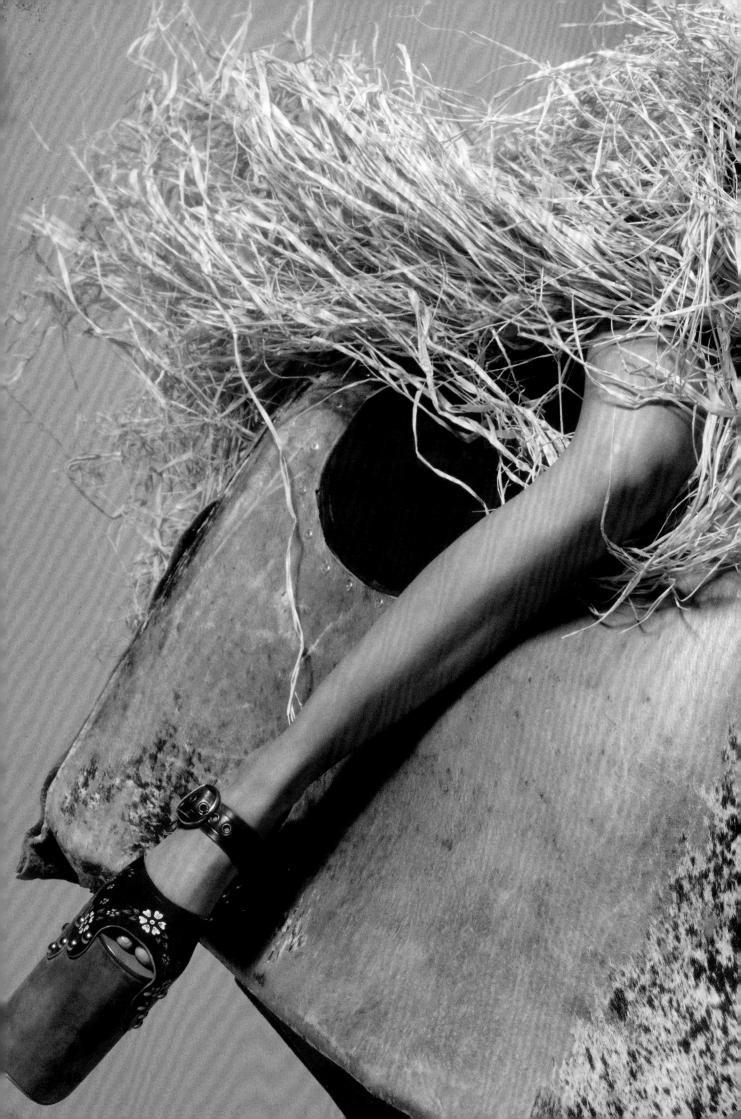

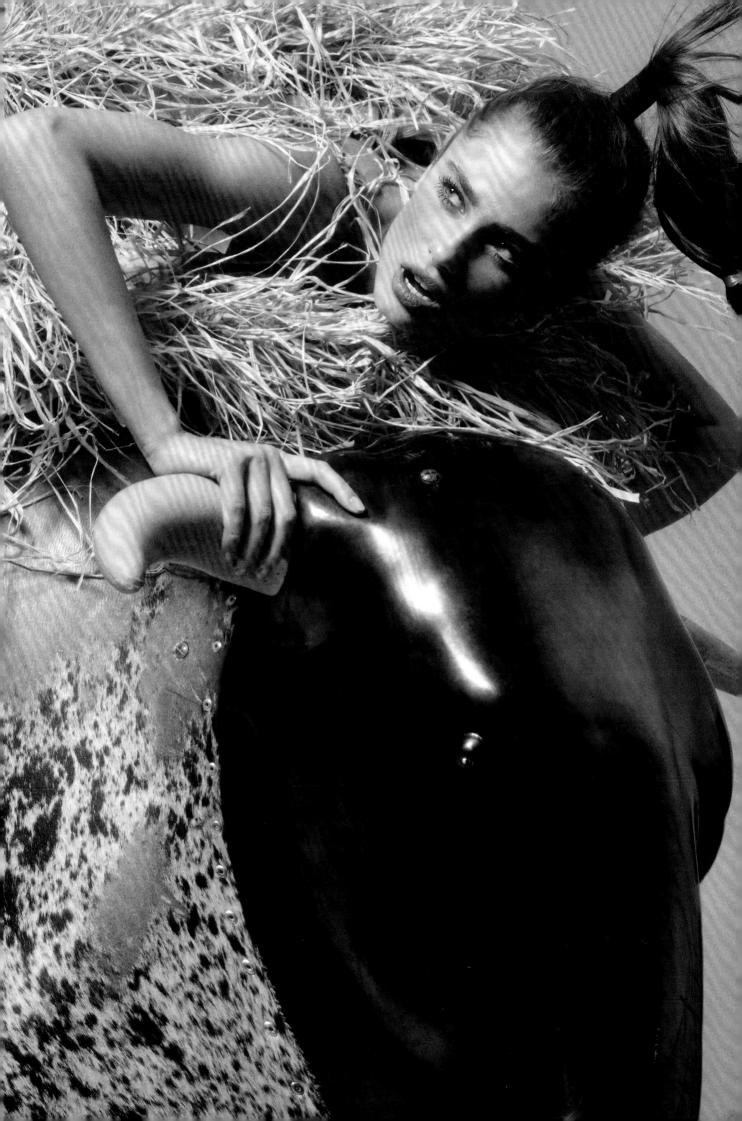

ANDREW MIKSYS

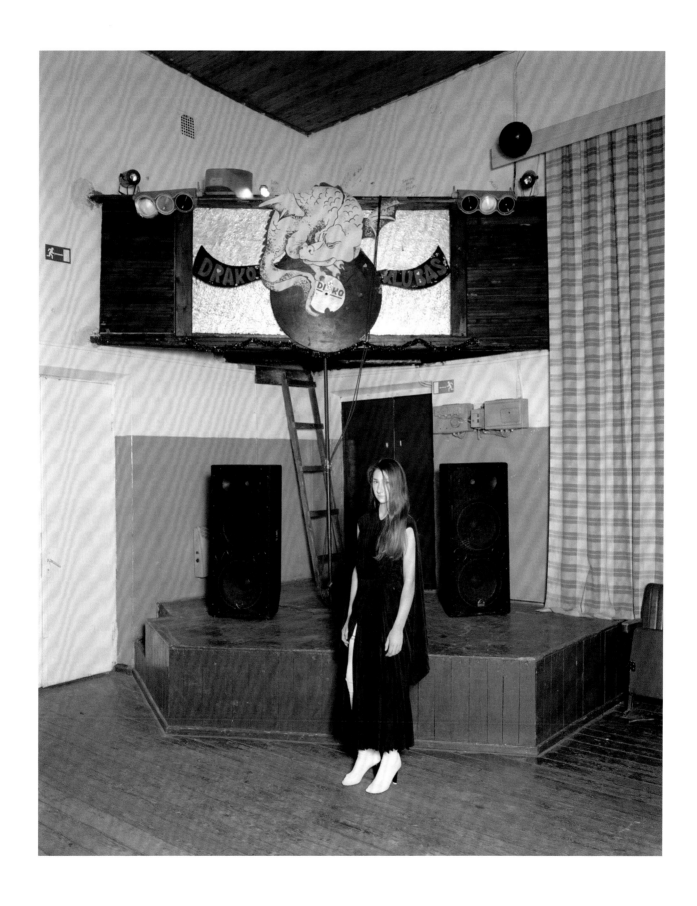

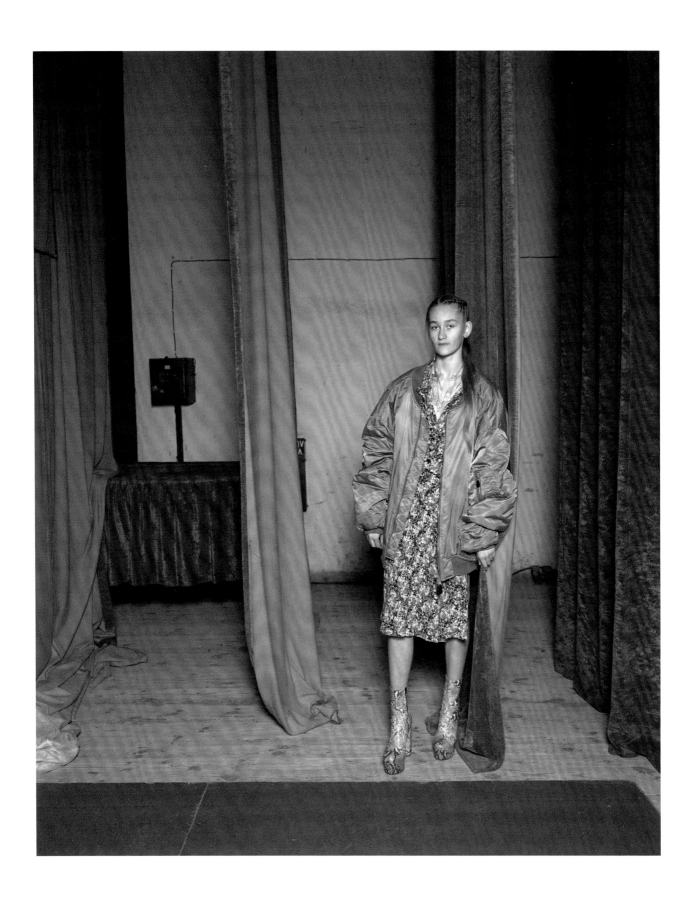

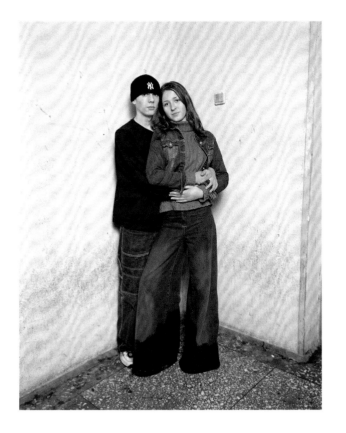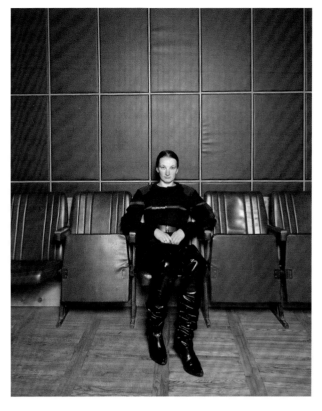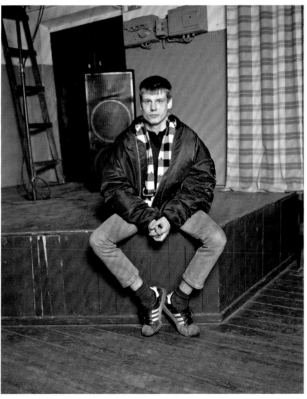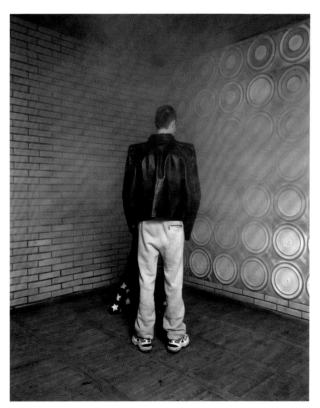

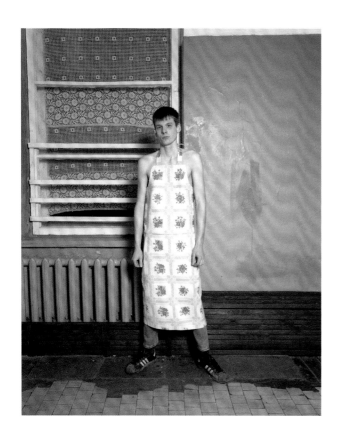
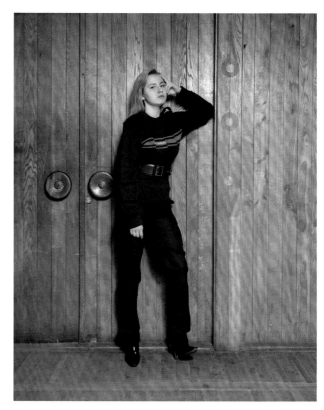
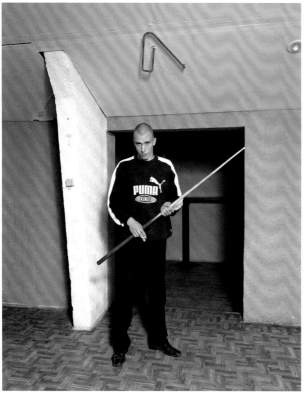
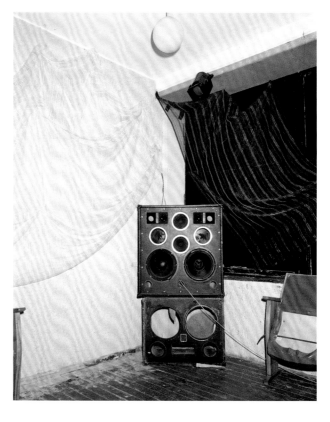

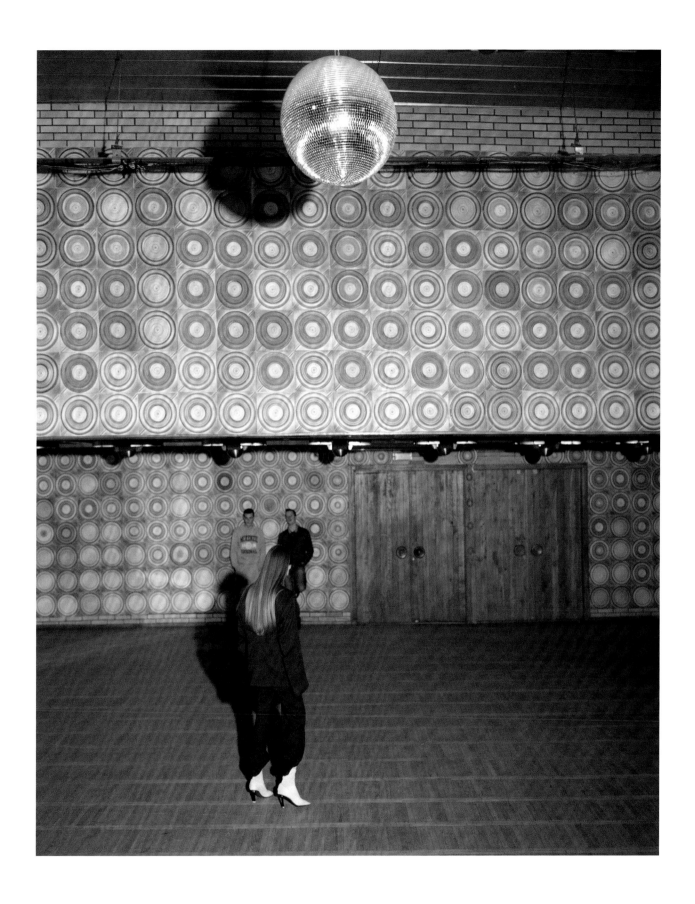

Michael Bailey-Gates

Michael Bailey-Gates is an American artist based in New York City. The Rhode Island native holds a Bachelor of Fine Arts in photography from the School of Visual Arts.

He collaborates with magazines such as *i-D*; *Re-Edition*; *The New York Times*; *Modern Weekly China*; *Man About Town*; *Replica*, among others.

224-229
The first double page and bottom of the 5th page
GQ Style
Stylist / Gary Armstrong
Hair Stylist / Silvia Cincotta
Makeup Artist / Kali Kennedy
Models / India Salvor Menuez, Michael Bailey-Gates

Second double page and third top left, 5 top right
Re-Edition Magazine / 5 / Fall/Winter 2016
Stylist / Matt Holmes
Models / India Salvor Menuez, Alexandra Marzella,
Claire Christerson

Third double page right
A Magazine Curated By - Eckhaus Latta
Stylist / Matt Holmes
Hair Stylist / Joey George
Makeup / Milky

Jeff Bark

Jeff Bark's photographs plumb the depths of a collective human experience in the manner of the great Master painters, from Titian to Jacques-Louis David. Bark was born in 1963 in Minnesota, studied photography in Santa Barbara, California, and is now based in New York. He works for such publications as *Dazed*, *AnOther*, and *Vogue Hommes*.

66-73
Nastia in Bloom / *Dazed* / March 2014
Styling / Robbie Spencer
Hair / Rick Gradone / AtelierManagement
Makeup / Lisa Houghton / Tim Howard Management
Model / Nastya Kusakina / Women

Jack Davison

Jack Davison (b. 1990) is a London-based portrait and documentary photographer.

He studied English literature at Warwick University but spent most of the time mucking around with cameras.

He works for numerous publications including *The New York Times*; *M*; *Luncheon*; *Double* and

British Vogue to name a few. He had his first solo exhibition in 2016 at the Foam Gallery in Amsterdam.

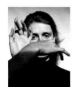

128-135
The images come from various series, some of which have never been previously released.

In order of appearance:

Port Magazine. We the group
Styling / Alex Petsetakis / 2014
Saska for *16 Magazine* / 2015
Personal work, Untitled / 2014
Modern Weekly China / Styling / Tim Lim / 2016
Amber Witcomb for *British Vogue* / Styling /
Lucinda Chambers / 2017
Cara Taylor for *British Vogue*
Styling / Lucinda Chambers / 2017
Jane for *Luncheon Magazine*
Styling / Mattias Karlsson / 2017
Personal work, Untitled / 2015
Lily for *Re-Edition Magazine*
Styling / Caroline Newell / 2016

Annemarieke van Drimmelen

Annemarieke van Drimmelen was born to Dutch parents in Australia in 1978. Growing up in the Netherlands, she started shooting with her mother's camera at a young age. While she always carried around a camera as a child, photography became an even more important part of her life when she started modeling.

Her exposure to professional photographers at work led to her realization that she loved being behind the camera. Annemarieke van Drimmelen has been a full-time photographer since 2008, dividing much of her time between London, Paris and New York.

Her own career as a model has given her a fluency in fashion imagery and the confidence to follow her own vision.

She collaborates with magazines including *The Gentlewoman*; *Holiday*; *WSJ Magazine*; *Vogue*; *T*; *M* and *The Last Magazine*. During her years as a noted fashion photographer she has also worked with a multitude of highend brands including *Chloé*; *Fendi*; *Hermès*; *Dior*; *Hugo Boss*; *Paul Smith*; *Theory*; *Rag and Bone* and *DKNY*.

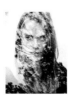

110-117
The Sophie Project (Personal work)
Styling / Dimphy Den Otter
The shot of the girl on the stool on white paper is a mixed media collaboration with Anouk Griffioen

Lena C. Emery

The German-born, Singapore raised photographer studied fine arts at Parsons Paris and subsequently worked as an independent art director in Berlin before moving to London in 2011.

Growing up in Southeast Asia and traveling extensively from a young age gave her the opportunity to become familiar with a variety of cultures and places. Working for the likes of *Dior*, *Lemaire*, *Stella McCartney*, *Louis Vuitton*, *Theory* and *Helmut Lang*, she is a regular contributor to publications like *The New York Times*; *T*; *WSJ Magazine*; *M*; *POP* and *The Gentlewoman*.

Emery was nominated for the FOAM Paul Huf award in 2015 and was selected UK Winner by the Magenta Foundation within the 2016 Flash Forward Emerging Photographers Award.

Lena C. Emery's photographs are not realist, because her subjects can be seen to be performing– with subtlety or pronouncement– and yet they are not constructed.

Instead they acknowledge that taking photographs, and being photographed, are true acts. Taking a photograph alters reality.

212-217
To Be Seen By Others
Sleek Magazine / Spring 2015
Styling / Luke Raymond
Hair / Maki Tanaka
Makeup / Nami Yoshida

Charlie Engman

Originally from Chicago, Charlie Engman started working with photography while completing a degree in Japanese and Korean studies at the University of Oxford.

Formerly involved professionally in theater and dance, with an abiding interest in visual and sculptural movement and gesture, he began using photography primarily as a note-taking device, notably creating "Domestic Diorama", a series of abstracted body studies, often using himself as the model.

Engman's images are at essence conceptual and visual solutions to the formal problem of picture making, pushing the scope and visual possibility of what is at hand to work with–models, clothing, props and sets, a certain space, light, the potential of post-production and

graphic design. Engman's commissioned work has appeared in publications such as *AnOther*; *Dazed*; *POP*; *Garage*; *The New York Times*; *T* and *Vogue USA*.

He has collaborated with clients such as *Stella McCartney*; *Hermès*; *Vivienne Westwood*; *Kenzo*; *Opening Ceremony*; *Farfetch*; *Sonia Rykiel* and *Nike*.

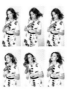

8-15
Multiplicity / *Garage Magazine* / 8 /
Spring/Summer 2015
Styling / Kate Lyall
Hair / Cyndia Havey / Streeters
Makeup / Isayama French / Streeters
Model / Lindsey Wixson / The Society Management
Set design / Jean-Michel Bertin

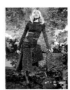

184-189
Women's Stylist Issue / *Modern Weekly China*
Fall/Winter 2015
Styling / Tim Lim
Set design / Spencer Vrooman
Hair / Ramsell Martinez
Makeup / Tsipporah Liebman
Model / Chloé Sevigny

204-211
The images in the third portfolio were taken from his digital diary, long held on his internet site.

Jason Evans

Jason Evans is a multi-disciplinary photographer whose visible output has been through the "style magazine" format, producing portraiture and fashion imagery typified by an experimental approach.

He also works in the music industry producing sleeves, videos and promotional materials for musicians whose work he enjoys.

His work has been exhibited internationally and included in several contemporary photography surveys. Evans has been working on the Internet's potential for image circulation notably through his positive site *www.thedailynice.com.*

He currently teaches photography at the University College for the Arts in Farnham, UK.

136-145
Eva, *Muse* / 40 / Spring/Summer 2015
Styling / Beth Fenton
Model / Eva Herzigova / One Management
Makeup / Mel Arter / Streeters.
Hair / Naoki Komiya / Julian Watson Agency

Ethan James Green

The New York–based photographer and ex-model, featuring in *Marc Jacobs*' SS16 ad campaign beside icon Bette Midler, has been documenting the city's queer community since 2017, pulling nonconformists in front of his camera straight from the street and social media. With the mentorship of New York downtown artist David Armstrong, Green began to photograph his close circle of New York friends and collaborators, as well as casting on the streets of the city.

His photographs brilliantly portray the vitality and particularities of today's originality, sexual identity and a timely iconography of contemporary style.

Green's work has been commissioned by publications such as *AnOther*; *Another Man*; *Aperture*; *Arena Homme+*; *Dazed*; *LOVE*; *System*; *Vogue Hommes*; *Vogue Italia*; *Vogue Paris*; *W* and *WJS Magazine*. He also received commissions from fashion labels such as *Adidas*; *Alexander McQueen*; *Diesel Black Gold*; *Dior*; *Fendi*; *Helmut Lang* and *Miu Miu*.

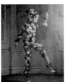

82-87
A fleur de peau / *Vogue Paris* / March 2018
Styling / Anastasia Barbieri
Makeup / Pedros Petrohilos
Hair / Cyndia Harvey
Set Design / Julia Wagner
Model / Edie Campbell / Viva

Janneke van der Hagen

Janneke van der Hagen is a Dutch photographer based in London who graduated from art school in Breda (NL) in 2008.

Next to her work in fashion, she enjoys working on her personal photography projects for an upcoming book, using everyday material and situations to transform them and give them a new meaning. Her commercial clients include *MaxMara*, *Lacoste* and *Van Cleef & Arpels* and her work has been fea-

tured in publications such as *British Vogue*; *Numero*; *10 magazine* and *L'Uomo Vogue*.

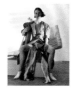

230-235
This portfolio comprises images from several series:

Numero China Magazine / 68 / April 2016
Styling / Janneke van der Hagen
Models / Elis and Viljam Nybacka

Numero China Magazine / 69 / May 2016
Hair / Jonathan de Francesco
Makeup / Janeen Witherspoon
Set Design / Amy Stickland / Webber Represents
Models / Jess Cole / IMG; Jessica,
Esrom and Huddi / Premier

Renaissance, *Supplement magazine* /
September 2016
Styling / Ali and Aniko
Hair / Nao Kawakami / Saint Luke
Makeup / Janeen Witherspoon
Models / Francesca / Linden Staub Agency; Adrian Hobbs / Models 1

Thomas Hauser

Thomas Hauser (b. 1961, Germany) lives and works in Berlin. He initiated his artistic practice as a representational painter, producing pieces very much influenced by American postwar artists such as Warhol or Lichtenstein, and also painters such as Max Beckmann, Balthus or Ernst Wilhelm Nay on the European scene. Discovering the influence of photography on painting, he started using pages from fashion magazines as a starting point for his own work.

For the first time in 1995, he used a computer to make sketches for paintings. Hauser scanned the found materials from magazines and created templates for big canvases. The next step was to use downloaded images from websites, mostly nude pictures from amateur sex- and porn-sites. Feeling uncomfortable with the use of other people's images, Hauser decided to take his own photographs for his paintings around 2003.

118-127
Kunst seidene Mädchen
Numero Berlin / 1 / Autumn/Winter 2016
Styling / Götz Offergeld and Sina Braetz
Hair / Patrick Glatthaar / Ballsall
Makeup / Min Kim / Airport agency
Models / Antonia Vonnahme / Modelwerk; Esther Heesch / Modelwerk; Mia Gruenwald / Place Models; Nicole Atieno / Supermodels Connect; Paula Schischel / Modelwerk; Sophia Liinewedel / Seeds; Basia, Cecile and Mitzuki

Julia Hetta

The Swedish photographer Julia Hetta graduated from the Gerrit Rietveldt Art Academy in Amsterdam in 2004. Her work has since been shown in magazines and exhibitions worldwide.

The images of Hetta contain both the very beautiful, sensuous and romantic, as well as the dark and lurid. Her color work reveals an almost Renaissance palette quality, while her black and white work is rich in contrast and does not fear the very dark, the very black.

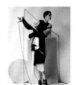

Power Lines / *Dazed* / Vol IV
Spring/Summer 2017
Styling / Hannes Hetta
Model / Marte Meivan Haaster / Viva
Hair / Tomi Kono / Julian Watson Agency
Makeup / Topolino / Calliste
Set designer / Sophie Glasser / Talent and Partner

Todd Hido

Todd Hido (b. 1968, Ohio) is a San Francisco Bay Area–based artist whose work has been featured in *Artforum*; *The New York Times*; *Eyemazing*; *Wired*; *Elephant*; *FOAM* and *Vanity Fair*. His photographs are in the permanent collections of the Getty, the Whitney Museum of Art, the Guggenheim Museum, New York, the San Francisco Museum of Modern Art, as well as in many other public and private collections.

He has over a dozen published books. Aperture published his mid-career survey in 2016. This is one of the very rare series he has produced for a fashion magazine.

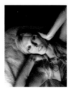

My Favorite Daydream / *Muse* / 38 / Fall 2014
Styling / Beth Fenton
Model / Catherine McNeil / The Society Management
Makeup / Mayia / Calliste Agency
Hair / Rolando Beauchamp / The Walll group
NYC&LA

Ruth Hogben

Ruth Hogben is a filmmaker and photographer based in London who completed her BA in Fashion Photography in 2003. In 2005, Ruth began assisting for Nick Knight.

Whilst working with Nick, Ruth discovered fashion filmmaking and collaborated on numerous films with SHOW studio. Since working on her own, Hogben's work has been published in magazines such as *Elle US*; *LOVE*; *AnOther*; *Dazed*; *W* and *The Independent*.

Ruth has created films and commercials for brands such as *Christian Dior* Parfums; *Fendi*; *Hugo Boss*; *Louis Vuitton*; *Gareth Pugh*; *Alexander McQueen* and *MAC Cosmetics*. She has also directed videos for international music artists Lady Gaga and Kanye West.

In 2016, she co-founded Lobster Eye with Andrea Gelardin, a creative studio based in London.

Metallic / *Dazed* / Spring 2014
Styling / Katie Shillingford
Hair / Martin Cullen / Streeters
Makeup / Petros Petrohilos / Streeters
Model / Hollie May Saker / Models 1

Sebastian Kim

Sebastian Kim is a fashion/editorial photographer based in New York City. He was born in Vietnam, raised in Iran, France and the USA.

He started his career assisting Richard Avedon and Steven Meisel. He contributes to several magazines, including *Vogue USA, Germany, Australia* and *Russia*; *Interview*; *GQ*; *Glamour* and *Allure*. He currently resides in Brooklyn.

New School / *V* / 49 / Fall 2007
Styling / Michelle Cameron
Makeup / Pep Gay / Streeters; John McKay / Frank Management
Hair / Esther Langham / Art + Commerce
Models / Daul Kim Elite; Svetlana K and Alannah Farrell / T Management; Anna Laryn and Taylor Warren / New York Models; James Chiles, Nick Rodocroy / Request; Bartosz Janowski / Red Model

Karen Knorr

"In April 2011, I received an email from Vanessa Reid, an international stylist who works as a contributing fashion editor for POP, inviting me to meet her in London to discuss a possible collaboration. I felt challenged by the fashion context of a series of fashion portraits of contemporary women that could be humorous and subversive. An initial proposition was made to Vanessa that we only photograph non-European women to reflect the diversity of London which has been my home since 1977. It was in the midst of the rumblings of the Arab Spring and I was considering hijabs, burqas and shemaghs...

The challenge was to find a location in central London large enough to accommodate about 20 different clothes arrangements over the period of two days. It also meant a total change in my working methodology, which is usually solitary and slow. We decided that we would quote my previous black and white work produced in the 1980s (Belgravia and Gentlemen) and I would bring it up to date referencing world events and the everyday through the use of text which was composed out of the answers to a questionnaire I sent around to the actresses/models after the photographic shoot."

Karen Knorr, 2013

Photographing Ladies / *POP* / 25 /
Fall/Winter 2011
Styling / Vanessa Reid
Hair / Maarit Niemela / D+V; Tomo Jidai / Streeters
Makeup / Florrie White / D+V
Models / Jasmine Guiness, Cynthia Fortune, Antonia Campbell, Poppy Lloyd, Fajer Al Rajaan

Glen Luchford

A self-taught photographer born in Brighton (1968), Luchford left school at 15 and moved to London where he worked at a hair salon.

In 1997, he signed exclusively to *Prada*, *NARS* and *DVF* and has since shot advertising campaigns for *Yves Saint Laurent*; *Levi's*; *Valentino*; *Mercedes-Benz* and *Calvin Klein*. He has collaborated extensively with British artist Jenny Saville with shows at Gagosian Gallery, MoMA and the Victoria & Albert Museum. Luchford's style is influenced by his love for cinema. He prefers to work in the studio using elaborate lighting setups to create his evocative and cinematic images.

In 2001, Luchford directed the film *Here to Where*, about a filmmaker wanting to make a film about a man stranded at an airport. His work has been published in magazines such as *Vogue Paris, Italia*; *British Vogue*; *Self Service*; *LOVE*; *Dazed*; *Vanity Fair*; *AnOther*; *Purple*; *V*; *Interview* and *W*.

16-21
Bray, County Wicklow, December 2017-18, 2015
Self Service / 44 / SS16
Styling / Jane How
Hair / Anthony Turner
Makeup / Yadim
Models / Lina Hoss, Suzie Leenars and Maggie Maurer

Andrew Miksys

Andrew Miksys is from Seattle (USA). For the last 15 years he has been living in Vilnius, Lithuania. His photography has been shown internationally including in exhibitions at the Seattle Art Museum, Vilnius Contemporary Art Centre, and Maureen Paley Gallery.

Miksys' work has appeared in many publications and online including *Dazed*; *The New Yorker*; *Harper's*; *HOTSHOE*; *BuzzFeed* and *VICE*. Since 2007, he has been releasing his books through his publishing imprint, *Arök books*.

His books include *Disko* (2013), from his series about Lithuanian village discos, and *Tulips* (2016), a new book about Belarus. For this series, he went back to the discos visited for *Disko*, and asked the local youth to pose in clothes designed by Demma Gvasalia.

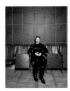

242-247
Vetements / *Dazed* / Vol IV / Spring 2016
Styling / Lotta Volkova
Clothes / All Vetements SS16, design by Demna Gvasalia
Models come from the villages where Andrew Miksys made his Disko project

Josh Olins

Josh Olins was born in London and currently resides in New York.

Although he lived in photography and the fashion industry for much of his early life, it wasn't until he studied art at Middlesex University that he found a love for the medium of photography and decided to follow his passion by working as an assistant in London in the early 2000s.

Since then, he has developed a style and aesthetic of strength and elegance that spreads across both his studio and location photography.

His work has been featured in *British Vogue*; *Vogue Paris* and *USA*; *WSJ*; *Interview*; *The Last Magazine*; *i-D*; *Dazed* and *Holiday Magazine*.

His clients include *Balenciaga*; *Calvin Klein*; *Jil Sander*; *Mugler*; *Isabel Marant*; *Narciso Rodriguez*; *Mango*; *H&M*; *The Gap*; *J Brand* and *Tommy Hilfiger*.

88-97
A Trip / *Holiday* / 373 /
Spring/Summer 2014
Styling / Clare Richardson
Hair / Shona / Julian Watson Agency
Makeup / Jurgen Braun / Artlist, and Emma Broom
Models / Lise Aanes / Heart Break Management;
Andrea Diaconu / IMG; Melina Gesto / Viva Paris;
Ashleigh Good / Elite

Mark Peckmezian

Mark Peckmezian was born in 1985 in Toronto and graduated from Ryerson in 2010, releasing his first book, *Photographs & Pictures*, as an artist's edition that same year.

Peckmezian's elegant and ageless images with a snapshot aesthetic predominantly focus on portraiture. He has a bold confidence in his own style developed from experimenting in his darkroom and is driven by a compulsion to make valid and authentic work.

Mark is influenced by vernacular photography and spontaneous portraiture, drawn to the beauty in the pensive moment, elusive emotional states and occasional humor.

Selected publications include *Dazed*; *POP*; *Noon*; *Document*; *Vogue*; *AnOther* and *Another Man*; *Double*; *Purple*; *Vogue Hommes*; *Holiday*; *The Gentlewoman*; *M*; *T*; *Fantastic Man*, and *Near East*.

Clients include *Hermès*; *Isabel Marant*; *Stella McCartney*; *Self-Portrait*; *COS*; *Melinda Gloss*; *Nicole Farhi* and *Victoria Beckham*.

146-153
These pages compile several images from different series including "too Blessed to be Stressed", published in *Muse* / 38 / Fall 2014, and images from a series for *The Happy Reader Magazine* 2014

For *Muse*:
Styling / Melina Nicolaide
Hair / Adam Szabo
Makeup / Dotti
Model / Lottie Hayes

For *The Happy Reader*:
Styling / Agata Belcen
Hair / Naoki Komiya
Makeup / Nami Yoshida

Sarah Piantadosi

Sarah Piantadosi is a London based photographer who regularly contributes to *Dazed*; *Another Man*; *Interview*; *Twin*; *Re-Edition*; *V*; *SHOWstudio*; *W* and *Vogue USA*. Her clients include *Alexander McQueen*; *McQ*; *Barneys New York*; *Hugo Boss*; *Les Girls Les Boys*; *Selfridges*; *Saks Fifth Avenue* and *Universal Music*.

104-109
Glitch It Up and Start Again / *Dazed* /
June 2014
Illustration / Doug Abraham aka BESS
Models / Mica Arganaraz / Viva Models and Kevin
Joseph Bailor
Styling / Celestine Cooney / Creative & Partners
Makeup / Thomas de Kluyver / D+V
Hair / Cyndia Harvey / Streeters

Joanna Piotrowska

Joanna Piotrowska (b. 1985 in Warsaw, Poland), lives and works in London. She received a BA in photography from the Academy of Fine Arts, Cracow in 2009 and an MA in photography from the Royal College of Art, London in 2013.

In 2014, MACK Books published her project FROWST.

Her solo exhibitions include: "What love has to do with it," Project Space, Hayward Gallery, London, 2014; Bloomberg New Contemporaries, Institute of Contemporary Arts, London, 2013; "*Give me yesterday*", Prada Foundation, Milan, 2016; "*ROOM*", Sadie Coles, London, 2016; "*These Rotten Words*", Chapter Gallery, Cardiff, UK.

98-103
First and third double pages:
Tank / Volume 8 / Spring 2016
Models / Giulia and Camilla Venturini
Styling / Caroline Issa and Nobuko Tannawa
Hair / Takuya Uchiyama
Makeup / Nobuko Maekaw

Second double page:
The back with leather gloves and the girl in the suit with her head to the back:
REVUE / 3 / 2017
Styling / Mauricio Nardi
Hair / Pawel Solis
Makeup / Marie Duhart

For the picture of two girls lying on the furniture:
Dazed / vol IV / Winter 2016
Models / Zuzanna Bartoszek and Maggie Maurer
Styling / Elisabeth Fraser Bell
Hair / Chi Wong
Makeup / Nami Yoshida

Robi Rodriguez

Rodriguez's is born in La Coruña, Spain and studied at Art-Centre College Pasadena, Los Angeles, where he assisted photographer Bob Richardson for two years.

He then moved to London in 2004 to pursue his career in photography. He regularly shoots for publications such as *T*; *Double Magazine*; *Interview*; *Holiday Magazine*; *AnOther* and *Document*, to name a few, and clients such as *Vivienne Westwood*; *Nina Ricci*; *Lanvin* and *Golden Goose*.

Exhibitions of his work include the London Art Fair, the Gallery for Modern Photography, Berlin, and IMA Concept Store in Tokyo.

190-195
Working Girl / *Dazed* /
February 2014
Styling / Robbie Spencer
Hair / Mark Hampton
Makeup / Thomas de Kluyver
Casting / Noah Shelley
Models / Adwoa Aboah, Daisy Lowe, Lili Sumner,
Kamila Filipcikova, Misha Hart, Arlette Ess, Lola Lali,
Michelle Urvall-Nyren, Roberta Hollis, Zoe Knibbs
Set Design / Janina Pedan

Daniel Sannwald

Daniel Sannwald (b. 1979 in Germany) is emerging as one of the true original voices in contemporary photography. In a landscape dominated by referential and repetitive imagery, Sannwald is establishing a strong and recognizable signature that is already catching the attention of some of the most influential trendsetters in the fashion and photography industries.

Sannwald studied at the Royal Academy in Antwerp and is now based in London. He regularly contributes to magazines such as *032c*; *10 Men*; *Arena Homme+*; *Dazed*; *i-D*; *POP*; *V* and *Vogue Hommes Japan*.

22-29
Georgia May wears Lipmix in Blue /
Garage Magazine / 7 / Fall/Winter 2014
Concept / Chaos Fashion
Makeup / Val Garland / Streeters
Hair / Cyndia Havey / Streeters
Model / Georgia May Jagger

Casper Sejersen

Casper Sejersen is a Danish photographer responsible for the photographic promotion of the film, *Nymphomaniac*. He then did this fashion series for *Self Service*, his very first one with the film heroine, Charlotte Gainsbourg. He has since ventured into a fashion photography career and regularly collaborates with *Dazed*, *Self Service* or *POP*. In 2015, he released "Belongs to Joe", a photographic essay compiled as a set of notes on Lars von Trier's film script for *Nymphomaniac*, published by MACK.

54-61
Self Service / 41 / Fall/Winter 2014
Model / Charlotte Gainsbourg
Styling / Marie-Amelie Sauvé
Hair / Tomohiro Ohashi / MAO
Makeup / Aude Gilles / Studio 57
Set Design / David Xhite

Noé Sendas

Noé Sendas (b. 1972, Brussels) lives and works between Berlin and Madrid and began presenting his work in the late nineties. The exploration of loss is a central motif underlying his repertoire.

Employing a variety of references, explicit or implicit quotations from artistic, literary, cinematic and musical sources is part of his raw material. Sendas' work explores the theoretical and material constructs of the body, the mechanisms involved in the observer's perception and the discursive potential of exhibition methods.

168-175
The Lady Vanishes / *Wallpaper* / March 2015
With photography by Ian Lehner
Courtesy the Artist and Michael Hoppen Gallery
Styling / Isabelle Kountoure
Set design / Maria Sobrino
Hair / Alexander Soltermann
Makeup / Naomi Nakamura
Model / Serena Amirante / Elite

Heji Shin

Seoul-born photographer Heji Shin has always had an eye for making the simple things extraordinary. She has since split her time evenly between Berlin and New York City.

She has worked on various photography projects, from edgy fashion editorial spreads to, most recently, a German sex education book for teenagers. Ranging from fashion models to zoo animals, Shin's subjects are highly staged and the artist often manipulates details using analog and digital production, such as double exposure. She has had solo exhibitions at Galerie Bernhard in Zürich and Real Fine Arts in Brooklyn.

Her work has been included in group exhibitions at "Foxy Productions" in New York and "Anna-Catharina Gebbers" at Bibliotheks-wohnung in Berlin.

38-43
The images are issued from various series

Intim sphäre / *Berlin Issue* / Issue 2 /
SS17
Styling / Burke Battelle
Hair / Shin Arima
Makeup / Seong Hee Park
Model / Svetlana Zakharova

Purple / SS18
Stylist / Camille Bidault Waddington
Hair / Rudi Lewis
Makeup / Stephanie Kunz
Models / Mariam de Vinzele / Viva Paris

Interview Germany /
April 2017
Kyle Luu / Stylist
Hair / Shin Arima
Makeup / Ingeborg
Models / Anya / The Society; Marihenny
Pasible / New York

Garbagio / *Interview Germany* /
September 2017
Stylist / Kyle Luu
Hair / Panos Papandrianos
Makeup / Ingeborg
Model / Alexandra Elizabeth

Ohne Filter / *Interview Germany* /
March 2018
Stylist / Kyle Luu
Hair / Lucas Wilson
Makeup / Stoj
Models / Dasha Shevik / Muse

Modern Matter / Autumn/Winter 2017
Stylist / Tamara Rothstein
Hair / Sabrina Szinay
Makeup / Stoj
Models / Erika / Next; Dasha / Muse; Manu / Next

Maurits Sillem

Maurits Sillem is a London-based photographer with a background in curating and the history of art having studied at the Royal College of Art and worked with photographs at the Victoria & Albert Museum.

His work is influenced by western painting and sculpture, contemporary dance, film and literature and has often involved actors as well as models in the creation of images exploring ideas about life in the city and the digital world.

"I am interested in what makes us who we are, why we do what we

do. I am also interested in making images which represent women in a healthy and dynamic way."

He has contributed fashion work to *POP*, *Dazed* and *Tank* and has worked with *Chanel*, *Courrèges*, *Burberry* and *Joseph*.

176-183
Maädchen herz / *Numero Berlin* / 4 /
Spring Summer 2018
Styling / Götz Offergeld
Model / Marjan Jonkman / Women Management
Hair / Federico Ghezzi / Saint Luke Artists
Makeup / Elias Hove

Juergen Teller

Juergen Teller (b. 1964, Germany) studied at the Bayerische Staatslehranstalt für Photographie in Munich before moving to London in 1986.

Considered one of the most important photographers of his generation, Teller has successfully navigated both the art world and commercial photography since beginning his career in the late 80s.

With his international reputation forged through collaborations with high-end luxury brands (notably *Louis Vuitton*; *Bottega Veneta*; *Marc Jacobs*; *Celine*; *Yves Saint-Laurent*) or the press (*W*, *POP*, *British Vogue...*), Teller is one of the world's most coveted photographers in fashion and advertising. His approach to photography is typically sharp and raw (bitter flash, red eye, absolutely no retouching or calculated framings) and often bathed in sex and nudity.

Teller also relates to elements from his personal history in surrealist instances, thus expressing his times by inventing the plastic language that fits him best.

This series, made with model Daria Werbowy and some of the photographer's personal archival material, is a tribute to Paris, published shortly after the dreadful attacks on 13 November 2015.

44-53
I love Paris. Paris from 1991-2016
POP / 34 / Spring Summer 2016

Daria Werbowy at Gare du Nord
1 December 2015
11:29 am till 12:50 pm
Fashion / Vanessa Reid

Charlotte Wales

Charlotte Wales is a British photographer currently based between New York and London.

She works for magazines like *Vogue USA*; *Vogue Paris*; *British Vogue*; *The Gentlewoman*; *T*; *Dazed*; *032c*; *POP*; *W* or *M*, and brands including *Hermès*; *Chloé*; *Celine*; *Louis Vuitton*; *Chanel* and *Area Studio*.

196-203
POP / 34 /
Spring Summer 2016
Styling / Charlotte Collet
Model / Natasa Vojnovic / Women Management
Hair / Chi Wong / Management Artists
Makeup / Kanako Takase /
Tim Howard Management

236-241
Kaia! / *POP* / 35 /
Fall Winter 2016
Styling / Charlotte Collet
Model / Kaia Gerber / IMG
Makeup / Jen Myles
Hair / Marki Shkreli / Tim Howard

The last double page is from the series
All About Tay Kay / *POP* / 36 /
Spring Summer 2017
Styling / Charlotte Collet
Model / Taylor Hill / IMG
Hair / Chi Wong / Management Artists
Makeup / Jen Myles

Erwin Wurm

After graduating from the Vienna School for Applied Arts, Erwin Wurm (b. 1954, Austria) became a sculpture professor at the Beaux-Arts in Paris and then at the University for Applied Arts in Vienna.

Wurm focused on the definition of sculpture very early on, and with his own pieces, challenged preconceptions on the matter by playing with its fundamental principles: void, volume, weight, balance.

"What was traditionally understood as sculpture was some three-dimensional thing that had to last forever. My feeling was that sculpture could also last but a few moments. I thus made photographs of these moments, and I consider these photos to be also sculptures."

Wurm is also known for his humorous approach to art–a means to make serious, or even grave matters more accessible. Notably his *One Minute Sculptures* (1997), for which he asks visitors to pose in the exhibition space, with objects of the everyday. He considers that any of the objects or material in our environment, even the most banal item, can be used for the purpose of art. Wurm represented Austria at the 2017 Venice biennale. Like many contemporary artists, Erwin Wurm also ventured into the world of fashion photography, as with this series realized for *Vogue Germany* with top model Claudia Schiffer.

30-37
Kunst Pausen / *Vogue Germany* /
November 2009
Model / Claudia Schiffer
Styling / Nicola Fnels

Acknowledgements
Patrick Remy would like to thank all the photographers as well as:
Savanna Widell, Fiona Chan,
Alexandre Lamarre / MANAGEMENT+ARTISTS
Daisy Parker, Flore-Adéle Gau / Webber Represents
Chris Smith / Charlie Engman Photography LLC
Drue Bisley / Ruth Hogben Studio
Valentine Avron, Stefanie Breslin, Gregory Spencer / Art Partner
Cat Marshall / Josh Olins studio
Elizabeth Norris / Artistrylondon
Kozva Rigaud / Shotview Photographers
Sally Waterman, Rozi Rexhepi / Juergen Teller Ltd
George Ruffles, Liberty Dye / CONCRETE REP. LTD
Jordan Hancock / M.A.P.
David Bault
Maria Grazia Meda and Nino Comba
Frédérique Destribats

Patrick Remy

Patrick Remy is a photography critic, independent editor and art director. He has curated many exhibitions on fashion photography, notably in Tokyo and Melbourne, and served as artistic director for *Planche(s) Contact* in Deauville between 2010 and 2014. In 1999, he founded Patrick Remy Studio, specializing in consulting and iconographic research for luxury brands and advertising agencies.

Patrick also collaborates with publishing houses such as Steidl, Prestel, Louis Vuitton, Rizzoli and Taschen. He has published about fifty books, including monographs devoted to Steve Hiett, Saul Leiter, Jonas Mekas, Massimo Vitali, Max Pam, Gerard Malanga, Guido Mocafico, Bettina Rheims, Jeanloup Sieff, Valérie Belin, Hiromix, Sonia Sieff, Kishin Shinoyama, Helmut Newton, Daidō Moriyama.

He is also the author of *The Art of Fashion Photography* (2014) and *Desire: New Erotic Photography* (2015).

He lives and works in Paris.

Antiglossy : Fashion Photography Now
Copyright © 2019 Patrick Remy

Art Direction and Editing : Patrick Remy
Graphic Design : Myriam Combier
Translation : Frédérique Destribats

For Rizzoli International Publications :

Editor : Ian Luna
Project Editor : Meaghan McGovern
Copy Editor : Mary Ellen Wilson
Production : Maria Pia Gramaglia and Barbara Sadick
Design Coordination : Kayleigh Jankowski and Olivia Russin

Publisher : Charles Miers

First published in the United States of America
by Rizzoli International Publications, Inc.
300 Park Avenue South, New York, NY 10010
www.rizzoliusa.com

Printed in Italy

2019 2020 2021 2022 / 10 9 8 7 6 5 4 3 2 1
Library of Congress Control Number : 2018961653
ISBN : 978-0-8478-6459-1